AMERICAN
FASHION
ACCESSORIES

© 2008 Assouline Publishing
601 West 26th Street, 18th floor
New York, NY 10001, USA
Tel.: 212 989-6810 Fax: 212 647-0005
www.assouline.com

Printed in China

ISBN: 978 275940 2861

CANDY PRATTS PRICE

AMERICAN FASHION ACCESSORIES

COUNCIL OF FASHION DESIGNERS OF AMERICA

JESSICA GLASSCOCK **ART TAVEE**

ASSOULINE

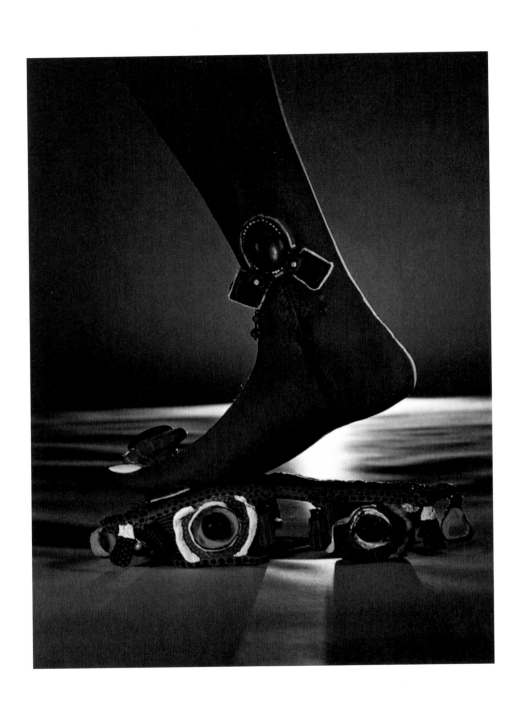

CONTENTS

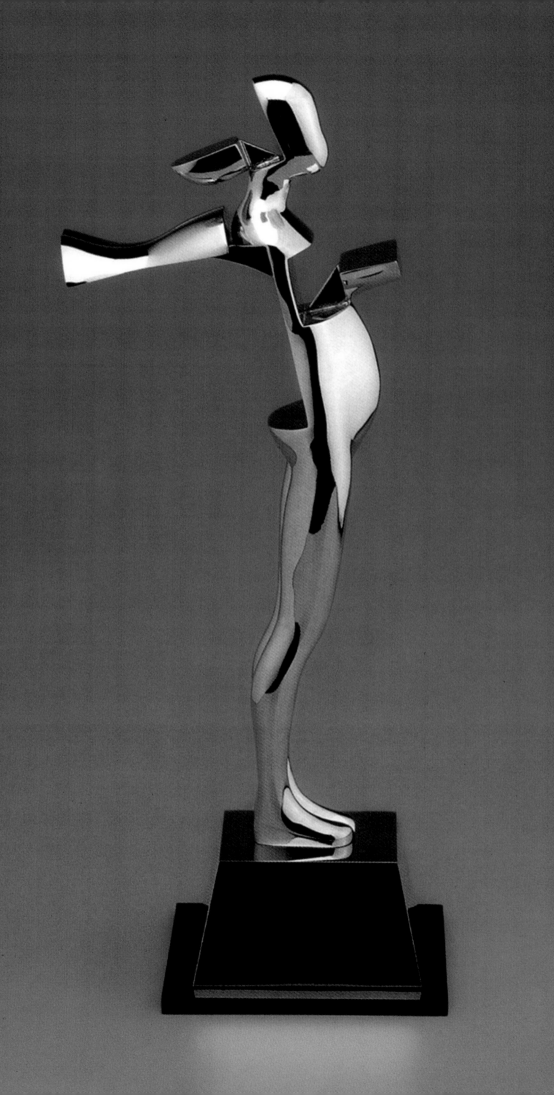

LETTER FROM CFDA VICE PRESIDENT

Reed Krakoff

I have been fortunate, both as an observer and as a participant during my tenure as President and Executive Creative Director of Coach, to witness first-hand the unprecedented rise in "stature" that accessories have been privy to.

We are living in a time that has seen the growth of accessories to superstar status, though in truth they have always played a vital role. Accessories have become fetish objects, signature pieces that continually reinforce and reiterate individual identity. Totems of the modern age, they telegraph tribal allegiances and personal style—all while performing the ultimate service of actually being useful. In the past decade or so, accessories have flooded the zeitgeist. Each season's new crop of "It" pieces is hotly anticipated by avid collectors. So great is the demand and so fertile the marketplace that many ready-to-wear designers have also thrown their hats into the accessories ring. The creative outpouring has been enormous and inspired.

This book, which was commissioned by the Council of Fashion Designers of America, is a testament that American accessories are major players on the world stage. As the Vice President of the CFDA, I have seen each year an increasing presence of every category of accessories in our organization. The strength of American fashion is a tribute to the efforts of the CFDA, a tireless advocate that does so much to create awareness and enhance the image of our industry.

A special thanks to our editor Candy Pratts Price. And finally, thank you to my fellow CFDA members whose imagination and innovation and talent is evidenced throughout this book. I am proud to be counted among you.

Left The Trova, designed by Ernest Trova, is the statue presented to each CFDA Fashion Award winner. Held annually since 1981, the CFDA Fashion Awards are the highest honor that can be bestowed on a member of the fashion community.

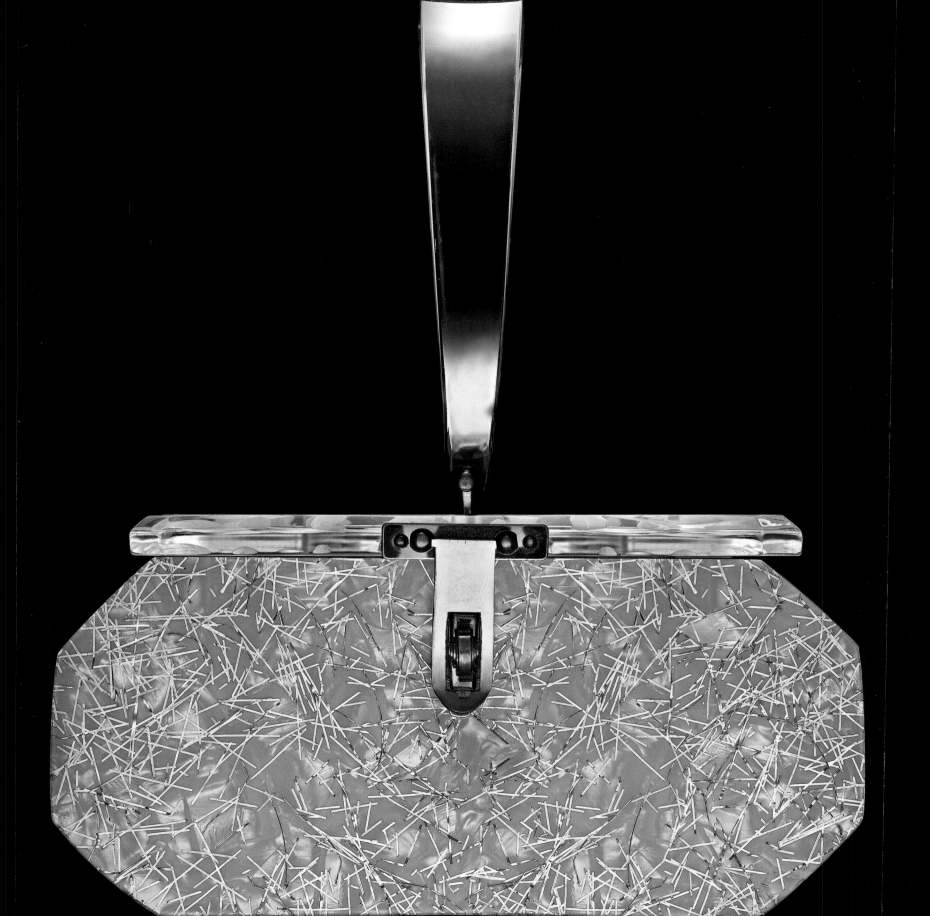

INNOVATION

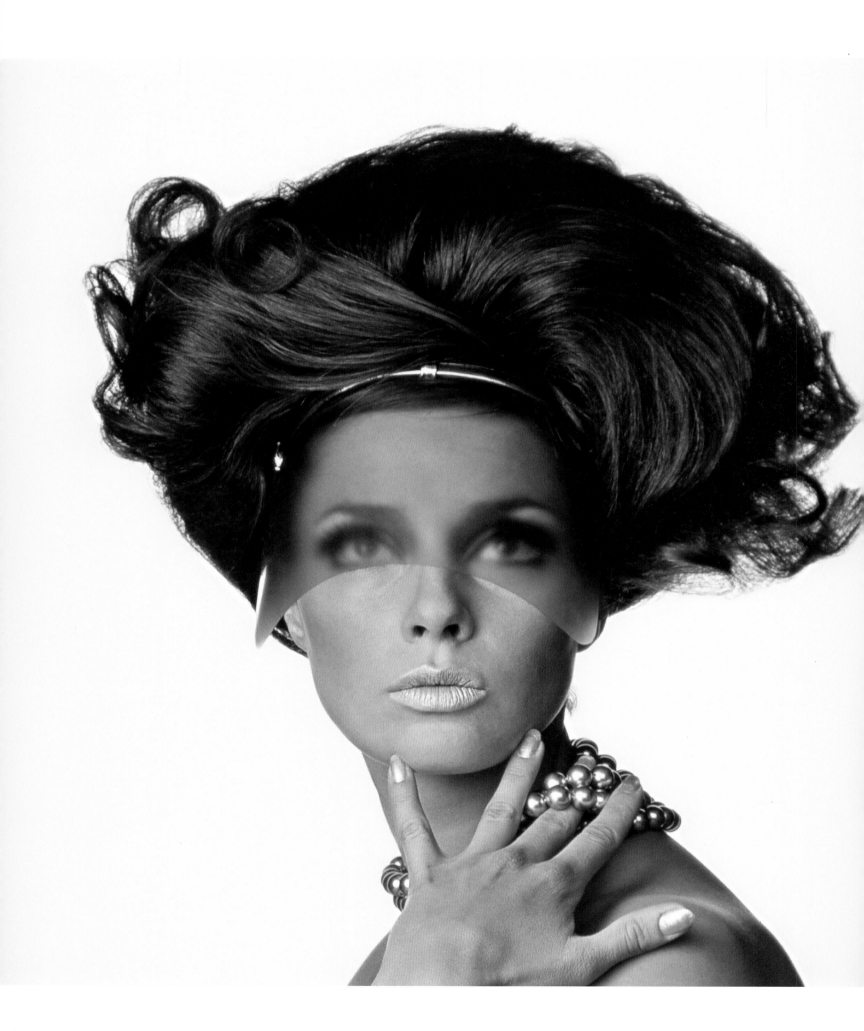

THE AMERICAN ACCESSORY AND
INNOVATION

In the early 1930s, E.I. du Pont de Nemours and Company sent one of its research chemists on a secret mission. The goal was no less than the transformation of an American accessory. He took an overnight train and slept next to the samples—the result of extensive experimentation in the DuPont labs. In the morning, he arrived at a commercial knitting mill. DuPont's mysterious, closely guarded cargo was nylon, and test runs at the mill proved that it would be ideal for the production of women's hosiery. After careful development, the final product went on sale in 1940, and women lined up at stores around the country. A few years later, American soldiers took the silky hose overseas to trade for all the European kisses they could handle. Thus it was that silk stockings, a luxury accessory with a European tradition dating back to Queen Elizabeth I, faded into oblivion. Only in America would men in white lab coats change the face of fashion.

That companies such as DuPont could enter into the story of the American accessory underscores America's unique role in the history of fashion: It is not exclusively beholden to past traditions. These calcified hierarchies of craftsmanship are distinctly European. But the American accessory designer does not believe there is only one right way to tan leather, to block a hat, or to build a shoe last. The only right way to design the American accessory is to answer one simple question: What works? Of course, this approach is a natural consequence of designing for Americans—a people with a short history, an advanced technology, a media obsession, and a fighting spirit. The American accessory need not be traditional or classic (though it can be). It is not wed to centuries of unchanging techniques. It is always new: a new design, a new medium, a new way of manufacturing, even a new way of wearing the old. The history and the tradition of the American accessory is one of innovation. And stories of innovation are the foundation of the bags, the shoes, and the jewelry that are celebrated in this book.

In the American design ethic of innovation, one of the first necessities is always functionality. In America, things have to work. This was especially true in the early years of the country's history, when there was a vast ocean between the United States and the Old Country,

Left **Visor, 1960s** A woman's crowning glory: here both a functionalist visor and an epic hairstyle by Kenneth Hair Salon vie for the title. *Previous page, left* **Florida Handbags, 1950s** Lucite, from which the body of this glitzy little purse is molded, was a plastic developed in the laboratories of DuPont in 1931. Though it made elegant accessories, it was originally intended to form the nose cone of an American bomber jet.

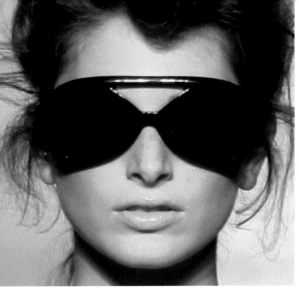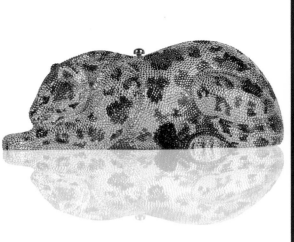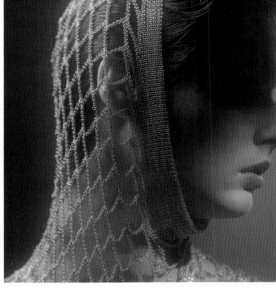

from whence, in the minds of the most dedicated followers of fashion, all style emerged. From the very beginning, American designers had to work twice as hard even to be thought of as second-best, always laboring to produce things that worked better and lasted longer. This zealous industriousness led to extraordinary innovations in the creation of those most pragmatic of accessories, shoes and bags. America's first offering to the world history of accessories was the carpetbag, introduced around the 1850s as a man's traveling bag. This piece started out with a dual purpose: Not just luggage, it could also be opened and used as a blanket during overnight travel and then latched up at the sides the morning after (a mercy during an era when railroad cars were not consistently heated). The version made famous in the aftermath of the Civil War by northern "Carpetbaggers" seeking profits during the reconstruction of the southern states was a remnant of a textile, usually a Brussels carpet, sewn up at the sides and sturdily affixed with a handle. This simple expression of American ingenuity could withstand a rough ride in the back of a horse-drawn conveyance and still protect all within. While perhaps not the most high-style manifestation of American design, the carpetbag was certainly ubiquitous, turning up in the hands of everyone from hawkers of dubious medicines to traveling men and women fulfilling Manifest Destiny. A carpetbag is also the magical carryall of America's favorite fictional nanny, Mary Poppins.

Other mass-manufactured bags created in America followed this ethos of practicality. The nineteenth-century "handbag" was, in fact, more often the product of a luggage or a leather-goods concern than of a high-style designer. It represented work, travel, and industriousness, rather than any pretension of luxury. The luxury handbags were relegated to evenings, and they were commonly homemade. One example is the hand-embroidered reticule. Of European origin, it was made many times over by American housewives in an

Left **Cynthia Rowley, 2006** Cynthia Rowley's take on sunglasses, invented in the ancient world but perfected in America. *Center* **Judith Leiber** The innovations of Judith Leiber come in only the most luxurious of materials. In the case of this snow leopard minaudiere, there are over 15,000 hand-beaded crystals to prove the point. *Right* **Ricky Serbin, 1986** The scarf, reinvented as a 14K gold head wrap.

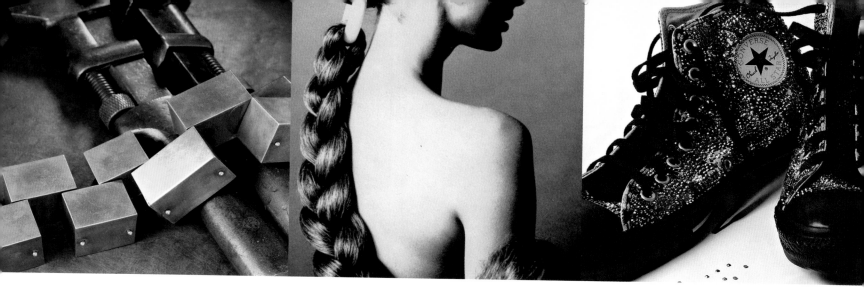

era when a hobby of fine needlework was considered an acceptable substitute for more worldly endeavors such as voting and having one's own bank account.

As women's roles shifted in the twentieth century, however, the high-style handbag came under the purview of American mass production. Of course, store-bought evening bags had been available previously, either as French imports or as productions of American dressmakers who affected French accents even if they were born on New York's Lower East Side; but these were imitation, not innovation. Into this breach came the most elegant of American contributions to evening accessories: the Whiting and Davis mesh bag. Based on expensively handmade metal mesh bags originating in the European gold and silver workshops of the 1820s, these were at first made of hand-linked precious metals. Then, in 1908, an American inventor, A. C. Pratt, patented a machine that made it possible to inexpensively produce metal mesh. Whiting and Davis, established in Massachusetts since 1876, purchased the patent and began making metal mesh bags in the 1910s. Its bags, no longer made of gold and silver but of base metals, ranged widely in style. Some epitomized clean Art Deco designs; others were overprinted with more feminine images such as Victorian-era flowers. In the 1960s, these same mesh bags were enamel-covered in pop-art colors. By the 1970s, they were simply polished to a high sheen in silver—a liquid-and-silken accompaniment to the polyester disco dress. Whiting and Davis even dabbled in clothing, of a sort, when it made armor for Ingrid Bergman's Joan in the 1948 film *Joan of Arc*. Though Whiting and Davis is mainly a wholesale supplier today, its bags are still available—not a bad run on one good patent.

This combination of ingenuity and elegance suffuses the history of the American bag, designed by makers both well-known and unknown. The use of a simple zipper (invented by an American, Whitcomb L. Judson, in 1893, and originally called a "clasp locker") as a closure for the handbag

Left **Robert Lee Morris, 1986** This photo of Robert Lee Morris's bracelet reveals the inspiration he takes from outside the traditional realm of fashion. He has found beauty not in flowers and fabrics, but in tools and architecture. *Center* **Dynel hairpiece, 1960s** In the 1960s, plastic was so ubiquitous as to even invade the fantastical hairstyles of the era. *Right* **David Dion, 2007** These classic American sneakers have gotten the all-star treatment from designer David Dion: The camouflage print has been covered in Swarovski crystals.

was introduced in 1923 in New York. While not exactly motivated by elegance (according to the handbag historian Caroline Cox, the zippers were added not as a technical innovation per se, but to break a strike by unionized handbag framers), the aesthetic soundness of the innovation was confirmed when Hermès, the French high-fashion house, placed a zipper on its Bolide bag that same year. A similar development was the introduction of a variety of pragmatic compartments into handbags—from Judith Leiber's whimsical secret compartment in her "007" bag to Bonnie Cashin's more refined designs for Coach. While the idea of specific compartments dates back to the luggage-based bags of the nineteenth century, Cashin's designs brought particularly appealing innovations to the necessity of managing one's essentials such as gloves, pens, calendars, and loose change. During her tenure at Coach, from 1962 to 1975, she combined the frivolity of bright playful colors with the functionality of mix-and-match bags in multiple sizes and exterior-attached change purses.

For shoes, the American accessory designer has also used novel solutions to create high style. Little known, but most important, William Young of Philadelphia came up with a set of right and left shoe lasts, which went into production in 1822, raising the bar for comfort in footwear. By the 1850s, a series of American inventions began to transform the shoe industry, including leather rolling machines, strip cutters, pegging machines, and specially adapted sewing machines. Still, the shoe historian Nancy E. Rexford recounts that American women remained convinced of the superiority of French shoes throughout most of the nineteenth century. They demanded French shoes even when none were offered, leading American shoe sellers to also manufacture "French" labels. The not-so-discerning consumers judged their counterfeits approvingly, praising and purchasing shoes they had previously rejected because of an American label. By the 1890s, American shoe manufacturers had standardized their production methods to the extent that they could quickly create dozens of styles. This ended the dependence on imported French shoes and led to rapid changes in American footwear fashion-trends. More important, it democratized the shoe market and made good shoes a wardrobe staple everyone could afford. (This was a particularly fortunate state of affairs as women's hemlines began to rise in the 1910s.)

American shoes also benefited from innovations in materials. While designers such as Beth Levine and David Evins led the high-style shoe market in the United States by introducing vinyl and stretch materials, a century earlier, the American inventor Charles Goodyear created the sole of that most American of shoes: the sneaker. In 1839, Goodyear discovered the vulcanization process of curing rubber (in which the properties of natural or synthetic rubber are made stable for wider applications). The resulting product was incorporated into footwear in the 1860s during a fad for croquet, when rubber soles were attached to canvas uppers in both slip-on and

Right **Sunglasses** Though sunglasses and visors are often indicative of Hollywood glamour, the apparatus in this Hiro photo captures the space-age quality of the accessory. The high-tech potential of sunglasses was also on the mind of American inventor Edwin Land when he thought to apply his light-polarizing technology to their lenses. His improvement became the first major commercial hit for the Polaroid company when they began manufacturing Polaroid Day Glasses in 1937.

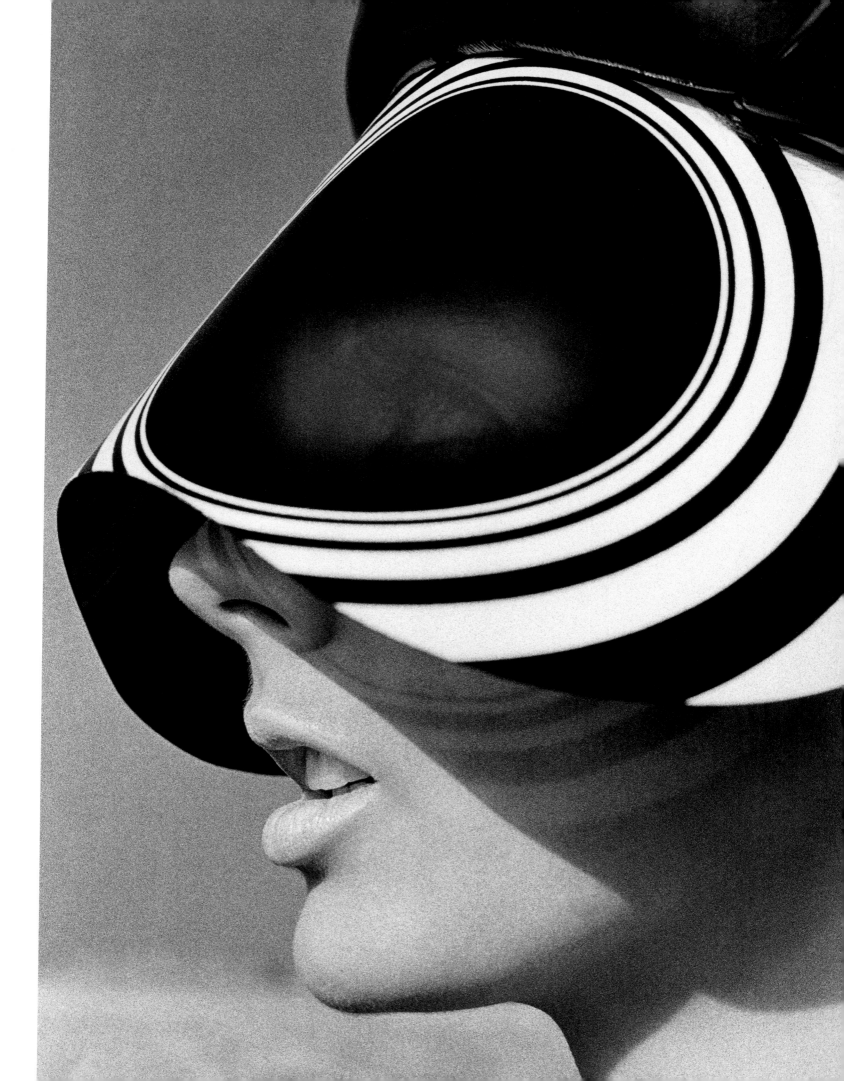

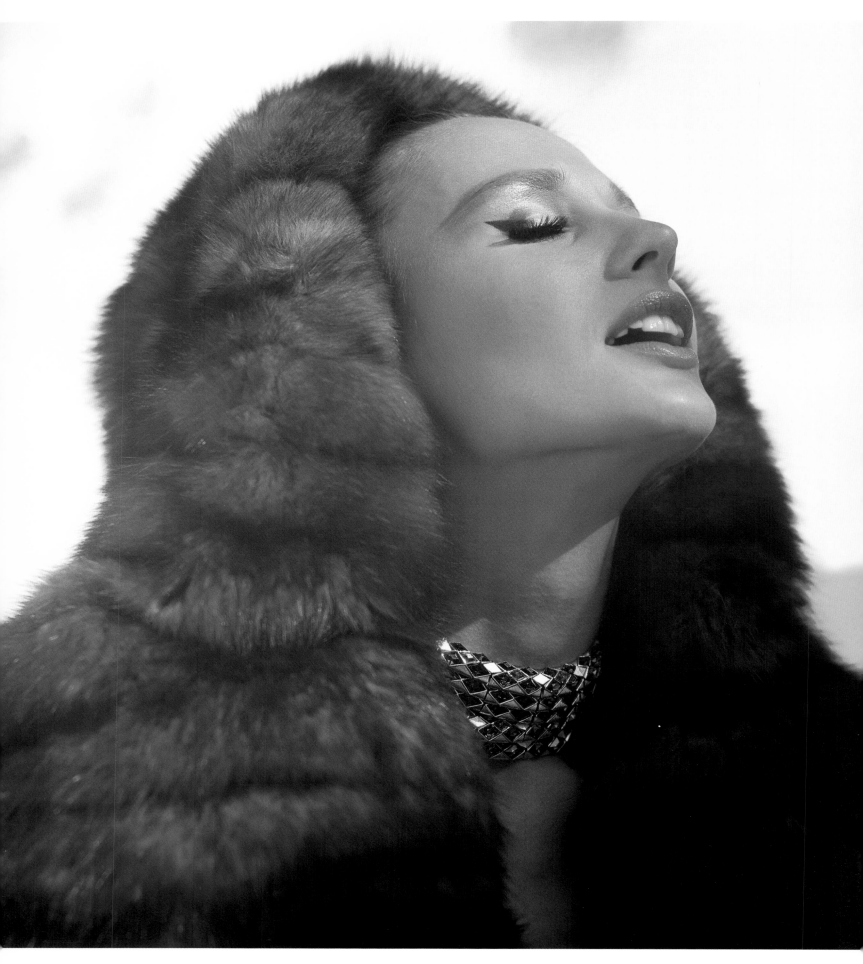

lace-up styles. By 1892, nine producers of Goodyear's discovery merged to form the unglamorously named U.S. Rubber Company (now Uniroyal). As a sideline to its bicycle-tire production (the company's bread and butter before it started making automobile tires), U.S. Rubber introduced Keds sneakers in 1917. Based on the "croquet sandal," the casual shoe was aimed at the children's and sports markets. From those humble beginnings, the sneaker slowly evolved into an iconic American shoe, often through technical innovation. The Converse Rubber Shoe Company introduced its version of the sneaker in the late 1910s, aiming for the more serious sportsman and the high-school basketball player. Converse soon redesigned the shoe at the suggestion of company salesman and basketball player, Charles H. "Chuck" Taylor, so that it offered more flexibility and an ankle-protecting patch. Blocked from selling in the department stores by U.S. Rubber, Converse pursued relationships with sporting-goods stores that helped to solidify its reputation as the serious sports-shoemaker by the 1930s. Meanwhile, Chuck Taylor's name went on the round patch of his sneaker, the Chuck Taylor All-Star, which has to date sold in the millions (though Taylor himself received only his salesman's salary in recompense). In the 1960s, the Vans sneaker company injected the concept of customization into the American athletic shoe, a practice initiated after a nitpicky customer found Van's existing color selection to be a shade off from what she wanted. The company owner suggested that she bring in her own fabrics, from which Vans would create a custom sneaker—at an extra charge. This marked the birth of the high-style sneaker, as expressive of personal identity as it was of athletic ability. And of course, Nike introduced multiple innovations (most famously the high-traction waffle sole), taking the American sneaker into the space age while constantly offering new colors, styles, and functions to its customers. The sneaker is classic American techno-fashion. In recent years it has achieved status as a collectible and as a valid fashion obsession, embraced by such contemporary high-style designers as Edmundo Castillo, a collector of the Vans line; Marc Jacobs, who created a series of designs for Vans in 2006 and 2007; John Varvatos, whose collaboration with Converse began in 2002; and Maria Cornejo, Imitation of Christ, and Nanette Lepore, all of whom utilized collaboratively designed Keds for their runway shows in recent years.

Though American designers have proven adept at producing necessities, the story of the American accessory designer's ingenuity can also be told through the design of the richest indulgence: jewelry. American jewelry begins with Tiffany & Co., founded in 1837. At first, its products were beholden to European influences (designers used tried-and-true techniques made American only by rendering, say, the bald eagle, rather than a European raptor). In 1886, the company introduced its first namesake innovation: the "Tiffany Setting," a six-prong diamond solitaire engagement ring in which the jewel was raised up from the shank of the ring,

Left **Trifari, 1963** This pairing of a Trifari costume jewelry necklace with a natural Russian sable fur shows just how successful American costume jewelry designers were in achieving high glamour even in glass, paste, and base metals.

highlighting the brilliance of the Tiffany diamond. Then came the work of Louis Comfort Tiffany, who established the Tiffany Art Jewelry department in 1902. In accordance with the new freedoms of the Art Nouveau movement, Louis Comfort Tiffany moved toward more prosaic materials in the design of fine jewelry. He introduced Favrile glass, an iridescent material created by mixing variously colored glasses together while in their molten states. This method was exemplary of the particular skill set of the American designer: It was a technical innovation that offered unique novelty folded into a method of manufacturing which would ultimately make jewelry in America a more accessible luxury. The history of Tiffany & Co. has been well documented, but it is worth noting again the prodigious talent that has marched through the company: Paulding Farnham, whose innovative nineteenth-century enamel techniques were adopted into mass production in the United States; Jean Schlumberger, whose fanciful creations were worn by quintessential American royalty such as Elizabeth Taylor; Donald Claflin, whose playful animal pieces rendered in gemstones evoke the pop influence of Disney cartoons; Paloma Picasso, whose exclamatory pieces redefined the scale of fashion jewelry; and Elsa Peretti, who created miniature modernist sculptures. Indeed, Peretti's "Diamonds by the Yard" may well be the ultimate expression of American acquisitive pleasure in un-necessities, and it was Tiffany that provided these luxuries while making itself the centerpiece of feminine sartorial ambition, all enclosed in perhaps its most influential design: the simple blue box. Tiffany's designers also illustrate another important component of the success story of the American design ethic: the embrace of immigrants. Tiffany & Co. recognized the talent of the Europeans Schlumberger, Peretti, and Picasso and recruited them. As much as Americans emphasized innovation, Tiffany recognized that quality could be most magical when combined with the skill set provided by the influx of master craftspeople immigrating from Europe, looking for a better way to create.

Raymond C. Yard also followed the fine jewelry tradition in America, adorning everyone from the Rockefellers to Joan Crawford. (She returned the favor by wearing his jewels in her films—partly as proof that Joan Crawford did not borrow jewelry, which was a significant matter for a striver like her). Yard's work ran the stylistic gamut from simple pearls to playful *Alice in Wonderland*-esque anthropomorphized rabbits, always emphasizing expensive gemstones and perfectly formed pearls. As Yard established his fine jewelry business in the 1920s, an entirely different American jewelry business had developed in the unlikely locations of Newark, New Jersey, and Providence, Rhode Island. The emphasis on innovative techniques that is integral to the American design ethic was also being exploited in the mass production of jewelry. If everyone could not be a Rockefeller or a movie star, then perhaps everyone might at least purchase a

Right **Vision Unlimited, 1972** Lucite had its heyday in accessories in the 1950s, but here composes the frames of a pair of oversized sunglasses. Though cheaper plastics were available, the warmth and weight of Lucite continued to draw fans.

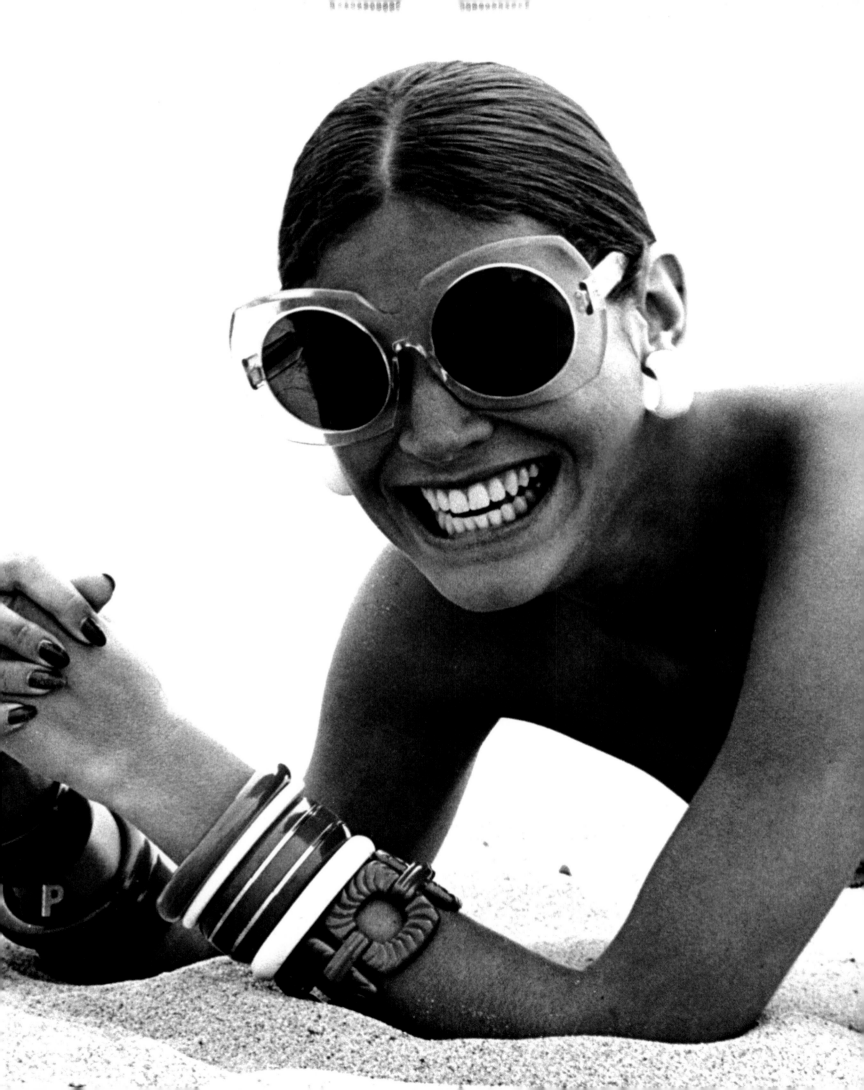

diamond (or rather, glass) brooch approximating the one worn by Joan Crawford. Such a dream was made possible in the East Coast workshops founded by European immigrant metalworkers who were primed to combine Old World craftsmanship with the lucrative possibilities of mass production. As America gained a sense of itself as a world power in the 1920s, inspired by the glamour of its own Hollywood stars and the spectacular flappers, fabulous fakery was embraced and costume jewelry rose in popularity. The trend was given the French imprimatur by Coco Chanel's proclamations in favor of the faux, but it was the American system of mass production that made it possible. The early decades of the twentieth century saw the founding of several high-style costume jewelry concerns in the United States, including the Monocraft Products Company (later Monet), Coro (later Corocraft), Trifari, and Eisenberg Jewelry. The American jewelers launched with the flappers, but their work reached its apotheosis in the consumers' paradise of the 1950s, when costume-jewelry parures were de rigueur—even in high society. This trend was cemented by the popularization of higher quality costume jewelry available from Miriam Haskell, Nettie Rosenstein, and Hattie Carnegie.

High-style and costume jewelry continued to come together in the work of Arnold Scaasi, who began designing costume pieces in 1958, when he created a series of butterflies—necklaces, pins, headpieces—to match butterfly-motif fabrics he was using. This led to a four-year foray into the world of costume jewelry during which time the designer devoted half of every Saturday to selecting stones and building prototype pieces with Jacques the Jeweler. In 1962, Scaasi finally asked his salesman how the jewelry was doing. "Oh the jewelry is doing just great," the salesman replied.

"How much money did we make on it this year?" Scaasi asked.

"Oh, we never made any money on it, but we always broke even. It didn't cost you anything," was the response.

"It cost me every fucking Saturday of my life the past four years, are you crazy?" Scaasi proclaimed. Scassi then dropped out of the costume jewelry business, but not before recommending Jacques the Jeweler to his good friend Kenneth Jay Lane. Lane had been designing shoes for Delman under the tutelage of the French master Roger Vivier, a task that included mastering the art of mass-producing Vivier's rhinestone heel. Lane's reappropriation of techniques applied to shoes along with his canny use of the preexisting costume jewelry industry in the United States would make him one of the most innovative designers of the century. He had that particularly American voracity that made him willing to try anything and use everything. Thus, his early designs set rhinestones over inexpensive compressed-cotton bases to make earrings and bracelets. He made his first faux-baroque pearls by coating metal with pearlized nail polish. He bought

Left **John Varvatos for Converse, 2007** The Converse sneaker has had the reverse trajectory of most accessories: it has inspired the design of clothing in the John Varvatos for Converse T-shirt shown here.

bracelets at the five-and-ten store and had them covered in rhinestones or snakeskin, just as one would shoes. To his catholic embrace of technique, Lane added the eye of an American on a perpetual Grand Tour, incorporating into his designs everything he saw—from Parisian society ballrooms to the museums of Europe to journeys to the Far East. He came, he saw, and he returned to America to make jewelry for everyone from Diana Vreeland to the dentist's receptionist. This was the design of the American dream.

Populism also plays a part in the history of another great medium for the American accessory: plastic. Technically defined as "organic synthetic or processed materials that are mostly thermoplastic or thermosetting polymers of high molecular weight which can be molded into set shapes," various formulations of plastics have been developed and utilized since the nineteenth century. Early plastics like celluloid and casein were created as inexpensive substitutes for horn, ivory, and tortoiseshell. Though cheap, these alternative substances were far from perfect. Celluloid in particular is highly flammable. In 1907, a new, more-stable formulation was developed when Leo Hendrick Baekeland, a Belgian-born chemist-entrepreneur living near Yonkers, New York, perfected a plastic that could be molded and, once hardened, set for life. He named the substance Bakelite and founded the General Bakelite Company to produce it. Bakelite jewelry pieces, later produced in more vibrant colors under the name Catalin by Reichhold Chemicals, are now collectibles, but in the 1920s they were the apex of modernity. Far from cheap, the material was commonly hand-carved and polished to perfection before being sold in department stores. Bakelite was used to make not only bangle bracelets, necklaces, makeup compacts, and shoe heels, but also radios and razors. Its malleability and amenability to all the colors of the spectrum made it prized both for its ability to imitate more expensive materials such as pearls, jade, carnelian, and goldstone and also as a high-tech material in and of itself.

The fact that Bakelite was not cheap led to its decline as cheaper plastics were invented. Lucite was the next popular plastic to emerge. Created at the DuPont laboratories in 1931, Lucite was an unlikely candidate for accessories production; its original intended use was for windshields, nose cones, and gunner turrets for bombers and fighter planes. But the material was, like Bakelite, fully moldable and could accept brilliant color during its manufacture. Lucite emerged in jewelry, transparent shoe heels, and most magnificently in purses in the 1950s. Some of the important designers in the forefront of this trend were Patricia of Miami, Rialto, Dorset Rex, Charles S. Kahn, and Llewellyn, but the standout was Will Hardy of Wilardy. According to the handbag historian Anna Johnson, Hardy discovered Lucite when he built a birdcage out of the material at age twelve. This led him to experiment with the medium until he

Right **Kenneth Jay Lane, 1992** Here, Kenneth Jay Lane has added a note of glorious excess to a black Bill Blass dress. Lane's inspiration for this piece was the eighteenth century high style of Marie Antoinette, but his jewelry can go from Versailles, to the pyramids of ancient Egypt, to the New York of the Roaring Twenties and back again. He shows the omnivorious appetite for inspiration typical of the American accessory designer.

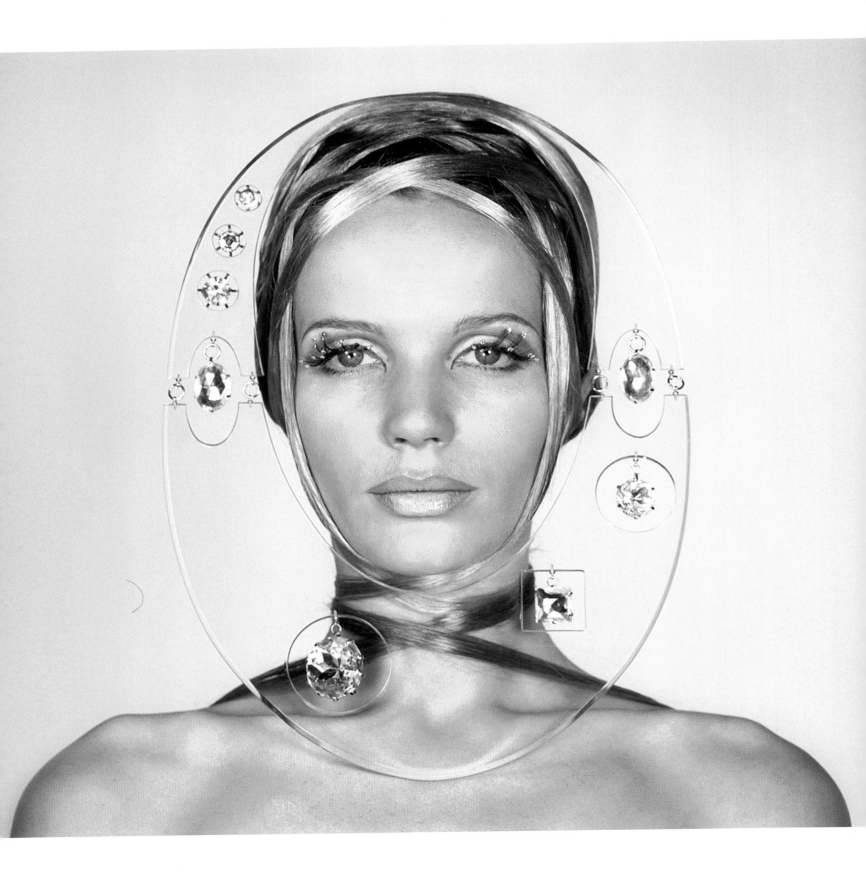

developed the Wilardy line: a collection of small, flashy purses in pearlescent colors. Classic 1950s Americana, the bags were embraced by pampered Barbie girls of the decade, who valued them because, as Johnson succinctly put it in *Handbags: The Power of the Purse*, "they were expensive, carried little, and tarnished easily. . . but looked fabulous." Indeed, the bags did have some drawbacks: They could be damaged by sunlight. Too much heat could even cause them to exude toxic liquid Lucite. Still, they were a triumph of design and technology, and as such have found an afterlife as collectibles.

Just as Lucite displaced Bakelite, in the 1960s the rage was for injection-molded plastics and PVC, both of which were used to make everything from blow-up furniture to shoulder-sweeping earrings, such as the plastic designs created by Giorgio di Sant'Angelo for DuPont. Shoe designers explored the possibilities of the new plastics as well when Beth Levine created her stretch-vinyl boots for Herbert Levine shoes. In this most plastic of decades, the adaptability to color and the fundamental cheapness of plastics were celebrated for the last time, as the phrase "Better living through chemistry" was transformed from a popular variation on a 1935 DuPont ad campaign to damnation by the countercultural rebellions of the late 1960s and early 1970s. As the values of disposability were called into question during the oil crisis of the 1970s, plastics lost their glossy appeal for consumers and designers alike and have since become a hidden material in most accessories. Still, some contemporary designers have embraced and revived the luxury plastics of the twentieth century. Patricia von Musulin uses Lucite alongside wood, silver, and rock crystal in her sculptural jewelry pieces. And the Lucite heel continues to be produced both as a common accessory for contemporary exotic dancers and in more high-style manifestations, such as Calvin Klein's 2004 version.

Finally, Americans made sunglasses, that iconic accessory of Hollywood stars. Certainly, tinted glasses had existed in the past, but the American scientist and inventor Edwin Land made them functional through the invention of inexpensive filters for the polarization of light. Land patented the process for making light-polarizing plastic sheets in 1929, foreseeing its use in photographic lenses. He showed it off to the American Optical Company, which signed a license agreement to use the polarizers for the making of sunglasses in 1935. Land established the Polaroid Corporation and began manufacturing Polaroid Day Glasses in 1937—sunglasses and sunglass lenses became Polaroid's first major commercial hit, selling more than a million pairs by 1939.

Better, faster, more: These are the demands of the American design ethic, and they drive achievement in the field of accessory design. The genius of American accessory designers is that they consistently meet this demand with style that can be embraced by the entire world.

Left **Giorgio di Sant' Angelo, 1968** Rendered in Lucite with rhinestones suspended within, this was the 1960s "Modern Tiara."

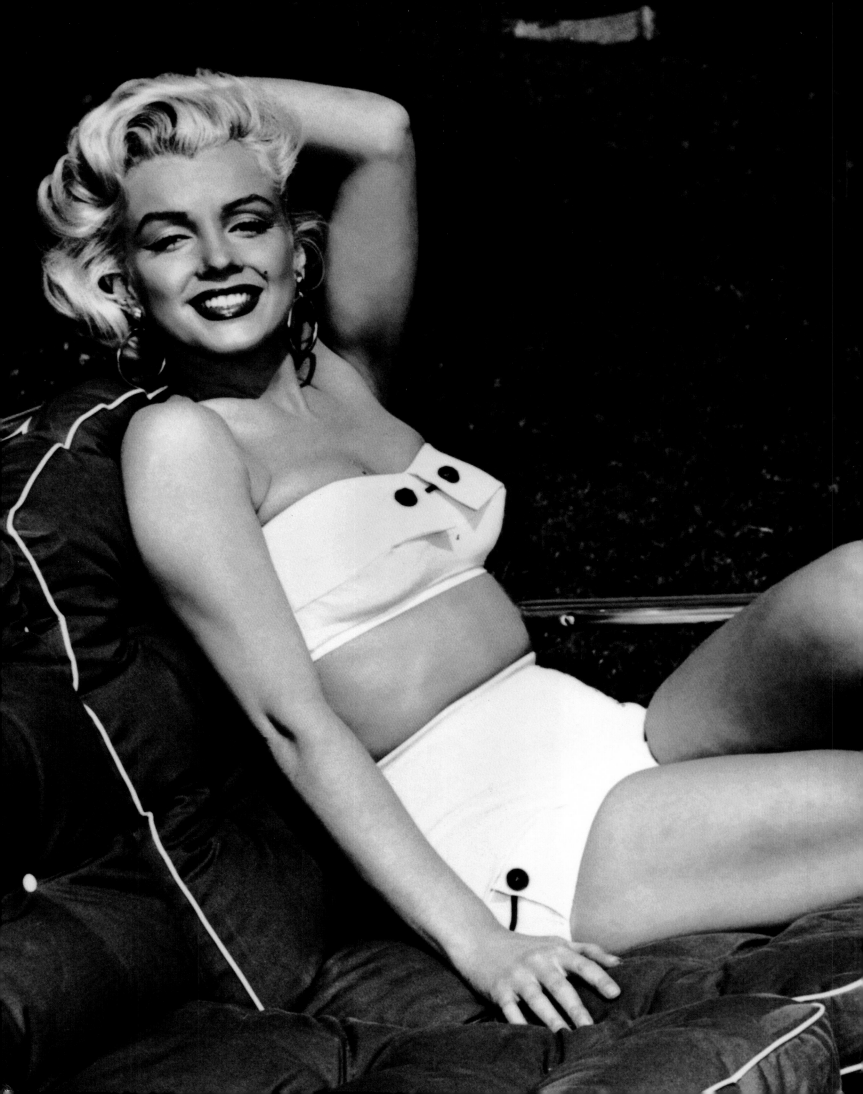

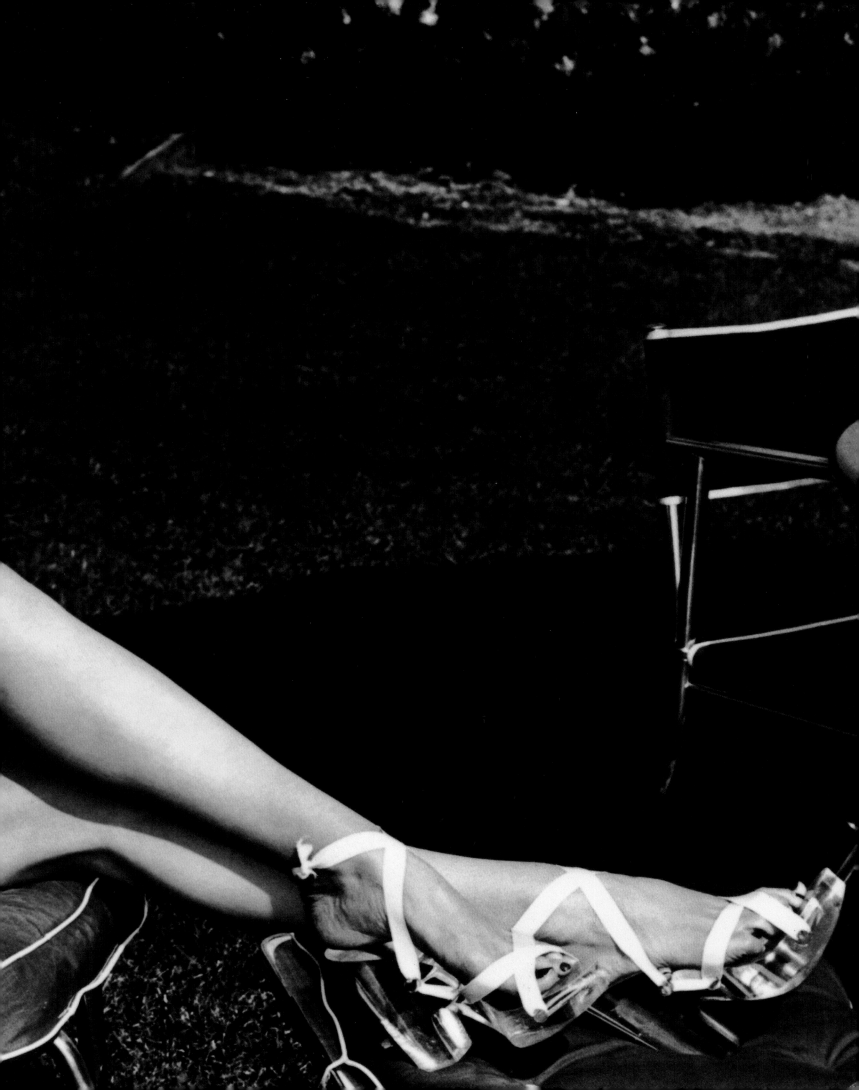

Publicity Stunt, 1949

Opposite Though they had every right, the DuPont company chose not to trademark the name "nylon," when their stockings made of the new polymer went on sale in 1940. The company thinking was that if the material's name was used freely, it would become synonymous with the stockings that were being revolutionized by it. That proved prescient, though it did not mean that other advertising wouldn't be utilized, as seen in the publicity stunt at right.

Marilyn Monroe in Lucite heels, early 1950s

Previous pages Marilyn Monroe may not have gotten her prince, but at least she found something like a glass slipper in these Lucite platforms, which reveal the versatility of this product of American chemistry.

Panty hose, 1998

Following pages Photographer Ellen von Unwerth locates nylon's eroticism in a mode probably not envisioned by the scientists at DuPont in the 1930s.

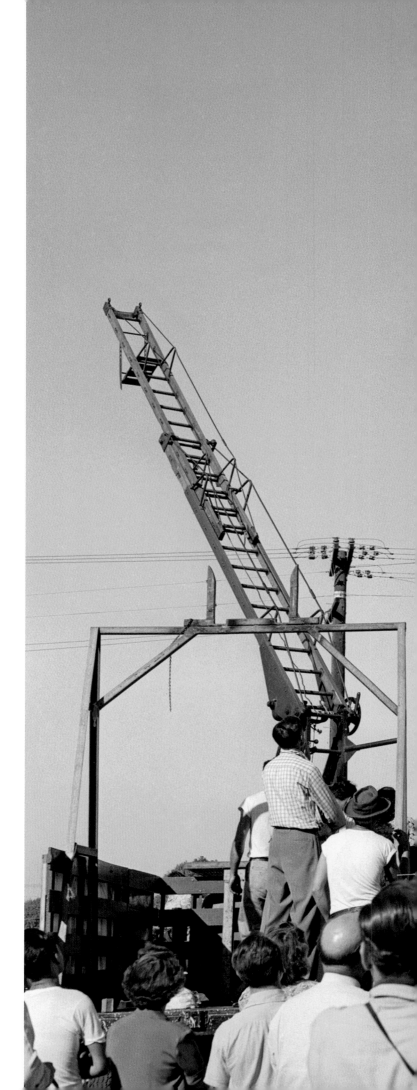

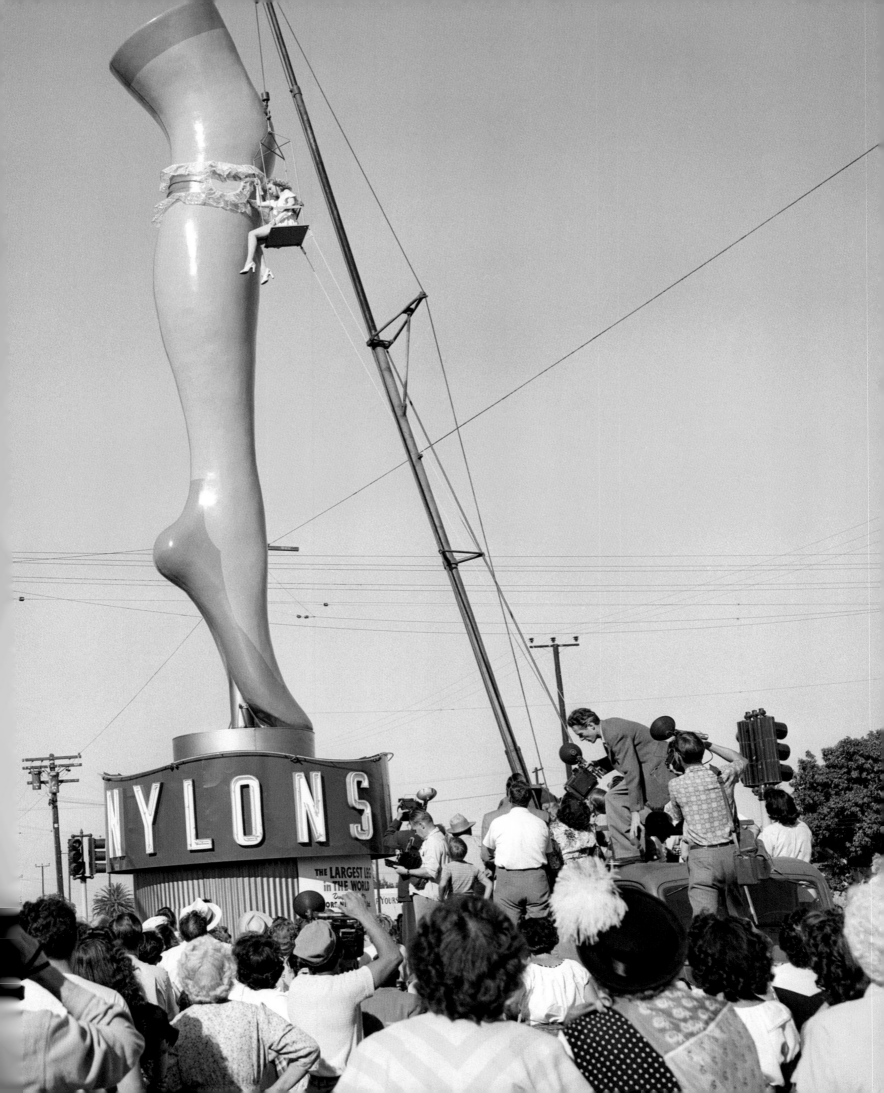

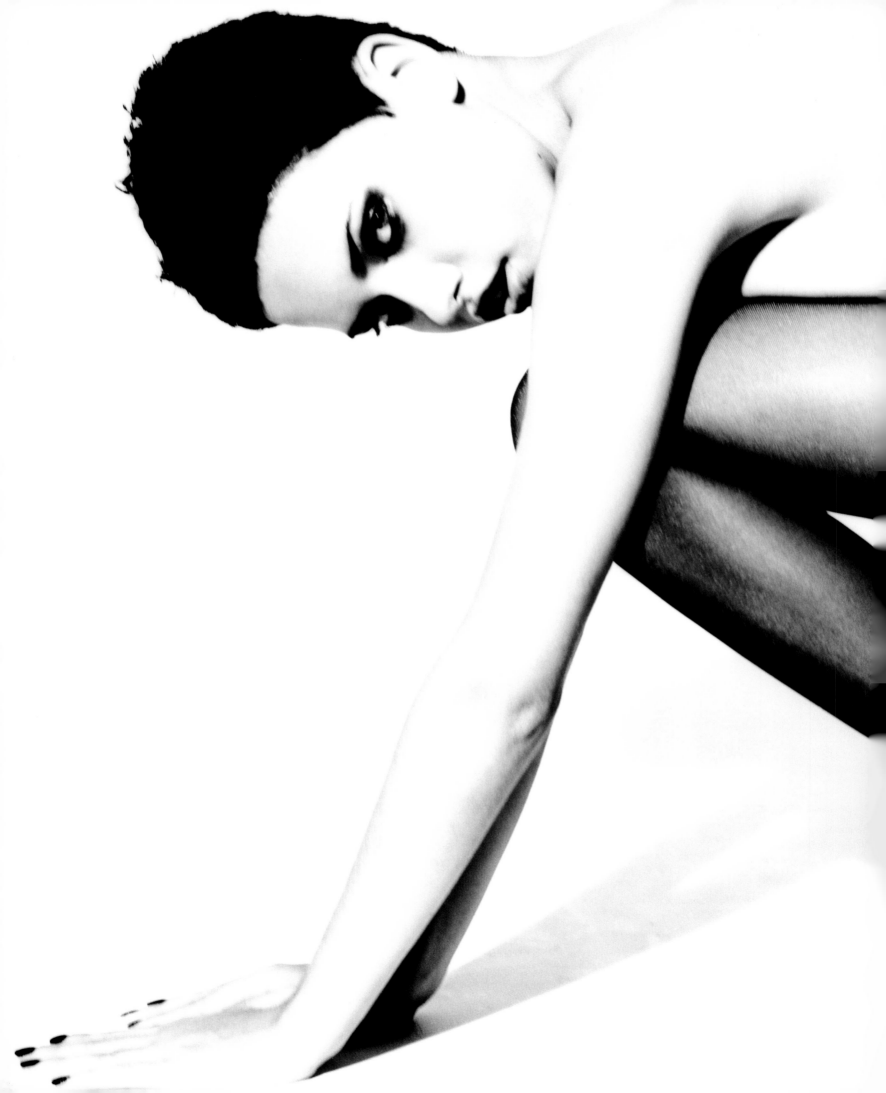

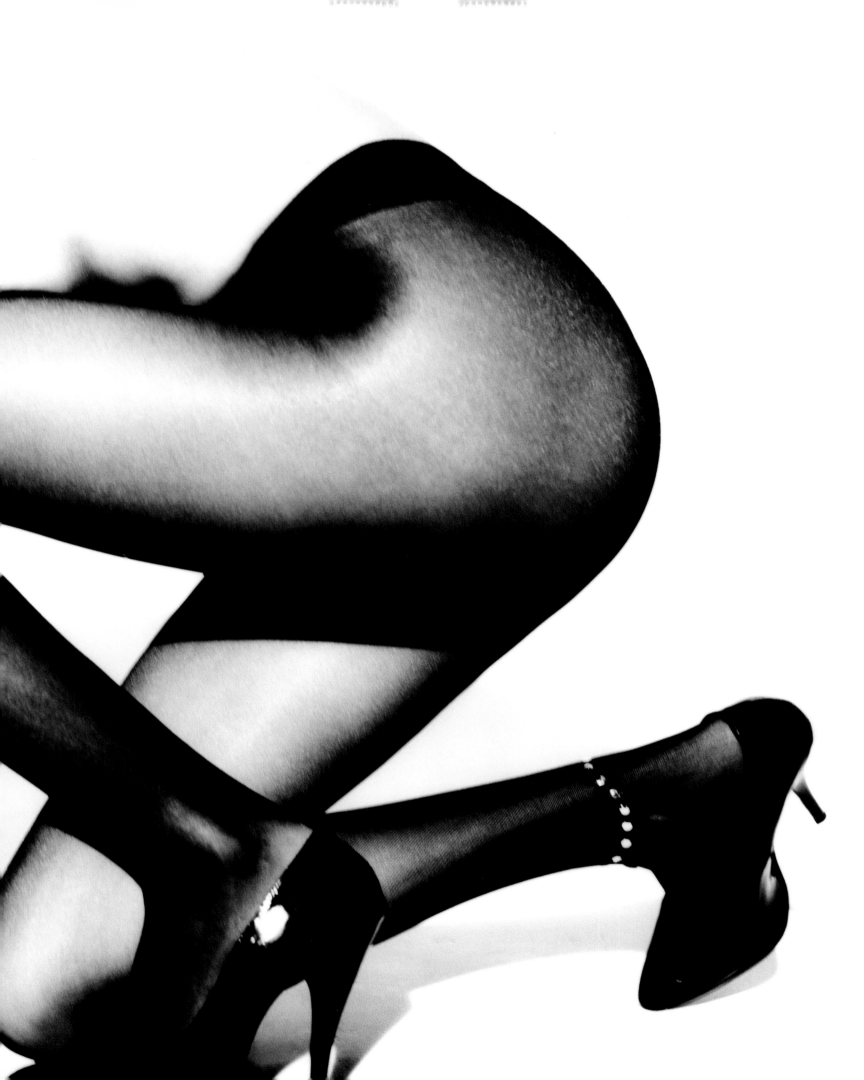

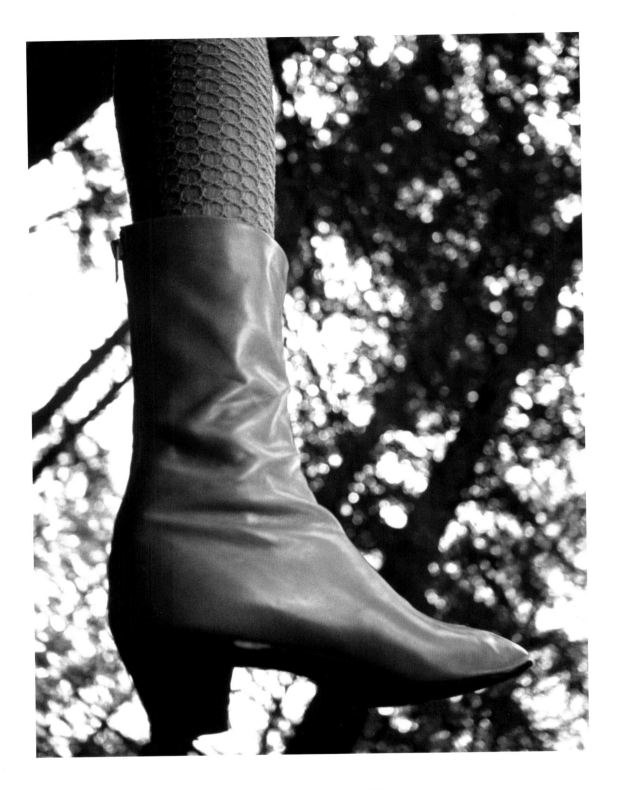

Herbert Levine, 1967

Above Shoes have been the object of American innovation since before the Declaration of Independence. From the invention of right and left shoe lasts in the nineteenth century to the free use of synthetic stretch fabrics by designers like Beth Levine for Herbert Levine in the early 1950s, the ability to rethink the possibilities of this most functional of accessories has been a hallmark of American design.

Playboy Heel, 1975

Opposite While not yet achieved quite as elegantly as in this image from *Playboy*, the ideal of the invisible shoe has been explored by several American designers, using materials as diverse as PVC and spirit gum.

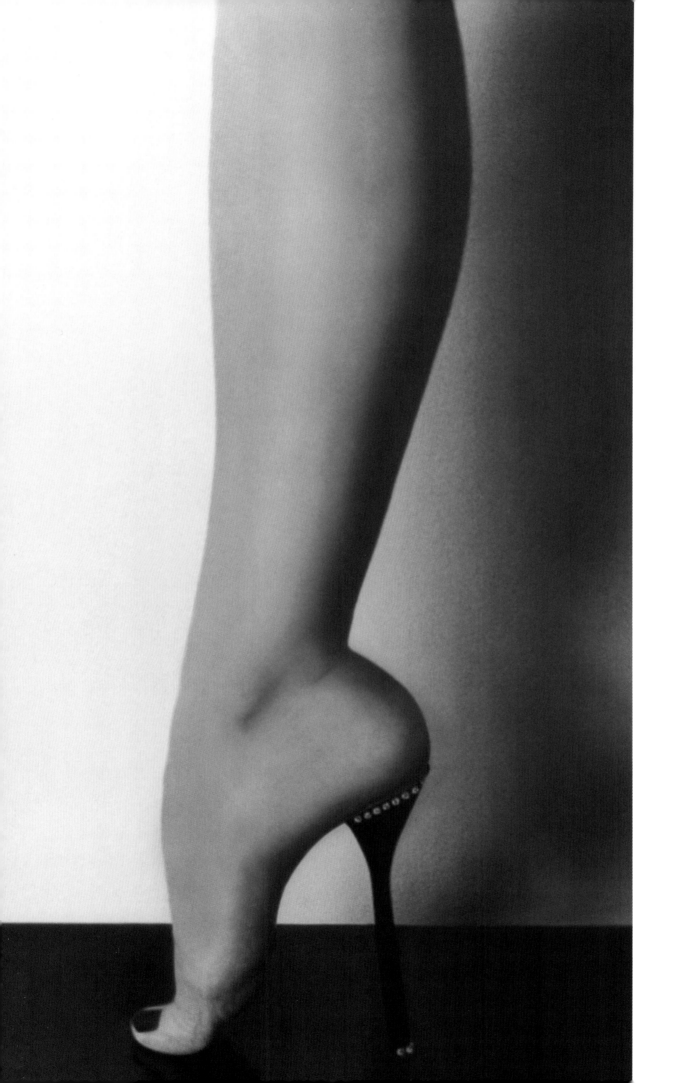

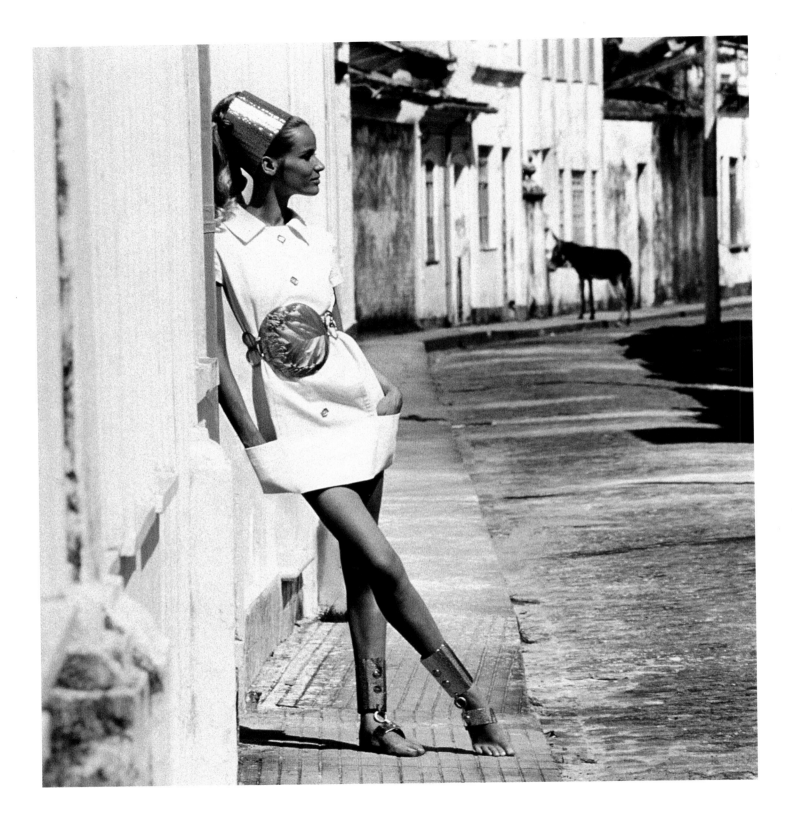

Giorgio di Sant' Angelo, 1968

Above American designers always show a willingness to explore prosaic materials, often with impressive results. Here, Giorgio di Sant' Angelo has used the decidedly non-precious metal of aluminum to fashion helmet, sandals, ankle cuffs, and belt buckle for the model Veruschka.

David Evins, 1965

Opposite The balancing act of shoe designer David Evins's career was to create rhinestone-studded bespoke shoes for Hollywood royalty and then translate that style to mass-manufactured shoes for I. Miller. Though not all those ready-to-wear shoes were over-the-top fantasy creations, his showmanship was often evident.

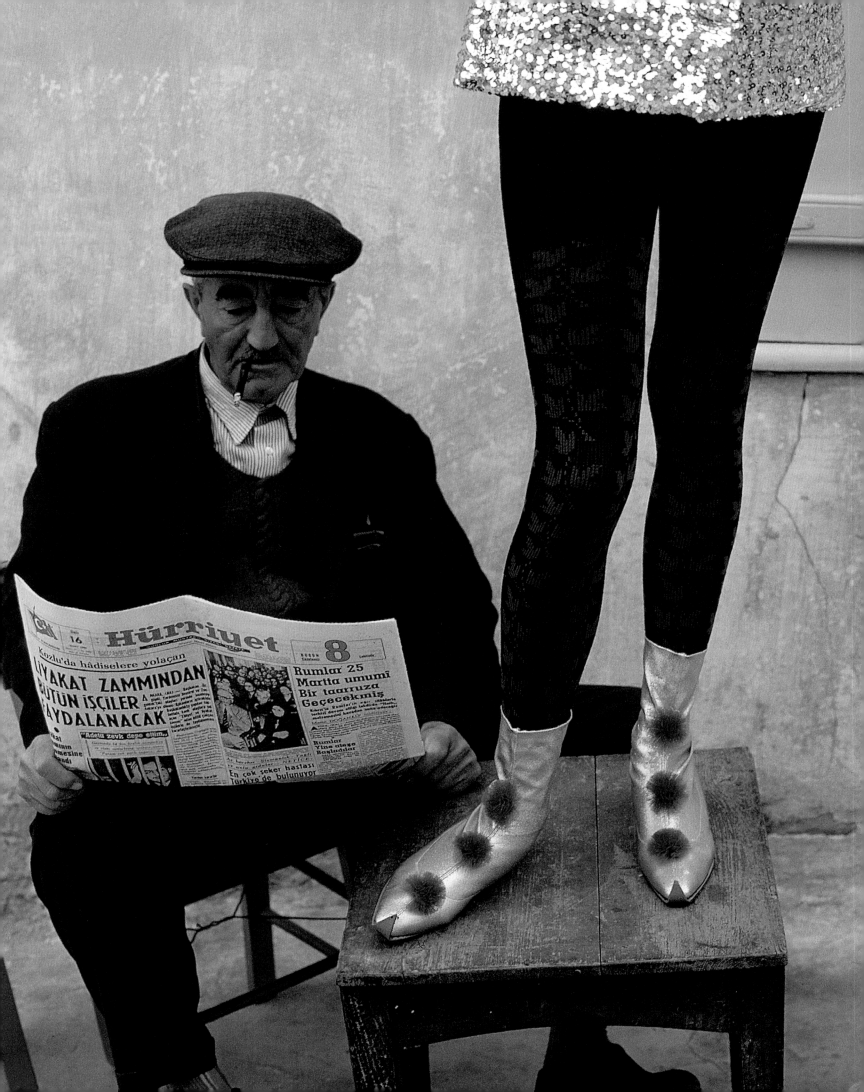

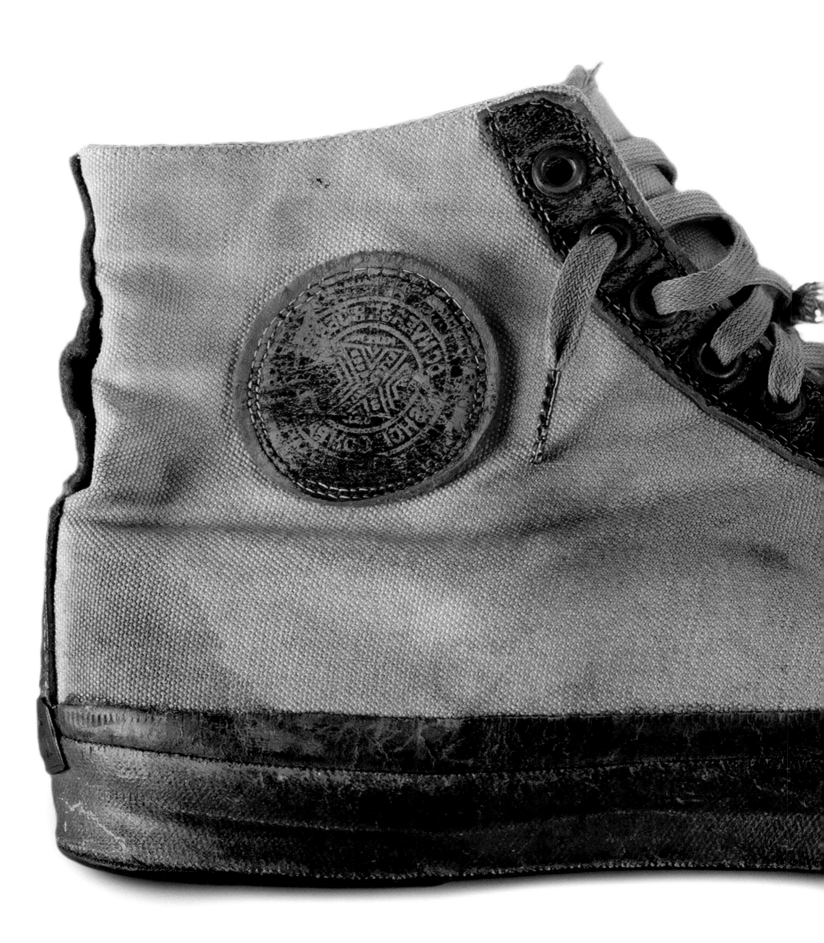

Converse, 1917

The key to the classic American sneaker was its comfortable and flexible rubber sole. First introduced to footwear as the sole of "croquet sandals" and then used as the base for Keds (a general sports and children's shoe), the rubber sole was elevated to true sporting status with its use on the Converse sneaker. Keds were play shoes, but Converse sneakers were for athletes — a status they maintained through the 1960s.

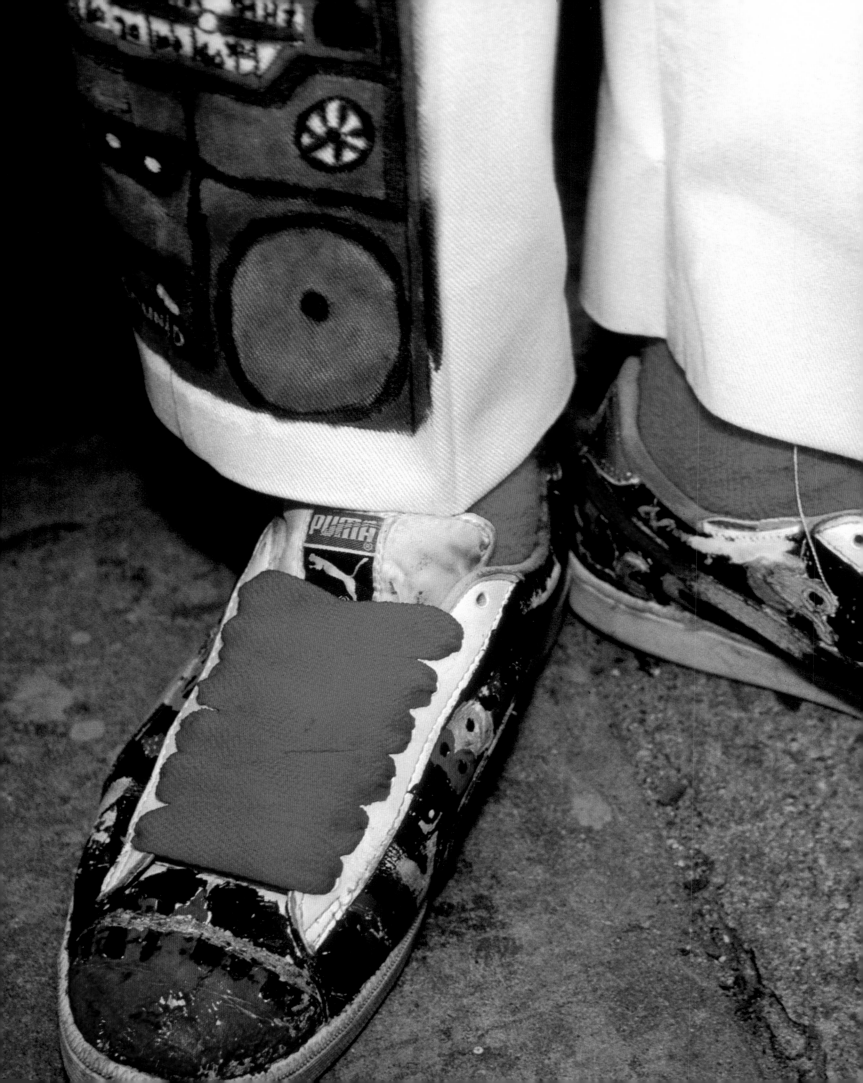

New York City

Americans took to the culture of customizing the sneaker which transformed the twentieth century child's shoe into a canvas of creativity.

Converse, 2005

Left The classic Converse Chuck Taylor All-Star High-Top.

John Varvatos for Converse, 2008

Opposite Converse remains iconic in the twenty-first century, most recently with new versions—the product of a collaboration with menswear designer John Varvatos.

Sears, Roebuck and Co., 1974

Following page American accessory design has always been marked by a willingness to adapt traditional dress. Thus the espadrille came into the design vocabulary. It was first promoted by Claire McCardell in the 1950s, and has been a standard style ever since.

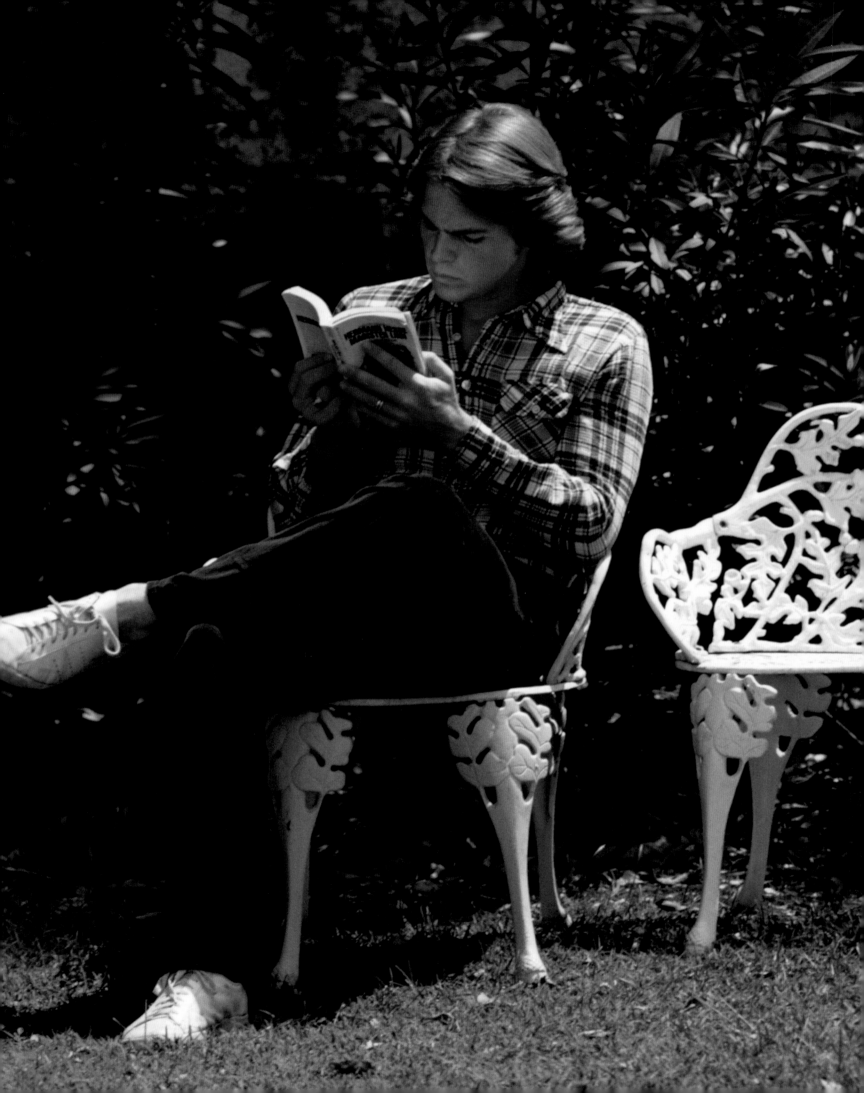

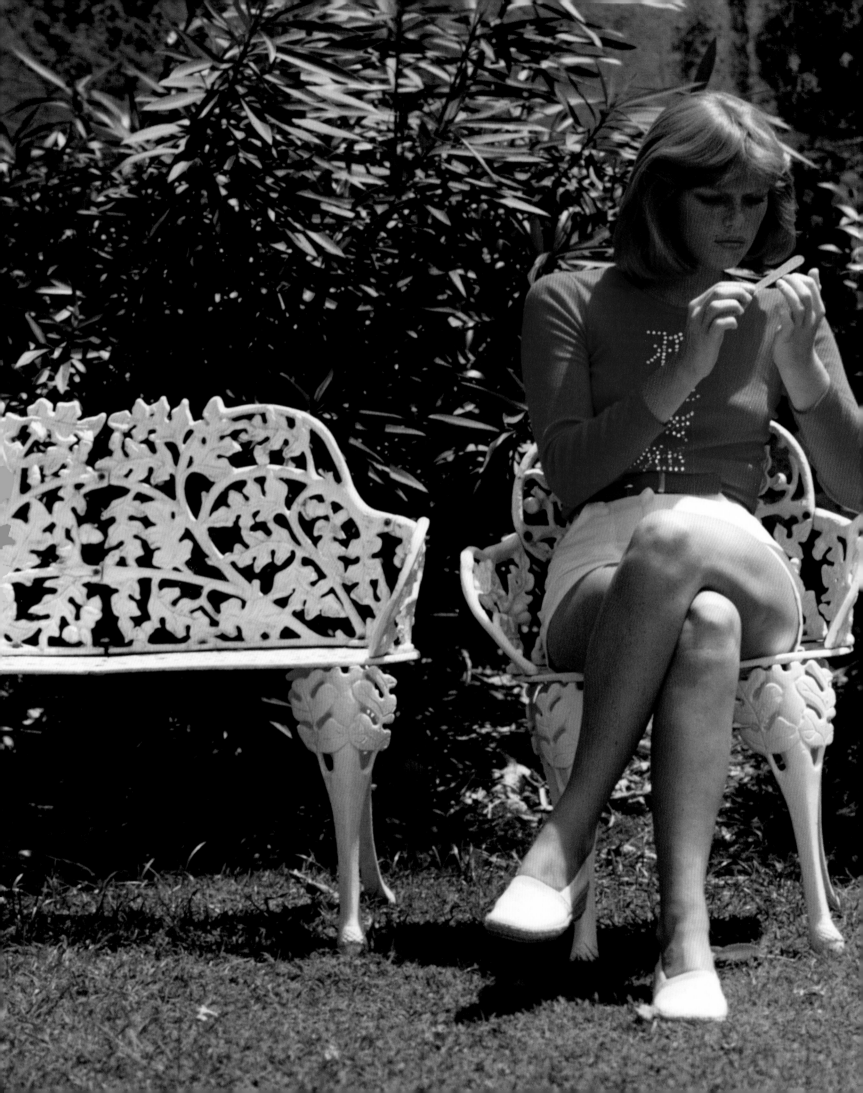

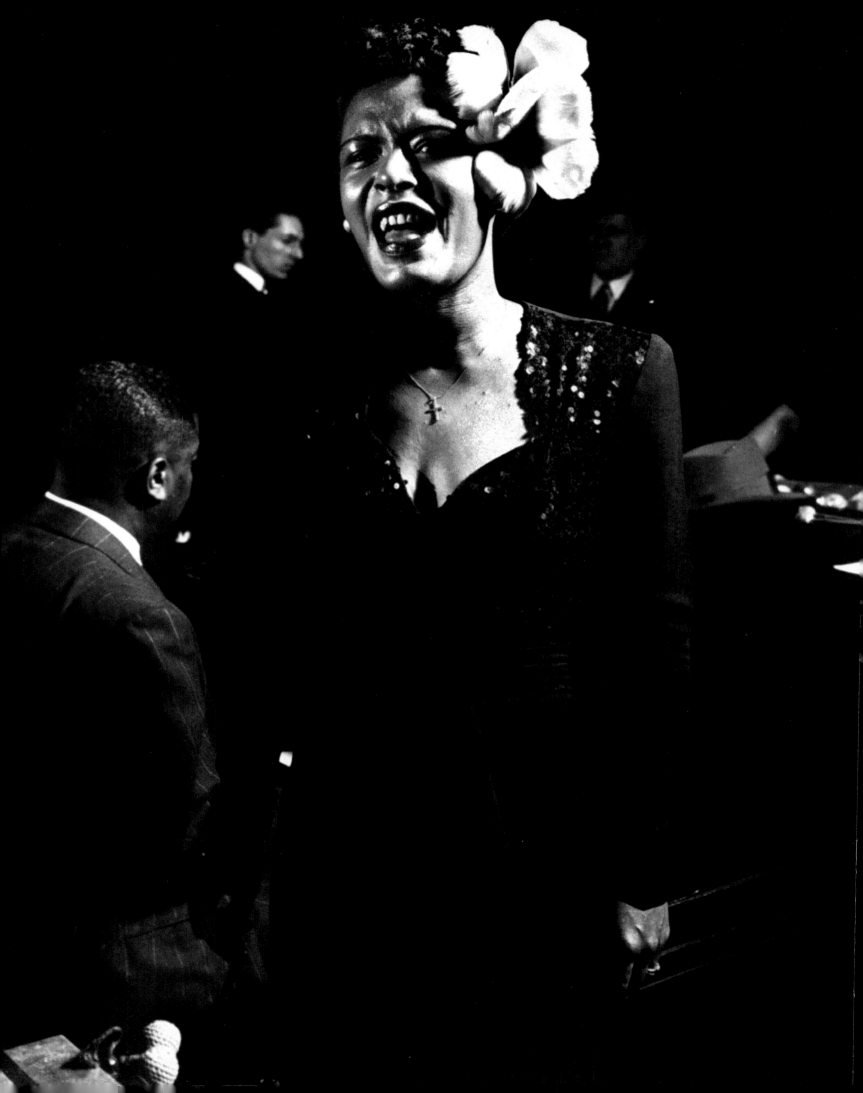

Paulding Farnham for Tiffany & Co., 1890

Above As the first great American jeweler, Tiffany & Co. sought to equal and surpass competing Europeans. Their innovative enamelling techniques helped to accomplish this not only with the historic pieces that were created, but also by allowing the "trickle down" of the techniques to American costume jewelers, thereby raising the quality of all American jewelry.

Billie Holiday, 1943

Opposite Innovations in American design are not solely the responsibility of designers. Icons of style have also taken a role as creators. Here, performing in the Esquire Jam Session at the Metropolitan Opera House, singer Billie Holiday forgoes the typical chapeau of the 1940s in favor of simple gardenia, denoting the unpretentious elegance of an American star.

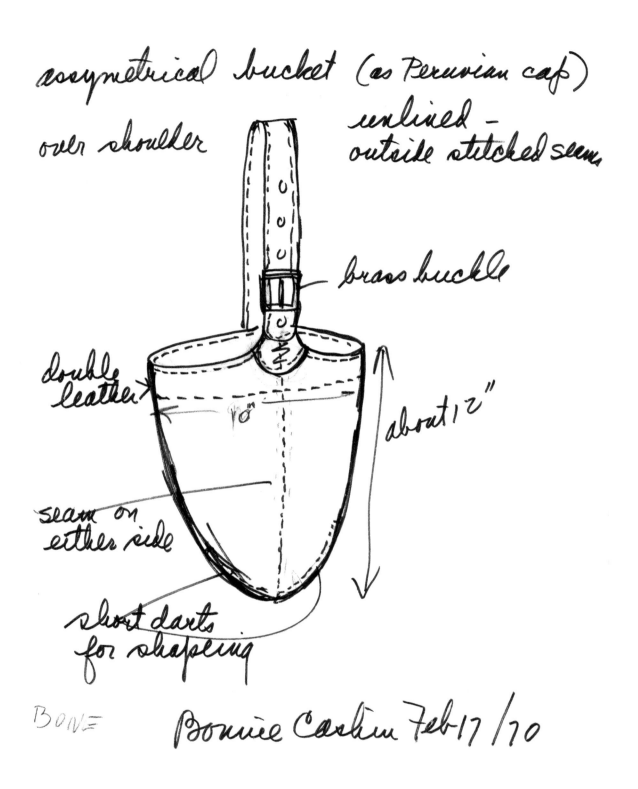

assymetrical bucket (as Peruvian cap)

over shoulder unlined –
outside stitched seam

brass buckle

double leather

about 12"

seam on either side

short darts for shaping

BONE

Bonnie Cashin Feb 17/70

Bonnie Cashin for Coach, 1970

Above Tellingly, in Bonnie Cashin's design for
this "Peruvian Cap" bag, a variation on the bucket
type of bag, the notes indicate that the structural
stitching and decoration are one. Nothing is
extraneous; nothing is hidden. That focus on
function is classic American accessory design.

Bonnie Cashin for Coach, 1972

Opposite With an Adele Simpson suit and
Halston hat, Bonnie Cashin's low-slung bag for
Coach shows her interest in the unstructured
styles that defined the early 1970s. 1960s purses
had been hard, rectilinear pieces, but Cashin was
interested in experimenting with packability and
bags that could be layered. By the time less-boxy
bags became the fashion in the 1970s. Cashin had
already showed Coach the way.

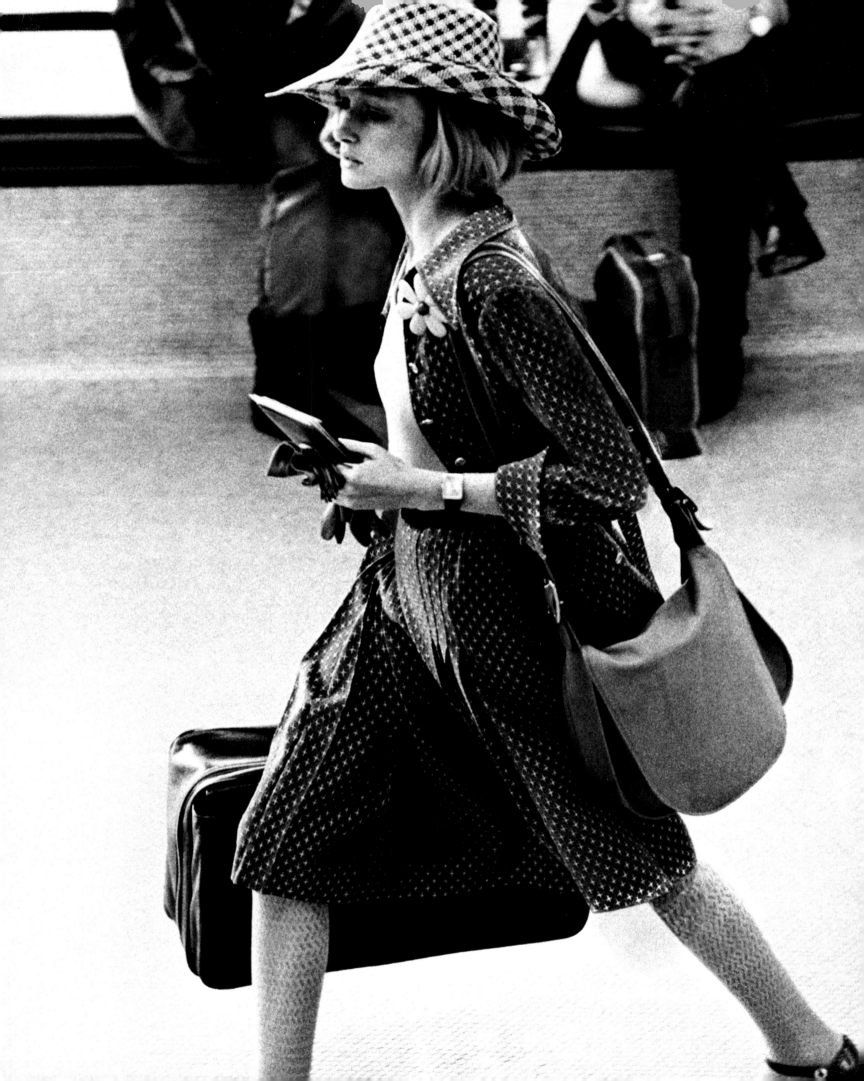

Judith Leiber, 1993

Below Though best known for her whimsical Swarovski-studded minaudières, Judith Leiber had already shown a charming sense of play when she premiered her first "007" bag, which featured a hidden secret-compartment. It was an early sign of the sense of fun (contained within an obvious commitment to luxury) that would define her career.

Barry Kieselstein-Cord, 1976

Opposite The simplicity of Beene Bag cotton knits prove a perfect frame for one of Barry Kieselstein-Cord's belts, as it undeniably takes center stage. Kieselstein-Cord's "cowboy" buckle shows the designer's ability to manipulate traditional forms into sculptural abstractions that blur the lines between functional accessory, jewelry, and body art.

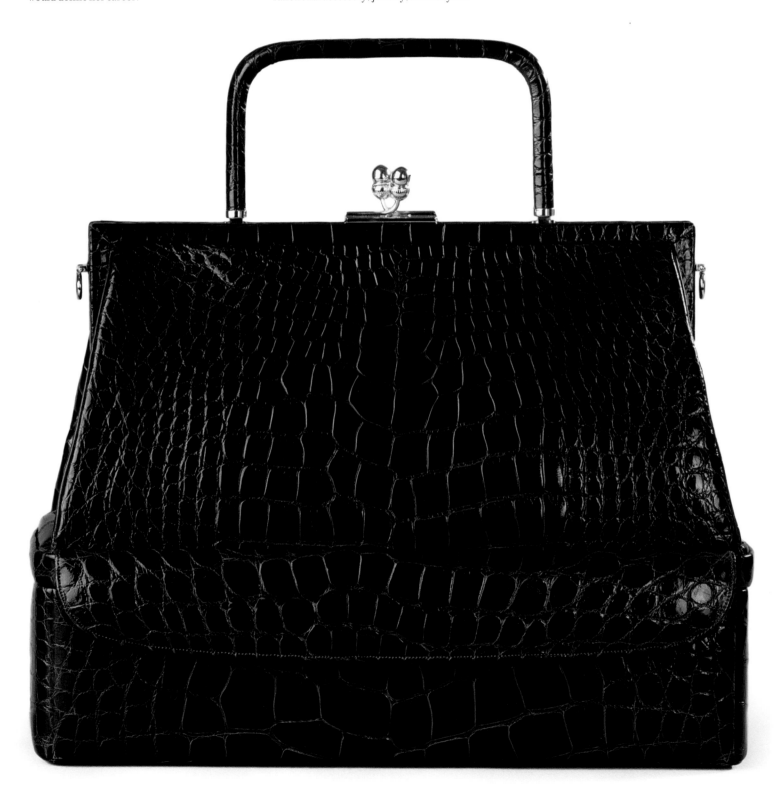

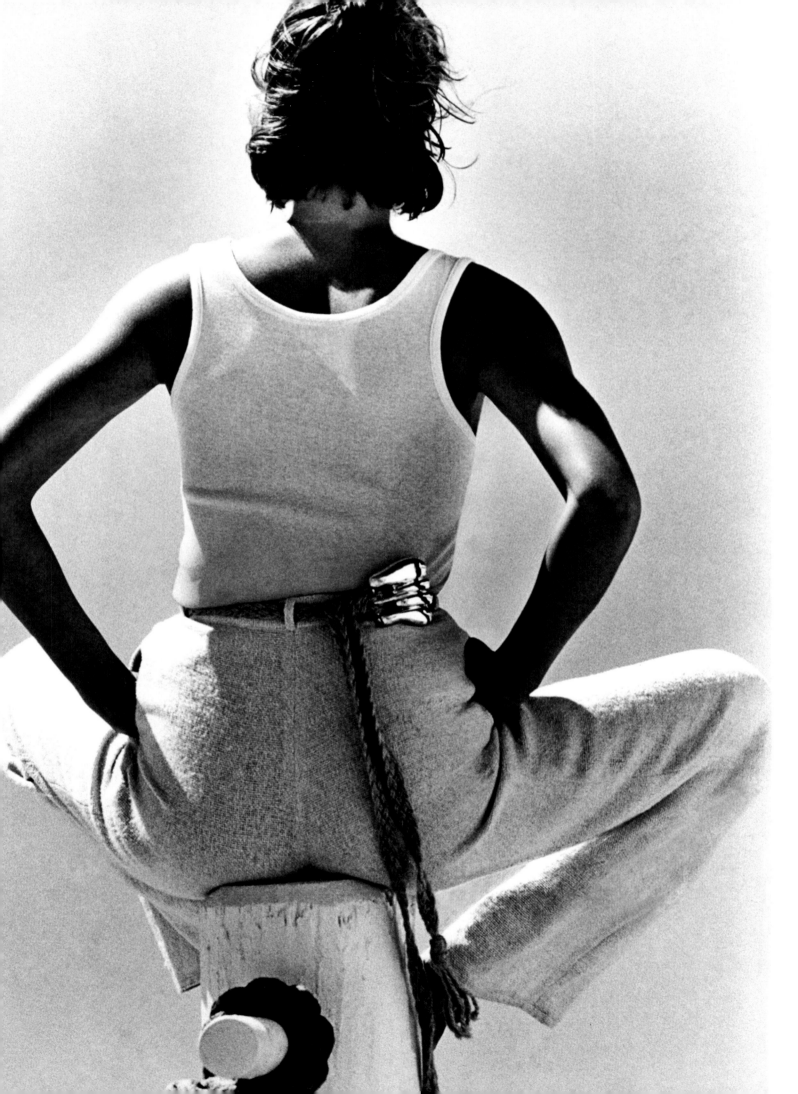

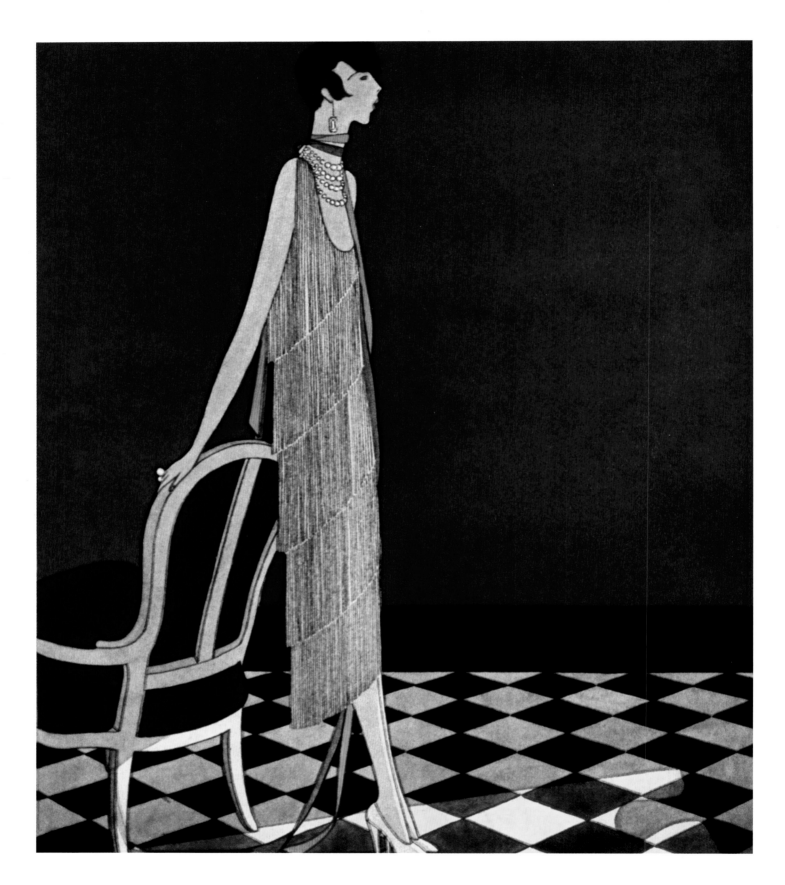

Illustration, 1925

Above The lean, rectilinear form of the American flapper served as the best publicity for American design in the 1920s. She brought youth, sex, style, and an endless appetite for the glittering products of American manufacturing.

Whiting and Davis, 1927

Opposite The Whiting and Davis mesh bag was based on a nineteenth century style, but used new machinery to render a product that had been made of gold and silver into an almost uniformly affordable bauble. The little purse didn't hold much, but its jewel-like flair made it the premier evening bag of the 1920s

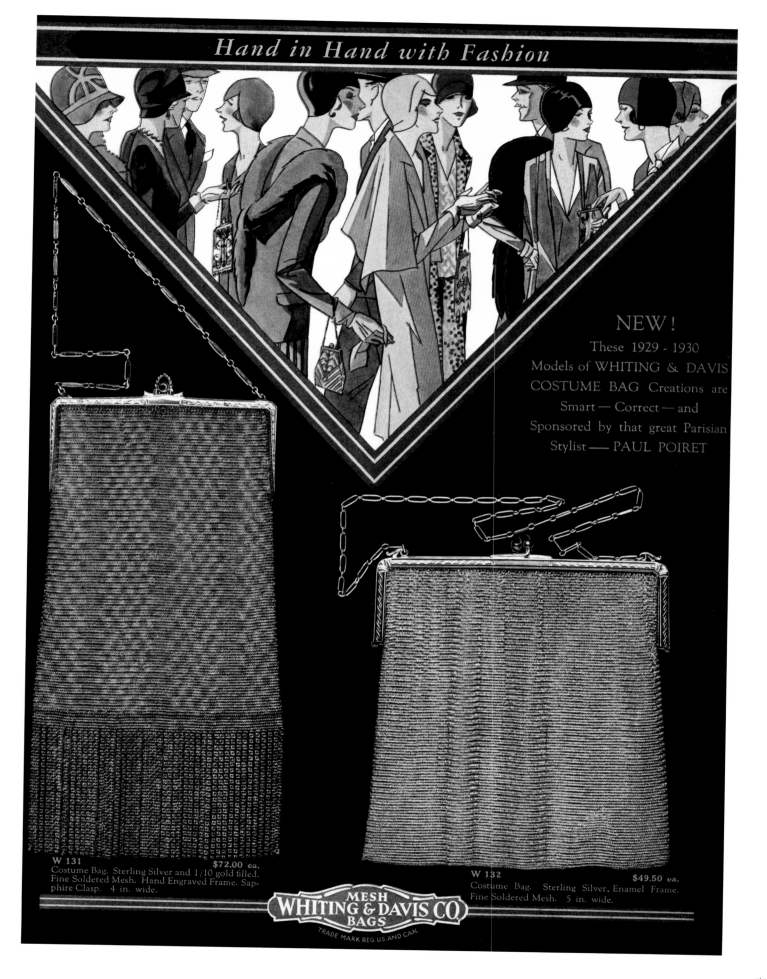

Hand in Hand with Fashion

NEW!
These 1929 - 1930
Models of WHITING & DAVIS
COSTUME BAG Creations are
Smart — Correct — and
Sponsored by that great Parisian
Stylist —— PAUL POIRET

W 131 $72.00 ea.
Costume Bag. Sterling Silver and 1/10 gold filled.
Fine Soldered Mesh. Hand Engraved Frame. Sapphire Clasp. 4 in. wide.

W 132 $49.50 ea.
Costume Bag. Sterling Silver, Enamel Frame.
Fine Soldered Mesh. 5 in. wide.

MESH
WHITING & DAVIS CO.
BAGS
TRADE MARK REG. U.S. AND CAN.

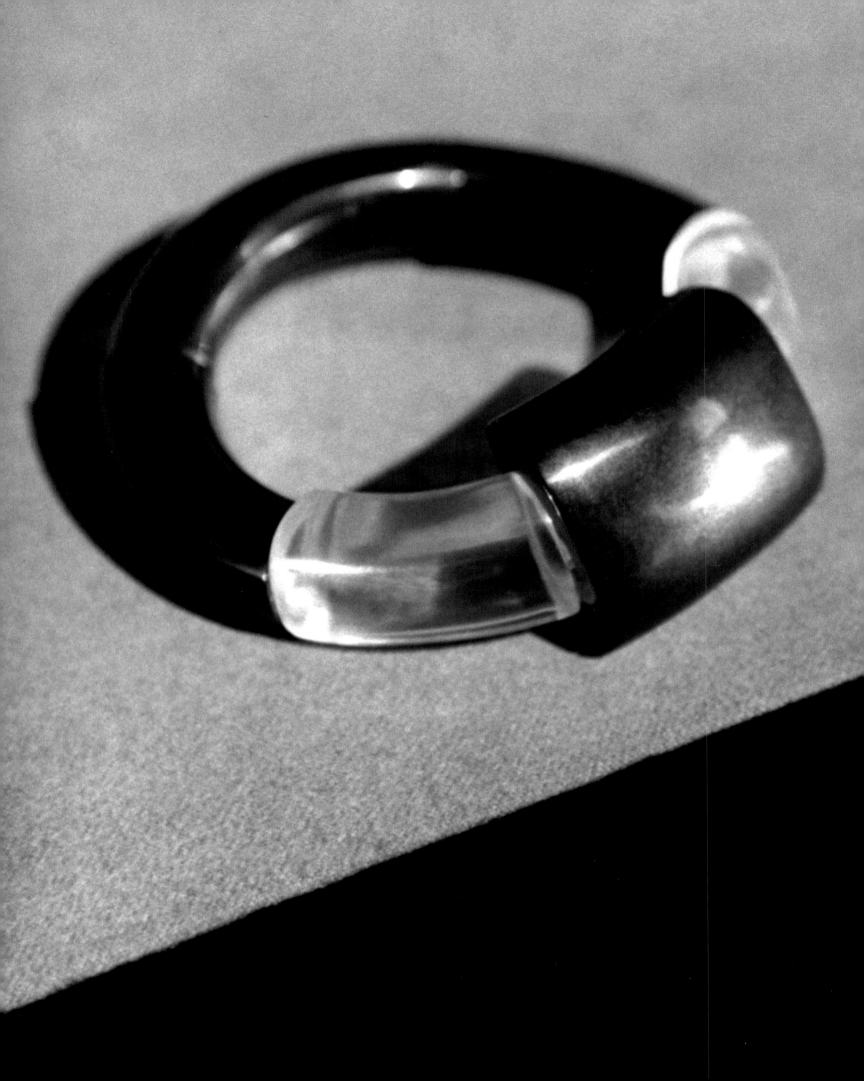

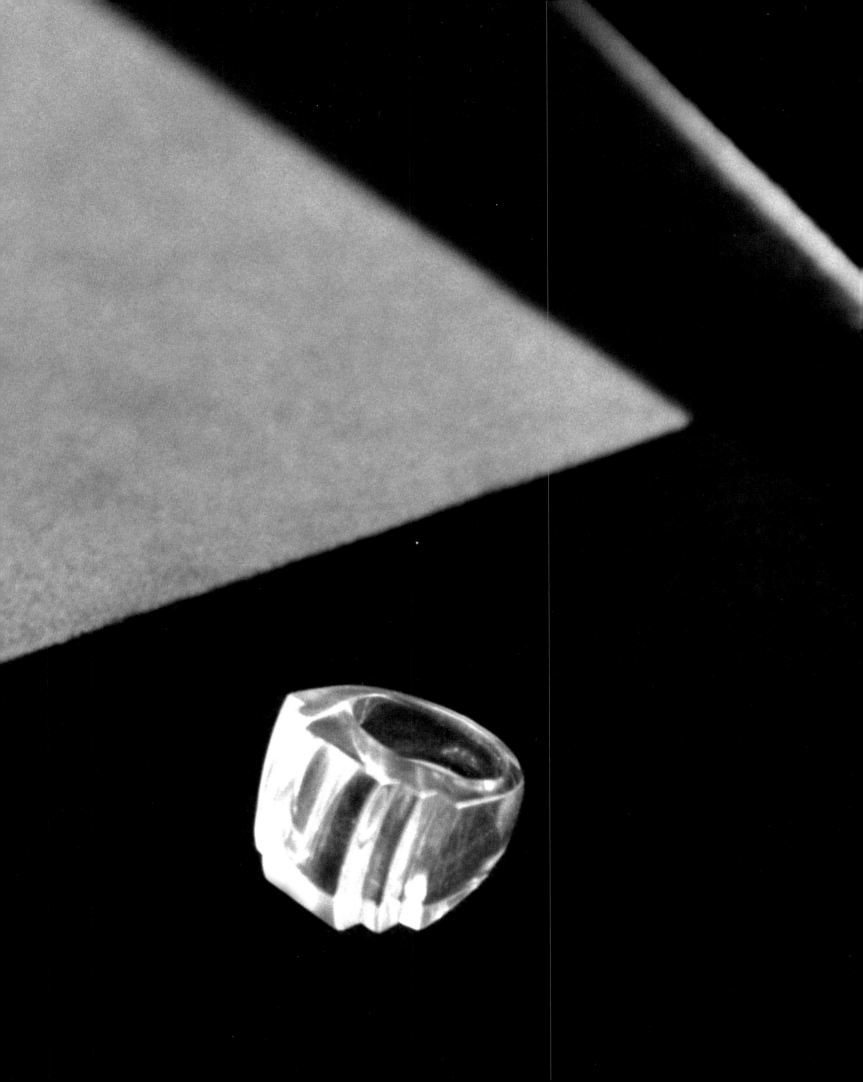

Daniel Brush, 1987

Below One of the earliest high-fashion plastics, Bakelite is both collected and used in contemporary design. In the work of artist/designer Daniel Brush, the material's warm luster holds its own next to 18k gold and diamonds.

Nancy Cunard, 1926

Opposite Shipping heiress Nancy Cunard was an avant-garde style icon who wore an abundance of ivory and wood bracelets. Bakelite was originally conceived to imitate and surpass these more precious materials.

Early plastics used in jewelry, 1929

Previous pages The original caption for this *Vogue* photo reads: "This ring and bracelet are made of an unbreakable composition resembling crystal." That "composition" was plastic, which at its introduction was considered luxe enough for use in jewelry. As an accessories medium, the value of plastic has ebbed and flowed over time, but American designers consistently rediscover its charm.

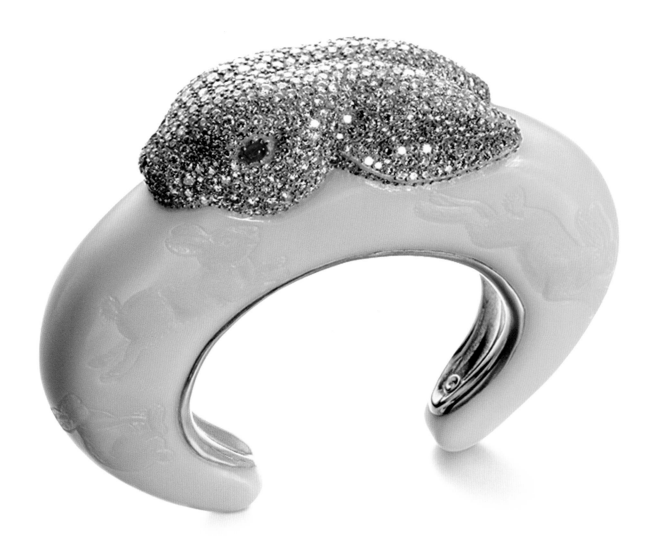

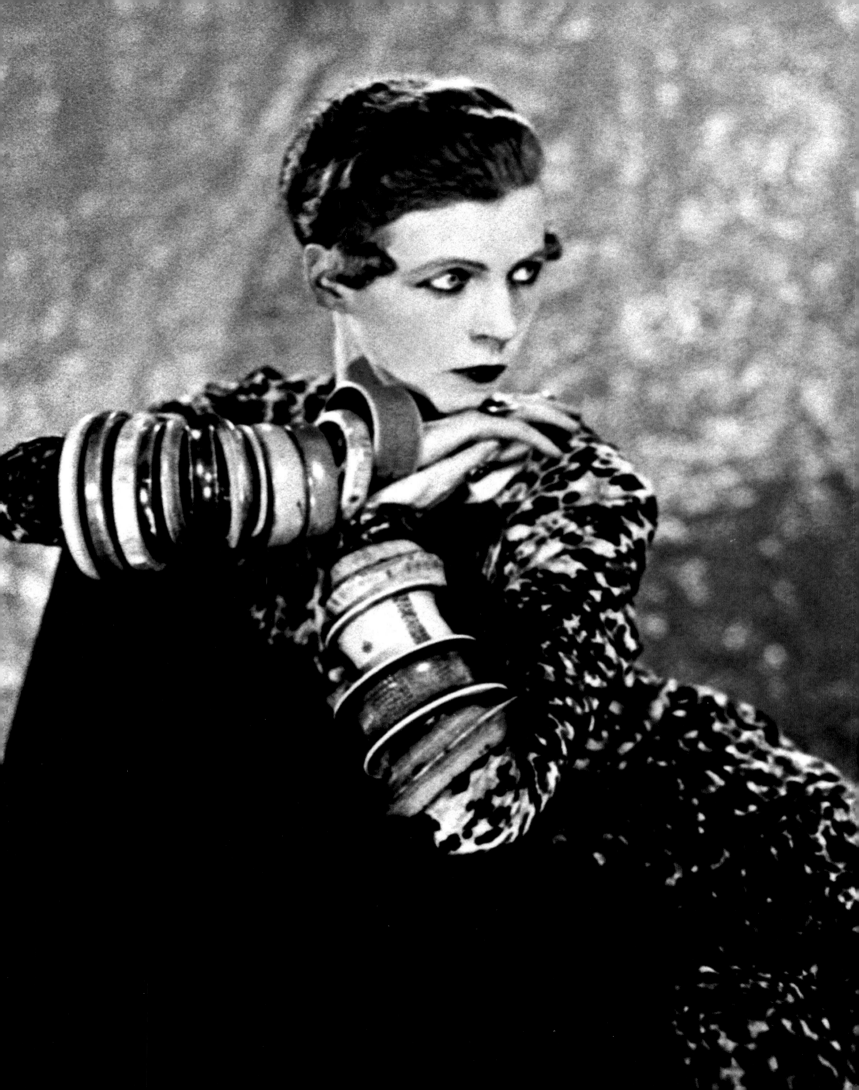

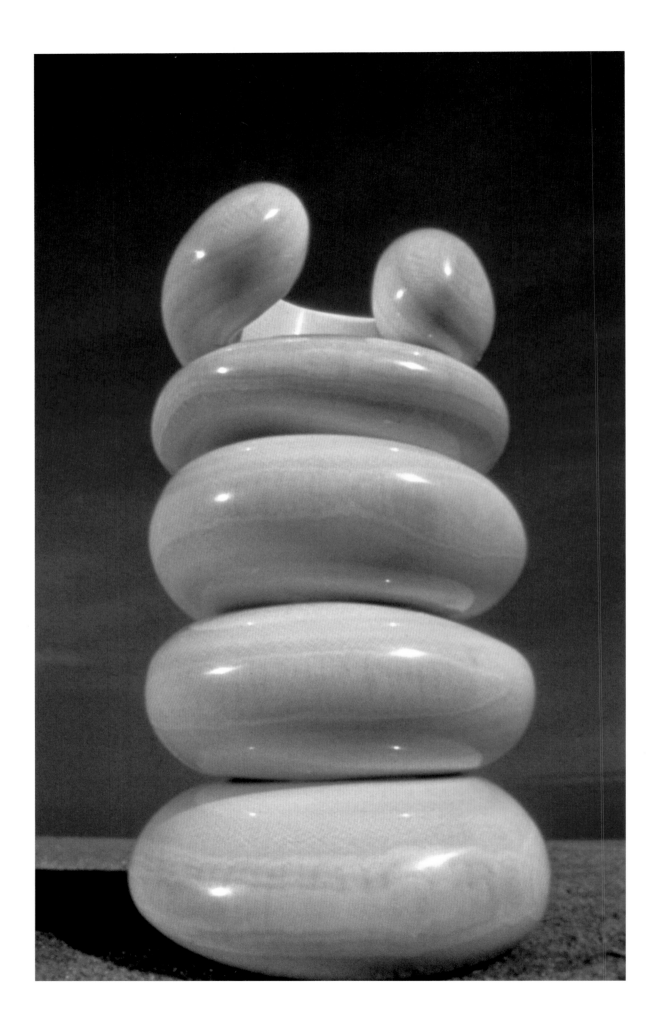

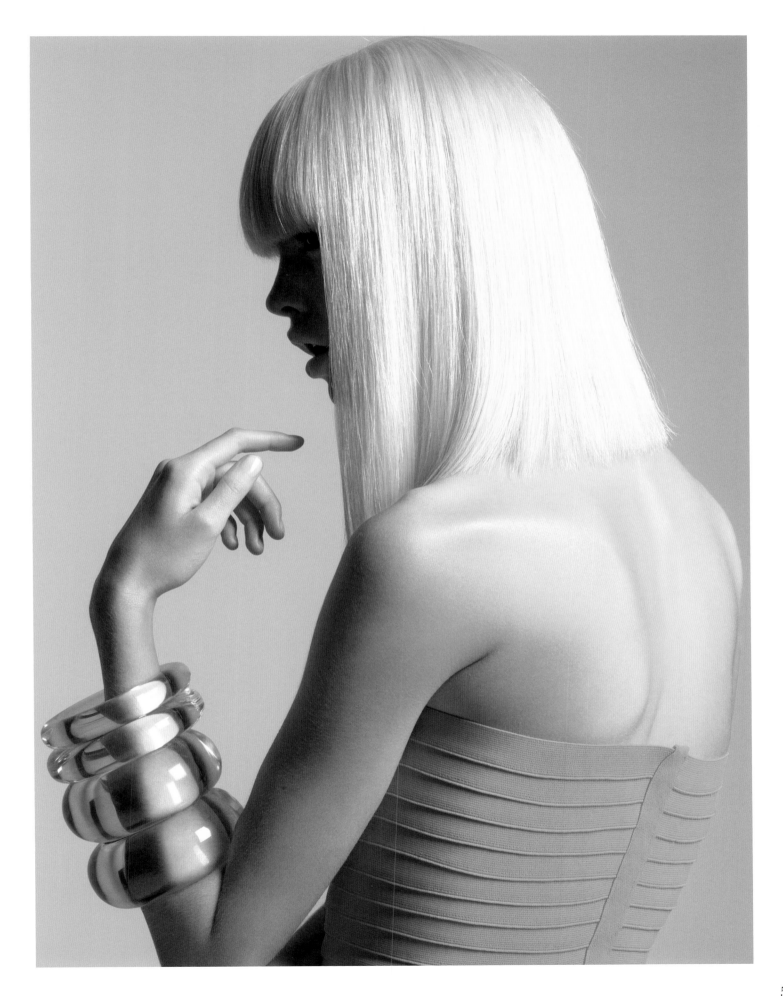

Bakelite, 1920s

Below This array of Bakelite bracelets gives some sense of the range of color and style that was available in the 1920s. (Even more colors came out in the 1930s.) Never a cheap substitute, the luxe appearance of Bakelite was achieved through handcarving and painstaking polishing finish. The same was true of non-accessory Bakelite pieces, such as razor handles, radios, and even dominos.

Patricia Von Musulin, 1981, 2007

Previous pages Designer Patricia von Musulin has used materials as diverse as wood, silver, rock crystal, ivory (at left), and Lucite (at right) to achieve almost monumental, sculptural effects with her jewelry.

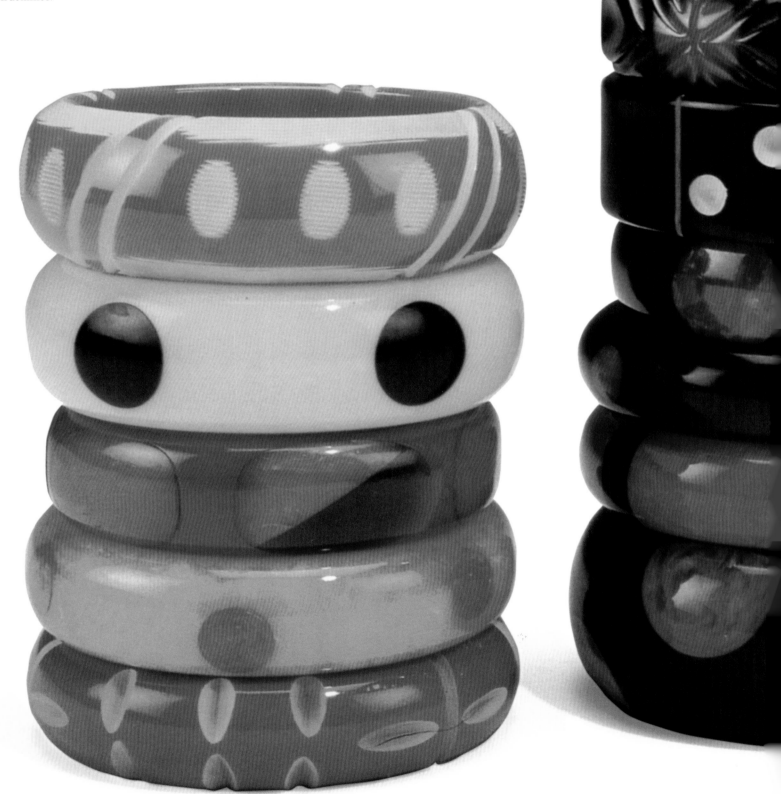

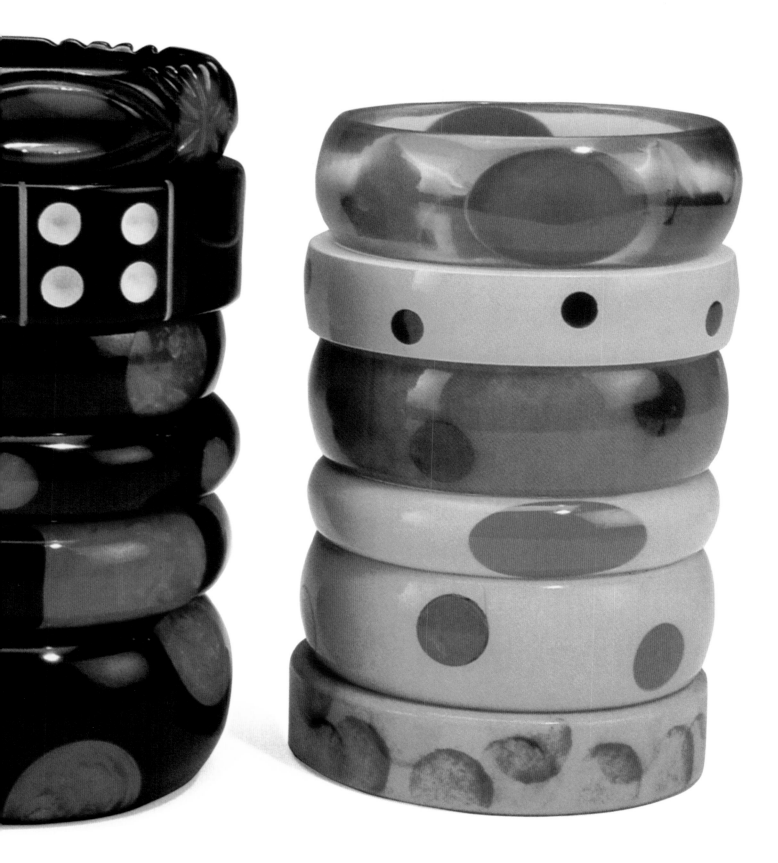

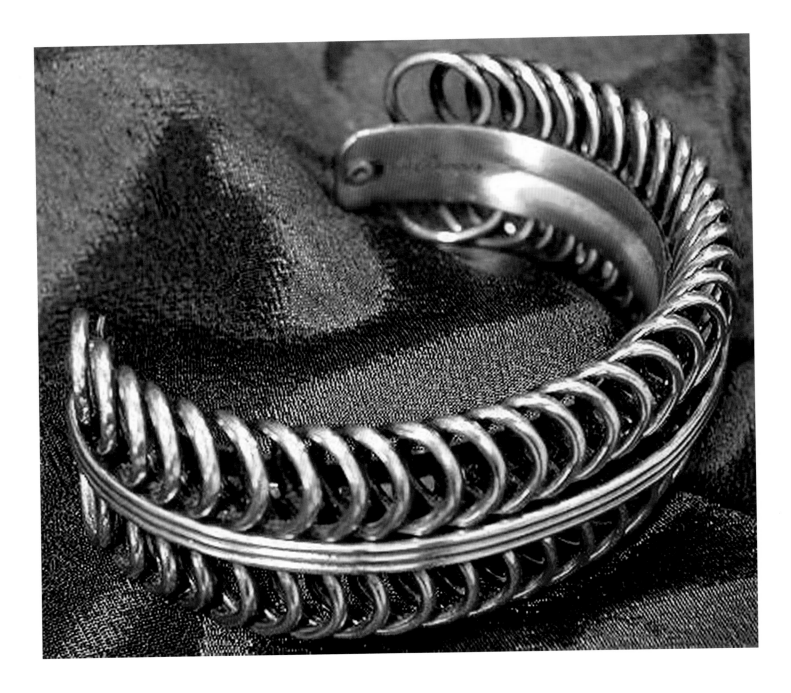

Renoir bracelet

Above The company Renoir was a major maker of copper costume jewelry in the 1950s and 1960s. The pieces could be plain, figural designs or could be shaped into more complex patterns, as shown here.

Copper bracelets, 1988

Opposite The bracelets at right show more detailed copper jewelry pieces.

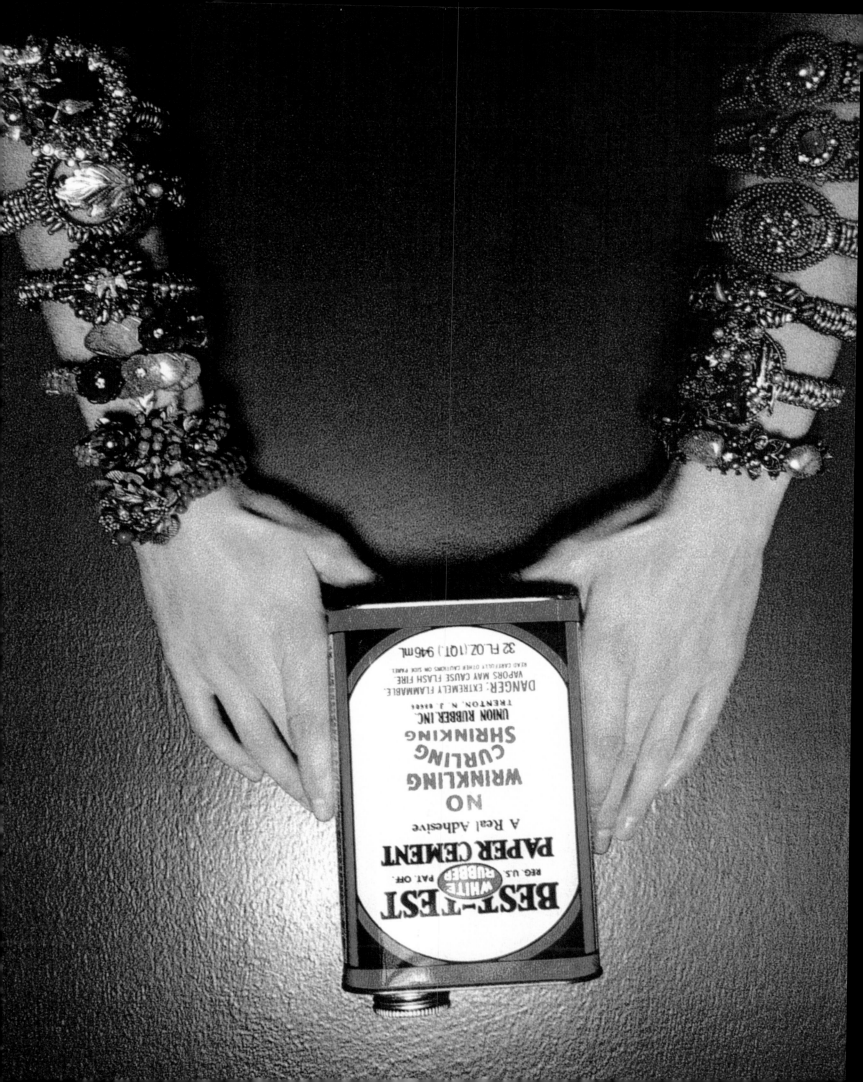

Monet, 1966

Opposite Monet was founded in the late 1920s and began manufacturing costume jewelry in the late 1930s. The company was particularly innovative in the area of earrings, developing clips that could be adjusted to relieve pressure on the lobes (a common complaint at the time).

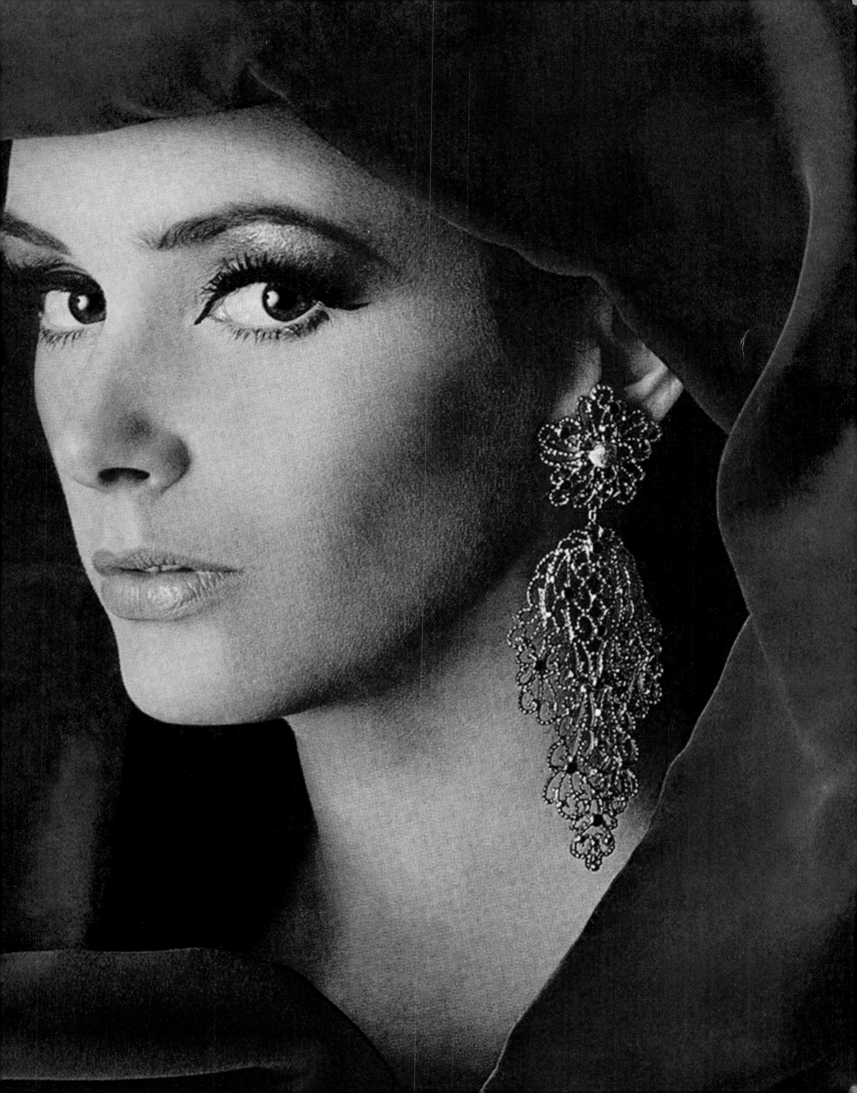

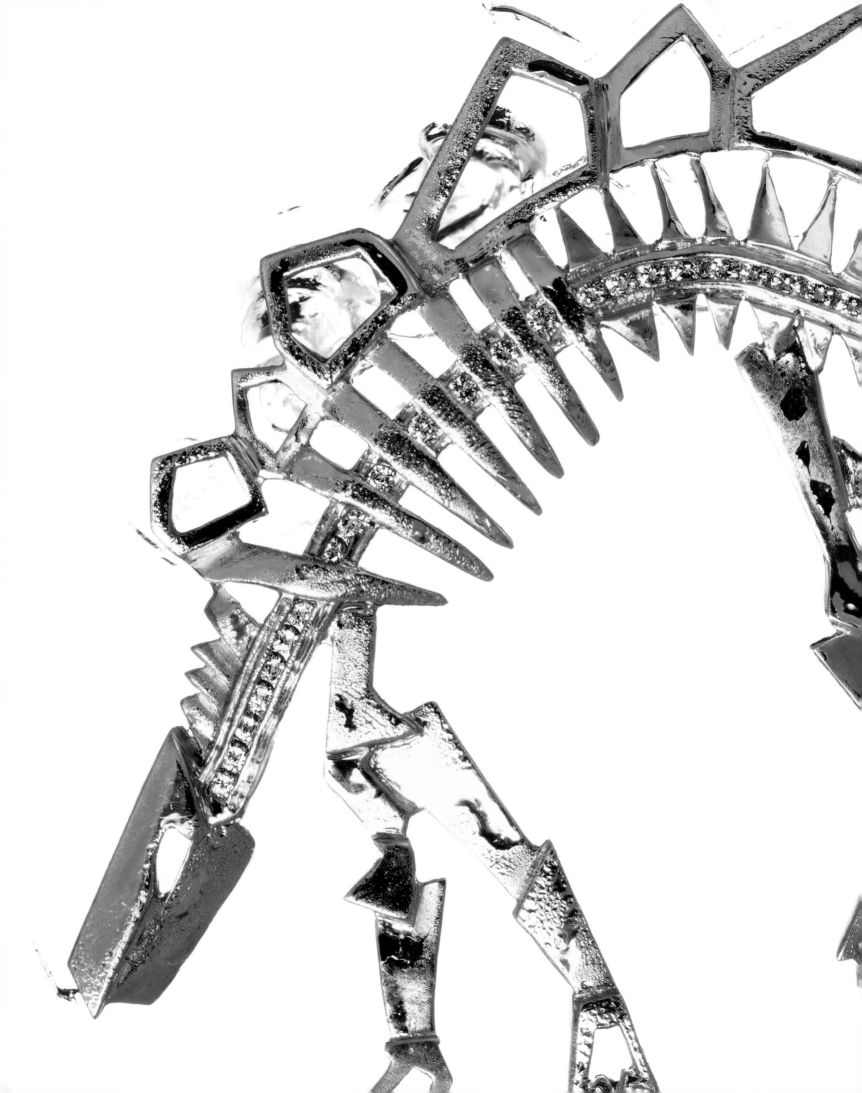

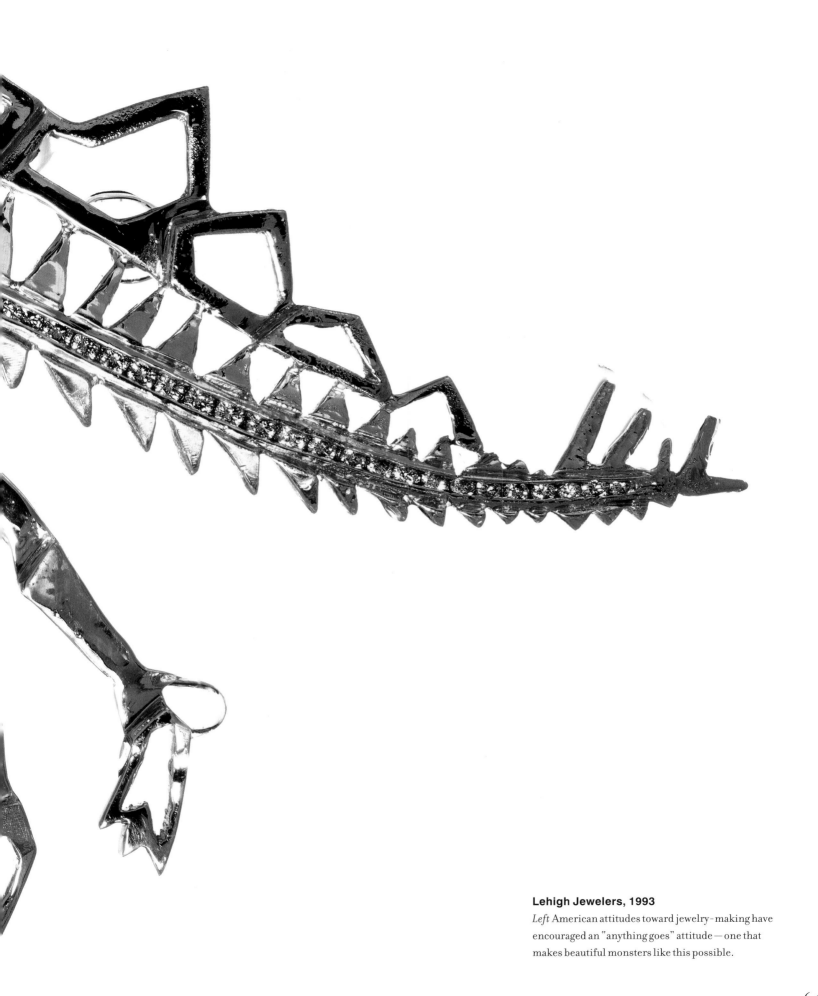

Lehigh Jewelers, 1993

Left American attitudes toward jewelry-making have encouraged an "anything goes" attitude—one that makes beautiful monsters like this possible.

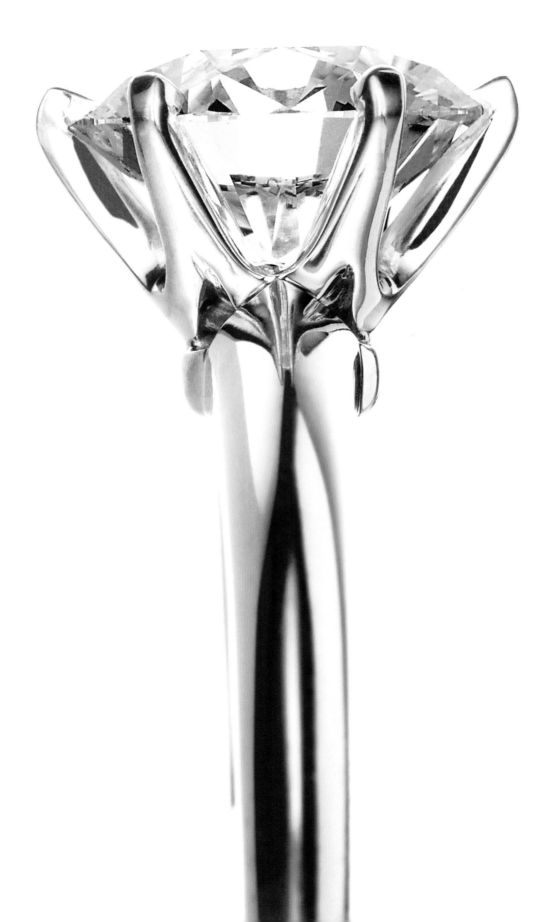

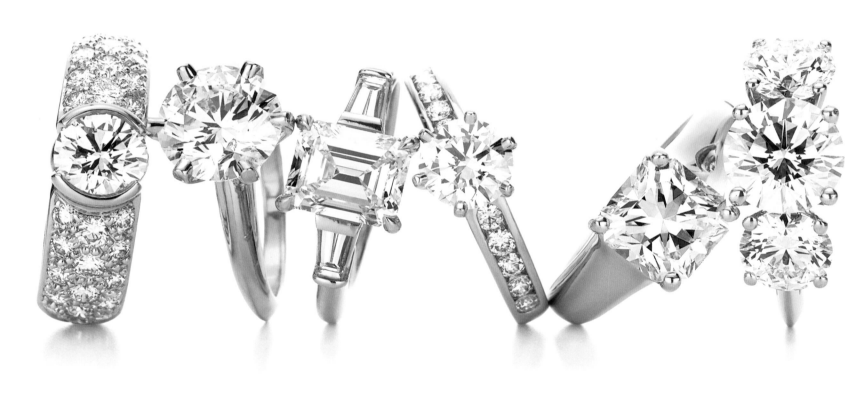

Tiffany & Co., 2005

America's first great jewelry innovation: the
Tiffany prong setting.

WORK

THE AMERICAN ACCESSORY
WORKS

The American woman ostensibly entered the workplace at the beginning of the twentieth century as an office worker—one particularly concerned about balancing her role as a wage-earner with her femininity. This is, of course, not the whole truth. Women, particularly American women, have always worked. They didn't necessarily get paid, but they worked. Thus, one of the great accessories trends of the nineteenth century was the chatelaine bag. Derived from a French word meaning "mistress of the château," this medieval revival hung from the waist and held at easy reach the keys, pencils, buttonhooks, and other supplies necessary to the proper administration of the home—women's most essential work during the nineteenth century. In the same period, women of less privilege worked in the production of accessories. America's nineteenth-century shoe industry in particular relied on home sewers who stitched slippers together in between cooking, cleaning, and breastfeeding. But in the twentieth century, the changing nature of work in America brought women outside the home into arenas in which they would begin to excel.

This transition didn't happen without a fight, which is why the suffragettes are the patron saints of the American woman of power. The woman's suffrage movement in the United States drew American women into the streets and into the government. They were a generation of women who were college educated and independent, and they decided that voting rights and a living wage were the best accessories. To acquire these, women needed, as working women do today, the right bag and the right shoes. The right bag was a leather-satchel shoulder bag that hung across their bodies and could hold their many political pamphlets and flyers while leaving their arms free for distributing them and blocking the occasional piece of rubbish thrown by men who were decidedly not in favor of the vote for women. The right shoes could be described as "sensible" (a dreadful word), but they were generally fashionable ready-mades, as suffragettes emphasized looking finished in their overall appearance, lest they be accused of being "unfeminine." The balancing act that the suffragettes originated is one that women continue today in the halls of power in the United States.

Left **Elsa Peretti, 1974** Jewelry designer Elsa Peretti strikes a pose wearing Halston in a 1974 photo shoot. Peretti and Halston both helped to create a fashionable aesthetic for the American working woman, at first as collaborators—Peretti designed a number of her early iconic pieces for Halston's lines—and then separately as Peretti became an independent entity and one of Tiffany & Co.'s marquee designers. The transformation of women in America in the 1970s is best represented by Peretti's accessory in this image: She wears an apron. The apron was typically associated with being tied to home and hearth, but here (and in black leather), it seems capable of much more. *Previous page, left* **Ralph Lauren, 2008** The alligator pump says, "I mean business."

As the suffragettes achieved much by marching, their history is intimately connected with that of the American shoe industry. Fortunately for the feet of these trailblazers of female power, that industry was the best in the world by the beginning of the twentieth century. The original American shoe was the moccasin, which was purchased from the Native American and then copied. Colonial women, in their challenging day-to-day work of helping to impose a new society on a vast continent, quickly recognized the functional superiority of the supple moccasin to the hard, ill-fitting Louis heel, so much so that the Native Americans and Colonial women began producing versions for export back to Europe. By the eighteenth century, brogans were being manufactured by the thousands in U.S. cities, and in the nineteenth century the shoe industry was marked by the inventions and innovations that are typical of the American fashion system. With the opening of a heel factory in 1888, American women were fully liberated from reliance on French imports, and American manufacturers surpassed the Europeans in offering greater variations in color and style. Most important to the suffragettes, the range of widths was expanded and the idea of comfort was introduced. These were shoes in which women could and did march to victory, and the style was universally accepted during World War I, when a great number of American women joined the war effort by entering the workplace. By the 1920s, when the goals of the suffragettes were achieved, the American shoes that had taken them there were the most comfortable and stylish in the world.

Of course, the sensible shoe has not been the American working woman's only weapon of choice during the course of the twentieth century. The 1920s saw her dressed in spectator pumps (a more perfect merger of fashion and function) and the streamlined cloche (an easy hat designed to protect an easy hairdo). Also in the 1920s, the suffragettes' and soldiers' satchels had become an integral part of the women's wardrobe, albeit transformed into

Left **BCBG, 2005** Working women have favored the simple, square shoulder bag since the time of the suffragettes. *Center* **Carolee, 2008** Carolee's whimsical bangle bracelets remind the wearer that some women's work takes place outside the office. *Right* **Monica Botkier, 2006** Monica Botkier's first bag design was aimed squarely at the working woman—specifically, it was made for then fashion photographer Monica Botkier herself. Having designed her "own little satchel," she found that other women wanted it too, transforming Botkier from photographer to accessory designer.

multiple, more feminized forms. The pochette bag, which originated as a leather outer envelope for the transport of documents in the eighteenth century, exhibits the clean, modern style that dominated the 1920s and 1930s, though it would not have served the suffragettes since it lacked a strap and required that an arm or a hand be used to support it and show it off. This stylish handbag has remained essential to fashion ever since.

The 1930s and 1940s saw the ascent of working women of style as American designers such as Claire McCardell and Elizabeth Hawes began their leadership in fashion. Hawes was a couturier and an accessory designer for hire, introducing playful gloves and unstructured handbags to the American market, while McCardell transformed the look of the shoe with her use of Capezio fabric ballet slippers specially manufactured with a hard sole, a clever response to the limitations on the use of leather during World War II. McCardell also promoted espadrilles and other flat-soled shoes in combination with her highly functional lines of clothing, which appealed to urban working women and suburban "hunter-gatherer" wives alike. The wartime era saw a boom in sensible shoes, as women took on factory work and adapted men's shoes such as the oxford, the brogue, and the gillie for their own purposes. However, as the era of Rosie the Riveter (and, of course, her signature head scarf) came to an end, working women were rendered somewhat invisible by the retrograde sexual politics of the 1950s and early 1960s. Eclipsed by the housewife, their new icon, if they had one to follow at all, was First Lady Jacqueline Kennedy in her smart suits, simple pumps, and pillbox hats. It fell to American innovators such as Bonnie Cashin to answer working woman's needs in the bright candy colors of the suburban utopia. Her hard-wearing bags with their secure closures, built-in compartments, and packability spoke to the potential of American women even when the nation was not showing particular interest.

Left **Gerard Yosca, 1997** Gerard Yosca, whose range in fashion jewelry design takes him from enamel to wood to feathers and back to metals, here offers the classic cuff, capable of deflecting failure, if not necessarily bullets. *Center* **John Hardy, 2007** The cuff, here in gold and silver with diamond pave by John Hardy, is the perfect piece of jewelry for the working woman. It doesn't jingle or dangle, but rather suggests a form of armor. This bracelet means business. *Right* **David Yurman, 2007** Part of the appeal of being a working woman in America is the luxury of self-reward. This is surely part of the impetus behind the escalating importance of American jewelry designers.

It was not until the 1980s that American women could begin to punch through the glass ceiling of the workplace. They did so with briefcase in hand, specifically the ones designed by Donna Karan. The idea of the briefcase was promoted by John T. Molloy, the author of the influential 1978 how-to tome *The Woman's Dress for Success Book*. It was one of many tips in an overall plan to masculinize the feminine wardrobe for purposes of camouflage. Karan's variation on the briefcase idea reinserted the feminine with the concept of satellite bags. Her briefcase could contain a small, feminine purse—hidden but ready for the lunch, dinner, or dancing that hardworking women had earned. The satellite bag skillfully supported the balancing act necessary for American working women; combining functionality and femininity, it was a rational luxury.

That tradition continues in the work of a number of contemporary designers. For some, such as the iconic designer Diane von Furstenberg, the values of working women have always been central. As she introduced the perfection of the wrap dress in the 1970s, von Furstenberg today offers the wrap bag, a witty play on tradition suited for the corporate battlefield. Elsa Peretti continues to design minimalist masterpiece jewelry for Tiffany & Co., as she did for Halston more than three decades earlier. In 1993, Kate Spade revitalized an American tradition with her nylon version of the tote bag, itself an American innovation introduced by L. L. Bean in 1944 as Bean's Ice Carrier, before the widespread use of refrigeration (it was renamed the Boat and Tote bag in the 1960s). Reed Krakoff upholds the traditions of the Coach line as the company's president and executive creative director, thinking from the perspective of what a professional architect, an interior designer, or a photographer would want when approaching handbag design. Lambertson Truex has designed bags that include pullout organizers and nylon cases for the working woman's laptop computer, all lined in the company's signature baby blue. Other functionalist designers include Monica Botkier, a former fashion photographer who happened into accessories design when trying to create the perfect urban-chic bag that would also serve her working life; Amy Chan, who has an expanded vision of accessories that includes leather aprons which can be folded into shoulder bags and "tool belts" for makeup artists; and Matt Murphy, whose architectural influences consistently lead to both elegance and pragmatism. Meanwhile, Joan Helpern designed shoes that were both sensible and delirious for Joan & David. Clearly aligned with the working woman, Helpern described her customer as "always running through airports." As with the ever-mobile suffragettes, that action is possible only if one is wearing the right shoes—designed in America.

Opposite **Donna Karan, 1986** From the start of her business in 1985, Donna Karan's focus was always the working woman. Karan's groundbreaking ad campaigns reinvented her look and reimagined her potential, while glamorizing the reality of her urban experience. *Following pages* **New York subway platform** Accessories for the working woman must always take into account the demands of city life, taking her from home to office and everywhere in between.

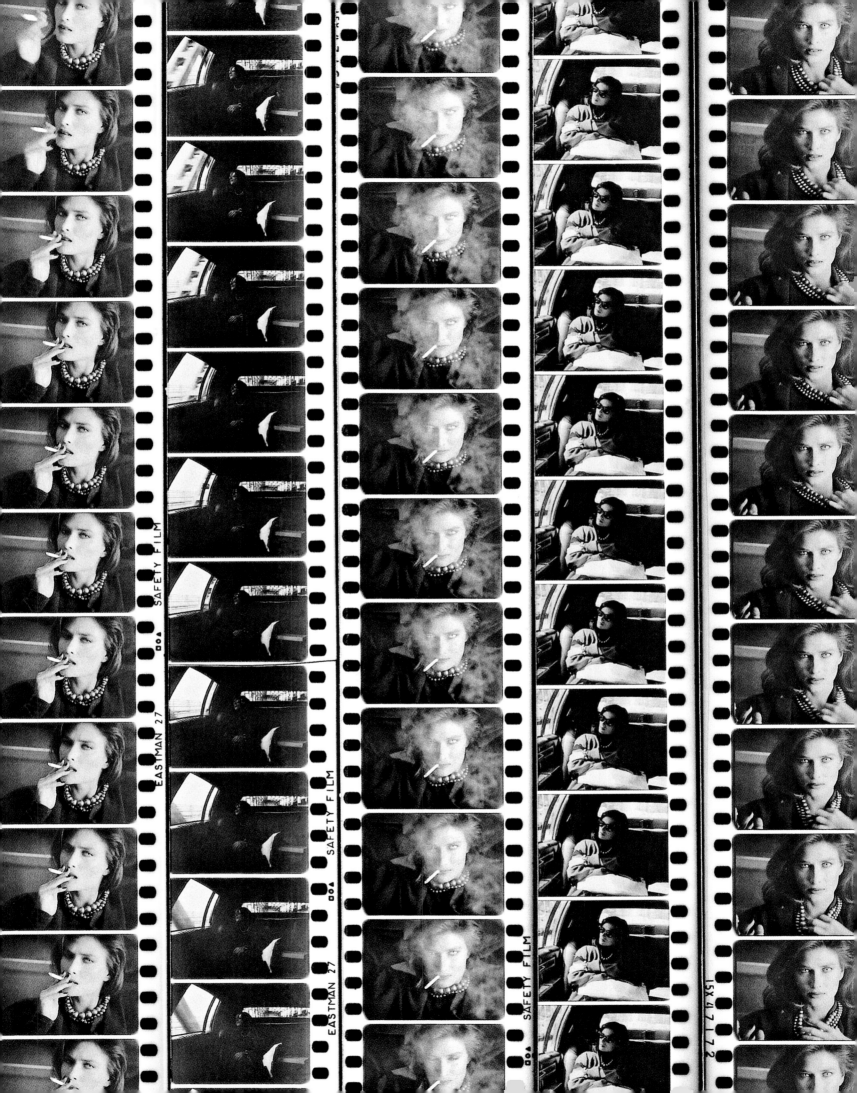

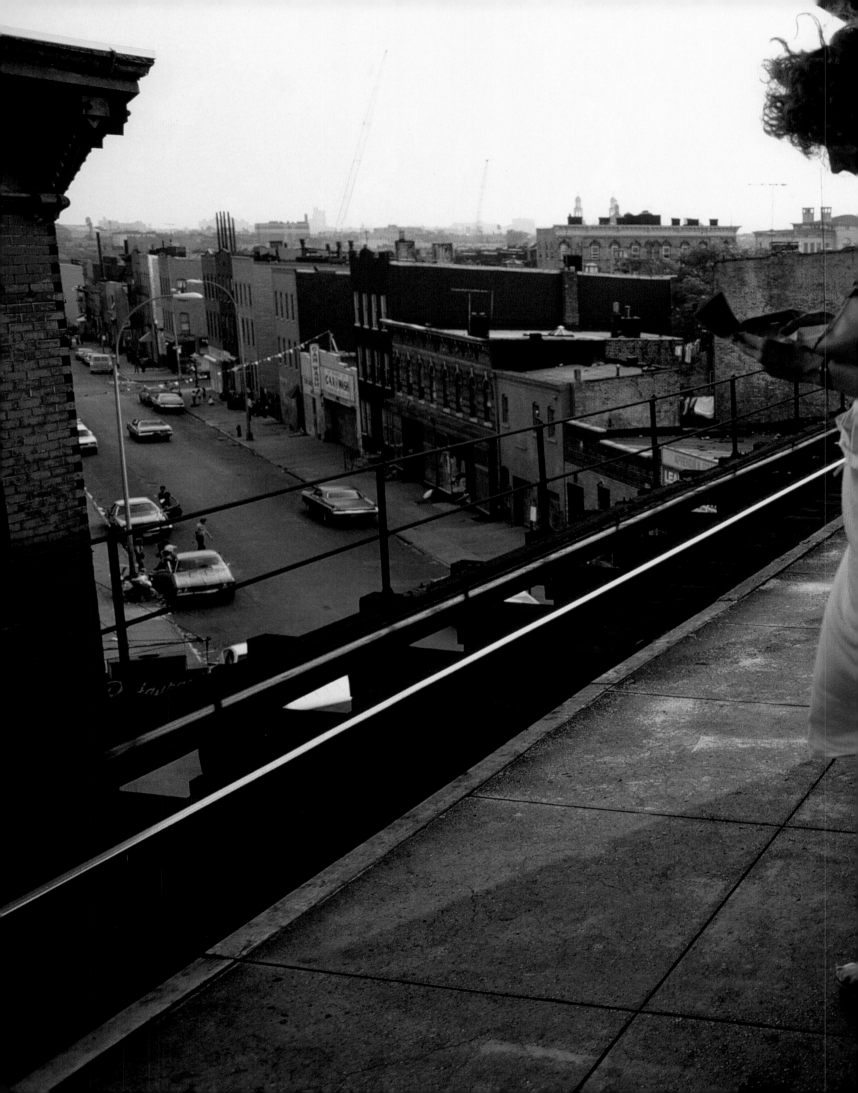

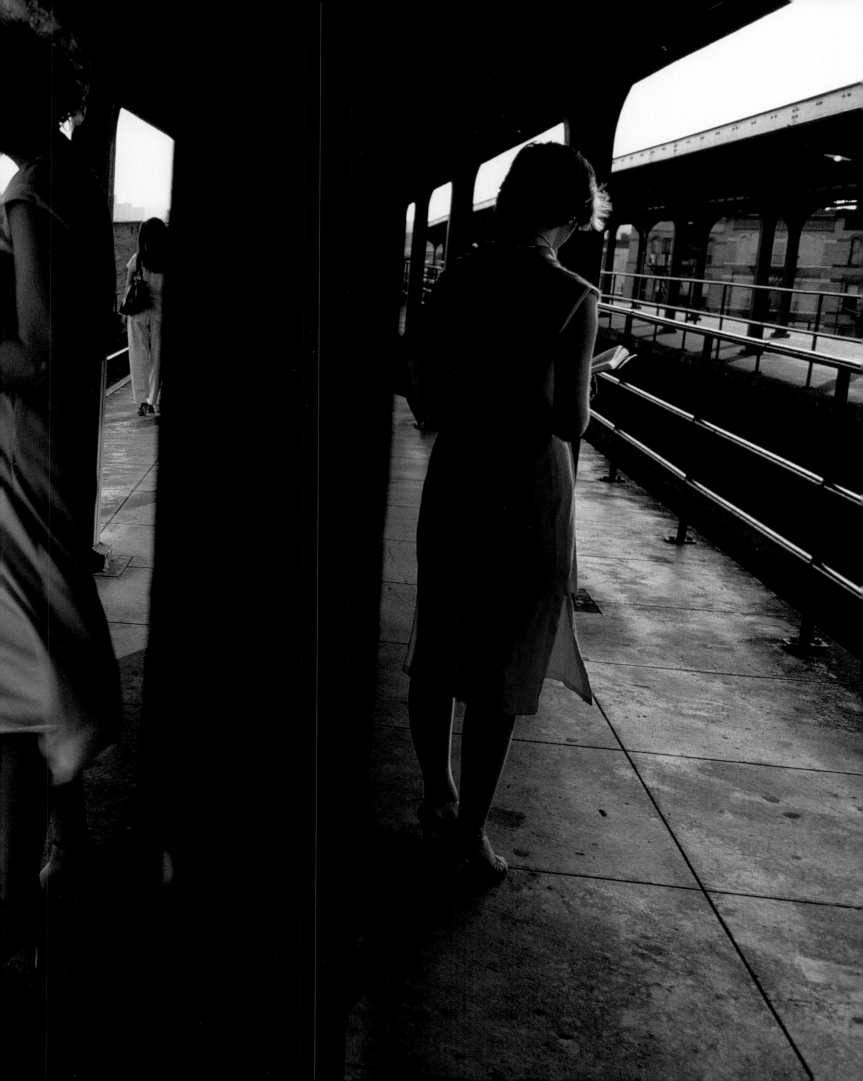

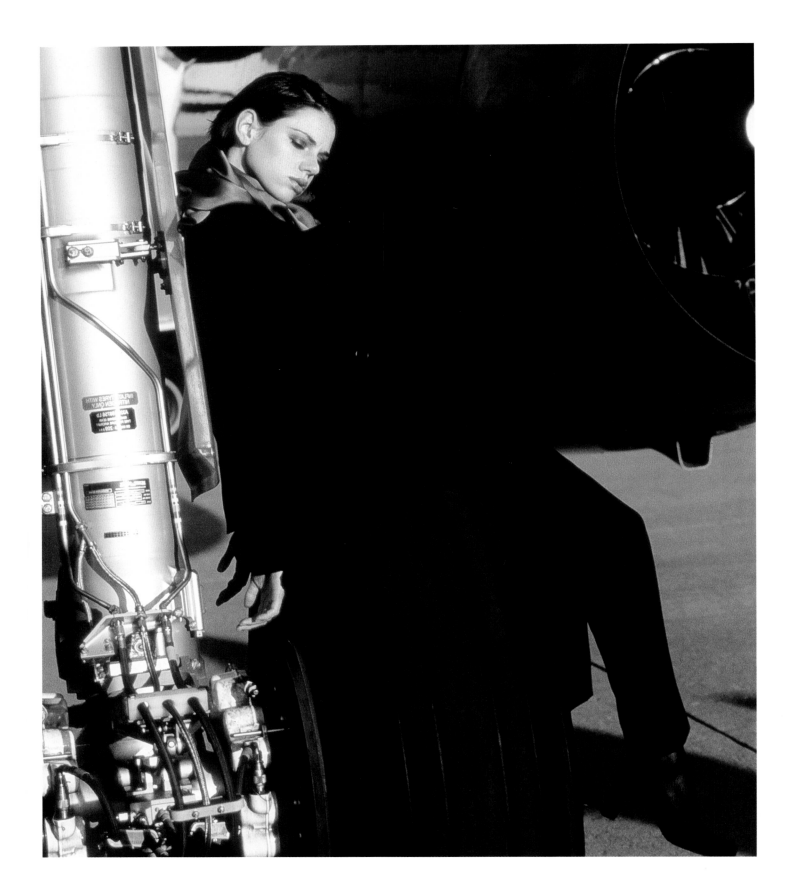

Stan Herman, 1999

Above Flight attendant at rest on the landing gear of a plane, exhausted, though still stylish, wearing a Stan Herman scarf.

American air travel, 1944

Opposite Travel is not a luxury, but a necessity for the working woman. Of course, that doesn't mean you shouldn't bring your best bag.

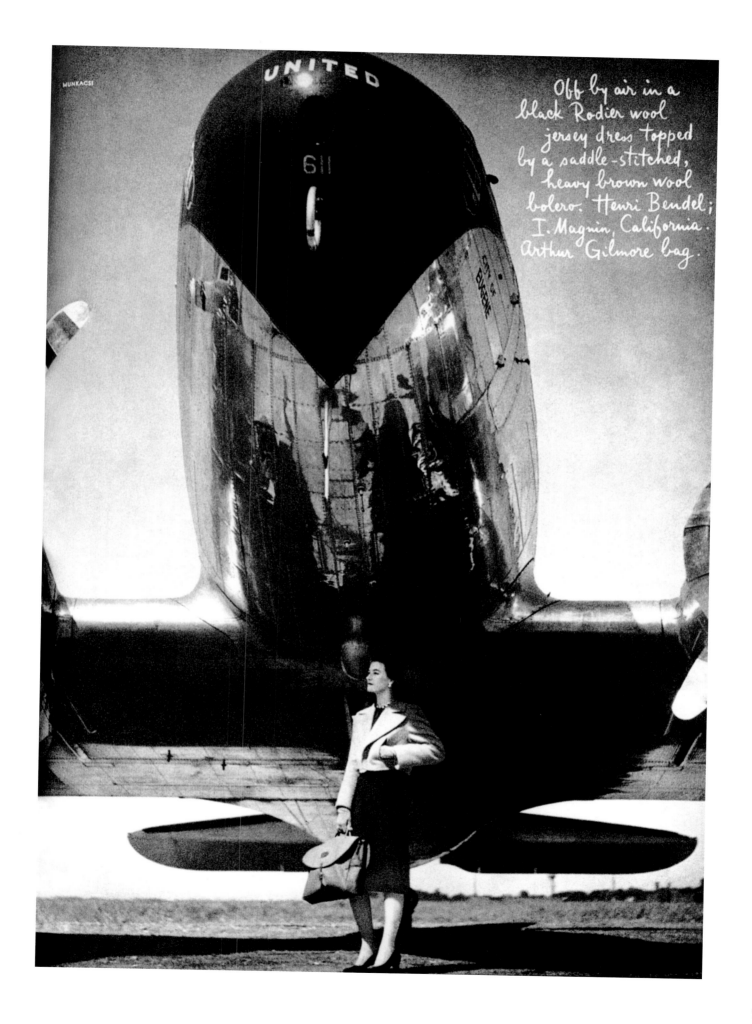

MUNKACSI

UNITED

611

Off by air in a
black Rodier wool
jersey dress topped
by a saddle-stitched,
heavy brown wool
bolero. Henri Bendel;
I. Magnin, California.
Arthur Gilmore bag.

Ralph Lauren, 1974

Above Ralph Lauren's initial success as a designer of high-end men's ties gave him a conspicuous advantage when designing for the working woman in America. He already knew the field in which style rather than fashion ruled the day. His classic but always feminine designs saw many women through the glass ceiling in the 1970s.

Halston, 1972

Opposite Halston always claimed that he was only as good as the women he dressed, and some of those women were among the most successful business women in America, including journalist Barbara Walters and former owner of the *Washington Post* Katharine Graham.

Shopping, 1956

Following pages Whether working or not, the American woman has always had a second shift as a shopper. This John Rawlings advertisement evokes the colorful consumer paradise of the 1950s.

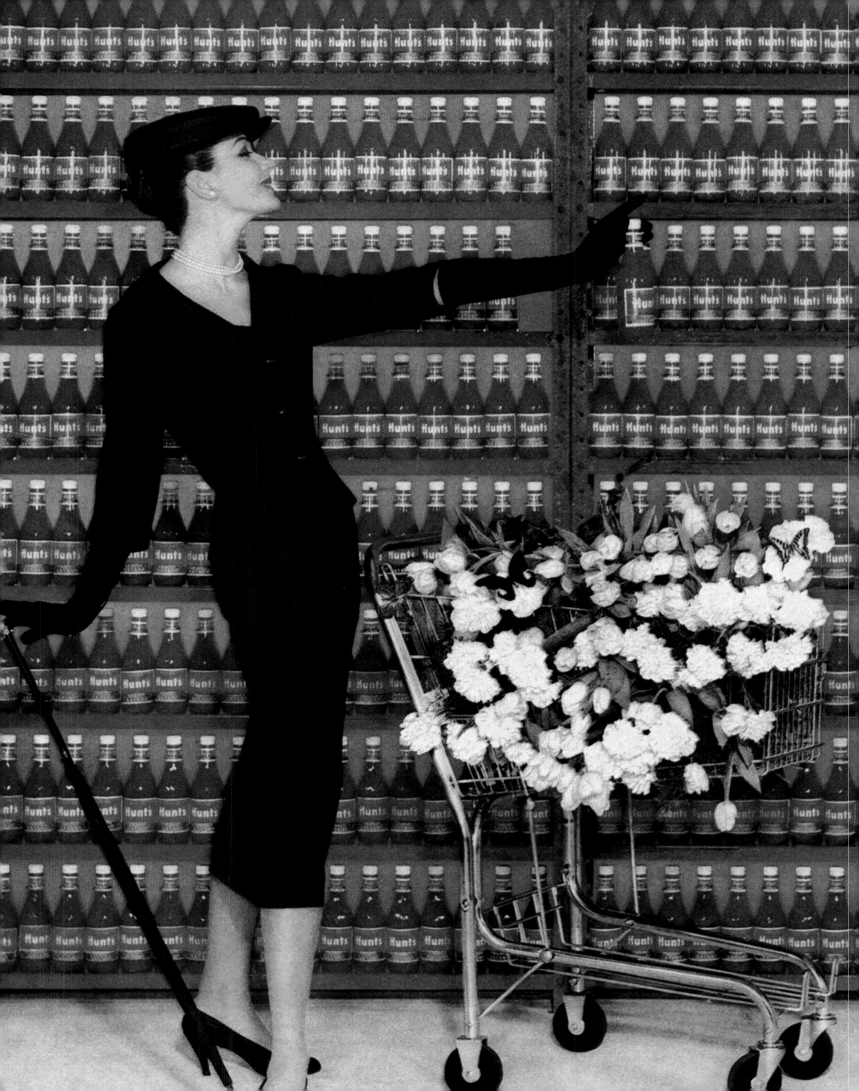

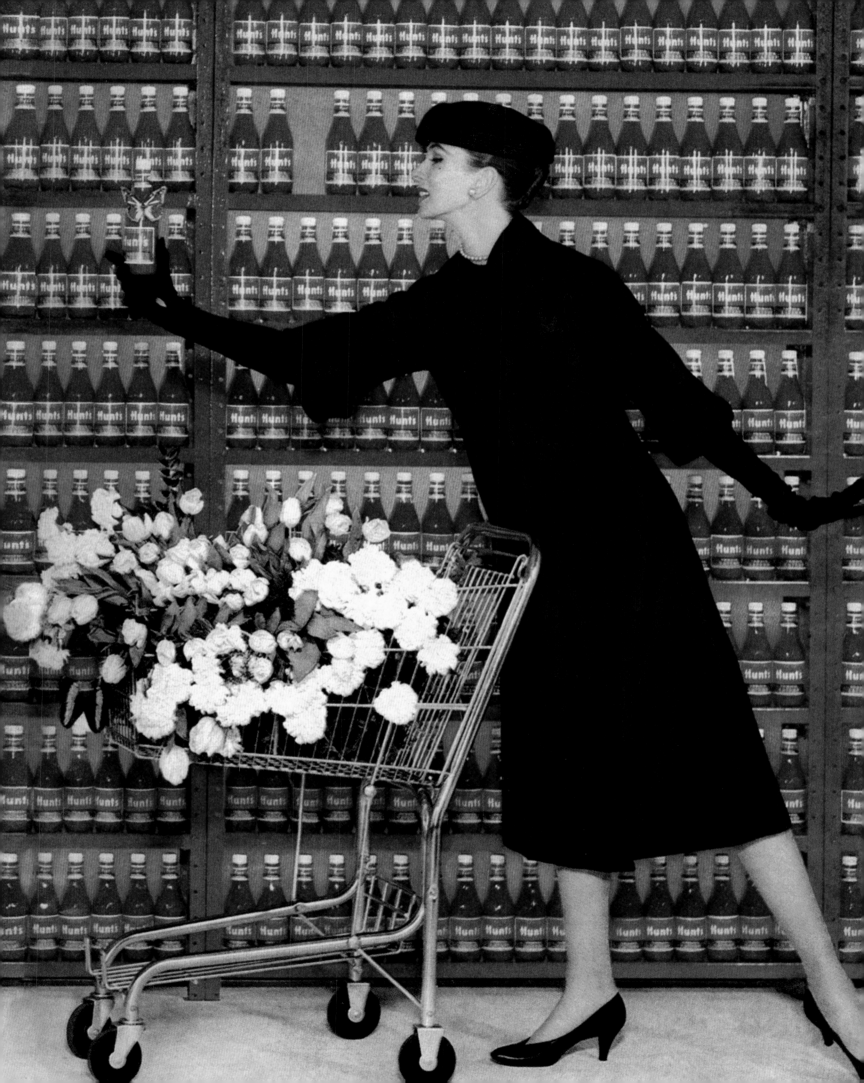

Kate Spade, 1993

Below The success of Kate Spade's simple tote bag in 1993 surely owes something to the appeal of its functionality. The tote was originally the invention of the L. L. Bean company, but Spade made it urbane and one of the first "It" bags of the late twentieth century.

Marc Jacobs, 2008

Opposite While some dress-for-success manuals would keep women forever in shades of beige, American congresswomen have always promoted unabashed reds as their color of choice to signify power and to magnify their prescence at the Capitol and on television.

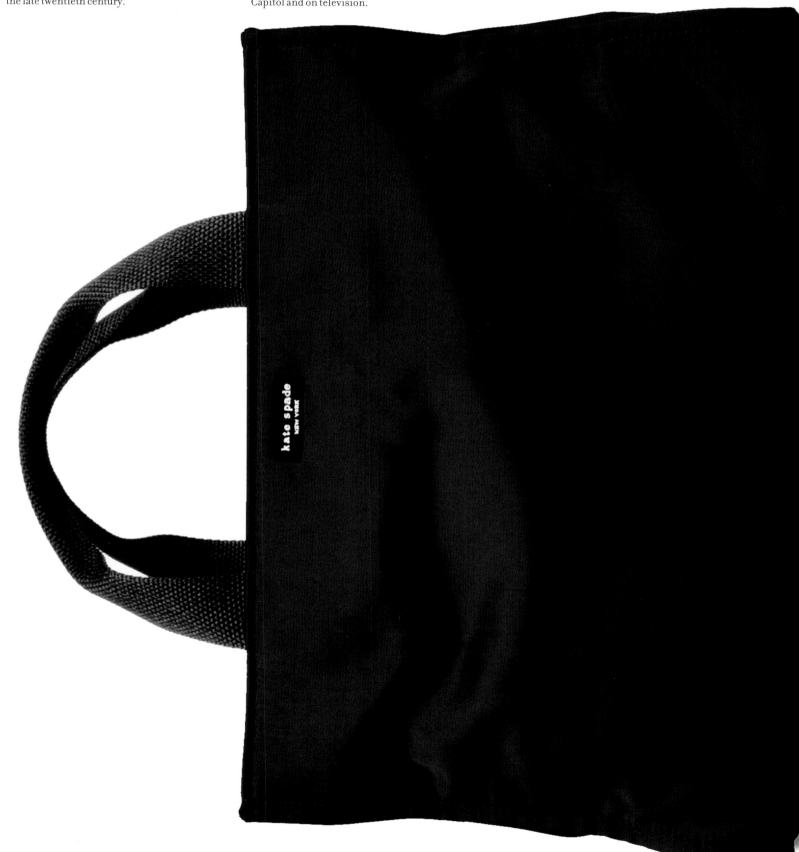

Gulf station, circa 1955

Right American corporations have taken care
to provide men with the right accessories
sometimes as well, as in the military-style cap
on the Gulf gas attendant.

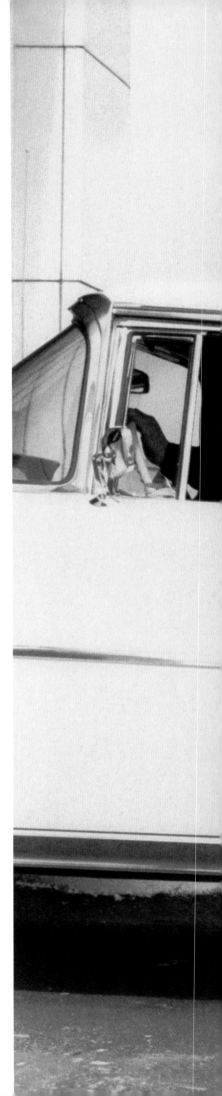

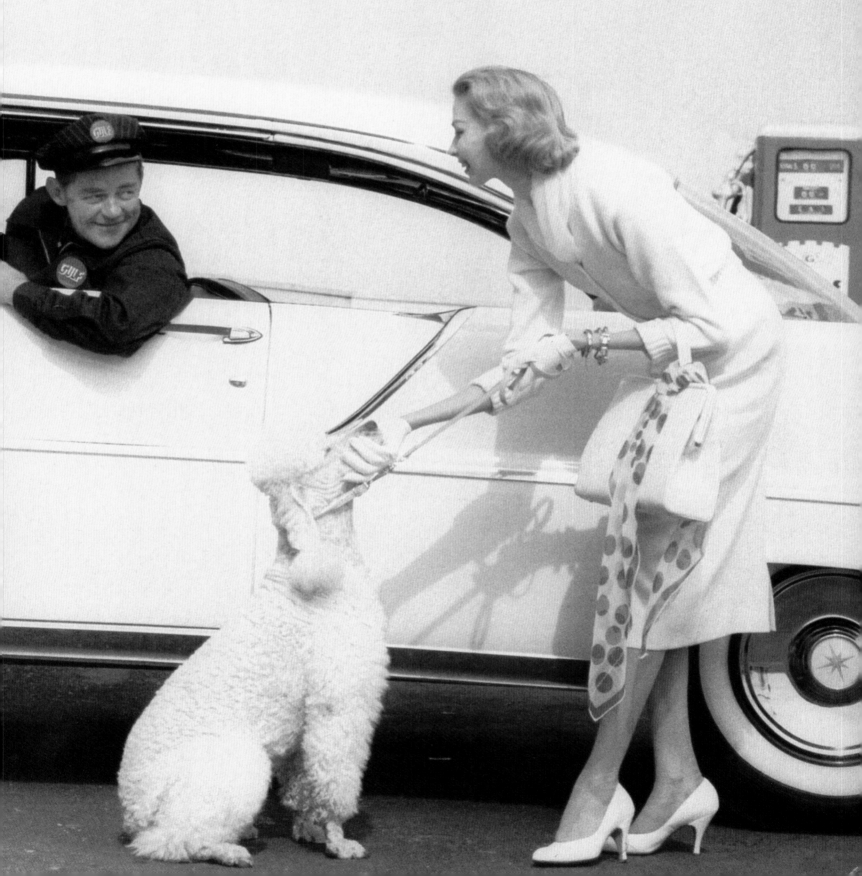

Edmundo Castillo, 2003

While Edmund Castillo is hardly a maker of the strictly "sensible" shoe associated with the American working woman, his beautiful, sharp heels hold appeal as a hard-earned luxury.

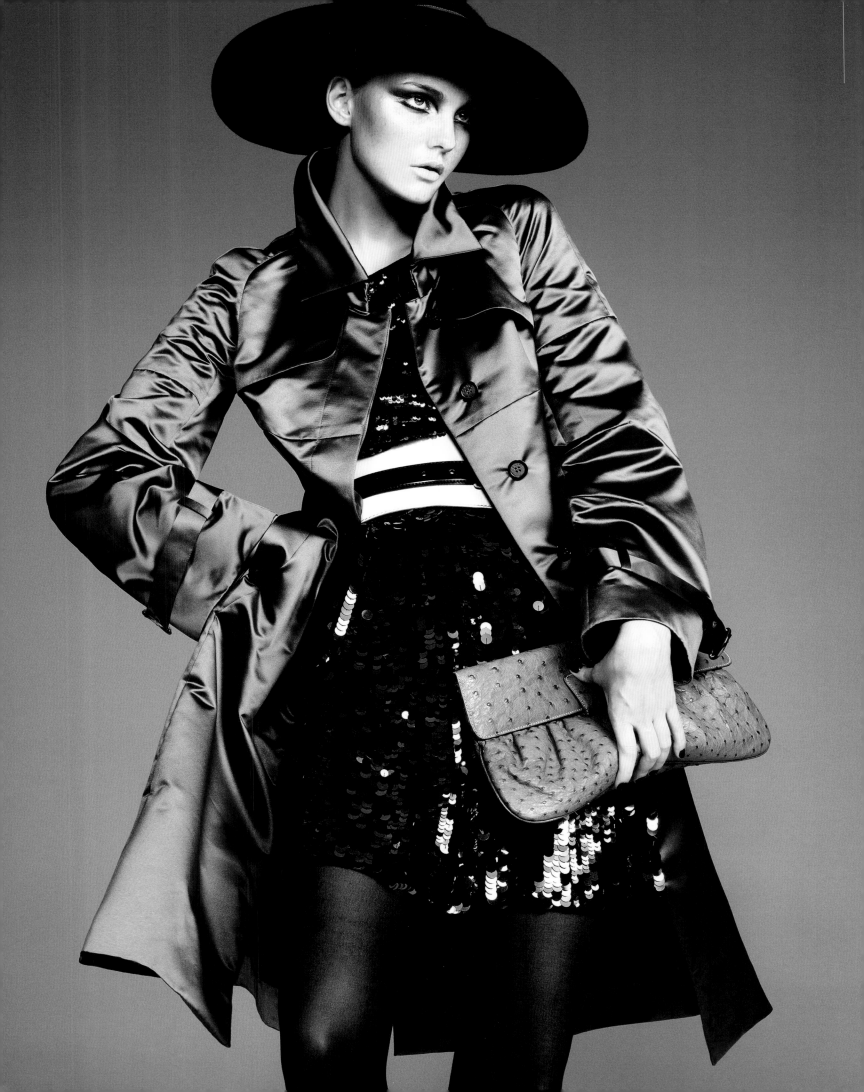

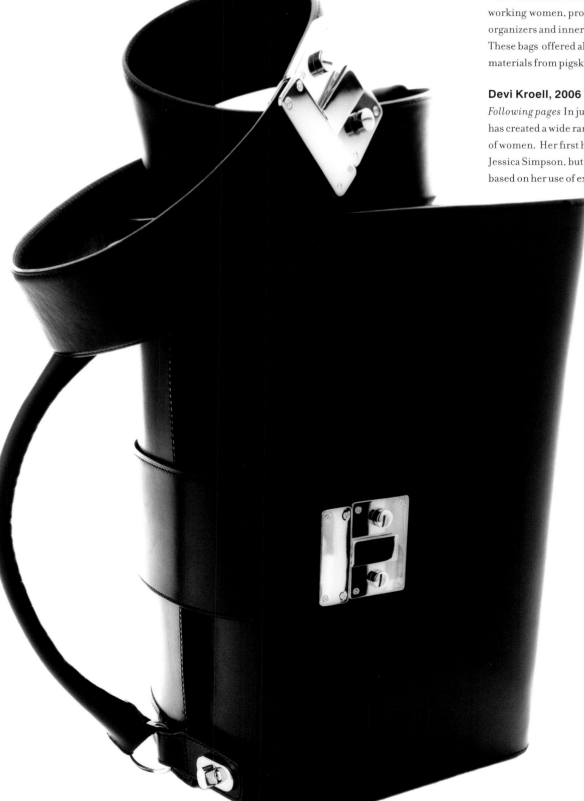

Calvin Klein, 1992

Left From his rise in the 1970s, Calvin Klein's clean minimalism was always tailored for the workplace.

Lambertson Truex, 2007

Opposite Ever since the very start of their business in the late 1990s, Richard Lamberson and John Truex have intended to answer the needs of the American working women, providing sizable bags with pull-out organizers and inner cases for laptop computers. These bags offered all that wrapped in luxurious materials from pigskin to crocodile.

Devi Kroell, 2006

Following pages In just a few short years, Devi Kroell has created a wide range of bags that appeal to all sorts of women. Her first hit was a roomy hobo bag worn by Jessica Simpson, but her continued success has been based on her use of exotic skins from python to perch.

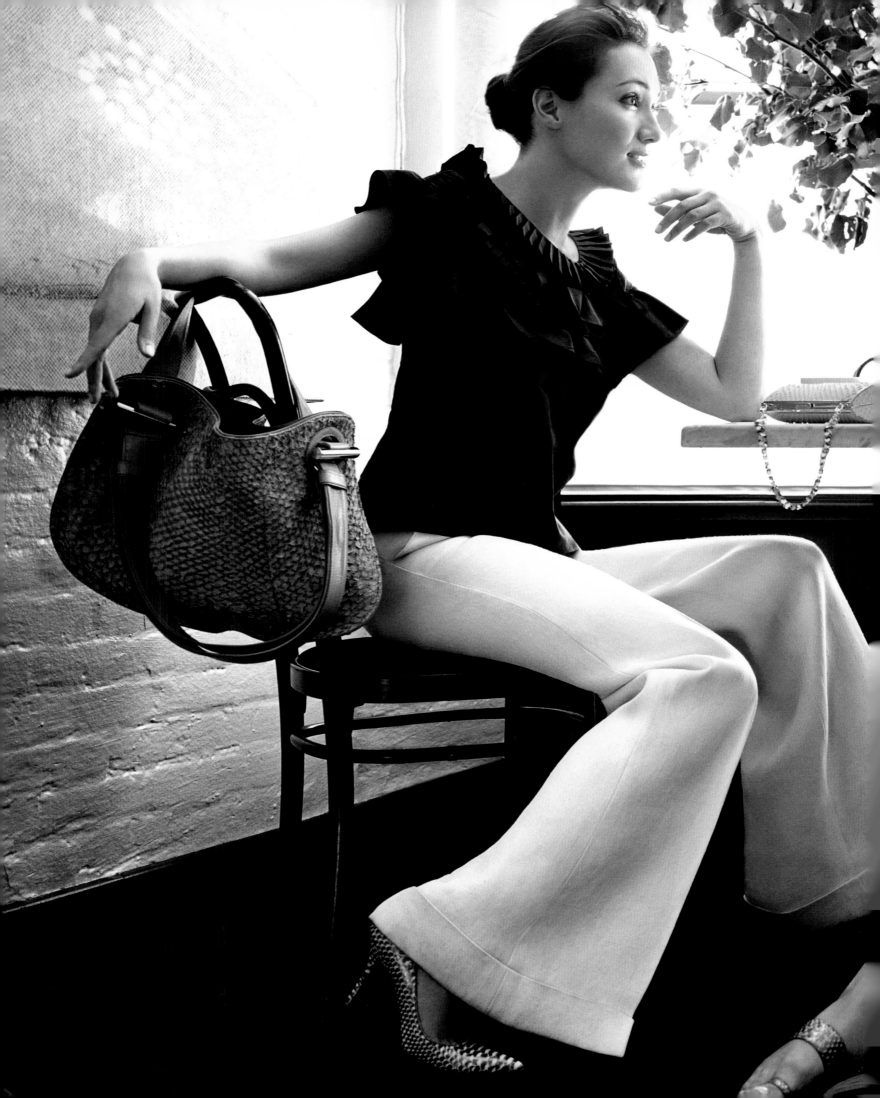

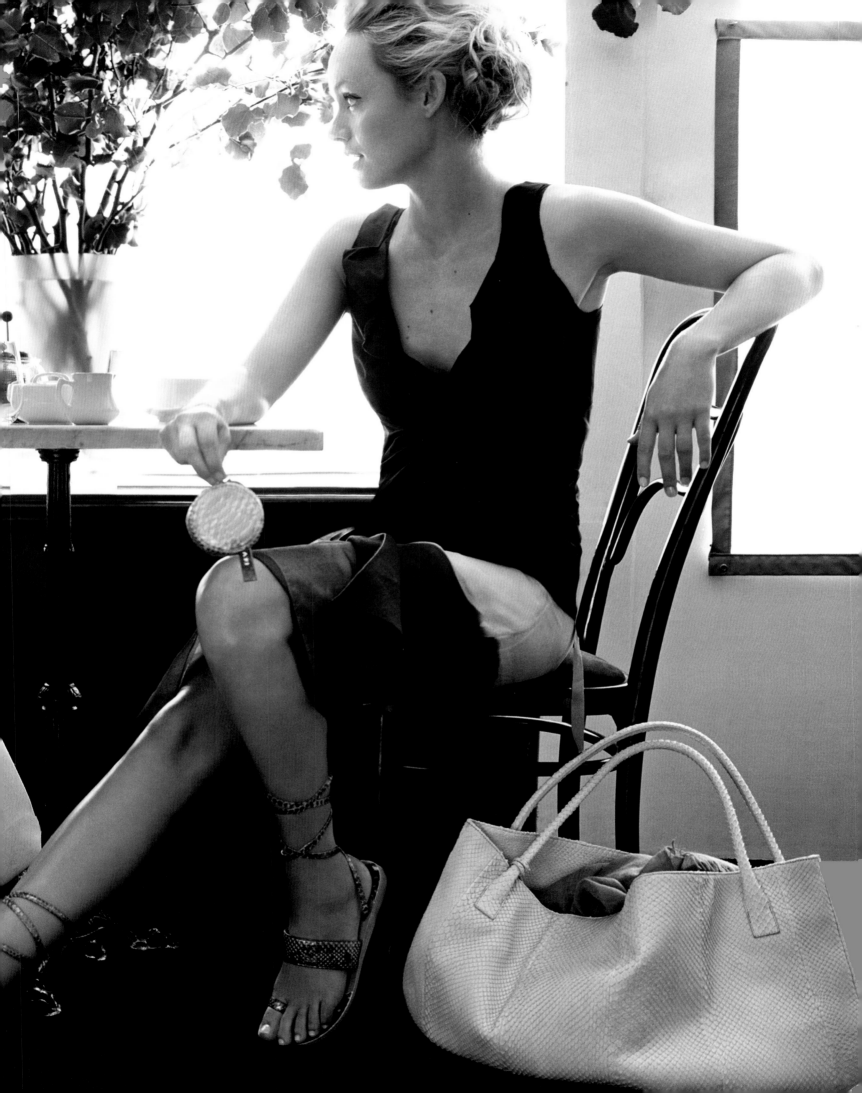

Zac Posen, 2008

Above In the 1980s, dress-for-success books recommended that women forgo a purse in favor of the briefcase. Fortunately, American designers have brought great style to this unassuming piece. Here Zac Posen has created a design that alludes to the envelope bag, common in the eighteenth century, but more striking in turquoise leather.

Kate Spade, 2006

Opposite The great dream of the American working woman has always been to have it all: baby, job, Marc Jacobs ensemble, and fabulous Kate Spade bag.

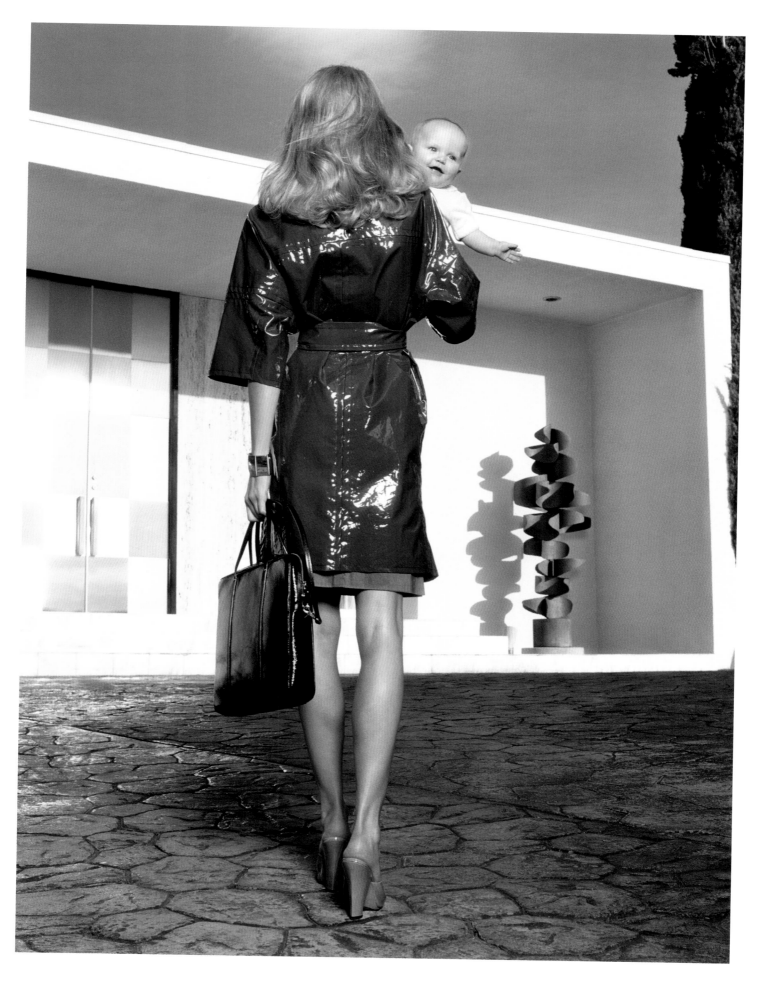

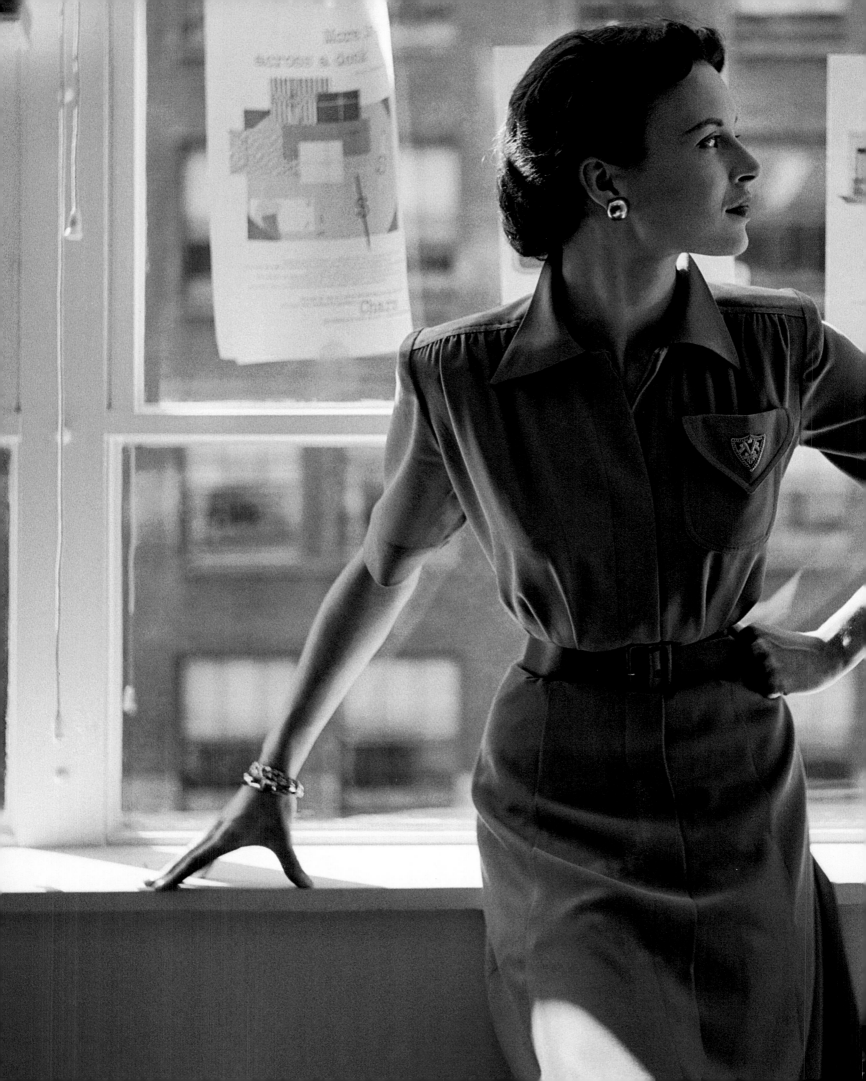

New York, 1950s

Left Though less visible in a world entranced by Paris fashions and the hothouse flowers who wore them, the working woman had a place in fashion magazines in the 1950s and American designers were always the most adept at dressing her.

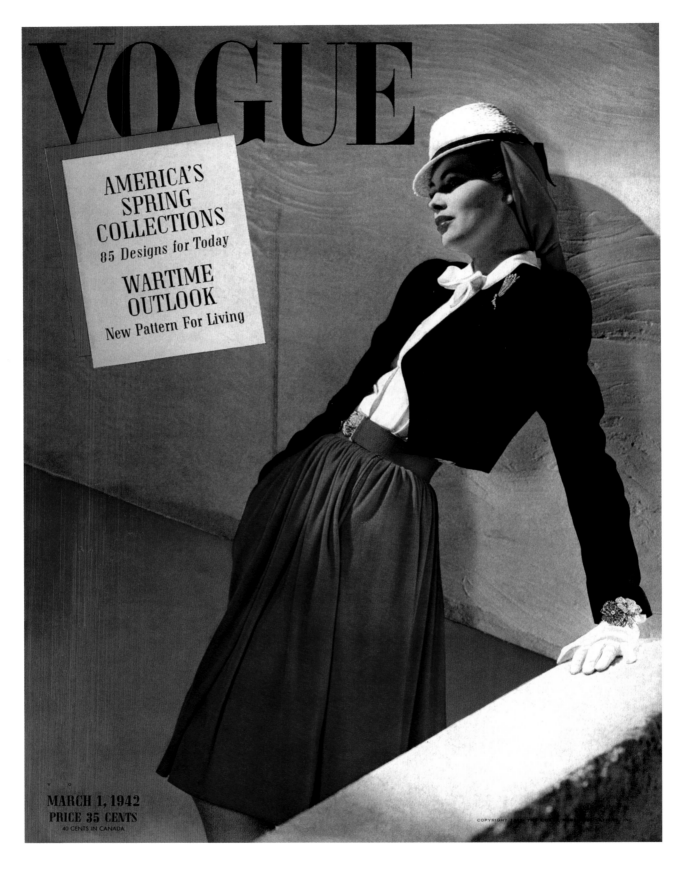

Vogue, 1942

Above During World War II, the working woman was held in especially high esteem in America because so many women joined the workforce with a patriotic fervor that has never since been equalled.

New York, 1949

Opposite New York women in front of the city they helped build.

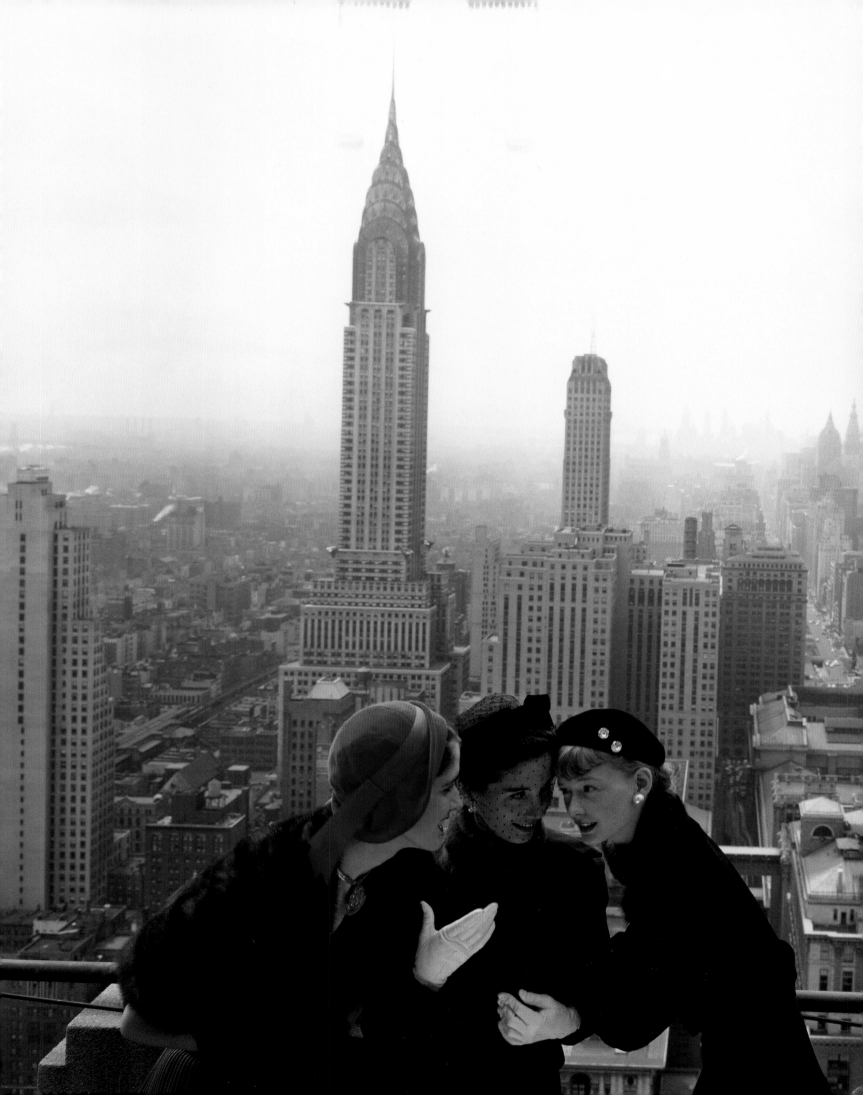

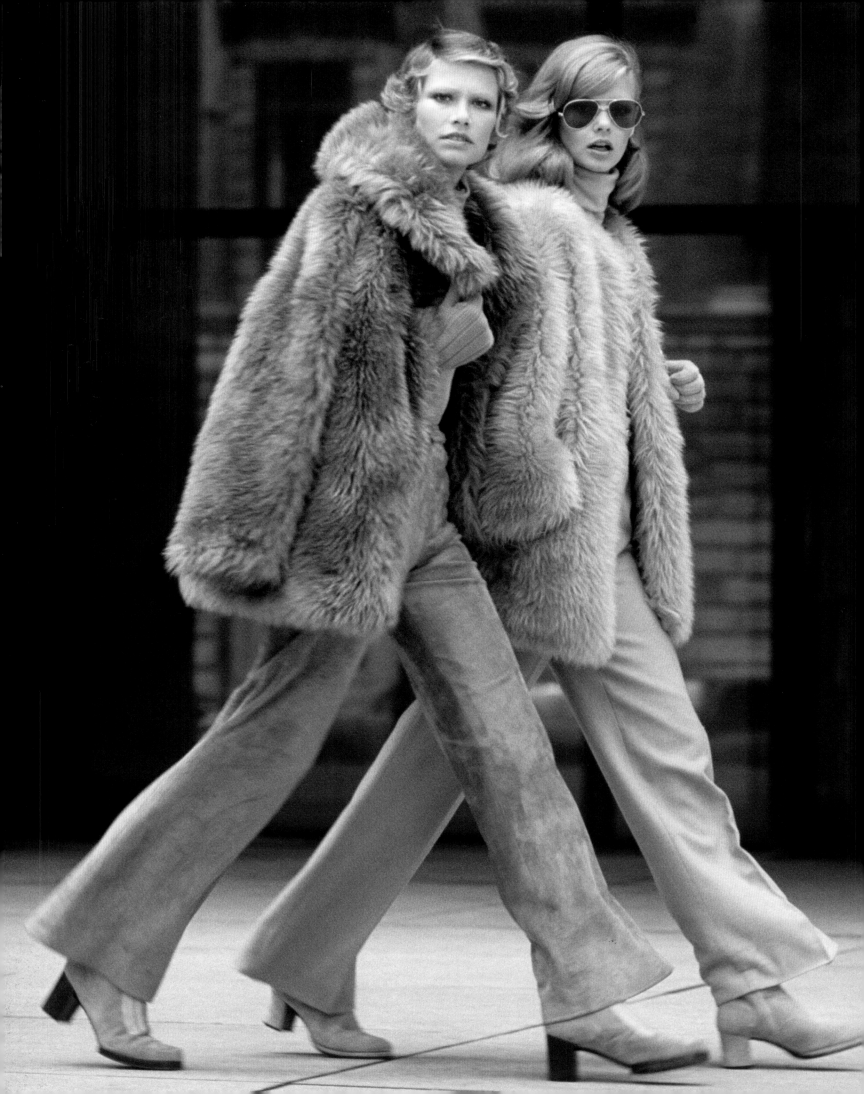

Coach, 2008

Above The Coach bag, currently designed by Reed Krakoff, is still a staple American accessory—well-made and irreproachably professional.

Bill Blass and Anne Klein, 1972

Opposite Working women in the 1970s often climbed the ladder of success in muted tones such as beige and camel. This camouflage helped them slip past the men who might have stood in their way.

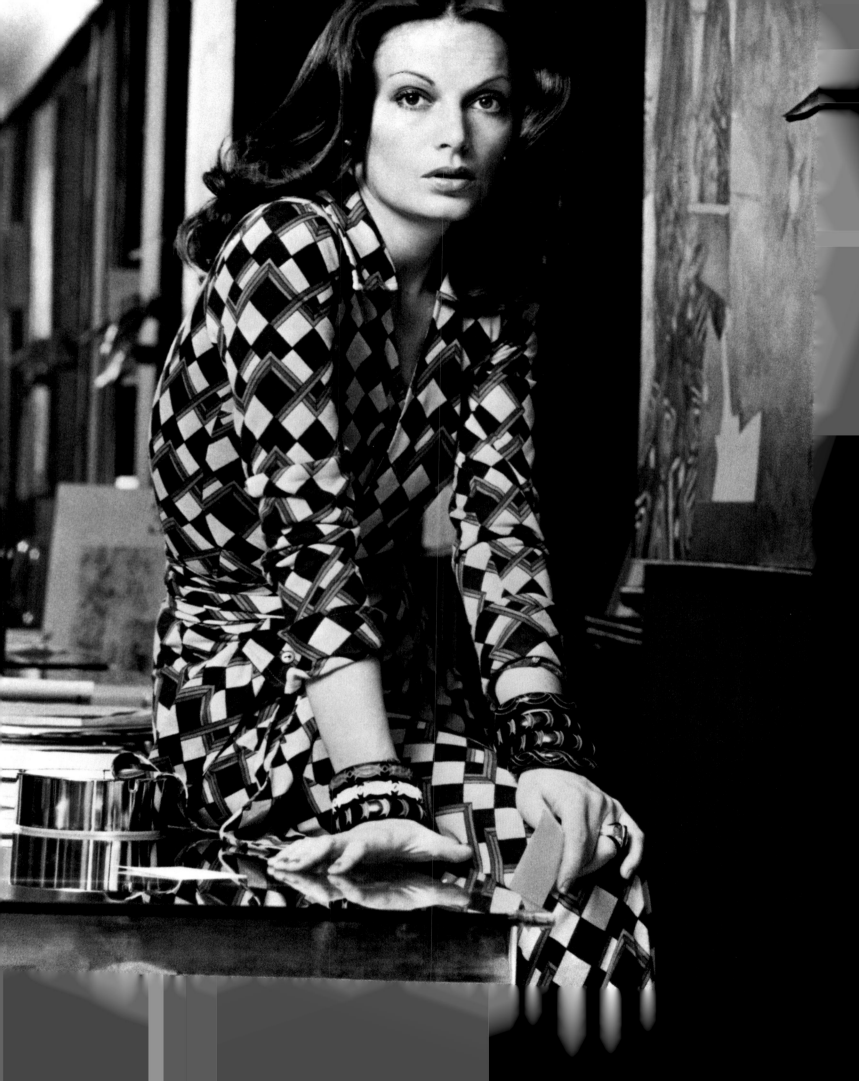

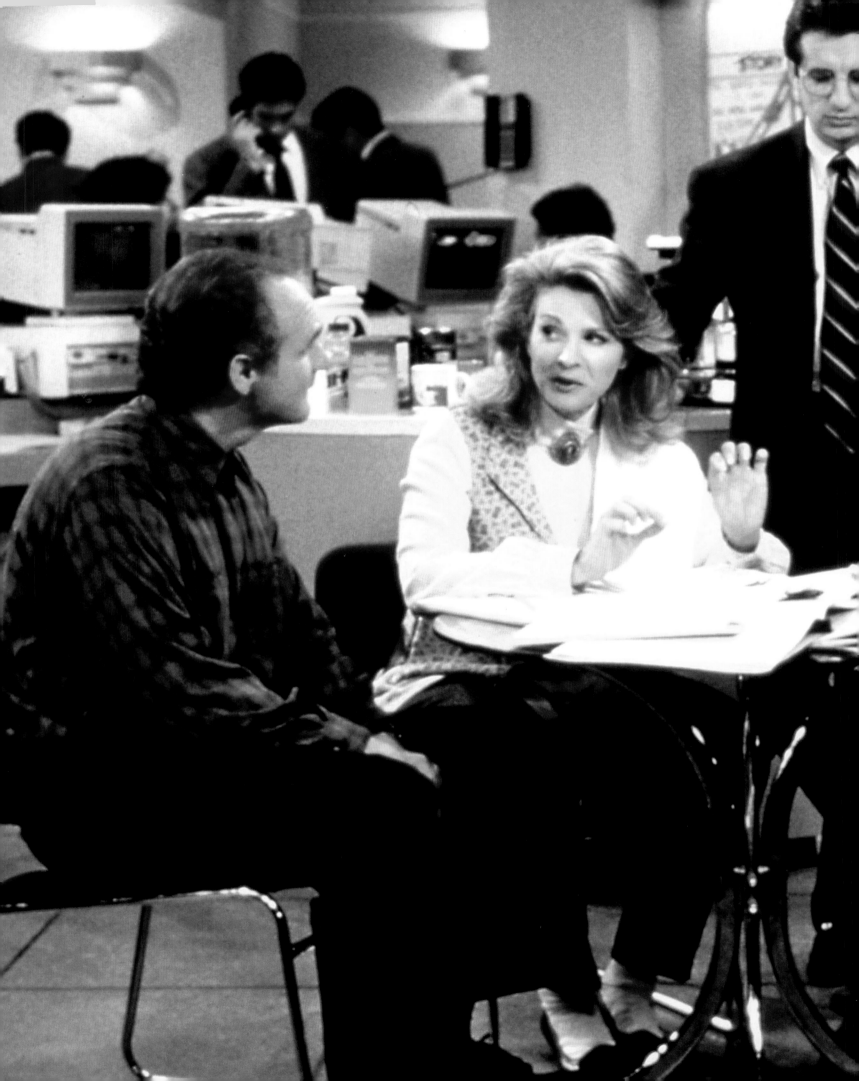

Murphy Brown, 1988

Left Starting in 1988, American working women got the Hollywood treatment on the television show *Murphy Brown*, which featured Candice Bergen as the title character.

Diane von Furstenberg, 2008

Previous page, left Diane von Furstenberg's "Sutra" bracelet combines gold and ebony links for a bold take on luxury.

Diane von Furstenberg, 1972

Previous page, right Diane von Furstenberg not only made the working woman's "It" dress of the 1970s, but also proved how glamorous running one's own business could be.

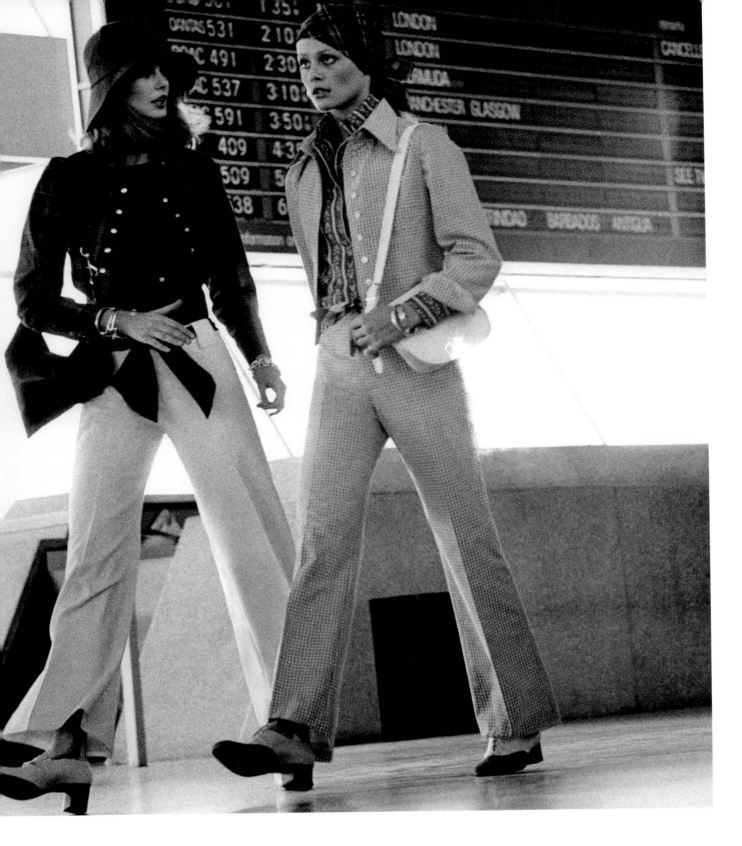

Anne Klein, 1972

Above Anne Klein's career in American fashion dated back to the late 1940s before she started her eponymous business in 1968. At Anne Klein Studio and in the department store-based Anne Klein Corners, the designer promoted business women's sportswear based on coordinating separates, a concept that extended to include accessories like belts, shoes, and scarves.

Marc Jacobs, 2006

Opposite American accessory design has come full circle as designers expand beyond handbags into luggage. The basis of the first American handbag was a small travel case—an item that could have been made by a leather-goods manufacturer, and not necessarily by a fashion designer. Since then, the carpetbag, the satchel, and the pochette have increasingly defined what the bag could be. Today, the elegance of the bag extends to fashionable luggage.

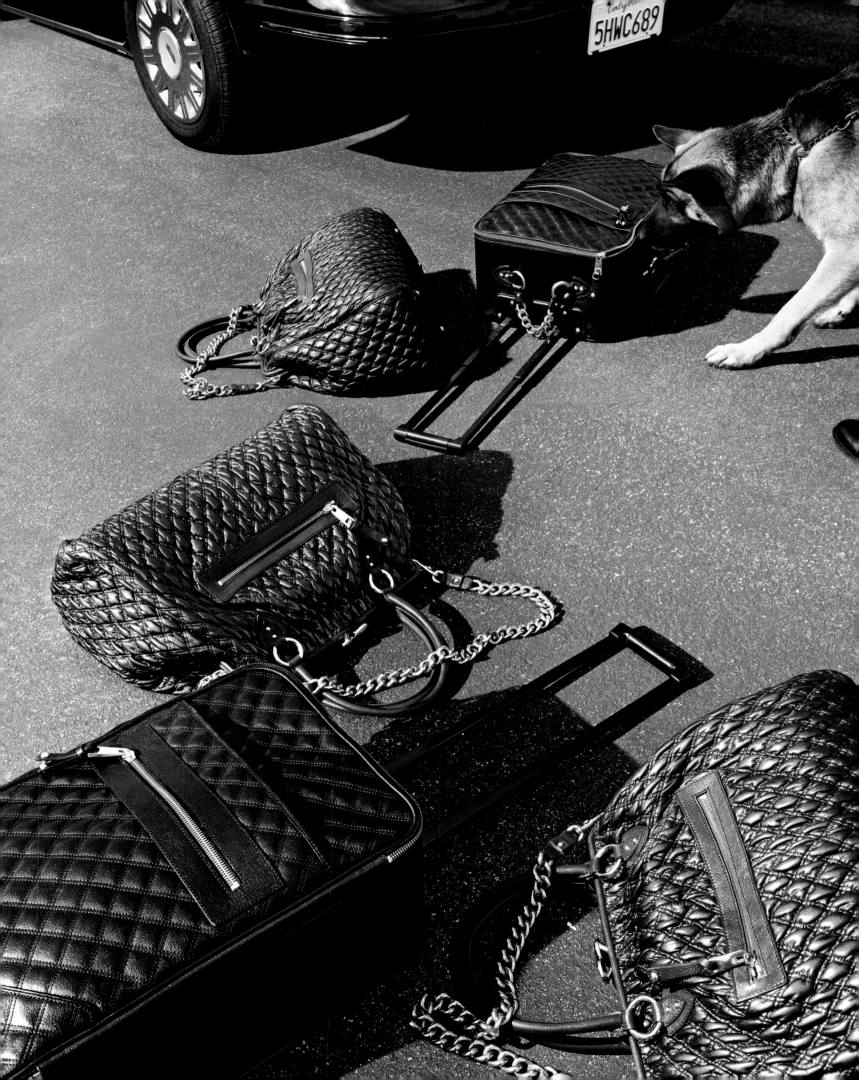

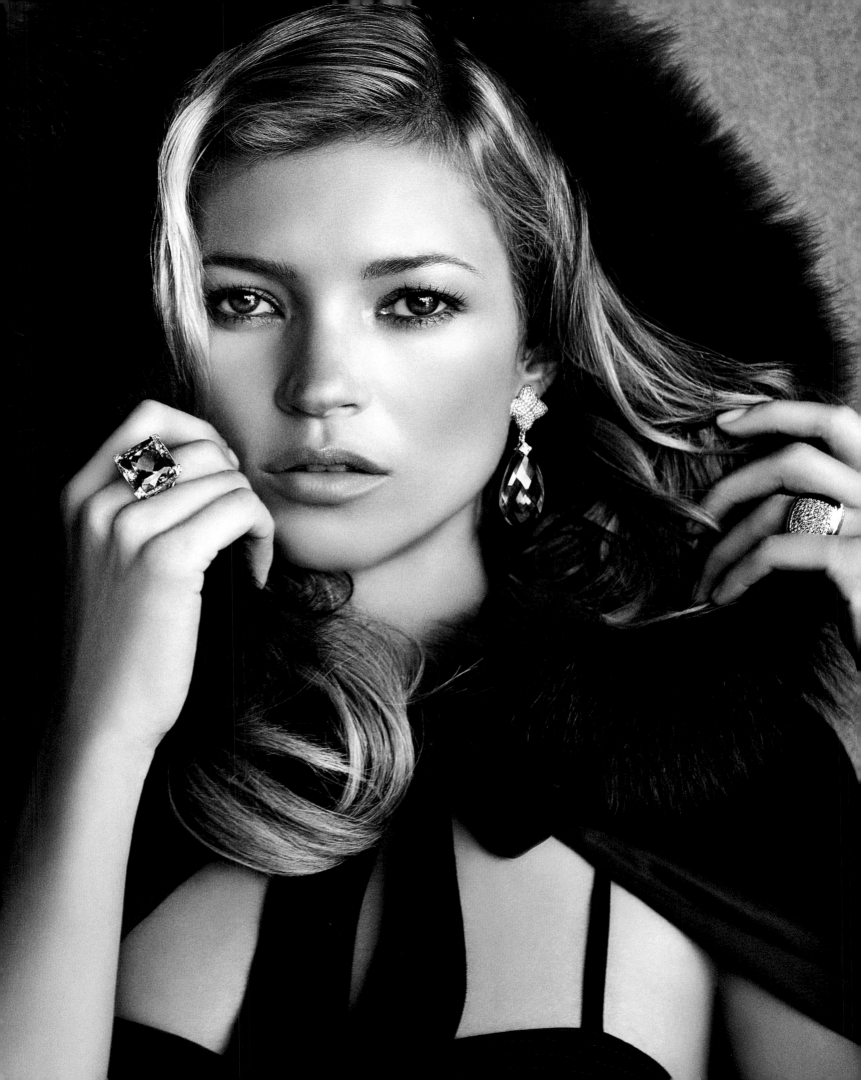

Robert Lee Morris, 1977-78

Above A collaborator with great American designers such as Calvin Klein and Donna Karan, Robert Lee Morris's sculptural jewelry designs evoke the ancient world of the Amazon warrior. This "barbed fanged and deadly cuff" is made of elkskin, bronze copper, and verdigris.

David Yurman, 2007

Opposite Accessible only once success has been achieved, David Yurman jewelry finds a balance between luxury and reality with fine gems and gold that can be worn everyday.

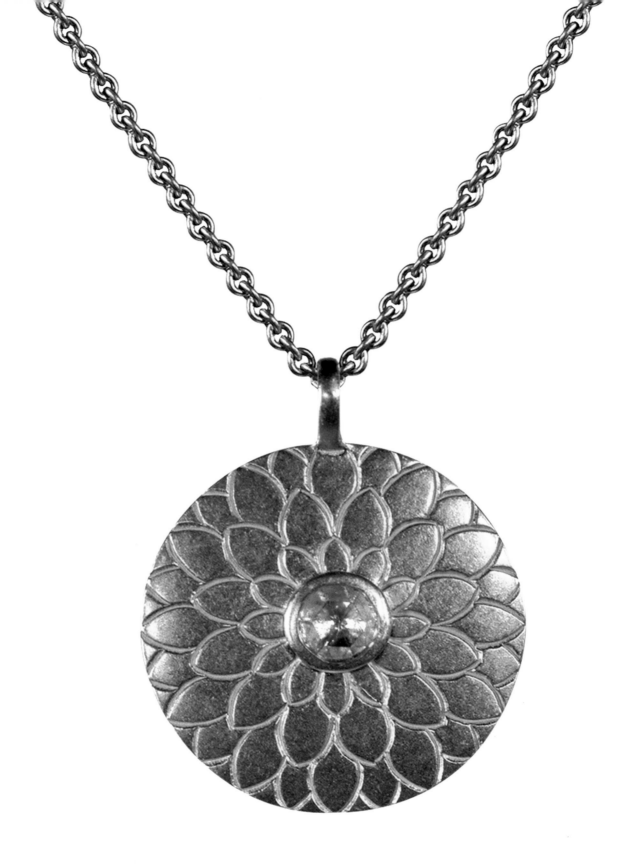

Me & Ro, 2007

Above Robin Renzi of Me & Ro has eschewed showiness in favor of simplicity in her jewelry, a philosophy born of her belief in the ability of jewelry to communicate and serve as personal amulet to the wearer.

Elsa Peretti, 1972

Opposite Bare, confident skin as the backdrop for Elsa Peretti's miniature modernist pendants.

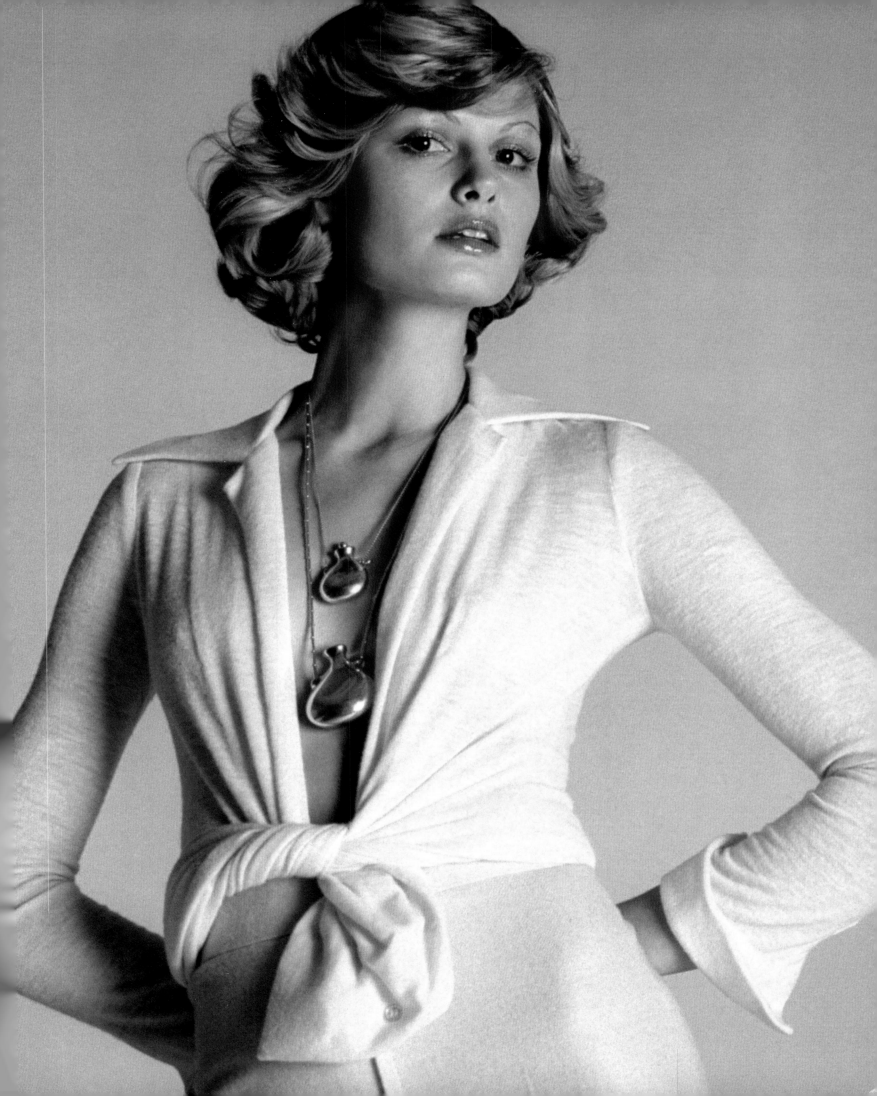

Liz Claiborne, 1978

Opposite From the launch of her company in 1976, Liz Claiborne both dressed as and was the consummate business woman. She expanded her line to include accessories in the early 1980s.

Narciso Rodriguez, 2000

Following page, left American women: over 100 years of marching . . . and counting.

Ralph Lauren, 2004

Following page, right One of the hallmarks of working women's dress has been the adaptation, and sometime wholesale theft, of elements of the menswear wardrobe. No one has proved a better co-conspirator in this endeavor than Ralph Lauren.

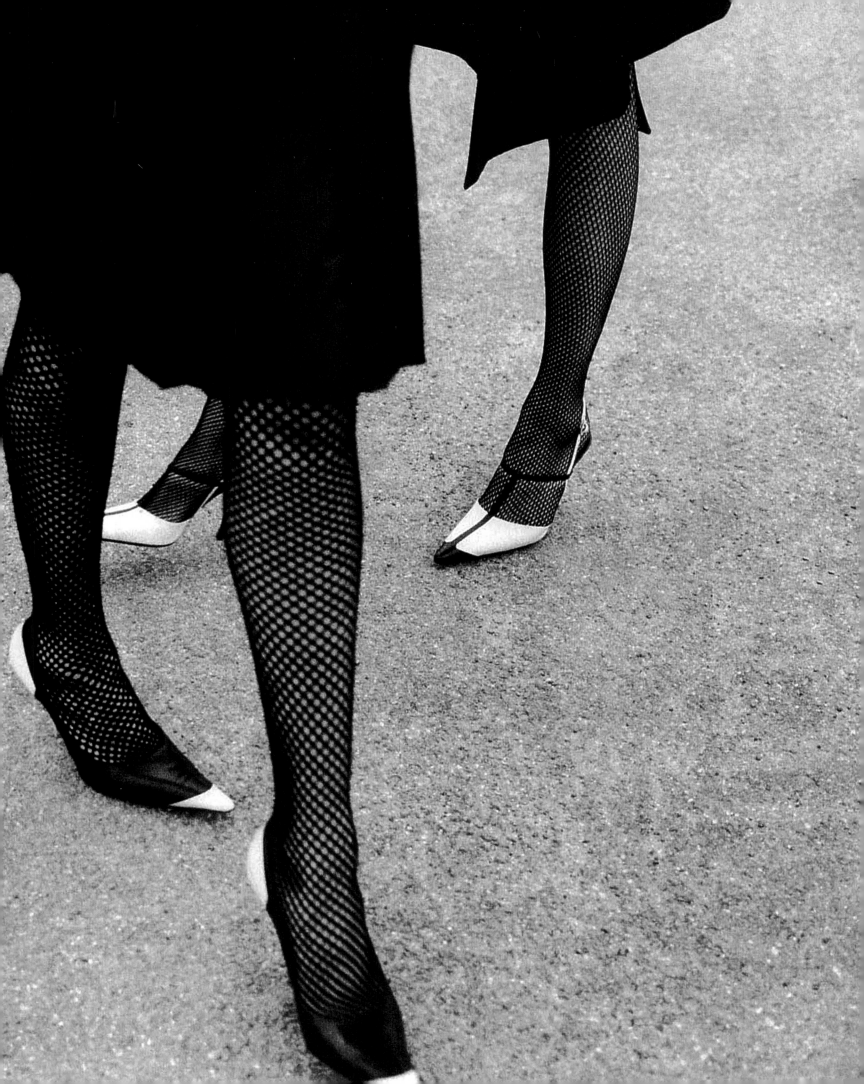

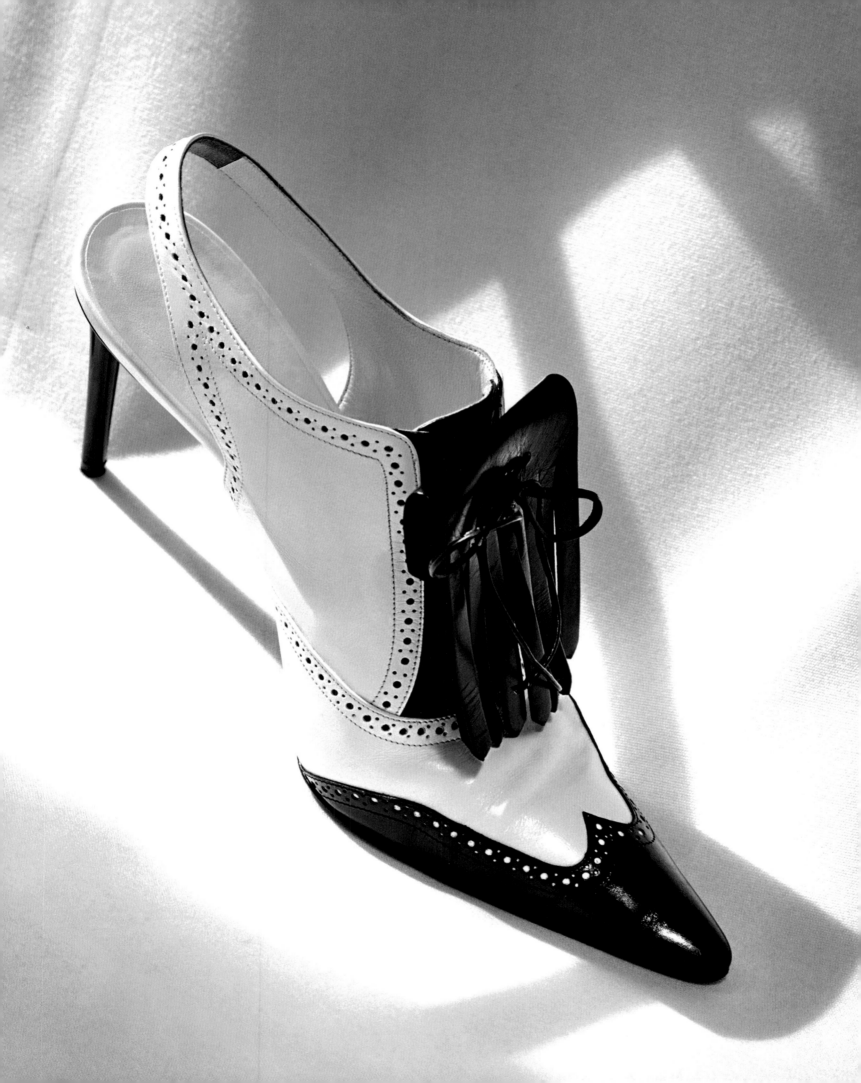

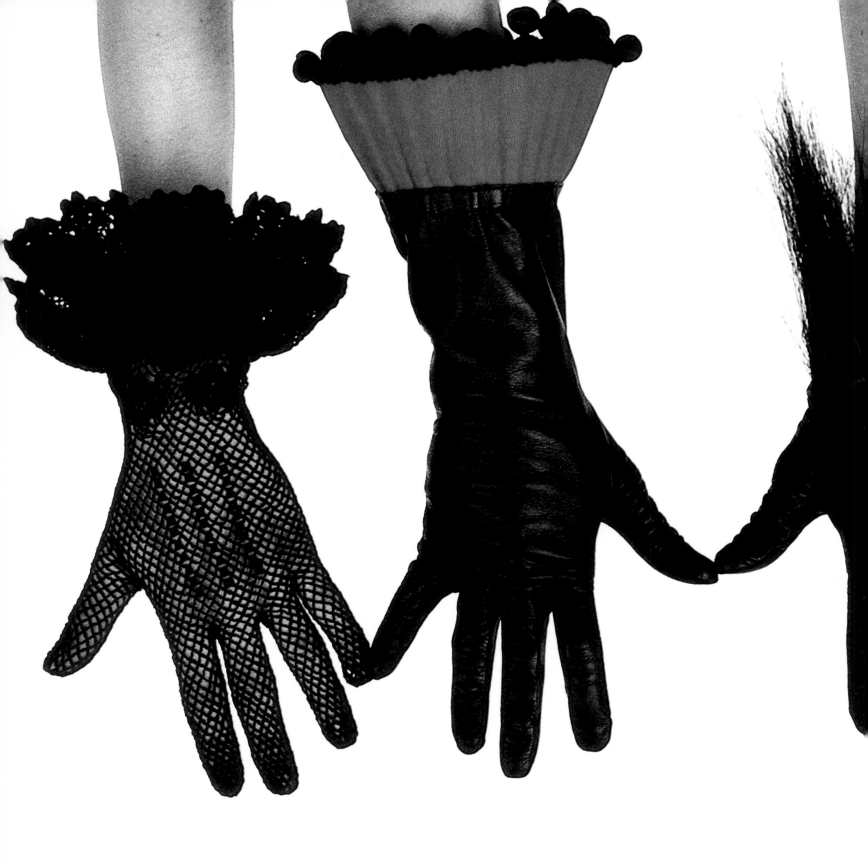

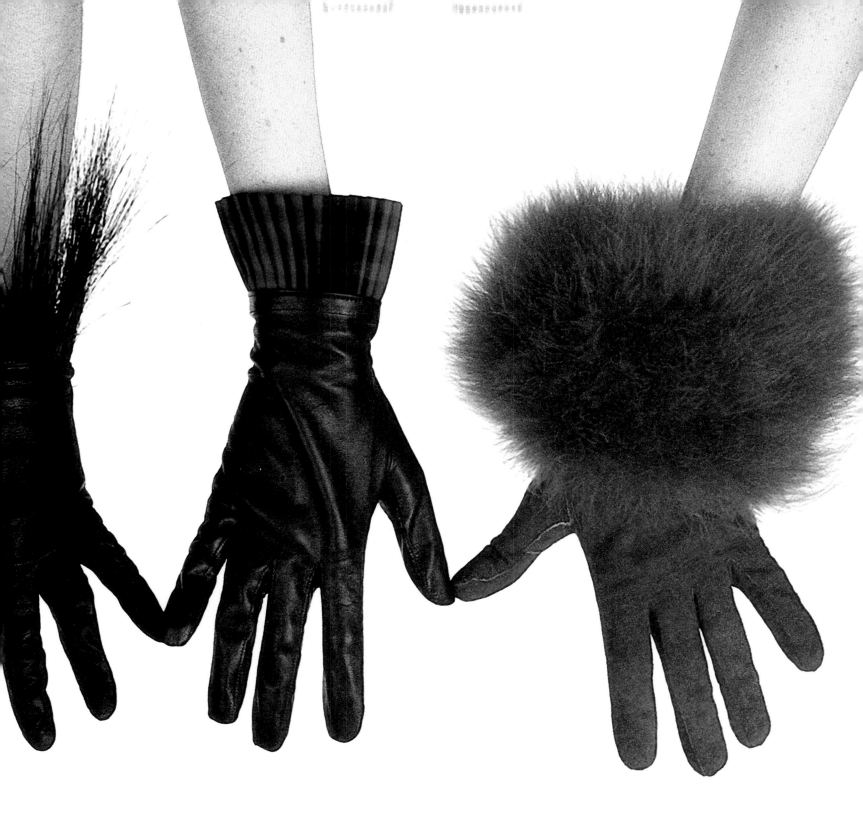

Geoffrey Beene, mid-1980s

Above These gloves are miles away from an oven mitt.

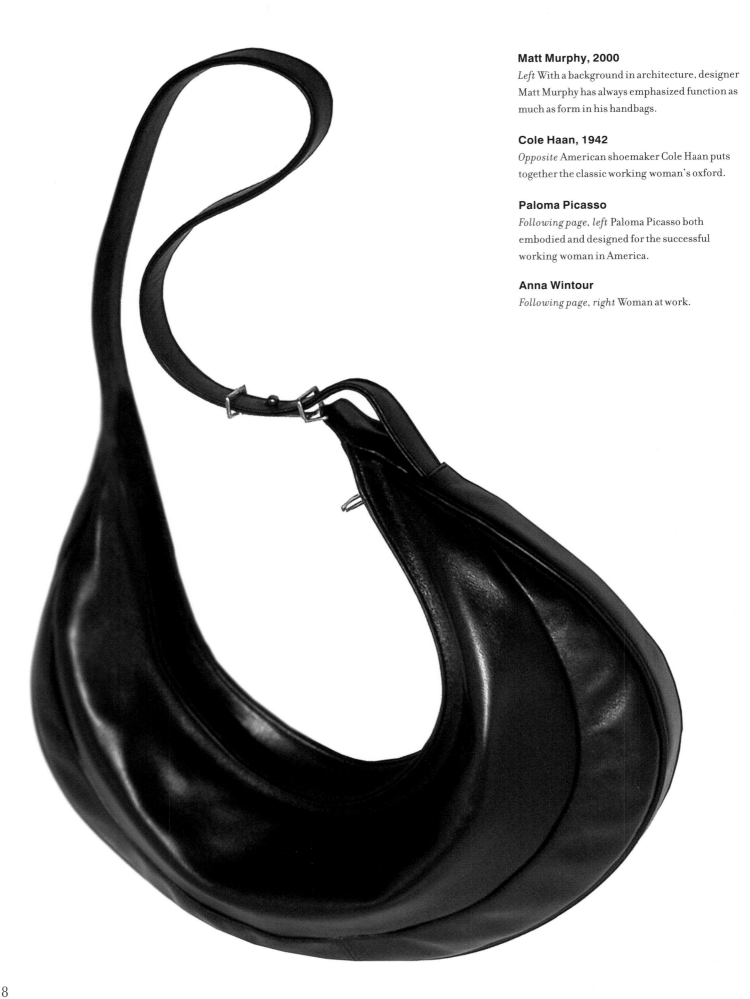

Matt Murphy, 2000
Left With a background in architecture, designer Matt Murphy has always emphasized function as much as form in his handbags.

Cole Haan, 1942
Opposite American shoemaker Cole Haan puts together the classic working woman's oxford.

Paloma Picasso
Following page, left Paloma Picasso both embodied and designed for the successful working woman in America.

Anna Wintour
Following page, right Woman at work.

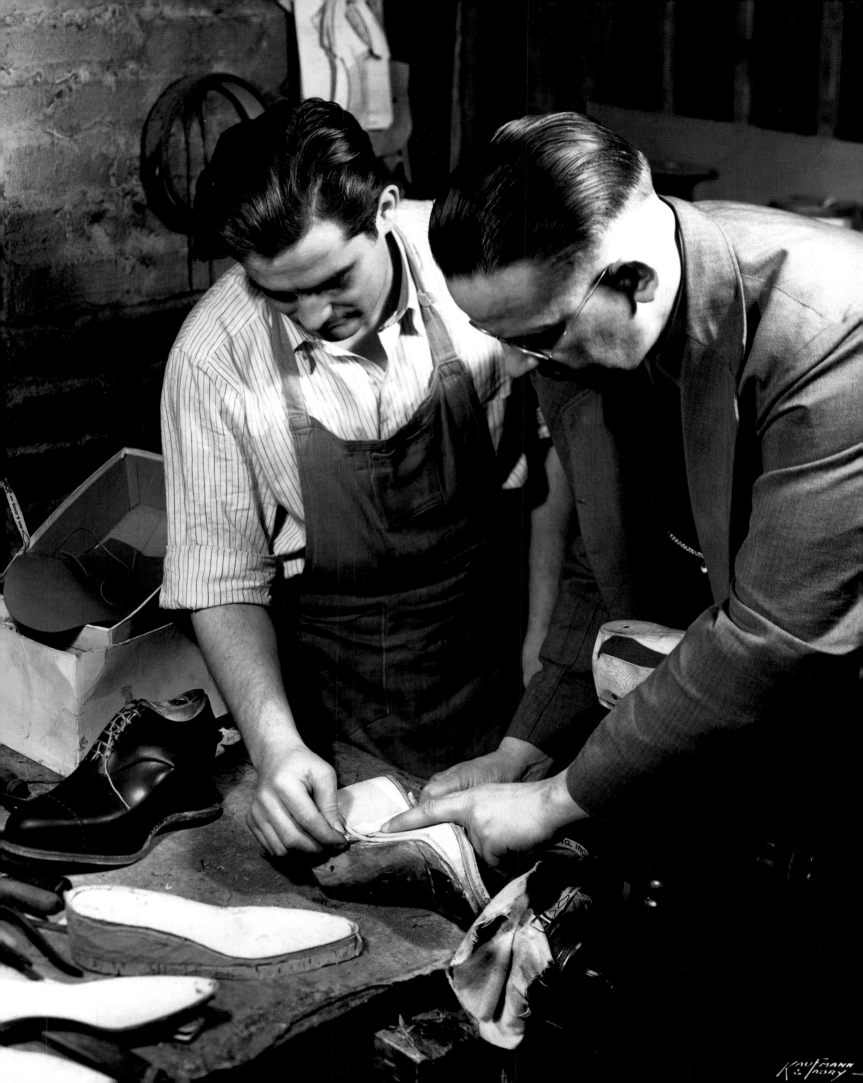

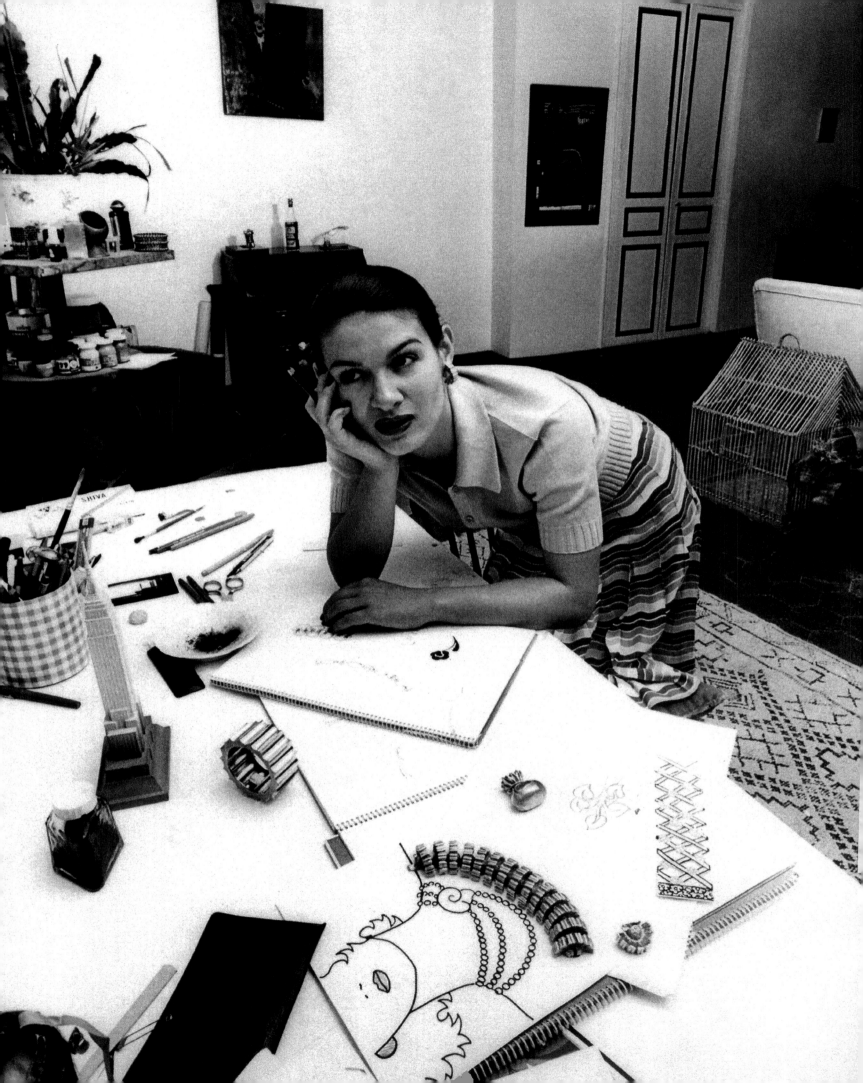

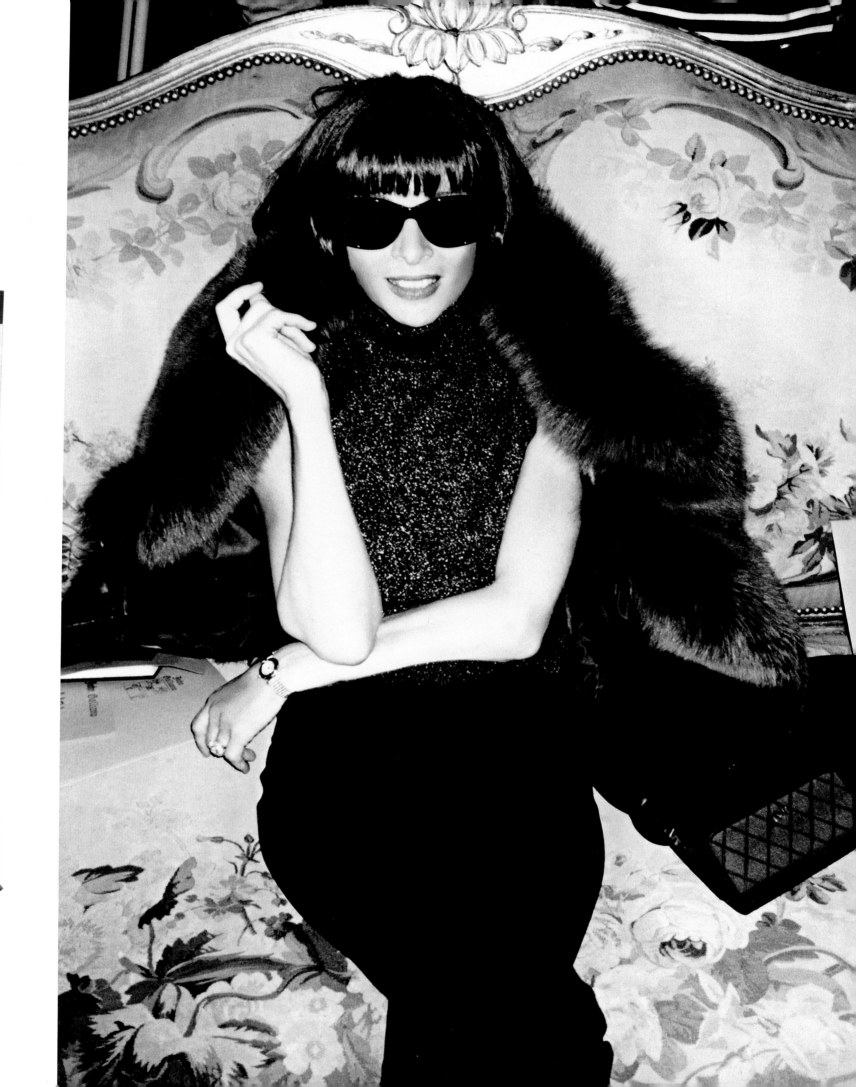

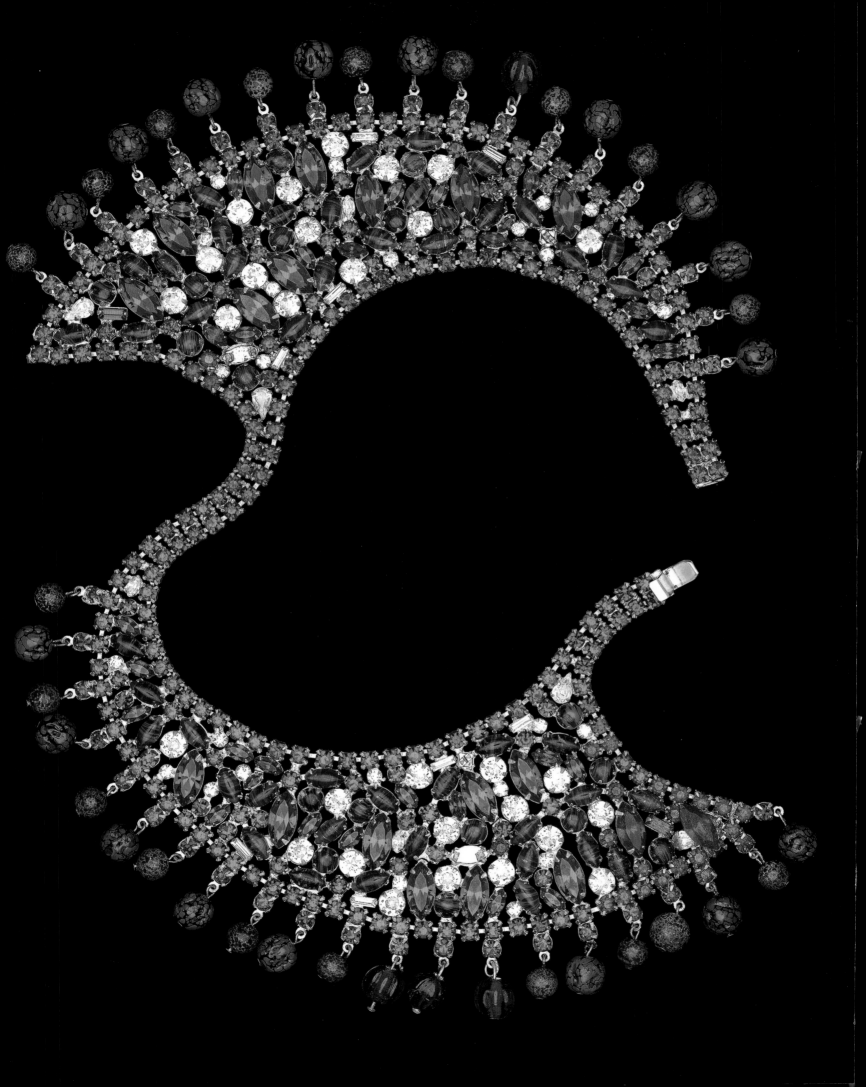

HOLLYWOOD

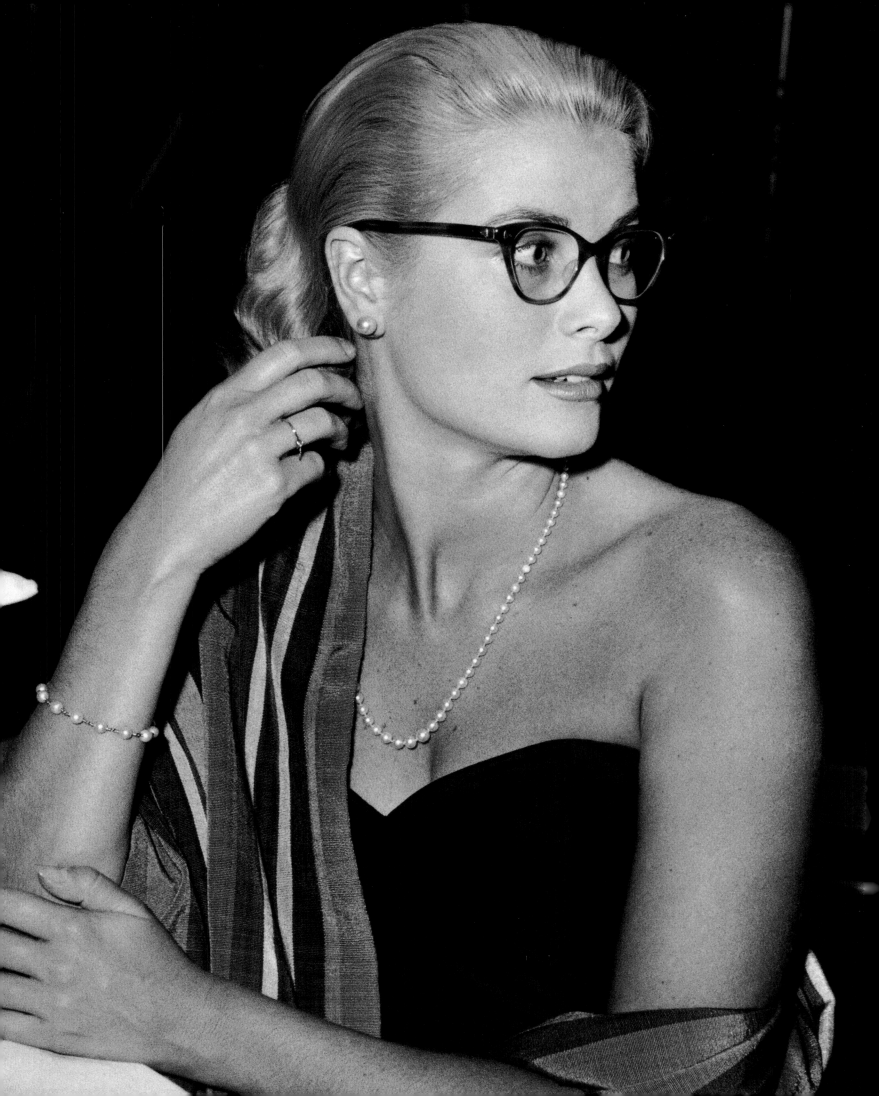

THE AMERICAN ACCESSORY
SHINES

Hollywood has always been America's not-so-secret weapon in the promotion of its style to the world. From the first flickering images of delightfully amoral flappers dancing atop tables to the present painstakingly dissected red-carpet fashion show at the Oscars, the Hollywood star has served as fashion instructor (and occasional cautionary tale) to the world. In the first half of the twentieth century, Hollywood's influence was more far-reaching than that of any New York fashion editor, and even since then the silver screen has served as a sourcebook that contemporary designers revisit again and again.

Of course, the tradition of the Hollywood clotheshorse was preceded by the Broadway stage clotheshorse. Theatrical impresario Florenz Ziegfeld elevated the act of being beautiful and beautifully dressed to spectacular extremes in his Follies, beginning in 1907. His showgirls—always tall, lean and elegantly patrician—were recruited from anywhere and everywhere, but especially at the American offices of the British fashion house Lucile, where Ziegfeld shopped for mannequins as well as stunning costumes for his stage shows. The Ziegfeld showgirls and their romantic escapades were breathlessly promoted by the producer, especially when one managed to snare a millionaire husband with her all-American glamour. More hushed was the gossip that would ensue when a showgirl acquired an ostentatious diamond bracelet. Known as service stripes, these were generally awarded during the more impermanent liaisons in which Ziegfeld girls sometimes engaged. In keeping with the tenor of the times, 1920s showgirls wore them in multiples when they could.

As Hollywood became a viable industry town in the 1920s, performers, writers, and designers migrated to the desert to finally invent an American woman of consequence. At first, Hollywood produced mainly historical and theatrical spectacles, punctuated with charmingly vulgar exploitation films on the subject of the flapper, best personified by "It" girl Clara Bow. While these images mesmerized the world, they didn't yet transform the meaning of American style or even suggest that there was such a thing (other than the garish display of too much, which Europeans already associated with the nation). The potential of film would instead be

Left **Grace Kelly, ca. 1950** Actress Grace Kelly in living denial of the idea that men would seldom make passes at girls who wear glasses. Hollywood actresses often represented types that were overlooked in the world of high-fashion, but Kelly was the high-fashion type—the icy, composed blonde goddess of the 1950s. *Previous page, left* **Arnold Scaasi, early 1960s** American couturier Arnold Scaasi's career in designing his own costume jewelry was brief but vivid.

realized in the 1930s through collaborations between a new group of more polished and ambitious stars and a host of exceptionally innovative costume designers.

The first among equals was Gilbert Adrian (born Adrian Adolph Greenburg in Naugatuck, Connecticut, in 1903, he used the single name Adrian from 1921 on). He started out designing costumes in New York for Irving Berlin's *Music Box Revue* before being swept away to Hollywood by Rudolph Valentino and his wife, Natacha Rambova. Once established at Metro-Goldwyn-Mayer, Adrian showed his true talent for realizing a new and singular American style on the screen. His first success story was in dressing Greta Garbo (whom he succeeded in pleasing after she had run two other costume designers off), but his greatest collaboration was with Joan Crawford. Crawford could have happened only in America, where the shopgirl Cinderella she played in various incarnations held particular resonance. She was a creature of the meritocracy, succeeding again and again through intelligence, adaptability, and bald ambition. Such characteristics were not associated with the woman of fashion in Europe, but Adrian made Crawford into a new kind of woman of fashion. He built an iconography around Crawford's somewhat challenging body (though slender and tiny, she had a long waist, broad shoulders, and "strong" facial features), that is still instantly recognizable. His solution was to emphasize, rather than diminish, what was singular about Crawford—he magnified her shoulders with padding and her face with hats and oversize brooches. This is, in part, how Adrian inadvertently ended up in the accessories business in the 1930s. Mass identification with Crawford led to emulation, and an American fashion industry in the depths of the Great Depression couldn't resist taking a piece of the pie. Consequently, American manufacturers relentlessly knocked off Adrian's accessories. One of his most famous successes was Greta Garbo's "Empress Eugenie" hat from the 1930 film *Romance*; it was a highly impractical

Left **Marc Jacobs, 2007** Jeweled headband. *Center* **Anthony Nak, 2008** Anthony Camargo and Nak Armstrong left New York to open their fine jewelry business in the burgeoning film center of Austin, Texas, which has played host to directors Richard Linklater, Robert Rodriguez, and Quentin Tarantino. *Right* **Raymond C. Yard, 1936** Raymond C. Yard's most famous Hollywood association was with Joan Crawford, though he welcomed anyone else willing to pay in full.

confection with a tilt over one eye and feather plumage, and it marked a complete and successful departure from the 1920s cloche. This creation's ubiquity appalled Adrian as the hat was conceived as an 1850s period piece that had no place in contemporary dress. His delicacy was disregarded by M.G.M. head Louis B. Mayer, who saw dollar signs in Adrian's work and made deals with Seventh Avenue and department stores to use a chain of in-store boutiques to sell legitimized knock-offs of Adrian's creations.

The movies didn't just sell Adrian's hats. They sold a range of other accessories that appeared in films, especially during the Depression, when an accessory seemed a justifiably frugal purchase in contrast to the purchase of a whole dress. The trend continued into the 1940s, with a greater focus on shoes. The first "Hollywood" shoemaker was actually an Italian, Salvatore Ferragamo, who moved to America in the 1910s and started creating shoes for historical epics like Cecil B. DeMille's *The Ten Commandments* and *The King of Kings*, while also cultivating an American celebrity clientele, but he returned to Italy in the late 1920s. David Evins, also an immigrant to the United States, became a more notable Hollywood shoe designer after an abortive career as an illustrator. He gained enormous publicity for his custom shoes for movies and movie stars, while producing a ready-to-wear label through manufacturer I. Miller. Evins's custom shoes were exemplary of the "fantasy shoe." The Hollywood client welcomed extremes, so Evins designed gloriously impractical rhinestone-encrusted shoes for Lena Horne, Ava Gardner, Judy Garland, and Marlene Dietrich among others. He also designed Grace Kelly's shoes for her wedding to Prince Rainier of Monaco and shoes for the Duchess of Windsor. Evins freely took inspiration from his Hollywood environs to his mass-market line, introducing Carmen Miranda–inspired platforms and intensely colored alligator pumps. Like Adrian, Evins produced high-fashion wares later in his career as well, including shoe

Left **Jay Strongwater, 2002** Having made a career designing "jewels for the home" as well as fine jewelry, Jay Strongwater is clearly attuned to the need for a dramatic setting. *Center* **Mish, 2007** Though inspired by a love of nature, the 18k gold and precious stones in Mish Tworkowski's jewelry add up to pure Hollywood glitz. *Right* **Cathy Waterman, 1997** The epic sweep of Cathy Waterman's studies and travel has a made her a natural jewelry designer for the beauties that populate the contemporary silver screen.

collections for Geoffrey Beene and Bill Blass, proving yet again that the reflected glory of the movies could lead directly to Seventh Avenue success.

Adrian never saw a dime from the sale of his designs for M.G.M. (which probably encouraged his self-transformation from costume designer to fashion designer in 1940), but neither did any other of the film designers of the 1930s. The legacy of Adrian, Travis Banton, Orry-Kelly (born John Kelly), and others would instead be their acknowledged role as what Margit Mayer termed "art directors of femininity." They honed and refined the image of the American woman in the form of the undeniably magnetic stars of the coalescing studio system in the 1930s. They turned shopgirl Cinderellas, smart-talking socialites, and film noir femme fatales into fashion icons—American-made from their smart chapeaus to their impossible shoes. The power of the Hollywood costume designer continued through the 1950s and 1960s, especially in the work of Edith Head. Her career began in the late 1920s, but she was acknowledged as a style leader in the 1950s, particularly for her work with stars like Elizabeth Taylor. Head's costume designs were marketed to American women as Adrian's had been before.

The stars themselves were showered with money for their successes, which enabled them to present a spectacular image in real life, when not presenting one on-screen. This was commonly expressed through jewelry—a continuation, perhaps, of the tradition of service stripes, with studio heads standing in for intoxicated Manhattan stockbrokers. In the 1930s, stars drove the American jewelry industry as much as the equally famous socialite set did. And like the rich, they bought rather than borrowed. Crawford was again a fashion leader, buying her gems from the New York jeweler Raymond C. Yard, as did Douglas Fairbanks, Jr., and Mary Pickford, while Gloria Swanson was also a spendthrift, claiming that her purchases were an attempt to shop America out of the Depression (an enviable task).

From the 1920s on, Hollywood jewels stoked the desire for costume jewelry, a trend that still ebbs and flows according to the vogue for conspicuous consumption at any given moment. Eugene Joseff of Joseff of Hollywood aptly exploited America's desire to emulate Hollywood by offering reproductions of pieces designed for films such as 1939's *Gone With the Wind*. On a larger scale, Corocraft, Trifari, Monet, and, most ostentatiously, Eisenberg Jewelry have fulfilled costume jewelry fantasies for Americans during much of the century. Meanwhile contemporary designers like Isaac Manevitz of Ben-Amun, who creates with unusual materials such as Lucite, pewter, and glass; John Hardy, who specializes in silver jewelry made according to techniques acquired from Balinese craftsman; and Kenneth Jay Lane, who designs with ample inspiration from Hollywood's golden age, transform costume jewelry into fashion jewelry that can fulfill the fantasies of today's shopgirls.

Left **Marlene Dietrich in the film *Dishonored*, 1931** Marlene Dietrich was an unlikely but effective cowgirl in Hollywood films. These boots, resembling proper cowboy boots only in heel and spur, were the fantasy of costume designer Travis Banton. It was the Hollywood designer who transformed the cowboy from working-class schlub to fashion icon, starting in the 1920s. His work was so effective that even "real" cowboys seek out more decorative boots today, supporting several custom-makers in the U.S.

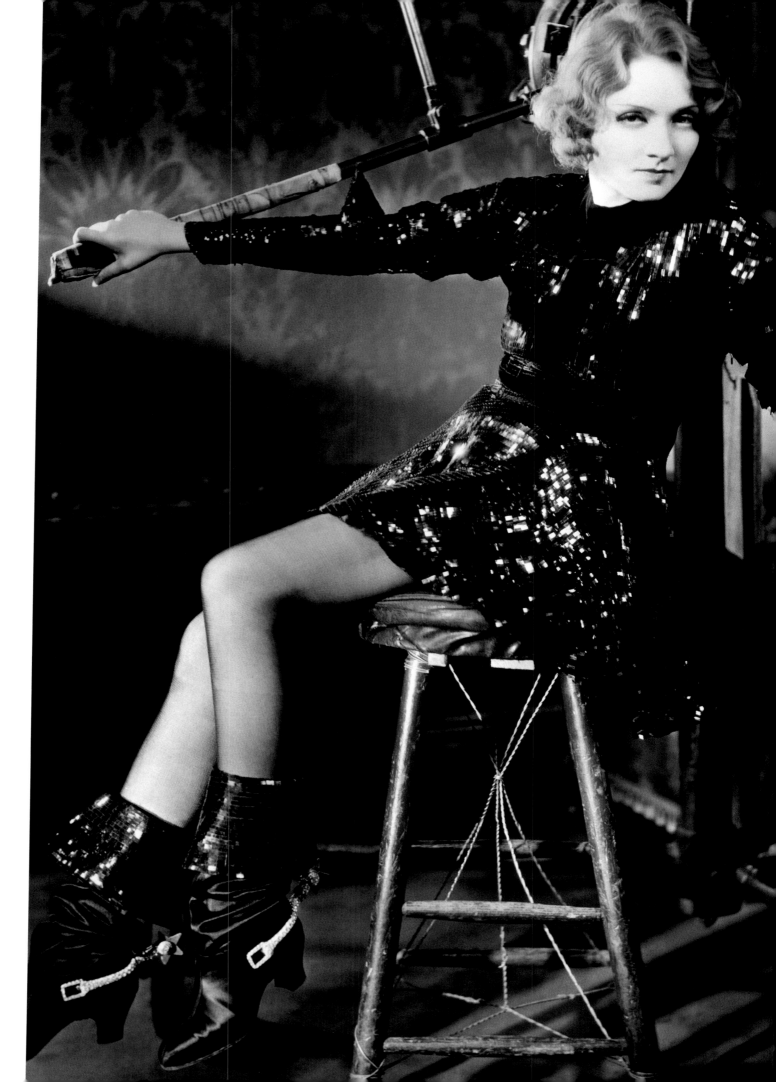

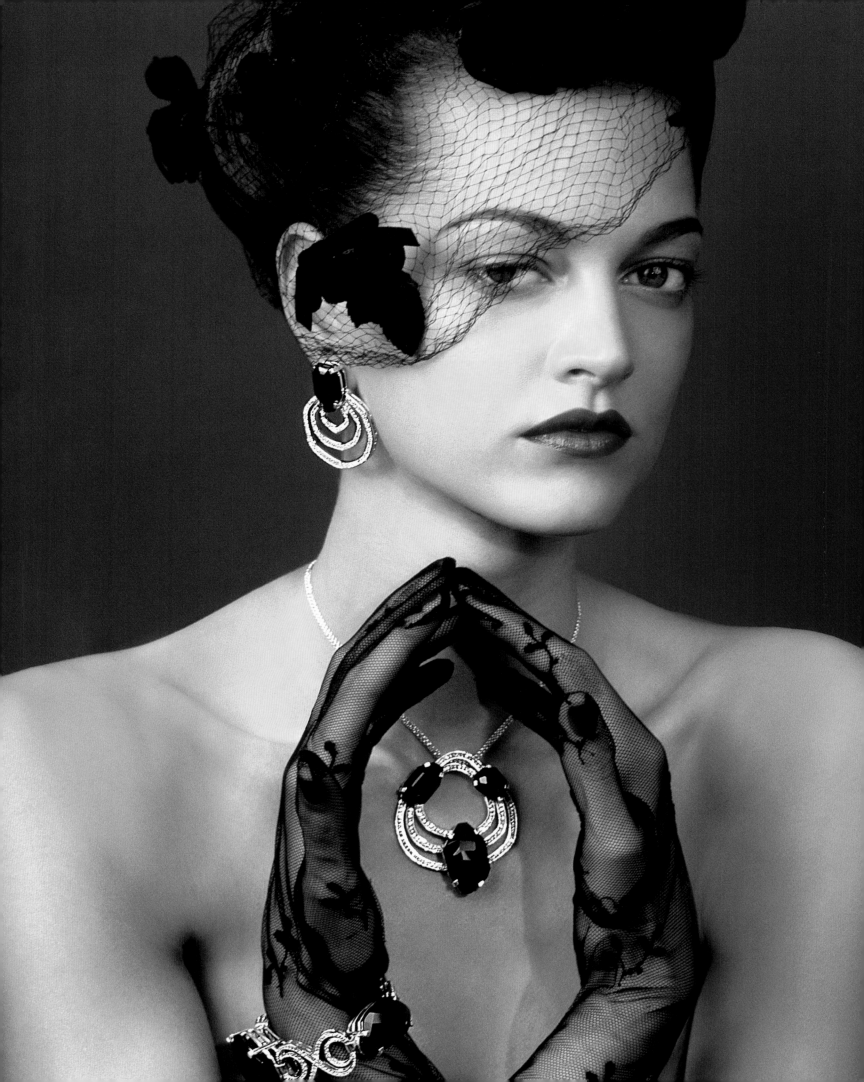

And from that same decade of the 1920s onward, the spending power and exhibitionist tendencies of Hollywood stars have supported incredible achievements in the field of fine jewelry. American fine jewelers Raymond C. Yard, Tiffany & Co., and Harry Winston have served Hollywood for decades, with Jean Schlumberger and Donald Claflin creating particularly notable pieces. Contemporary designers adorning today's Hollywood include Alexis Kirk, who inadvertently became known for designing a belt with gold elephants worn by Nancy Reagan in the 1980s; Anthony Nak, a collaboration between the furniture designer Anthony Camargo and the dressmaker Nak Armstrong, which has located its business in the up-and-coming film-industry center of Austin, Texas; Mimi So, who started out working at her parents' jewelry store at Canal Street and the Bowery before opening her own store on Fifth Avenue and Forty-seventh Street; Erica Courtney, who (appropriately enough for a jeweler patronized by the glitterati) started her design career embellishing sunglasses with Swarovski crystals; and Cathy Waterman, whose organic forms and cultivated exclusivity reflect a connoisseur's eye for gemstones as well as an educated command of design history.

As Hollywood made the American woman sparkle, so too did it help to "invent" the most iconic American man: the cowboy. Though the American West had a well-established narrative by the end of the nineteenth century (dime novels and Wild West shows had taken care of that), it was the Hollywood western that created the look of the cowboy. In the hands of specialized designers, the traditional tools of a cowman's trade—saddle, spurs, rope, Stetson hat, bandanna, and boots—became vehicles for incredible artistry, especially the boots. Until the advent of the Hollywood western, most cowboys wore simple, functional store-bought boots, but, as the boot historian Tyler Beard notes in *The Cowboy Boot Book*, after 1920, "stitched spiderwebs, decks of playing cards, flowers and vines, prickly pear cacti, longhorns, eagles in flight . . . new leather colors and exotic skins . . . appeared on men's, women's, and even children's feet all over the country." As portrayed by Tom Mix, John Wayne, Roy Rogers, Dale Evans, Gene Autry, and later, Clint Eastwood, the American cowboy was the first of a pantheon of mythical figures invented in Hollywood that has gone on to become recurring characters in the history of American fashion as well. The cowboy's first wave of success was in the 1920s, flush with the silent and later singing heroics of that era. Another heyday of cowboy merchandising came in the 1950s, when the westerns were recast for television's smaller screen. In the 1980s, the most subtle and refined examination of the cowboy took place as the film genre became symbolic of both innocence and innocence lost, while American designers like Ralph Lauren expanded the audience for the cowboy's boots, belts, and bandannas with his women's wear versions.

Left **Stephen Dweck, 2007** Though his earliest jewelry pieces were hand-carved stone bangles, Stephen Dweck has since emphasized glamour jewelry, as in this striking black diamond set.

The western is not the only influential film genre in the United States by any means. Gangster films from the 1920s to the present provide men instruction in slick style with a hint of sexy, antisocial aggression, usually topped off with a sharp fedora. Science-fiction films from the Flash Gordon and Buck Rogers serials of the 1930s and 1940s through the B-movie boom of the 1950s to the ever-increasing array of mutant superheroes that populate movie houses today continually provide images of what modernity looks like. Their influence has manifested in fashion through the sleek PVC purses of the 1960s and a widening array of pristinely designed communication devices. Even minigenres or single films sometimes inspire the fashion world, such as the 1970s blaxploitation films *Shaft* and *Cleopatra Jones*, which introduced outrageous platform shoes and low-slung belts; 1974's *The Great Gatsby*, which showcased the menswear designs of Ralph Lauren on the undeniably appealing Robert Redford; and 1967's *Bonnie and Clyde*, which doubled the production of the beret in America with just one shot of Faye Dunaway as its tragic antiheroine.

For some contemporary designers, this font of visual ideas has been a consistent inspiration. Ralph Lauren has drawn boots, shoes, belts, and more from the American western. Glovemaker Carolina Amato specifically cites Hollywood as her inspiration, saying, "Marilyn Monroe and Jayne Mansfield . . . the fifties were great gloves, great shoes, great hats, great wraps and shawls . . . it was the inspirational time for me." Patricia Underwood's refined hats capture the seemingly unattainable glamour and polish of the most cultivated stars of a studio system now defunct, as does the more fanciful work of the milliner Eric Javits and the hair accessory designer Colette Malouf. Ultimately, the relationship between Hollywood and American fashion has come full circle, with stars again central to promoting fashion. The difference is that American designers can now take the role as "art directors of femininity," since Hollywood made the American woman of fashion worth beholding.

Right **Eric Javits, 1986** Unwilling to surrender to the dearth of hats in everyday fashion since the late 1960s, Eric Javits has carved a career in millinery with wonderful runway hats, Easter bonnets, and cocktail hats.

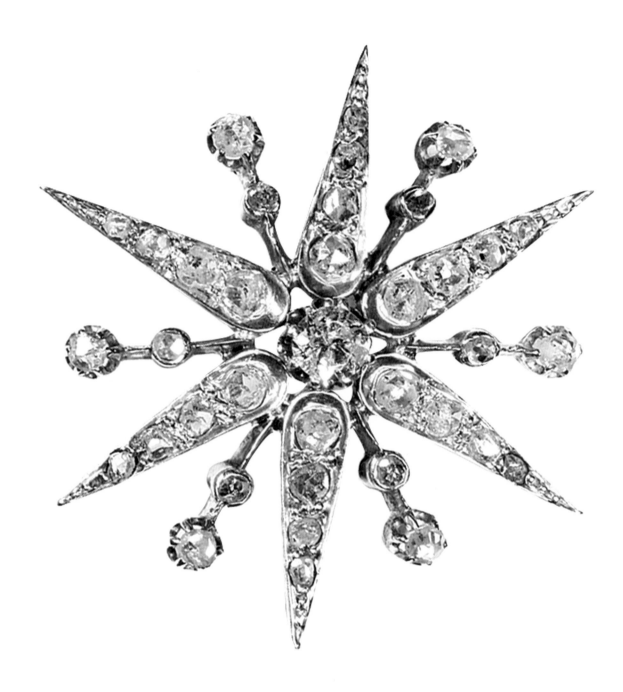

Renee Lewis, 2008

Above Renee Lewis's practice of building jewelry out of antiques and flea market finds assures her customer that each piece will be unique - a considerable concern on the red carpet.

Erickson Beamon, 2007

Opposite Vicki Beamon and Karen Erickson have referred to themselves as chameleons, ever shifting their style to meet the needs of designers whose runways their jewelry graces. Creating everything from Indian-influenced pieces to Day-Glo Bakelite, their range would make any actress jealous—or desirous of their assistance.

Flato, 1938

Following pages Paul Flato was a "jeweler to the stars" from the 1930s, and his combination of technical mastery and imagination made him popular on-screen and off. Flato created important pieces, but as notable were his whimsical ones, such as a diamond bracelet in the shape of Mae West's corset. Following page, Katharine Hepburn wears a suite of Flato jewelry in the Robert Kalloch-designed film *Holiday*.

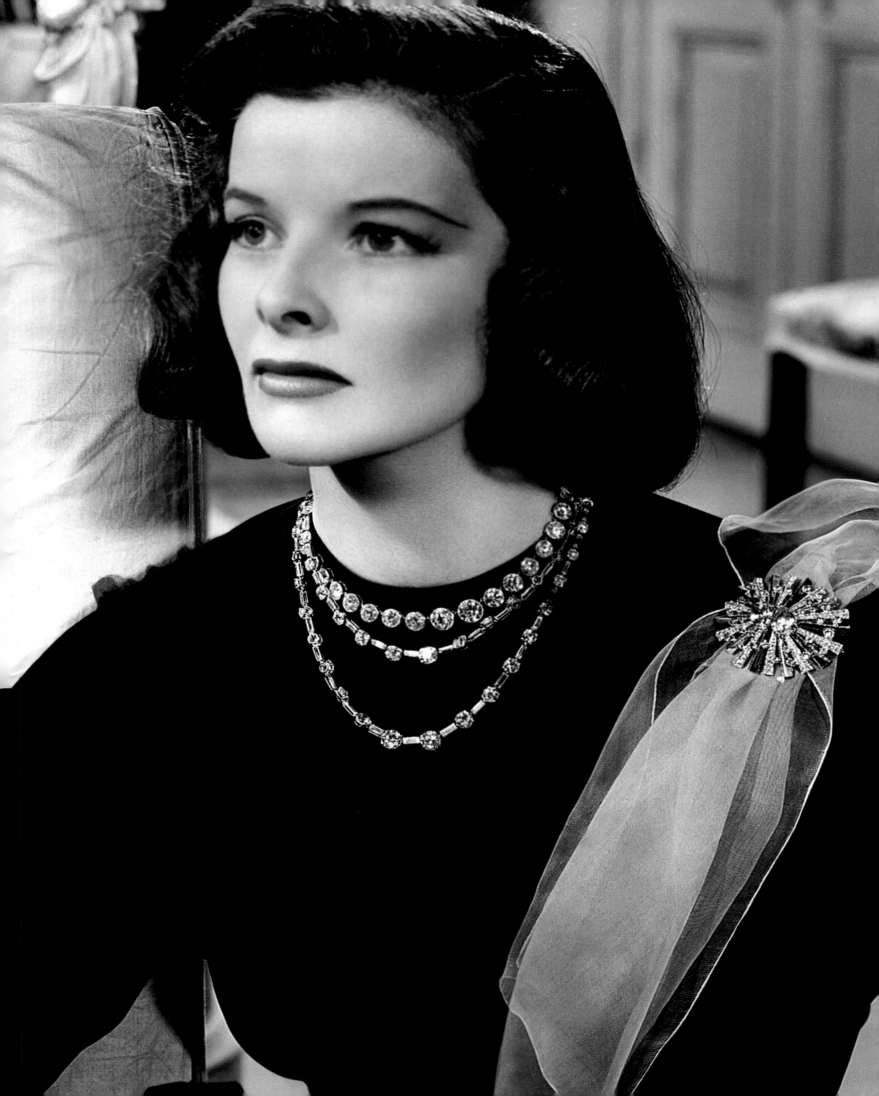

Erica Courtney, 2008

Above Erica Courtney has been Hollywood-inspired from the start of her career in Dallas when she bedazzled sunglasses with Swarovski crystals. Hollywood embraced her when she made the move from Texas to L.A. and from costume to fine jewelry. Since then, her work has appeared both in front of paparazzi and on the big screen.

Liberace photographed by Annie Leibovitz, 1981

Opposite How much is too much? Mercifully, this was not a question that concerned Liberace, whose excess of accessories assured all others that they were well within the bounds of good taste.

Costume jewelry

Following page, left With elegant craftmanship, even base metals could be transformed into glamorous jewelry by American designers.

Carolina Amato, 2007

Following page, right Carolina Amato's business was born in the late 1970s, but the films of the 1950s serve as a major inspiration: "great gloves, great shoes, great hats." Amato has recounted that her connection to the era has been noted by a surprising fan base: Neo-burlesque performers have approached her at design shows to compliment her gloves and their suitability to retro-striptease performance.

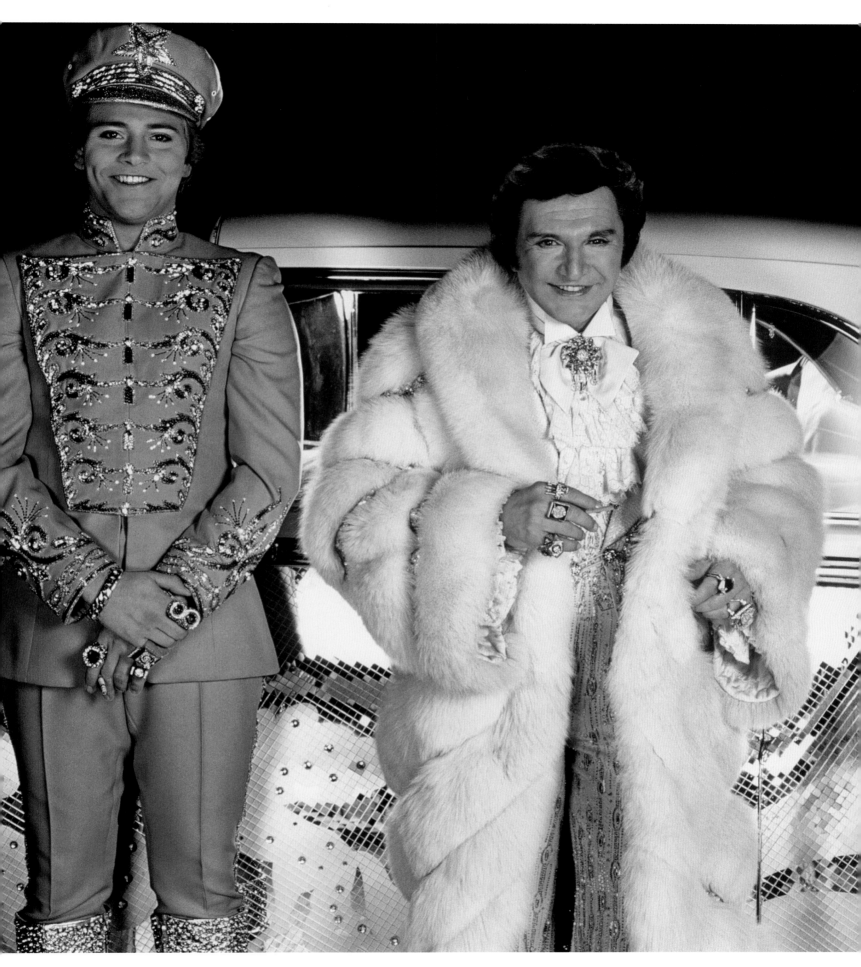

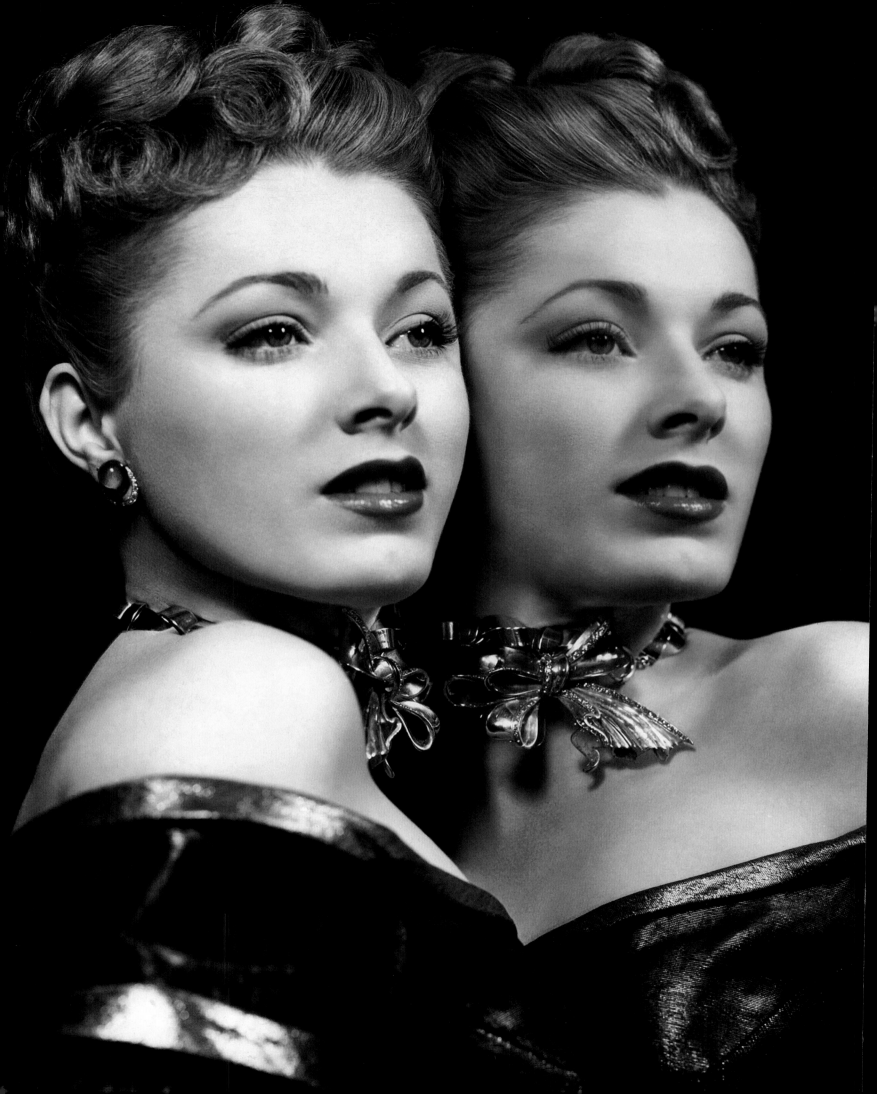

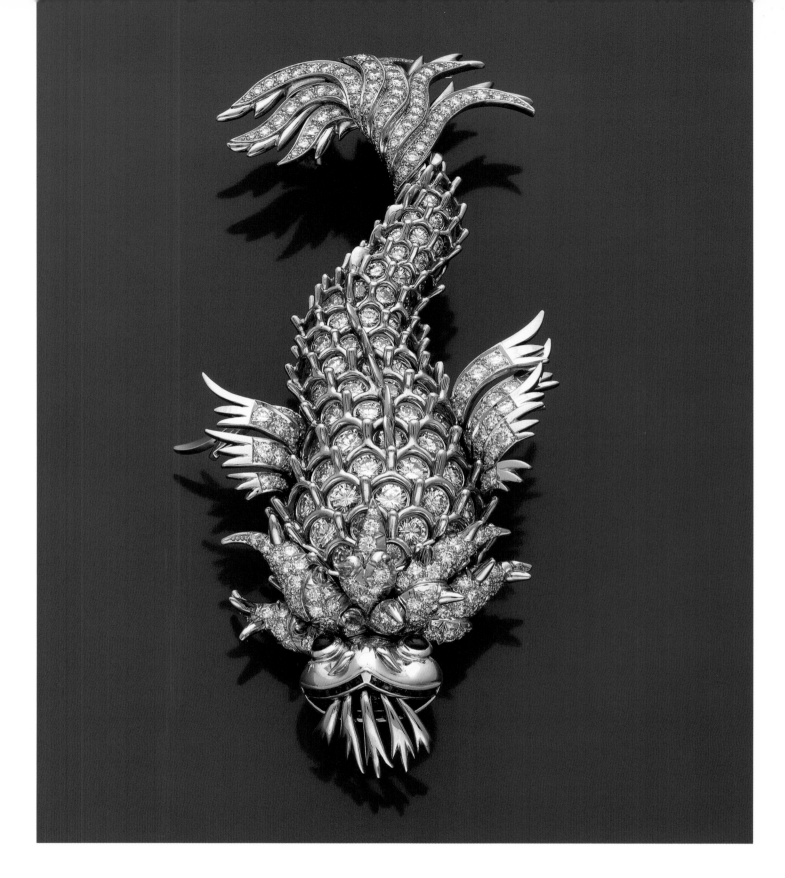

Jean Schlumberger for Tiffany & Co., 1964

Above When the vivid imagination of a great fine-jewelry designer collides with the spectacular taste of a movie diva, everybody wins. Such is the case with this design, from the mind of Tiffany & Co.'s Jean Schlumberger to the lapel of screen-great Elizabeth Taylor.

David Evins, 1956

Opposite In 1956, Grace Kelly became real-life royalty when she married Prince Rainer of Monaco. Instead of glass slippers, Kelly wore shoes by David Evins, a Hollywood shoe designer since the 1940s who also did a ready-to-wear line for I. Miller that aptly exploited the publicity the designer's Hollywood clientele provided.

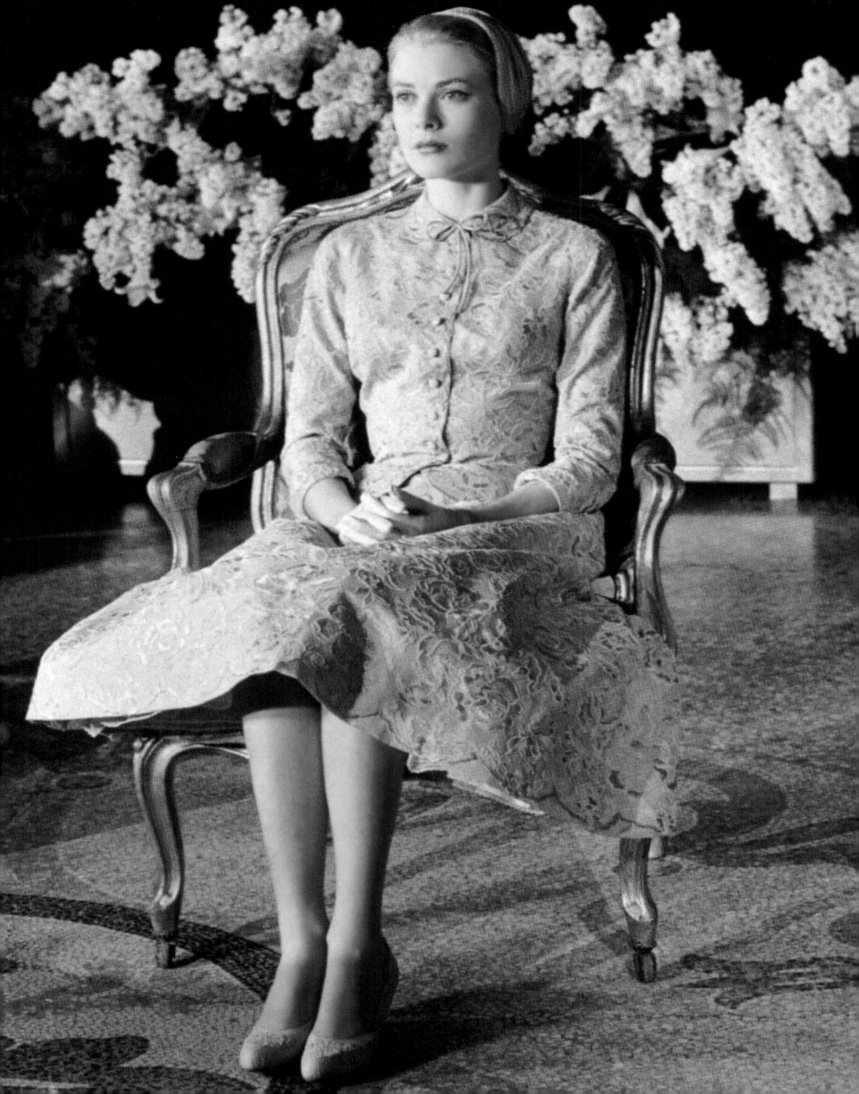

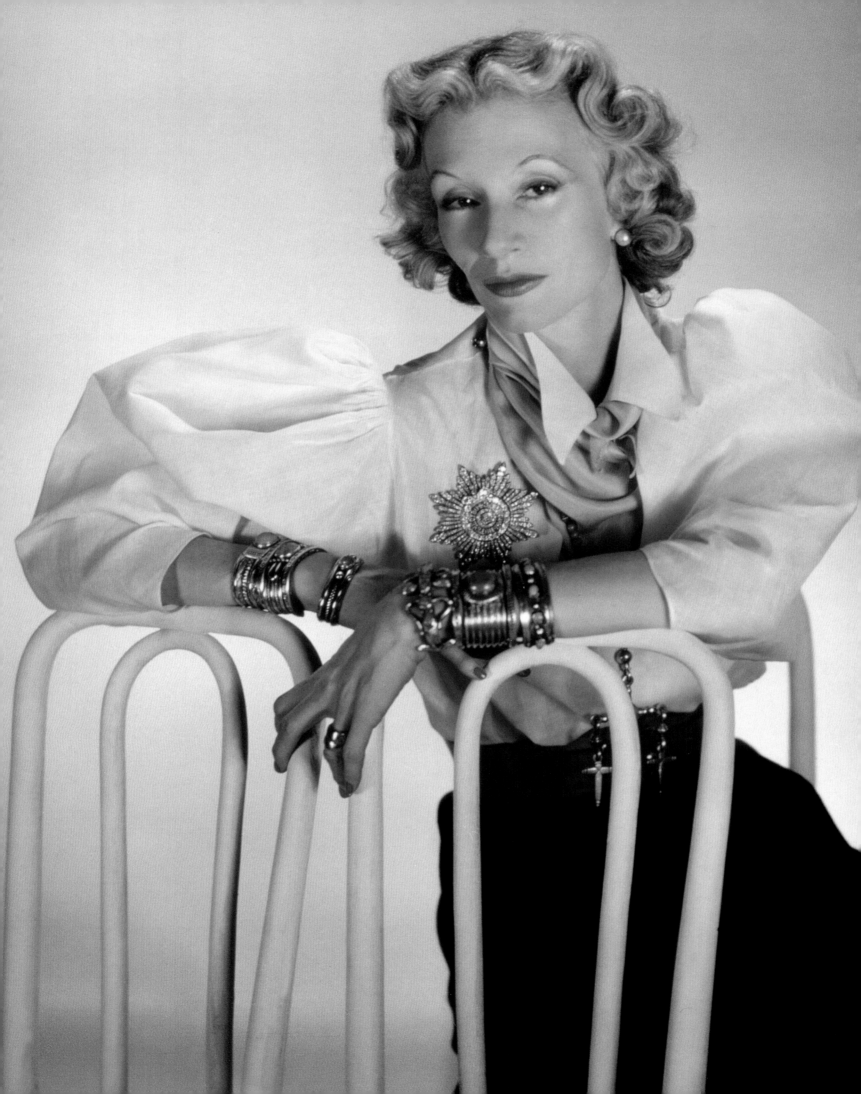

Millicent Rogers

Opposite While the American western brought native American jewelry into the public eye, socialite and collector Millicent Rogers gave the same materials a much more elegant take that translated well to the world of high fashion.

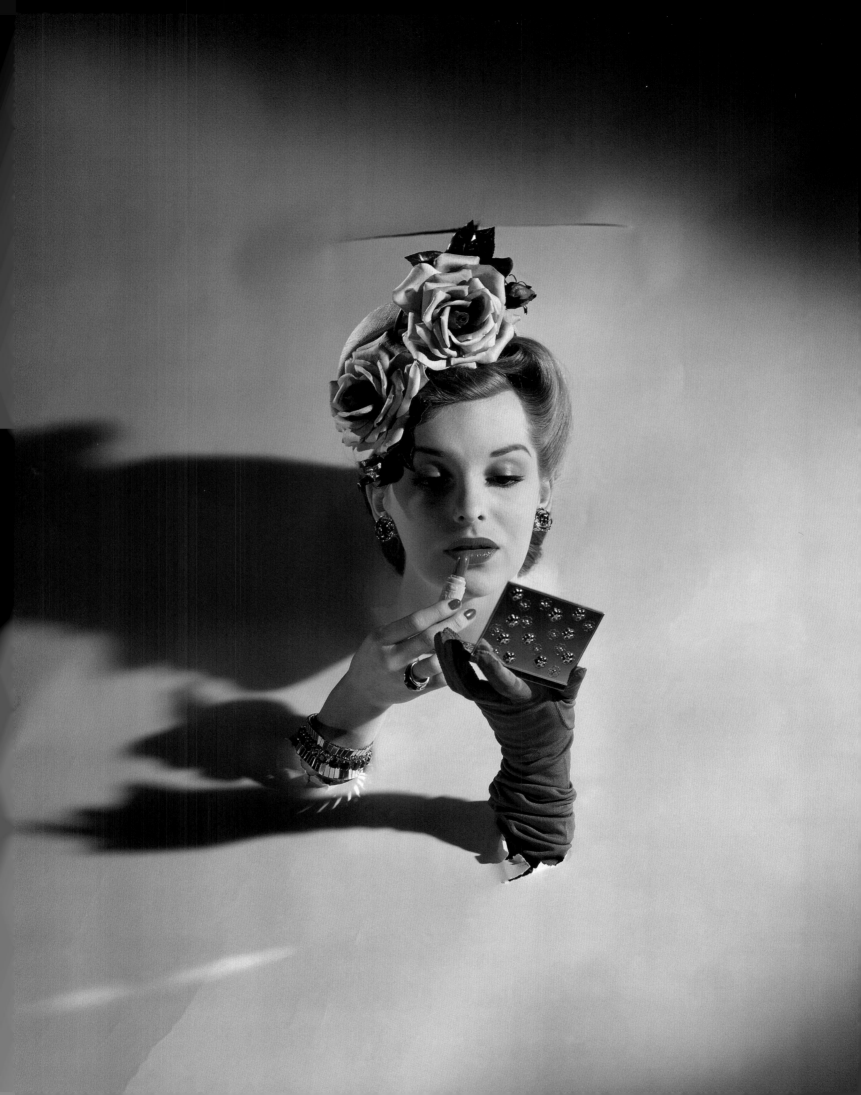

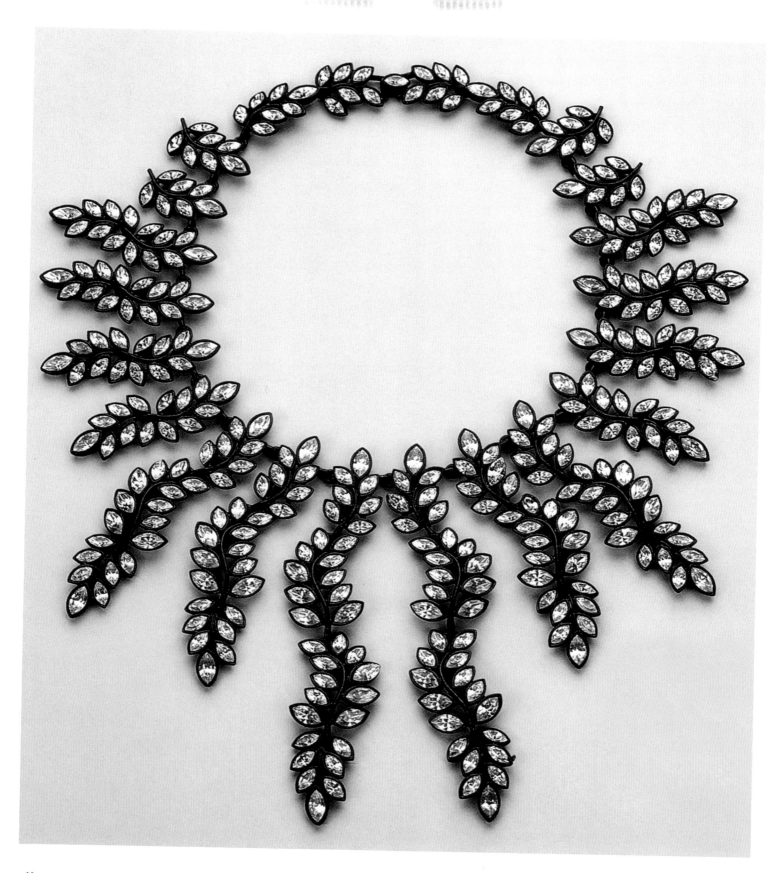

Kenneth Jay Lane, 1985

Above Costume jewelry designer Kenneth Jay Lane has been consistently inspired by old Hollywood, especially in the 1930s when the jewels were real and never borrowed.

Woman applying lipstick in Lilly Daché hat, 1943

Opposite Hollywood's capacity to promote accessories is well-documented, but equally important was the way in which Hollywood changed makeup. Before the painted faces of the silver screen flashed around the world, makeup was thought of as, frankly, a bit sluttish. Once the glamorous effects of masterful make-up were seen though, the very act of applying lipstick was elevated to an artform.

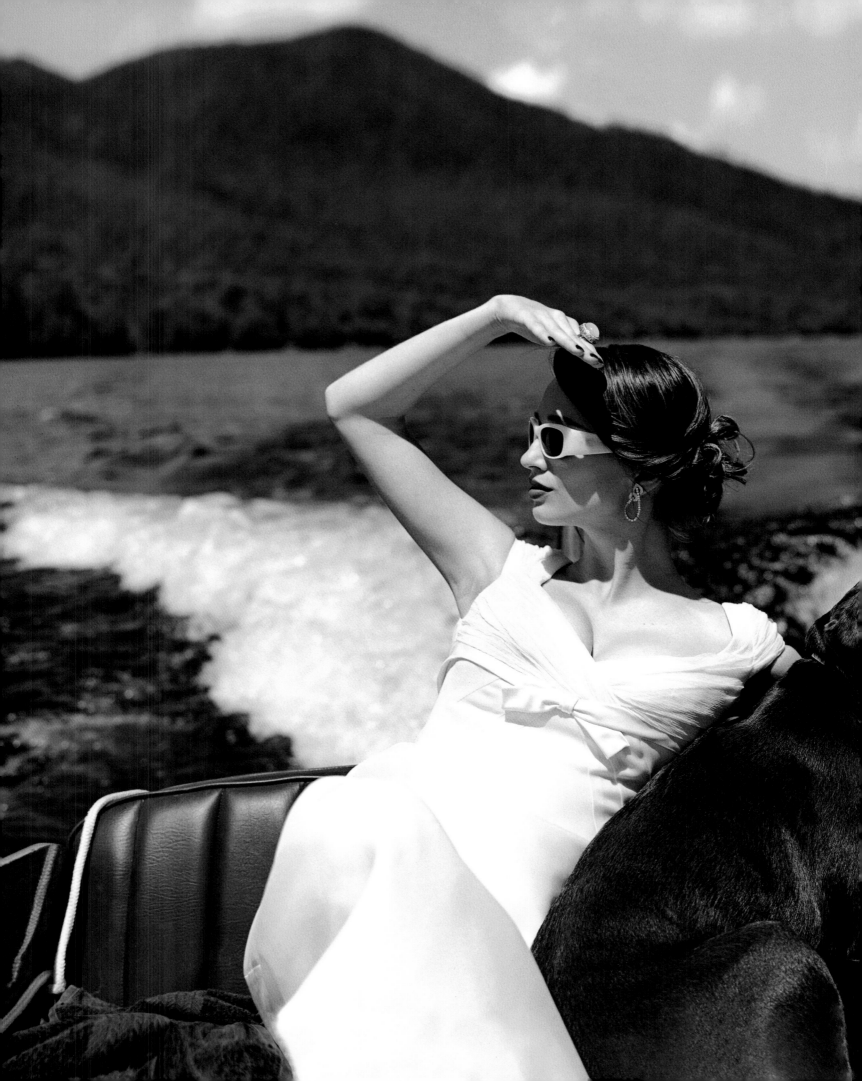

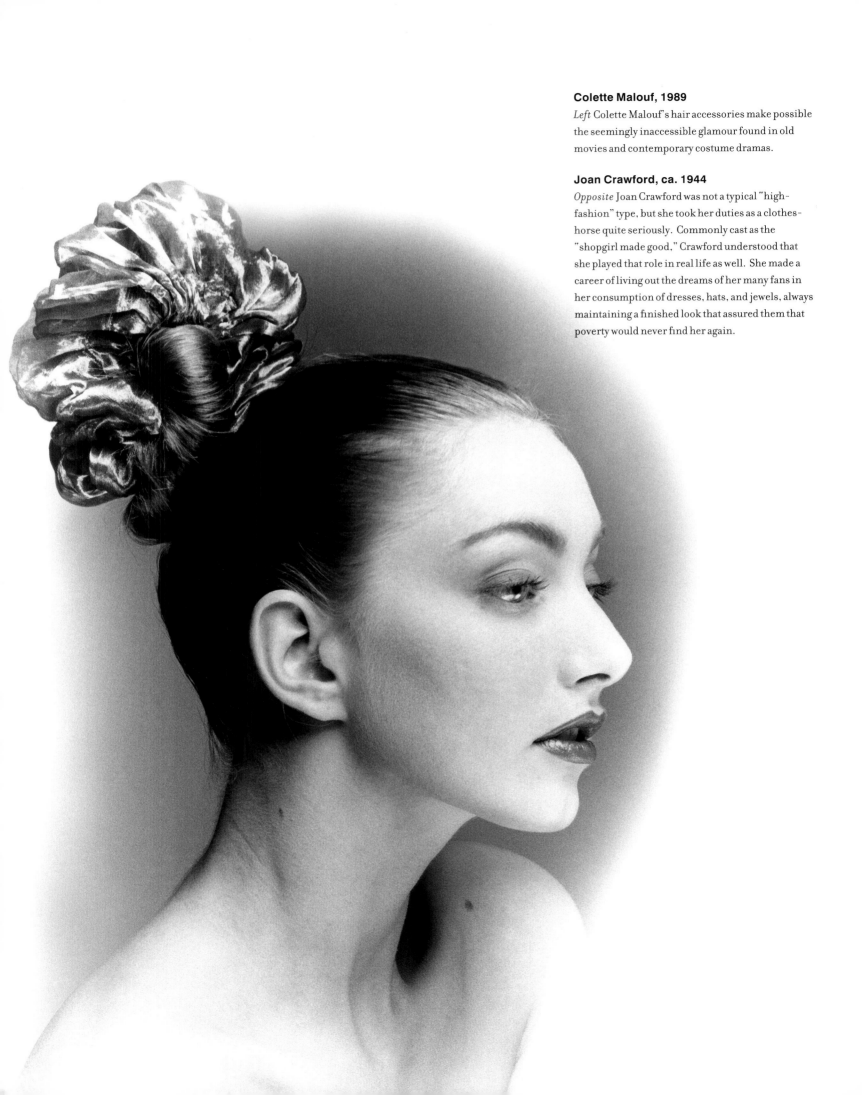

Colette Malouf, 1989
Left Colette Malouf's hair accessories make possible the seemingly inaccessible glamour found in old movies and contemporary costume dramas.

Joan Crawford, ca. 1944
Opposite Joan Crawford was not a typical "high-fashion" type, but she took her duties as a clothes-horse quite seriously. Commonly cast as the "shopgirl made good," Crawford understood that she played that role in real life as well. She made a career of living out the dreams of her many fans in her consumption of dresses, hats, and jewels, always maintaining a finished look that assured them that poverty would never find her again.

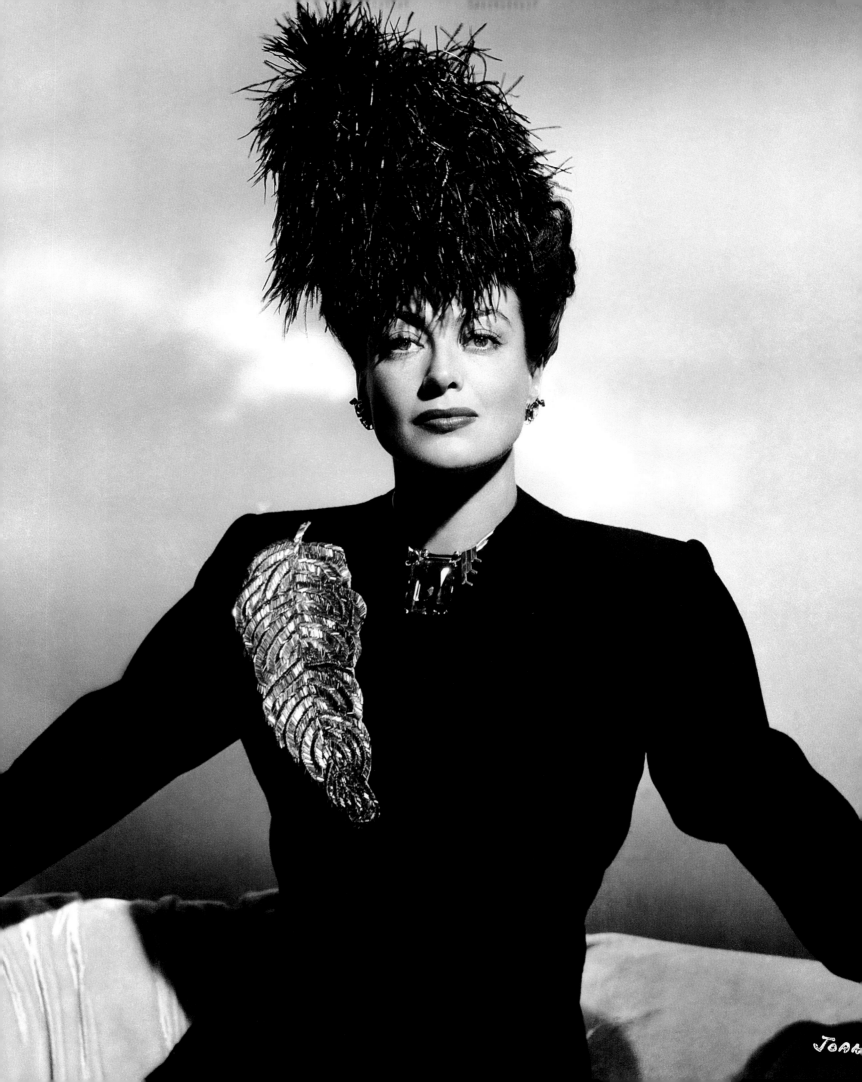

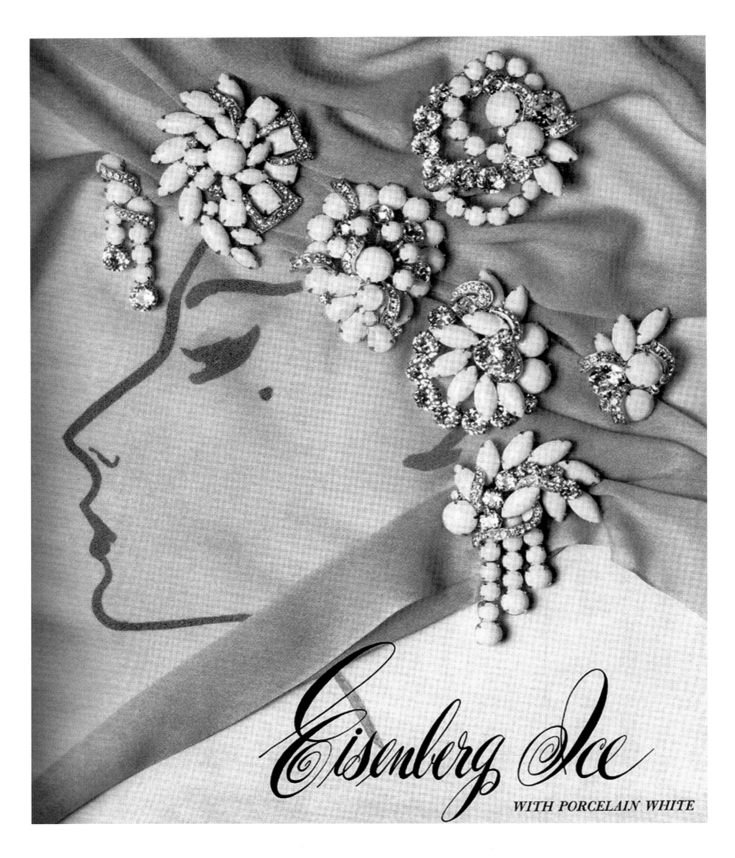

Eisenberg Ice

WITH PORCELAIN WHITE

Eisenberg Jewelry, 1958

Above Eisenberg Ice was a line of intentionally over-the-top costume jewelry that perfectly captured the "more is more" aesthetic of 1950s Hollywood. The company had started as a clothesmaker, but switched to jewelry in the 1920s when rhinestone dress clips started disappearing off their stock.

John Hardy, 2004

Opposite This red carpet-ready necklace is a publicity stunt waiting to happen.

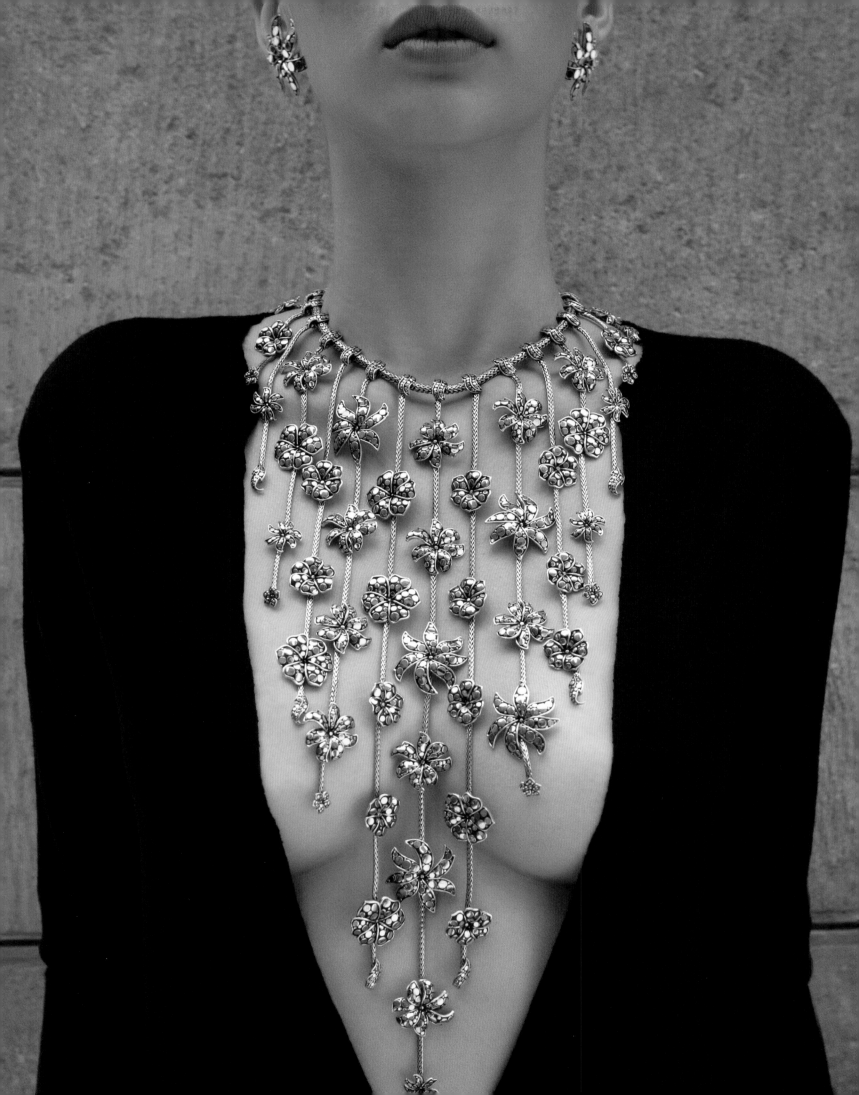

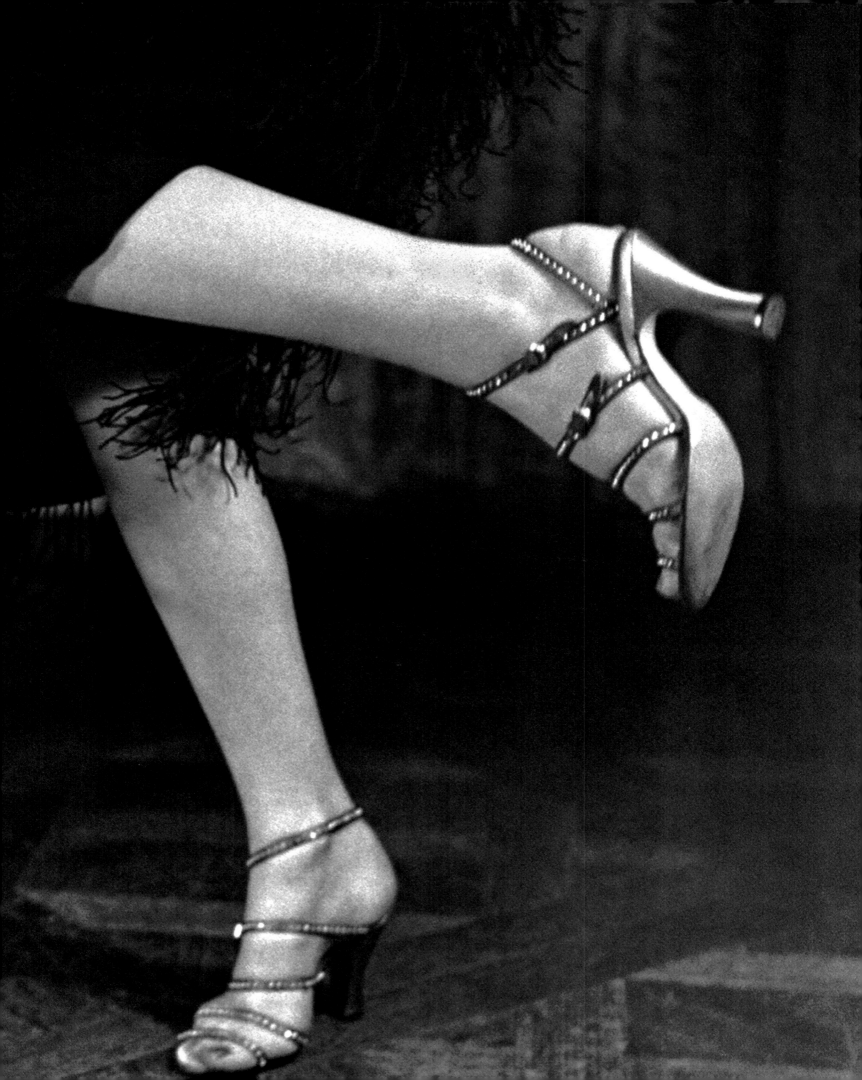

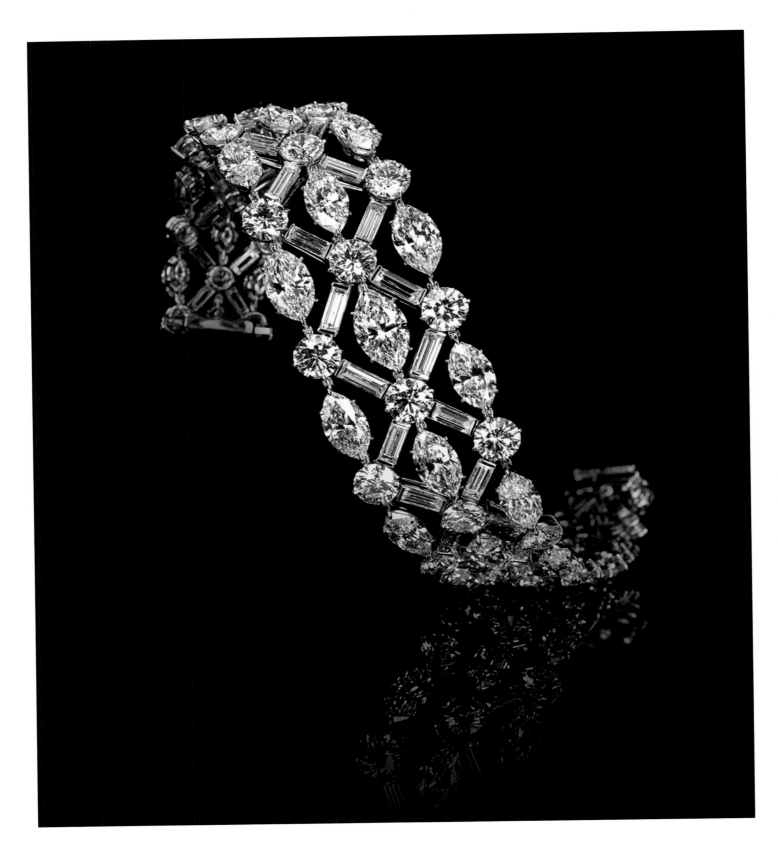

Harry Winston

Above Harry Winston has always had a firm grasp of what Hollywood publicity can achieve and has therefore put his work on display with all the young beauty and armed guards he can muster, making his one of the most commonly mentioned names on the red carpet.

Black, Starr and Frost, 1928

Opposite Diamond bracelets received as a gift from a suitor were ribaldly referred to as "service stripes" in the 1920s, implying that certain sexual services had been rendered to obtain them. Ideally, they were worn in multiples.

Charleston dancers, 1920s

Previous pages Glamorous though impractical, rhinestone-studded shoes were embraced by the ostentacious American flapper and then perfected by Hollywood shoe designer David Evins, who created bedazzling shoes for Lena Horne and Ava Gardner, among others.

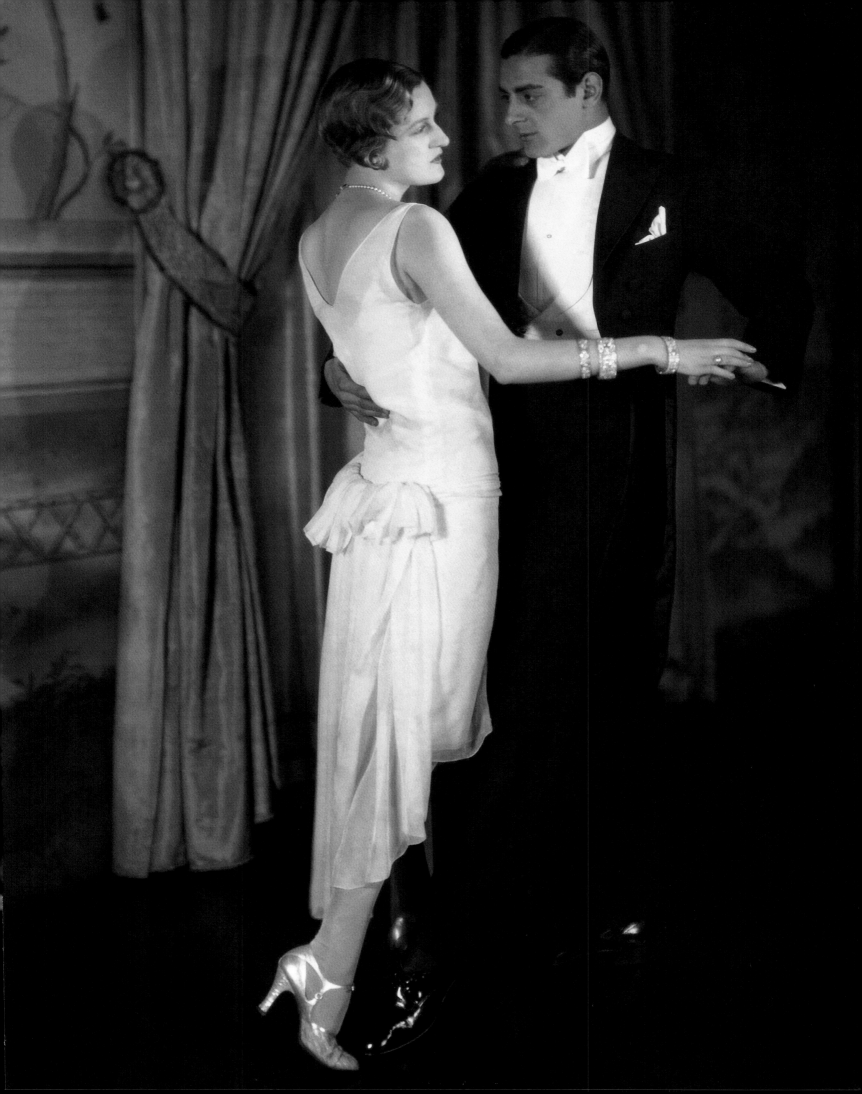

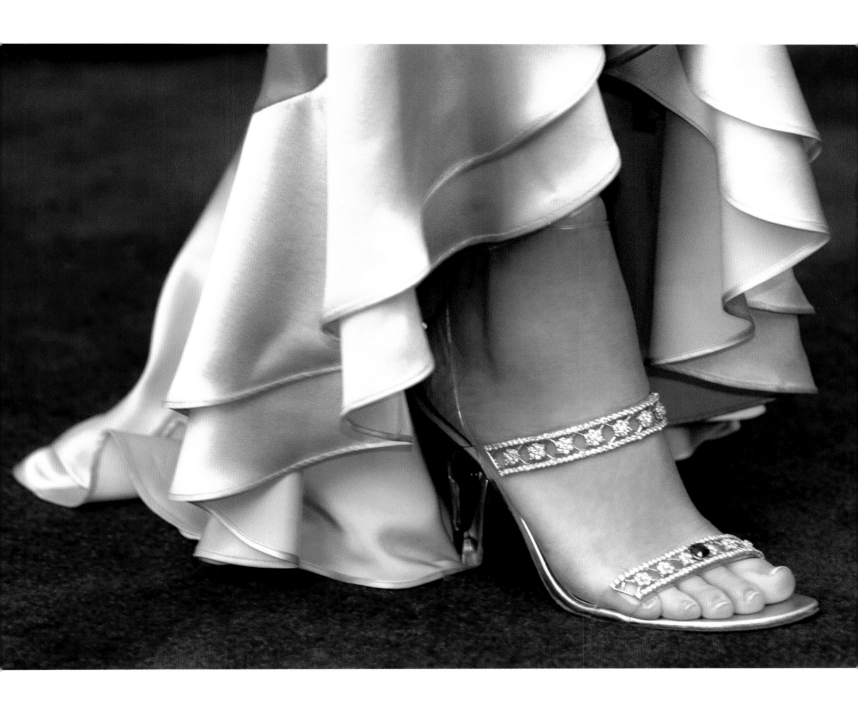

Stuart Weitzman

Above Beautifully executed by Stuart Weitzman, these are a Hollywood favorite: rhinestone shoes. Created and conceived to make mere glass slippers look dowdy.

Koret, 1943

Opposite A glamorous handbag.

Elizabeth Taylor, 1950s

Following page, left Elizabeth Taylor was an avaricious collector of jewelry who impressed even the acquisitive Andy Warhol with her diamonds.

Raymond C. Yard, 1952

Following page, right Pink cadillacs can be kitsch, but real emeralds never are.

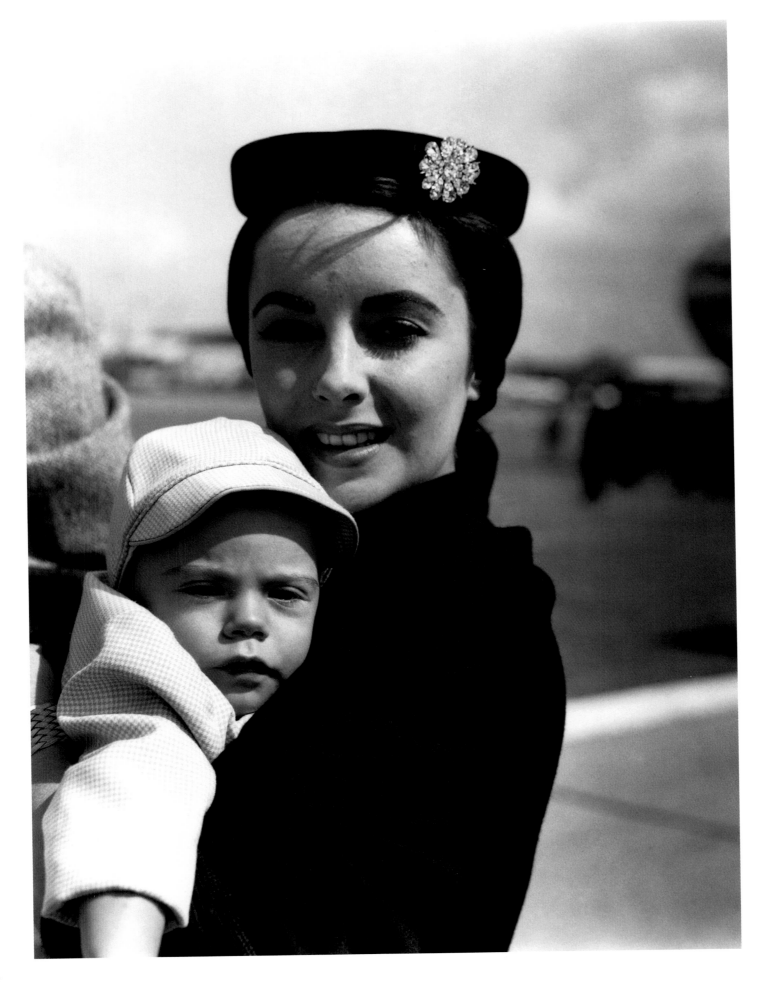

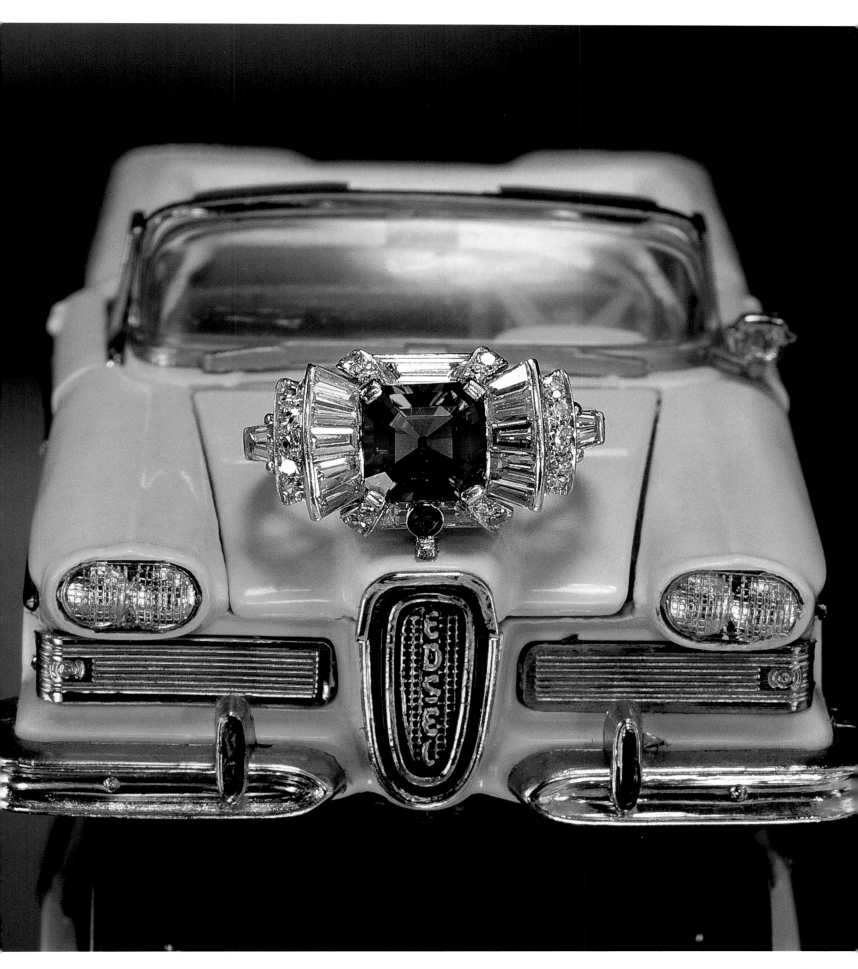

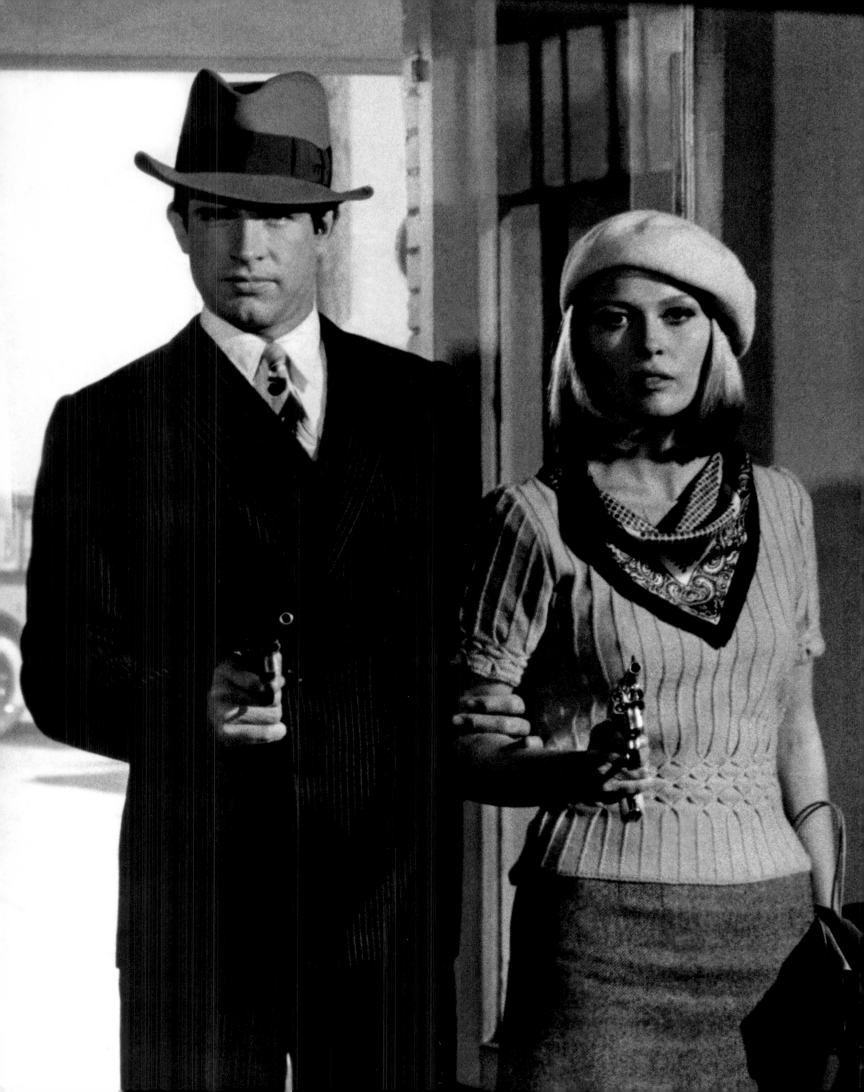

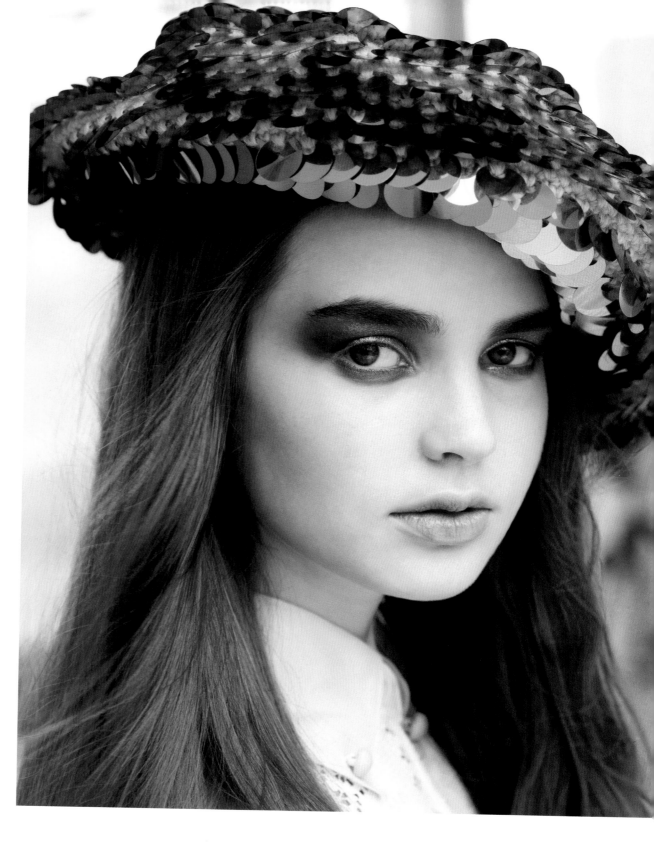

Marc Jacobs, 2007

Above The beret, here rendered in gold sequins by Marc Jacobs, remains a perennial favorite.

Warren Beatty and Faye Dunaway in the film
***Bonnie and Clyde*, 1967**

Opposite In her work for the film *Bonnie and Clyde*, costume designer Theadora Van Runkle had an uncanny moment of prescience as she created a visual outline of the 1930s revival that would have a great deal of force in the 1970s. She also sparked a major trend when she placed a beret on Faye Dunaway's head—production of the hat doubled that year. Even without the studio leadership that marked the 1930s era, Hollywood films could still sell through to fashion's followers when the right alchemy was created.

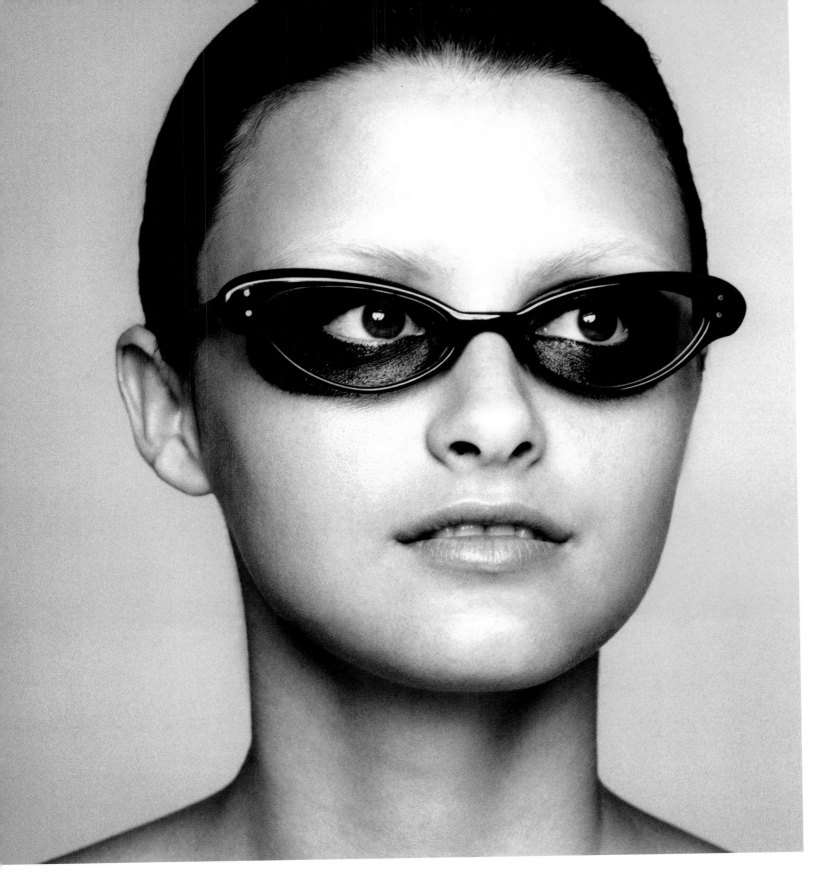

Selima Optique, 2001

Above Selima Salaun mixes her own designs and vintage frames with confidence in her boutiques. Her new takes on classic shapes in eyewear easily transform the wearer according to their own Hollywood fantasy.

Robert Marc, 2006

Opposite As an eyewear designer, Robert Marc is unafraid of bringing the drama, using bow tie and sharply rectangular shapes as well as more traditional ovals.

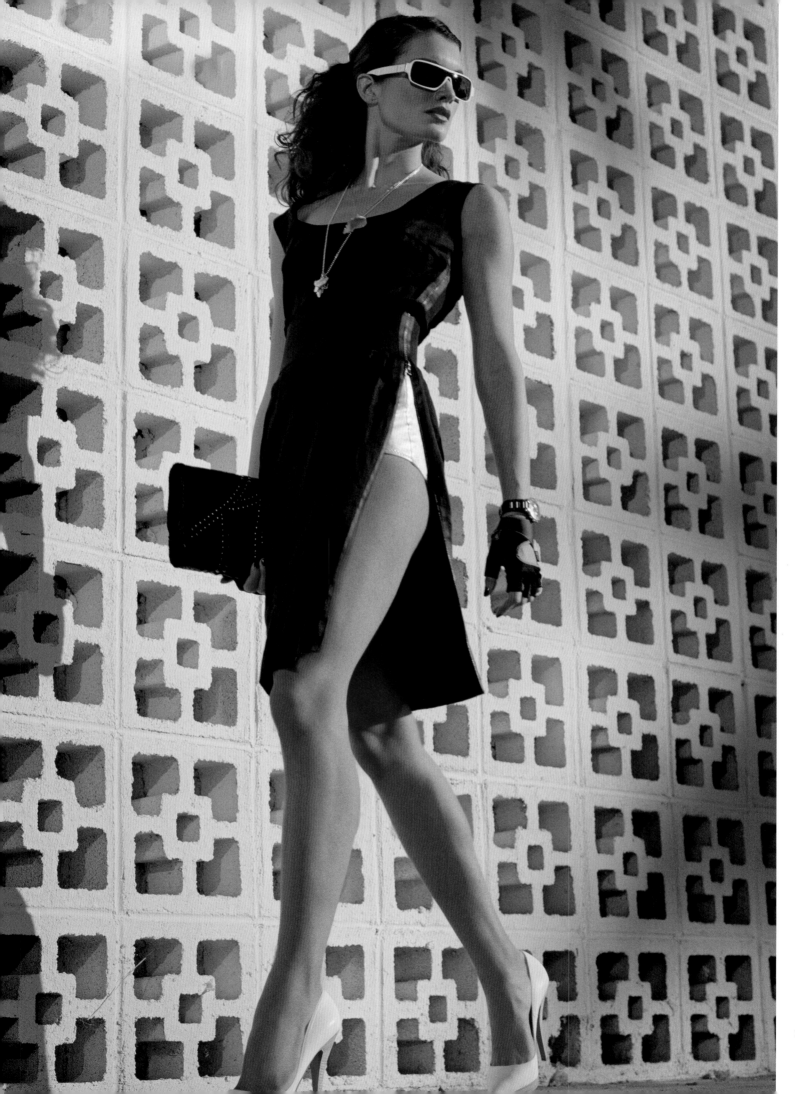

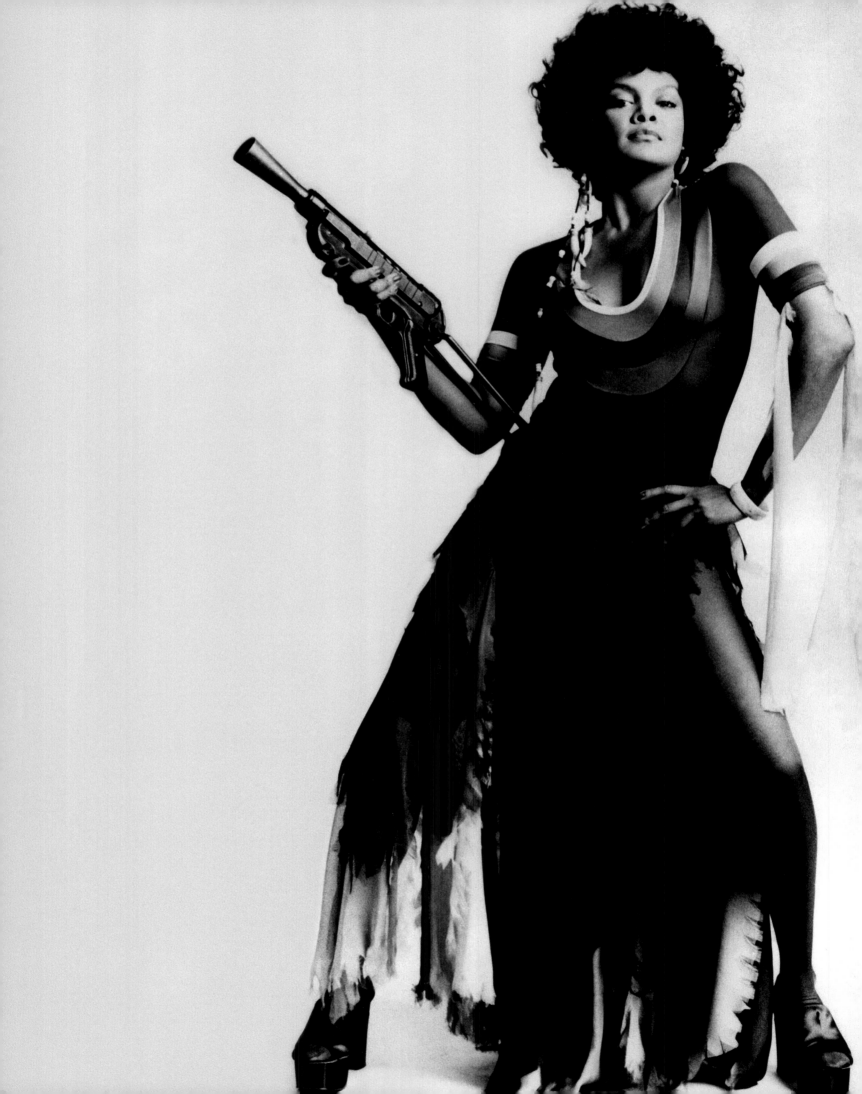

PHI, 2007

Right A contemporary take on platforms that owes a great deal to the aggressive feminine ideal portrayed in blaxsploitation films.

Tamara Dobson in the film *Cleopatra Jones*, 1973

Opposite The blaxsploitation film fad of the early 1970s gifted the fashionably adventurous with a number of accessory options. In this still from *Cleopatra Jones*, costume designer Thomas Welsh has offered substantial platform shoes, long feathered earrings, and light weaponry. One of the selling points of the films was that they portrayed "real" ghetto life, but in fact they were as fantastical as any 1950s musical, which probably made up a lot of their appeal.

Peter Fonda in the film *Easy Rider*, 1969
Ray-Ban sunglasses, 2006

Following pags Ray-Ban sunglasses have had their fortunes raised by Hollywood more than once. In the film *Easy Rider*, anti-hero Peter Fonda made them iconic by association for the 1960s generation. When worn by Tom Cruise in *Top Gun* they retained their rebellious meaning filtered through an entirely different set of values in the 1980s. Both times, sales of the Aviator frames skyrocketed.

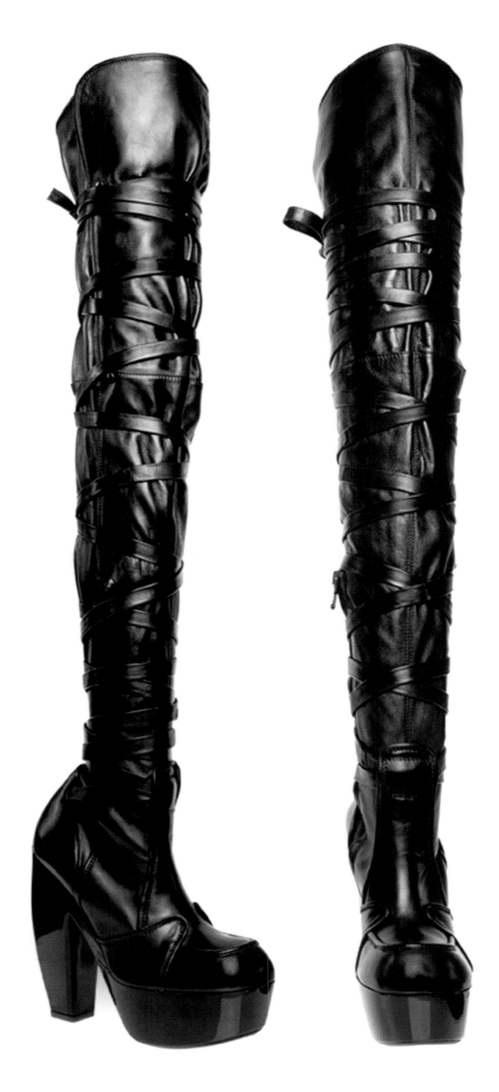

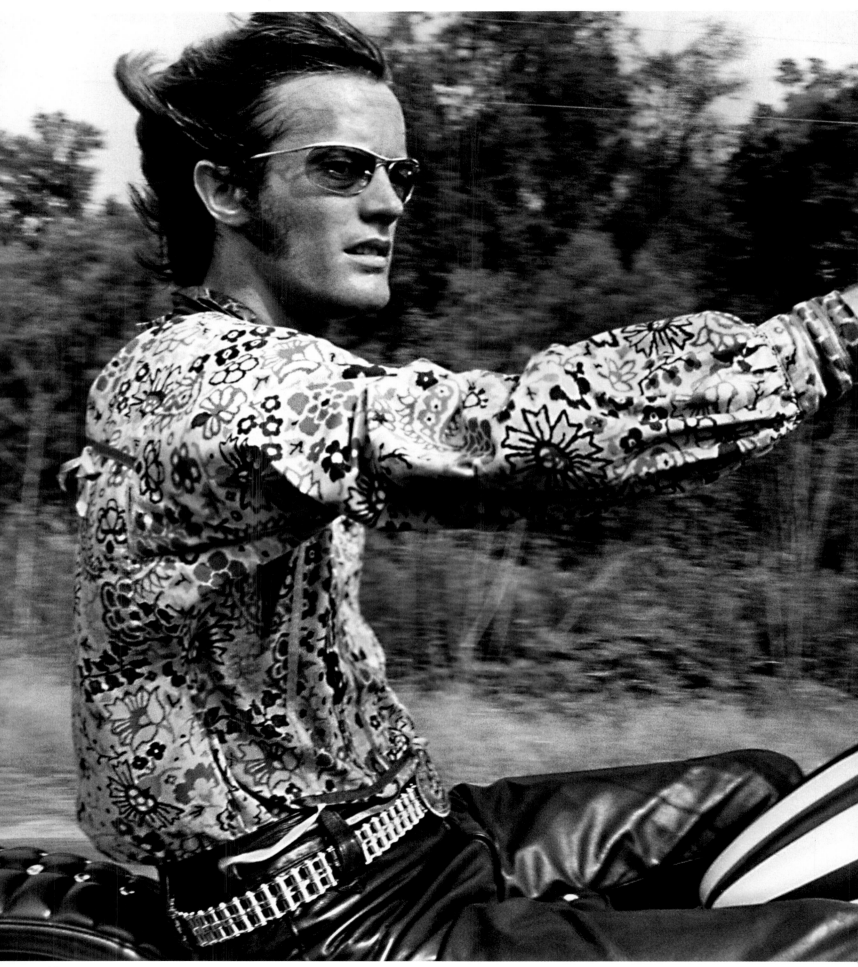

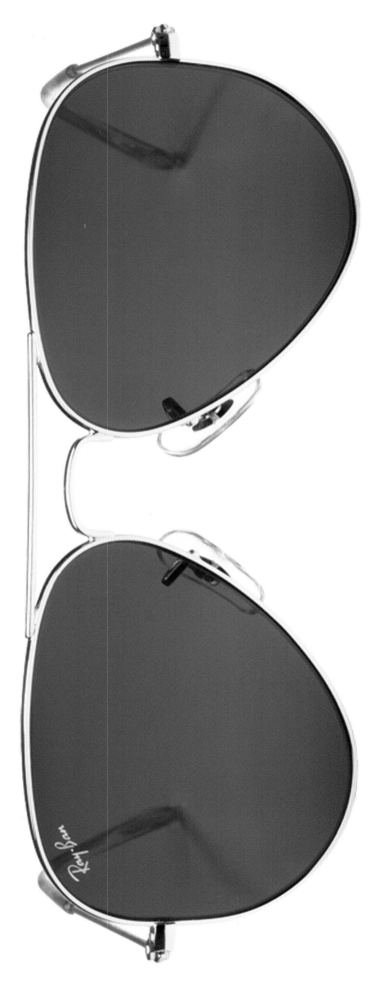

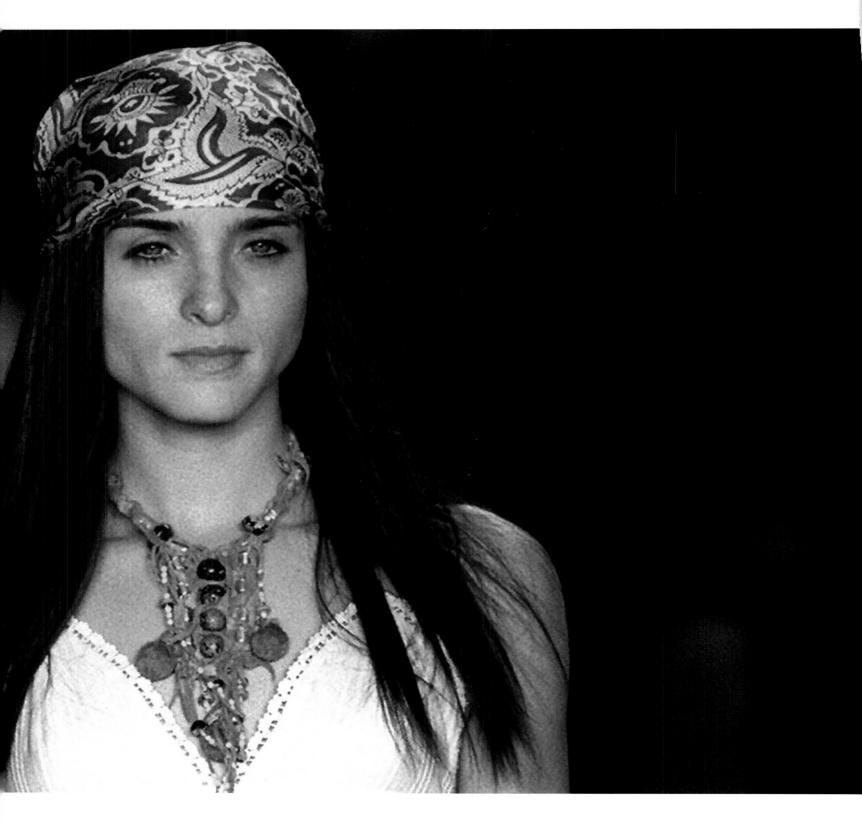

Anna Sui, 1999

Above The bandanna came into the American
fashion vocabulary through the sartorial style of
the working cowboy and then through the more
spectacular stars of the Hollywood western. As the
western evolved, so did the meaning of the
bandanna from dust guard to bandit's mask to
tourniquet. The western was revised and so was
the bandanna, becoming hippie style by the 1960s,
which is alluded to in Anna Sui's version here.

Bob Dylan, 1976

Opposite Bob Dylan's adaptation of the bandanna
affirms the countercultural affinity for the
romantic figure of the American cowboy.

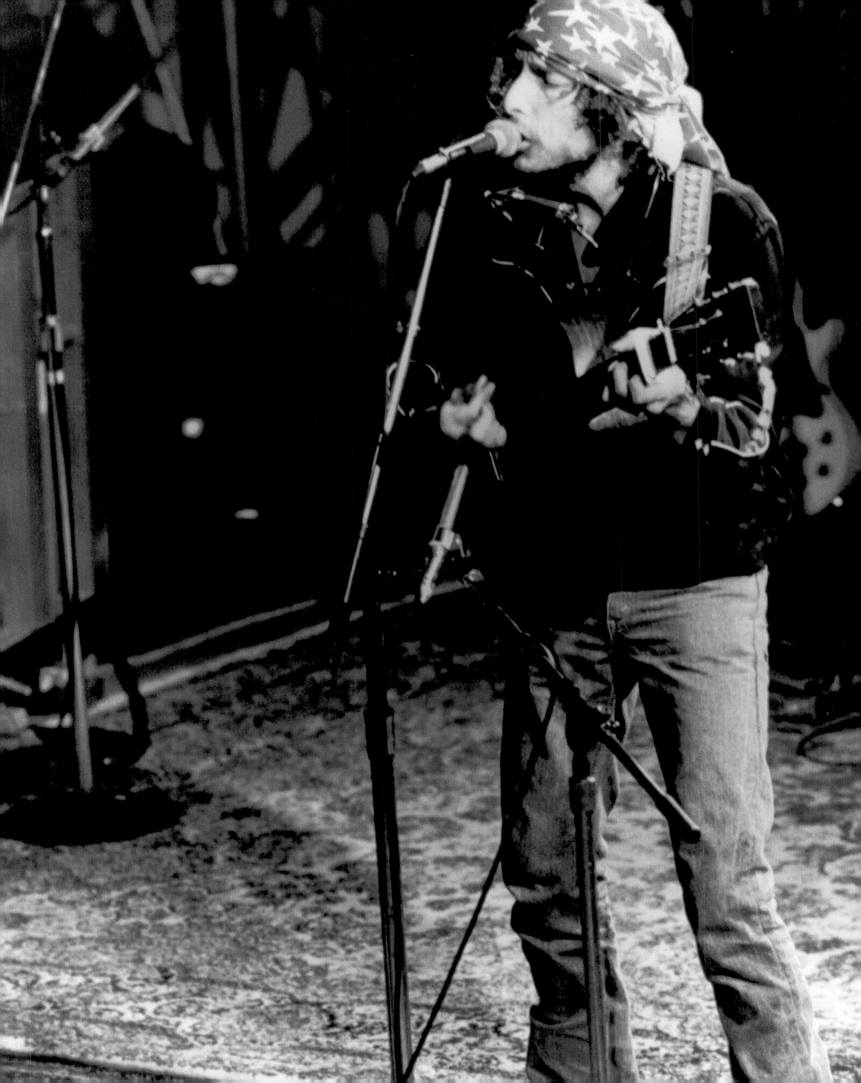

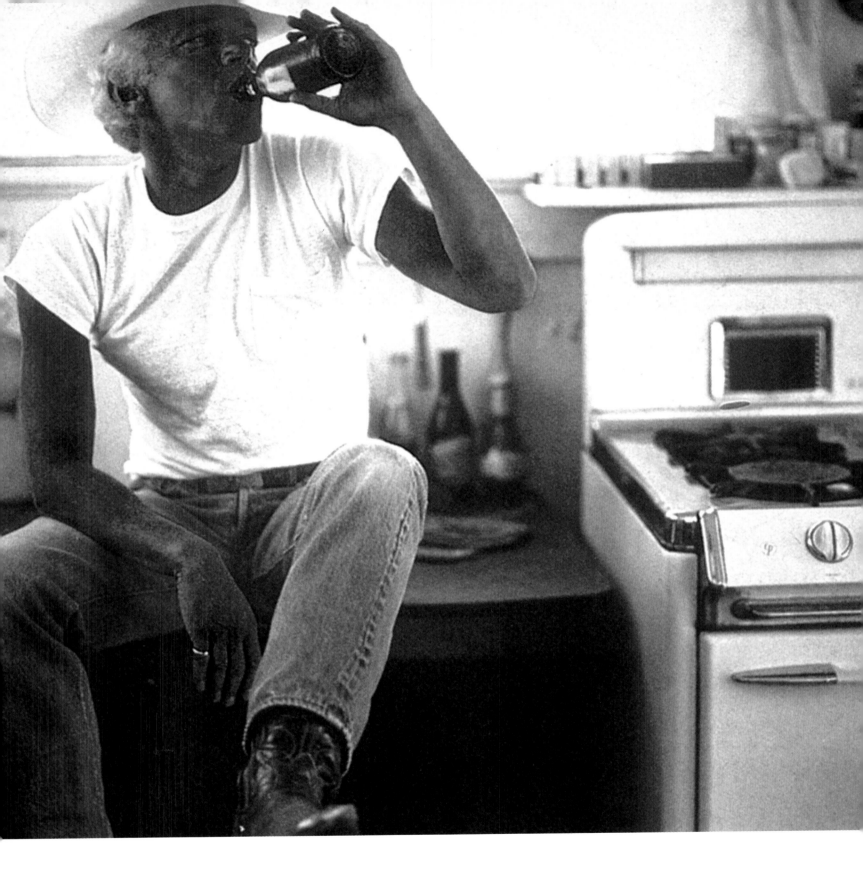

Ralph Lauren, 1985

Above The American cowboy is one of several traditional figures consistently revisited by Ralph Lauren in his designs. This Bruce Weber portrait of Lauren captures both the pared down simplicity and the sexual magnetism of this icon—the very elements that had attracted Hollywood's attention in the first place.

Palace Boot Shop in Houston, Texas

Opposite It was Hollywood that made ornate cowboy boots a popular item, but it has been custom shops in Texas and other parts of the American West that have kept the traditions of the hand-made, individually-fitted, craft boots alive.

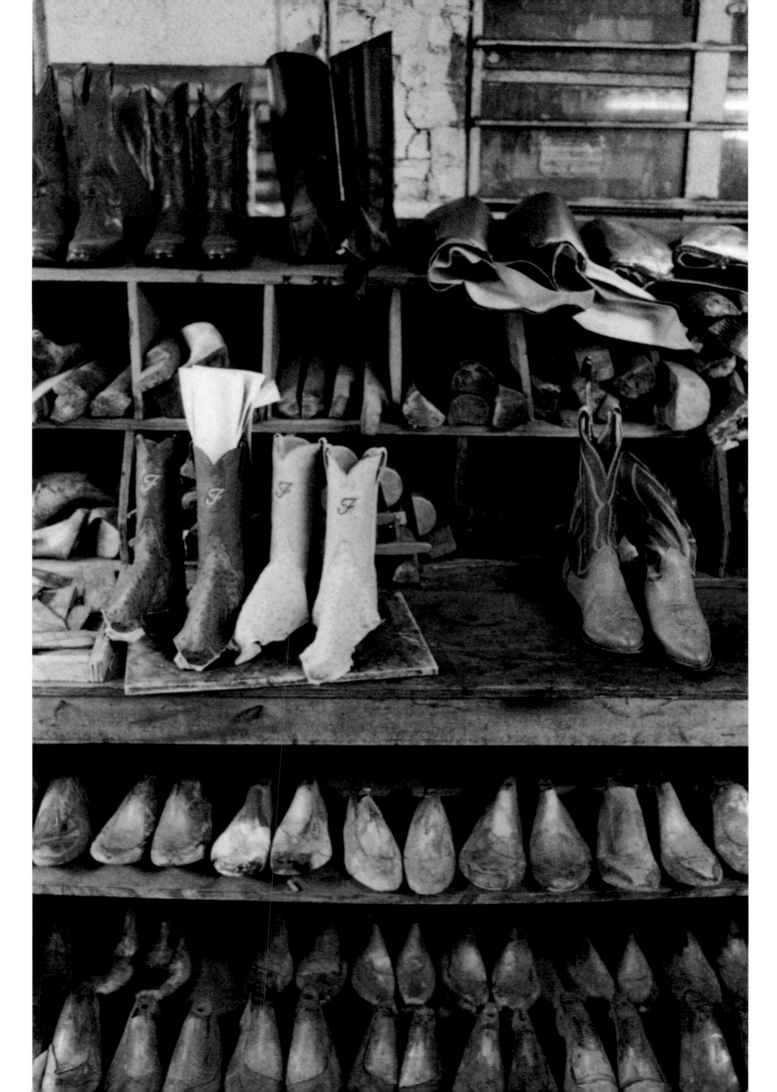

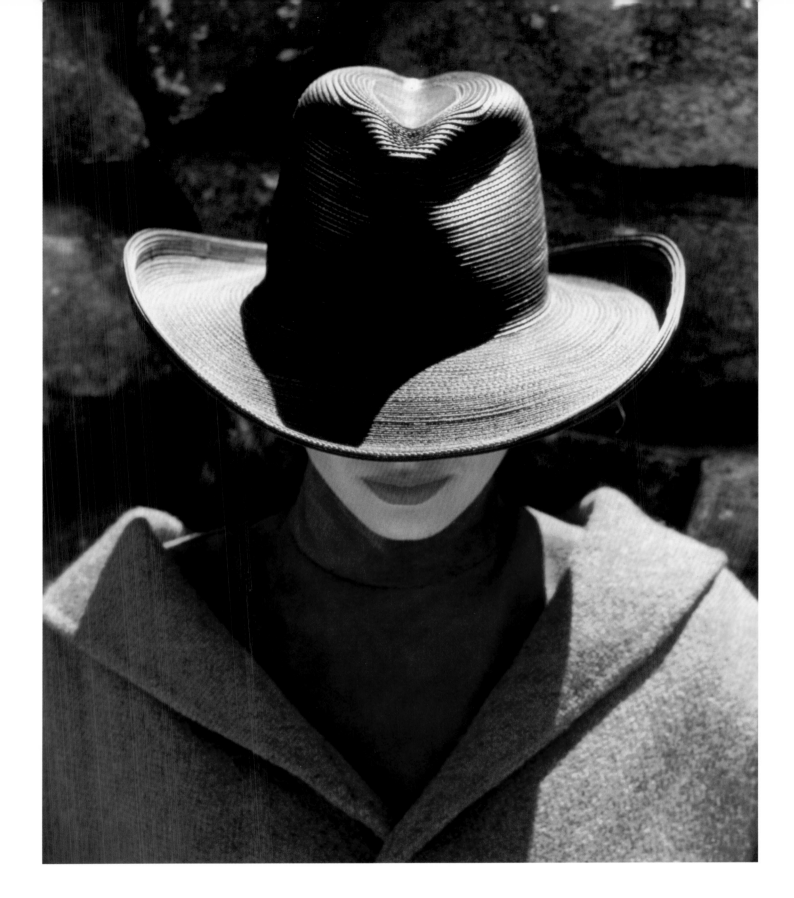

Patricia Underwood, 1993

Above As a traditional milliner who relies more on shape than adornment to create style, Patricia Underwood is the ideal contemporary fashion designer to take on the cowboy hat. Her signature version speaks of the functionality that a real cowboy's hat ought to have.

John Travolta in the film *Urban Cowboy*, 1980

Opposite In another example of the power of film to launch a fad, Gloria Gresham's costume designs for *Urban Cowboy* put the traditional cowboy hat, for better or for worse, on the streets of New York and L.A. and in other places in which there were no cows.

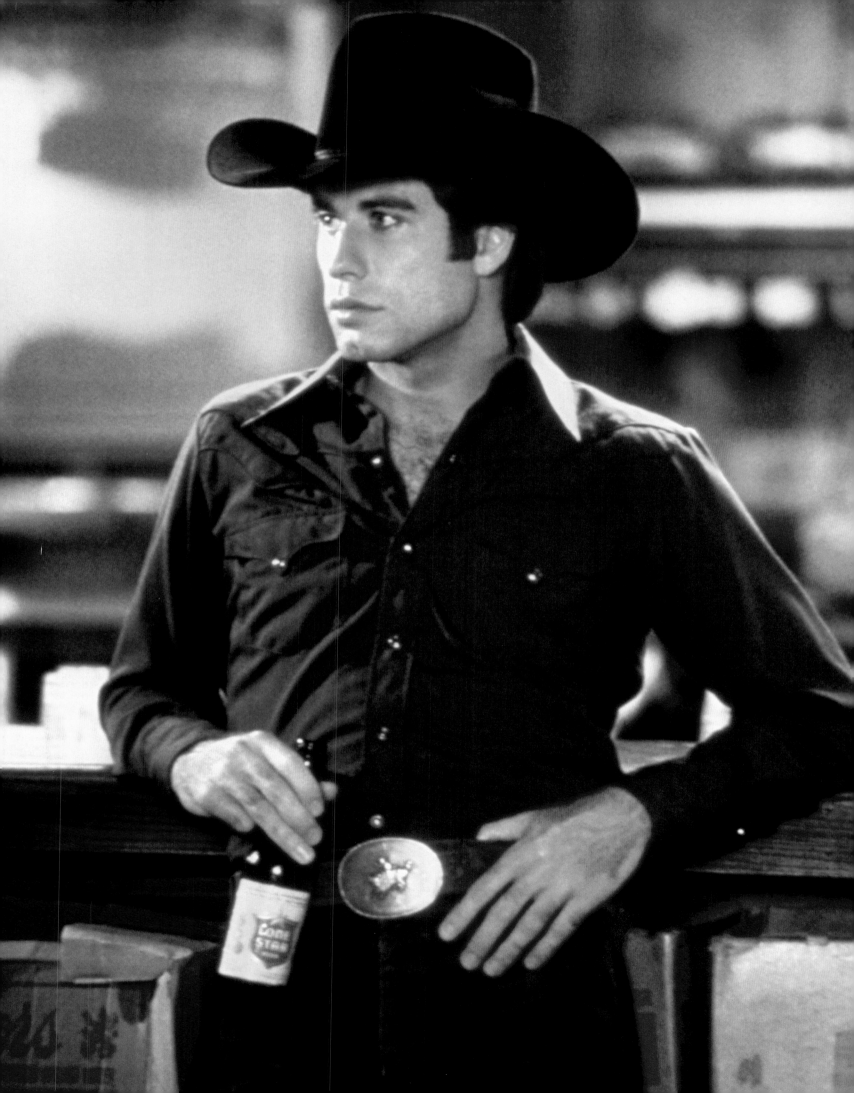

Donald Claflin for Tiffany & Co., 1965

Right Donald Claflin's playful anthropo-
morphized animals were inspired in part by
Disney films, which offered up a wealth of
surrealistic imagery to all fields of design over
the course of the twentieth century.

Rafe, 2008

Opposite Rafe Totengco provides a balance of glitz
and casual elegance that evokes the "California
lifestyle" of the 1950s.

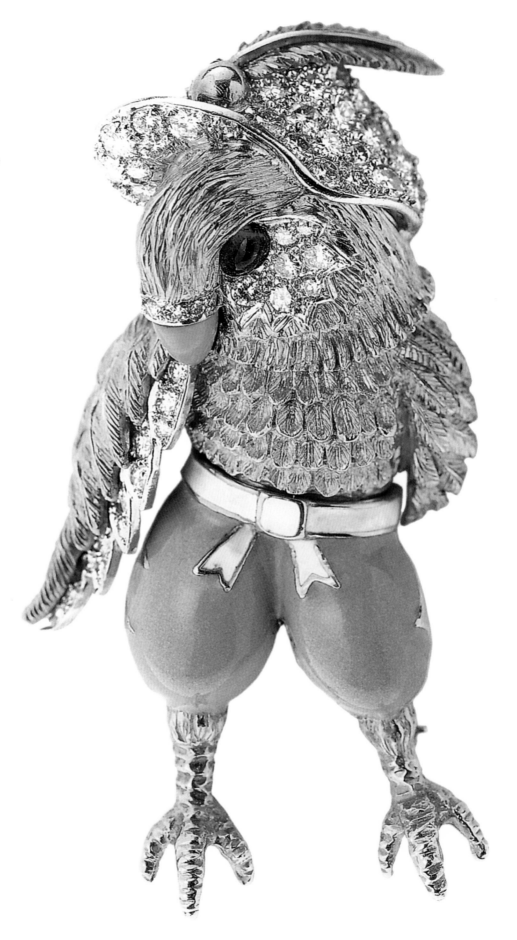

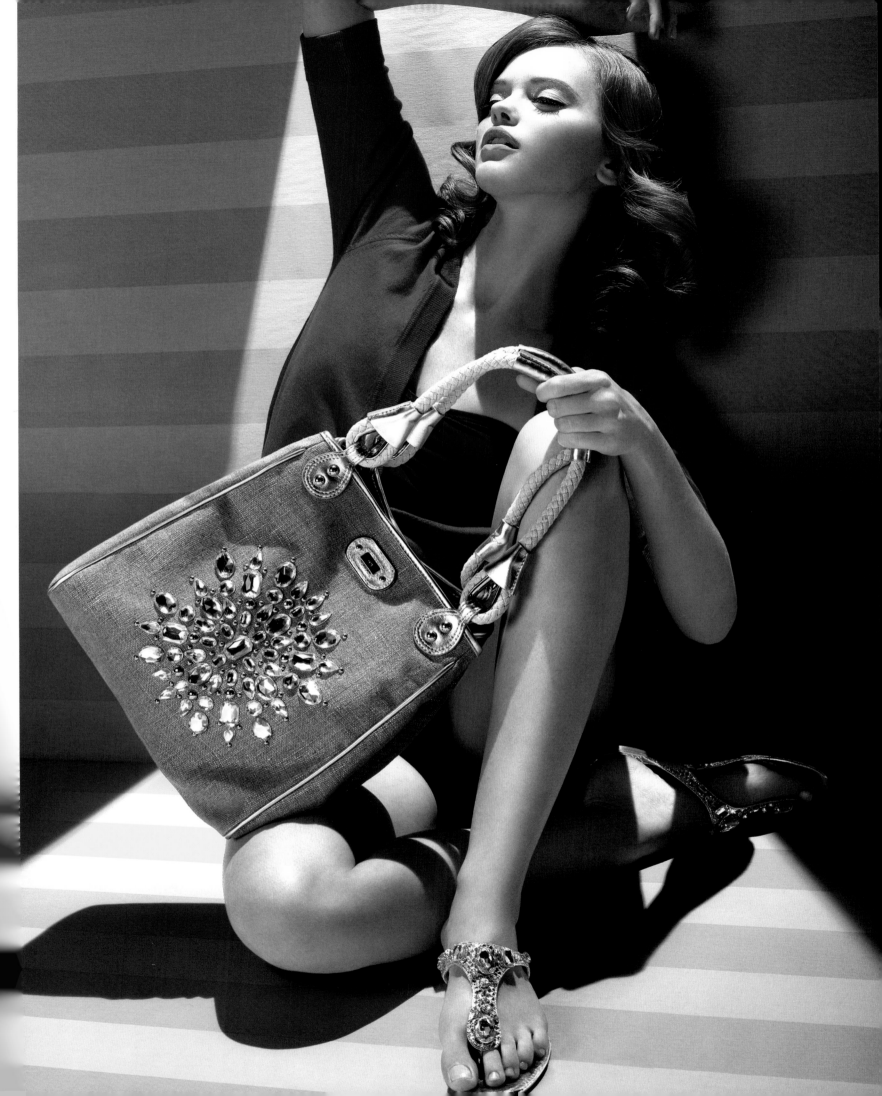

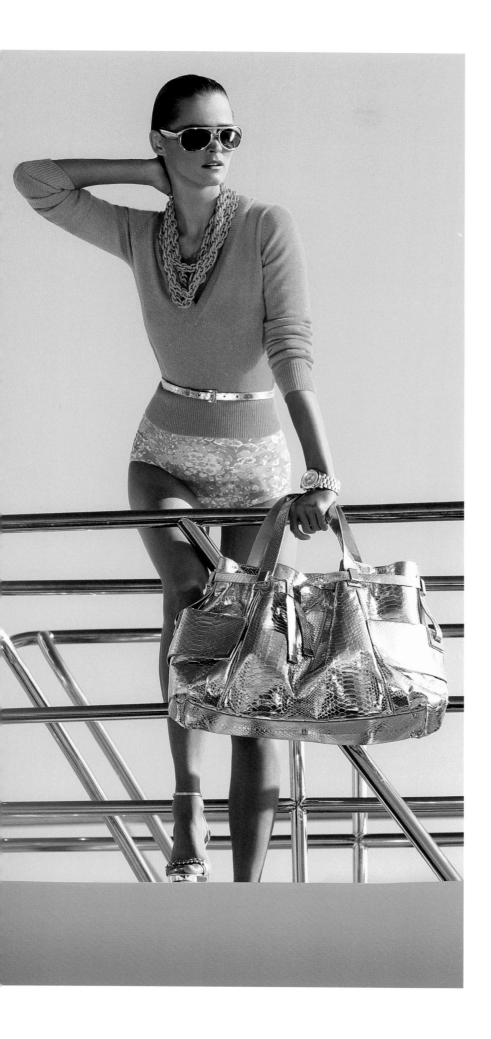

Michael Kors, 2008

Left The poolside photo shoot for Michael Kors correctly pinpoints the stream of Hollywood inspiration that runs throughout the designer's work. The gold sunglasses, belt, bag, and shoe suggest a starlet's fearless embrace of the Hollywood fantasy.

Rod Keenan, 2006

Following page, left Rod Keenan's classic fedora atop a suit by Brooks Brothers reads as an updated version of Diane Keaton's style in *Annie Hall*.

Diane Keaton and Woody Allen in the film *Annie Hall*, 1977

Following page, right In Woody Allen's *Annie Hall*, costume designer Ruth Morley worked with Ralph Lauren to create the signature style that became known as the Annie Hall look and featured the appropriation of the men's necktie as its keynote.

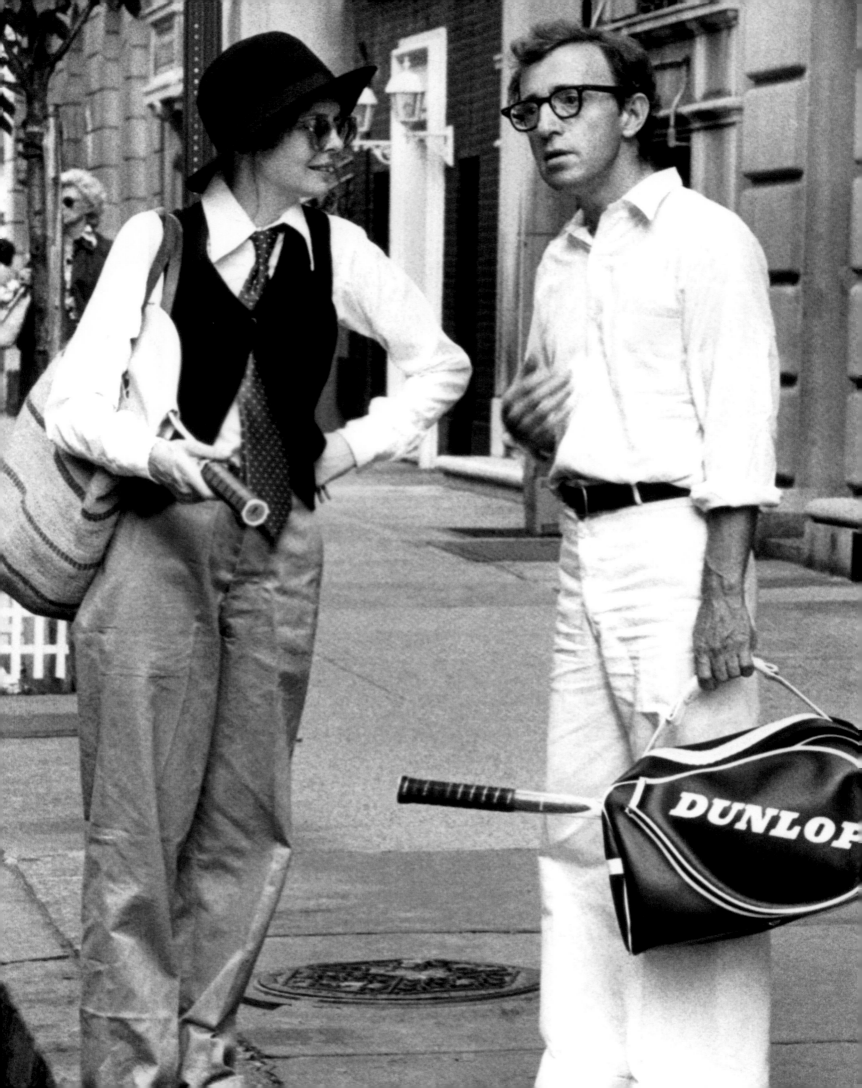

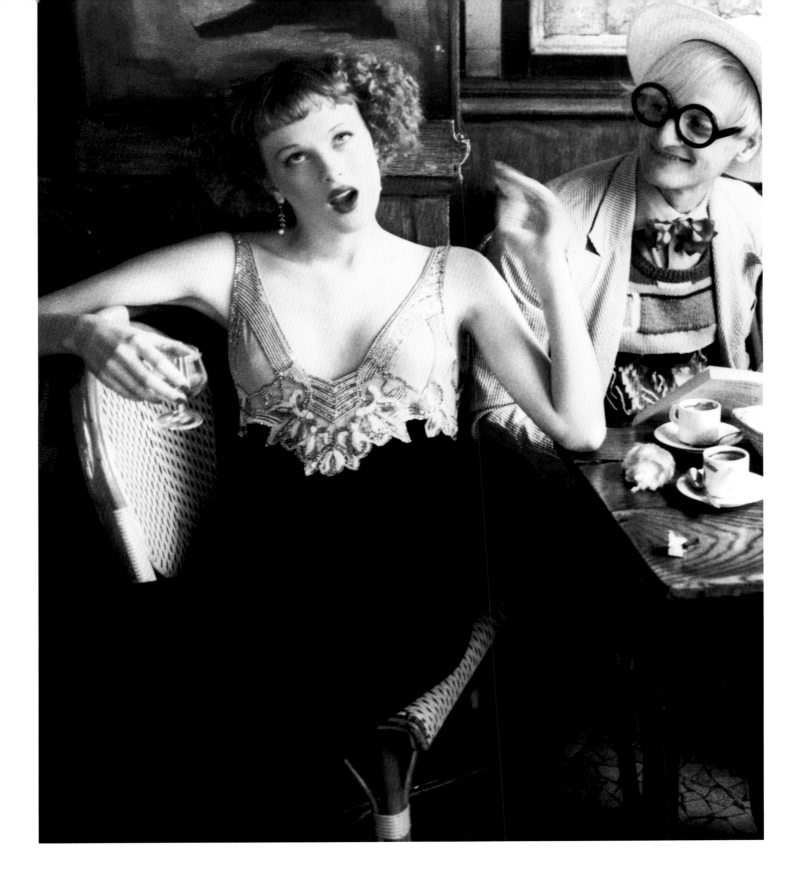

Cathy Waterman, 1997

Above Cathy Waterman's earrings add a note of
elegance to the look of this model in a screwball
movie-heroine moment and an Isaac Mizrahi
ensemble.

Katharine Hepburn, 1932

Opposite Katharine Hepburn, curled up
irreverently in what was probably a very
expensive dress by costume designer Walter
Plunkett, was Hollywood's anti-fashion fashion
plate. She rejected fussy, overdone clothes for a
simple, signature style that still influences
American fashion today.

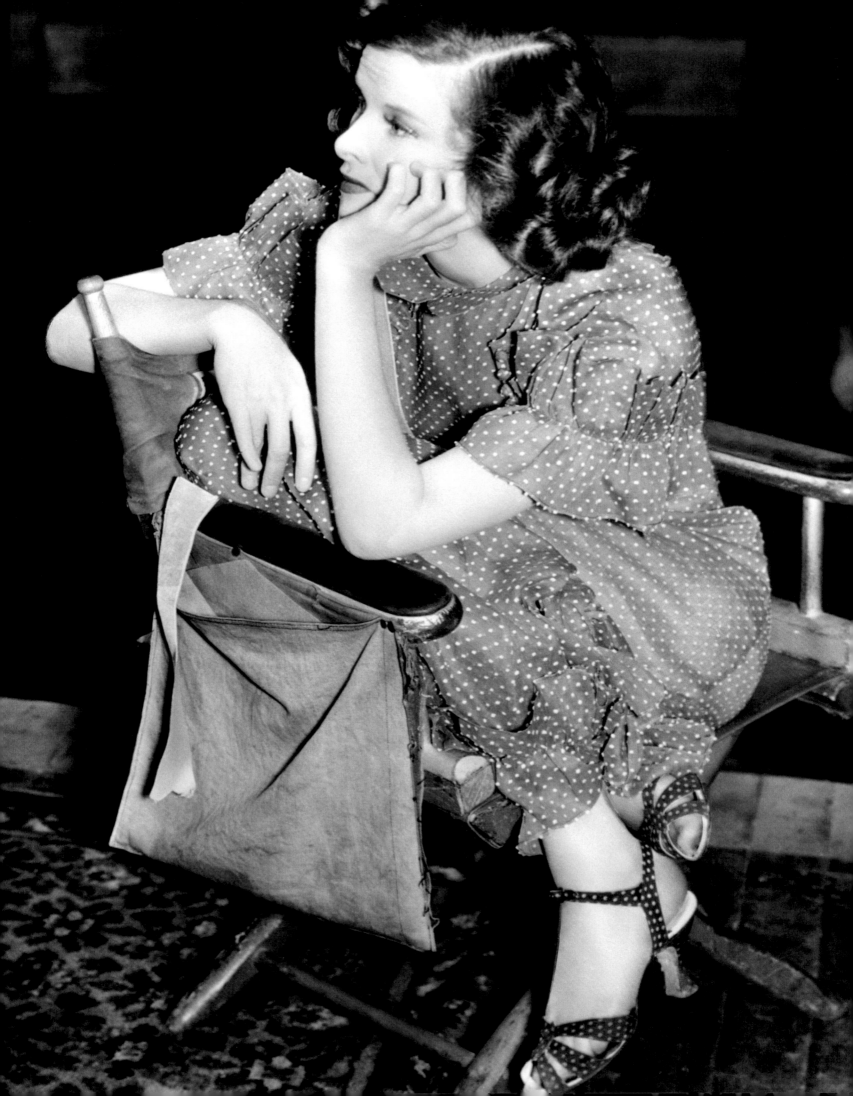

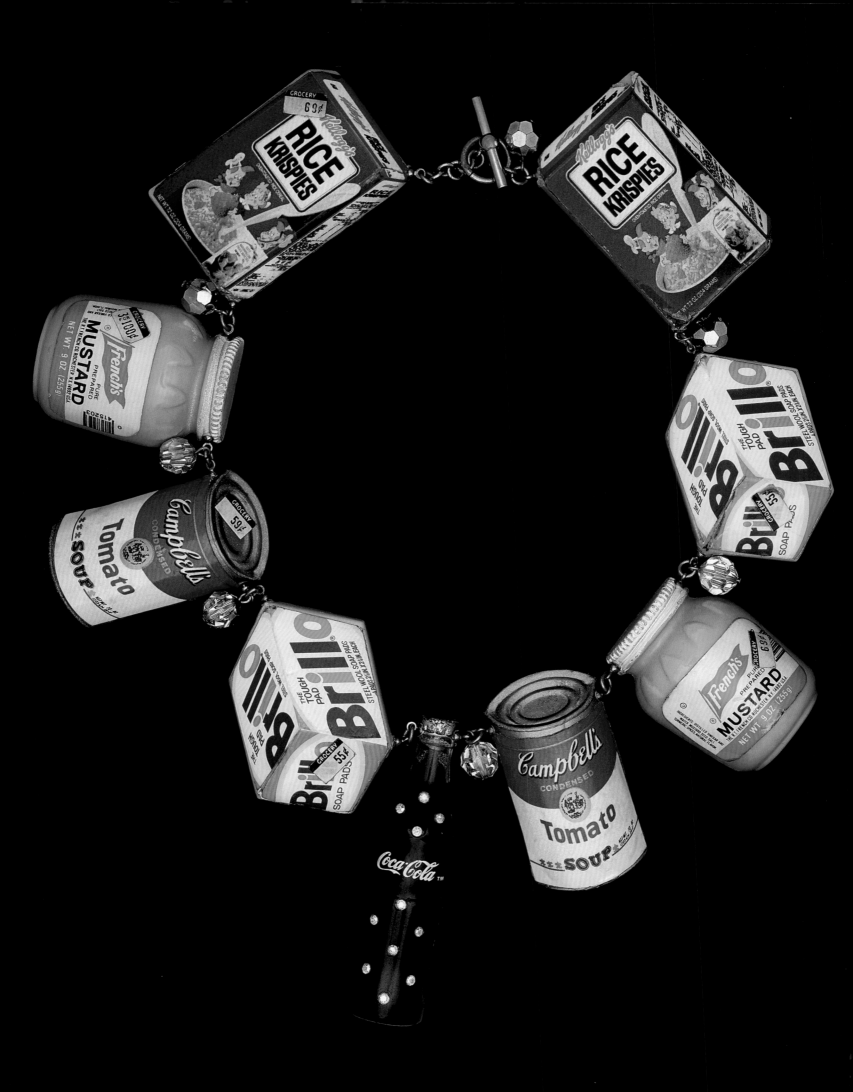

POP CULTURE

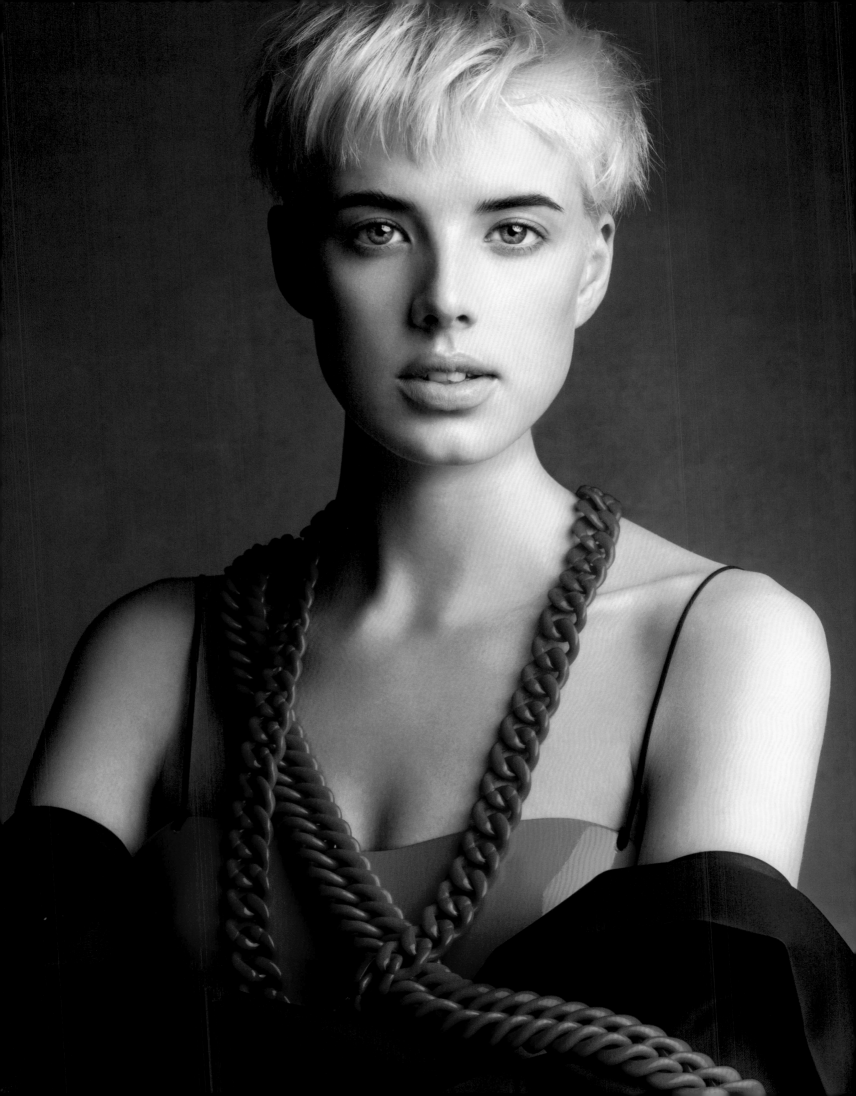

THE AMERICAN ACCESSORY
POPS

While the glamour of Hollywood films was an unstoppable vehicle for the promotion of American accessories, equal if not more credit must be given to America's increasing dominance of world popular culture during the course of the twentieth century. The nation's first fashion icon, the Gibson Girl, appeared in cartoonlike illustrations by Charles Dana Gibson for mass-market magazines. Her role was not to define high style but to poke gentle fun at changing sexual mores in the 1890s. She ultimately swept both categories, becoming an instantly recognizable icon of beauty and modernity by 1900. In the 1920s, the flapper emerged to conquer the world as yet another icon, and she didn't do it dressed in Chanel. This creature celebrated on posters, in short stories, and in popular radio songs was a woman of the people in her department-store cloche, Newark-made costume jewelry, nude rayon hose, and dance shoes from Bob, Inc. All those girls in long fake pearls were endeavoring to be as much a Zelda Fitzgerald as a Coco Chanel. Thus the speeding culture and its ornaments in the twentieth century are revealed to be equal parts designer innovation and viral harbingers of the zeitgeist.

American popular heroics, especially as they have emerged in the worlds of music and sport, have given rise not only to whimsically trendy items, but also to revitalized ideologies of production—for example, the resurgence of traditionally crafted objects during the hippie movement of the 1960s. The trends are easily identified and too numerous to recount in full. There's the charm bracelet, embraced by everyone from Mamie Eisenhower to Marc Jacobs; the zoot-suiter's platinum watch chain; the bobby-soxer's black-and-white saddle shoes; the hippie chick's fringed bag; the punk rocker's army surplus boots; the grunge era's ubiquitous knit watch-cap, and so on and so on. More striking are the style changes driven by shifts in popular values, usually precipitated by the mainstream takeover of a subculture that had been percolating underground. Popular trends through the 1950s, however, remained blissfully unaware of subcultural style, which would have been labeled deviant anyway. While Elvis Presley's blue suede shoes may have been worn on feet attached to legs and hips that moved

Left **Janis Savitt, 2007** Janis Savitt's jewelry designs are so wide-ranging that they can barely be narrowed into as expansive a category as "Pop." The rope of red resin links shown here is an obvious match, but doesn't represent her work in fine jewelry, which is equally striking and not always evocative of outsider attitude. *Previous page, left* **Stuart Freeman necklace** An almost literal expression of the Pop fashion accessory, Stuart Freeman's necklace cribs Andy Warhol's deified consumer objects.

a bit too suggestively, that nice boy from Memphis who dreamed of being a movie star repre-sented no threat to the complacent consumer culture of the 1950s. In fact, with his consider-able ability to sell all sorts of merchandise, he dovetailed with it perfectly. "Pop" only meant popular then, and the accessories in this category were products of the by-then well-oiled machine of American mass production. The real marketplace discovery was of the American teenager, who screamed for Elvis and rapturously embraced some of the most kitschy novelty items of the 1950s, drawing the attention of designers as a force to be reckoned with.

Pop started to mean something more in the 1960s, when the Pop Art movement emerged, best personified by the artist Andy Warhol. In a sense, Pop Art deified the popular object (or person or image) by staging it as fine art on a canvas. It celebrated the nonfunctional, the ephemeral, and the expendable. Of course, there was a precedent for this; the Surrealist art movement had reveled in conflating low (popular) and high (fine art) cultures. Surrealism found a voice in fashion through couture designers such as Elsa Schiaparelli and also through American hat designers like Bes-Ben and Hattie Carnegie, who joyfully made hats of things like flowerpots that traditionally had no place on the human head. Also influenced by the 1930s art movement was the American bagmaker Koret, one of the first to abandon copying French handbags in favor of playing out the implications of Surrealism with items like a bag with a telephone cord as a strap. The lure of Surrealism continues to intrigue shoe design-ers such as Gunnar Spaulding and George Gublo, the founding partners of Gunmetal, who perhaps in a nod to Schiaparelli placed industrial brass zippers on a pair of their shoes as a decoration.

Most exemplary of the influences of Surrealism and Pop Art in shoe design is the work of Beth Levine for Herbert Levine shoes. Launched in 1948, the husband-and-wife company had

Left **Chrome Hearts, 2006** These silk scarves evoke the overlap between biker and psychedelic subcultures, an alliance created by acid-guru Ken Kesey. *Center* **Vera Wang, 2007** Vera Wang's use of felt and stone show a counterculturist's affinity for primitive materials. *Right* **Mary Ping, 2007** Mary Ping shows an outsider's irreverence for the mores of high fashion, especially in her affection for canvas which she uses to create, among other things, copies of iconic Chanel and Gucci bags for her line Slow and Steady Wins the Race. Here is her multi-fabric Oxford "No. 15 Shoe."

188

decades of success with ideas both innovative and simply outrageous. In the 1950s, the couple invented a new kind of mule, the Spring-O-Later, in which a strip of elastic in the insole snapped the heel of the shoe up to the wearer's heel as she walked. Marilyn Monroe swore by them. In Levine's more whimsical mode, she cheekily played with the divide between stocking and shoe with her shoe tights; she pioneered the use of stretch vinyl in the early 1950s, long before Pop Art's permission to be plastic was in full effect; she conflated shoes and more solid structures, bringing wood and bamboo into her heel constructions; she attempted to create "invisible" shoes using transparent vinyl and even sticky pads on the soles in place of traditional uppers; and, in a particularly Pop Art moment, she created a thong with an Astroturf insole and affixed a blooming plastic flower to its toe straps to secure the shoe. If David Evins made shoes for classic Hollywood, Levine made shoes for the Youthquake, most famously designing the boots which Nancy Sinatra wore while performing the 1966 dance classic "These Boots Are Made for Walkin'."

While Pop Art's profound influence on fashion in the 1960s was expressed through high fashion's embrace of prosaic materials such as cheap plastics, its lasting influence can be found in the work of designers who make art out of everyday materials and images. Contemporary examples are Eugenia Kim, who incorporates found objects and other detritus of daily life into her hats; Katrin Zimmermann of Ex Ovo, who juxtaposes rubber with semiprecious stones in some of her jewelry; Robert Lee Morris, who is best known for his sculptural metal cuffs but has also created jewelry with Warholian motifs like the Campbell's soup can; Wendy Gell, who has adorned Disney character jewelry with precious stones; and Judith Leiber, whose ultraluxe crystal-encrusted minaudières in the shapes of all the animals on Noah's Ark perfectly capture the audacity of Pop Art's portrayal of the prosaic.

Left **Dennis Basso, 2008** Traditional crafts like crochet, used here to create the leather rosettes on Dennis Basso's crocodile clutch, are currently in revival as part of a DIY radical craft movement with roots in hippie and punk subcultures. *Center* **Twinkle, 2007** Wenlan Chia's vision for the Twinkle company expands beyond a one-way vision of seller to buyer, embracing a more communal ideal with two instructional books published and even the occasional offer of knitting classes in New York City. *Right* **Trina Turk, 2004** Trina Turk's California style takes influence from that most iconic of the West Coast tribes: surfers.

While pop art celebrated a culture of consumption, the hippie counterculture, which emerged in the late 1960s, rejected those values and actively sought new materials and methods of production that could bring about the utopia it envisioned. The new permissiveness ushered in by pop art enabled the early hippie trends to be easily assimilated. Thus Diana Vreeland's *Vogue* featured long-haired models wearing body jewelry, anklets, headbands, oversize low-slung belts, and moccasins and carrying beaded suede bags with fringed trim—all accessories popularized by the counterculture. The more far-reaching outcome, however, was the influx of new designers who entered the world of fashion inspired by the values of the movement. Carlos Falchi was one: He began by making patchwork leather clothing for himself and his co-workers at Max's Kansas City, a popular downtown New York rock-and-roll nightclub, in the late 1960s. His designs attracted attention and led to commissions from celebrities such as Miles Davis, Mick Jagger, and Tina Turner. Falchi had acquired his leather-working skills not in a fashion program but at his elementary school in Brazil, and he honed them in home experimentation with aniline dyes in his bathtub. Falchi's work, which ultimately manifested in the iconic Buffalo bag, among other accessory designs, embodies the freedom and experimentation of the 1960s counterculture. He started out as an autodidact; he emphasized hand-crafted materials; he offered up his creations to rock stars (not movie stars); and he sought out unusual raw materials—especially those neglected or rejected by the mainstream fashion industry. This ethos is still embraced by Falchi and numerous other contemporary accessory designers. The jewelry designer Dean Harris has utilized materials as diverse as green beetle wings, aluminum, and plastic for his 18k gold jewelry. Vicki Beamon and Karen Erickson of Erickson Beamon became jewelry designers by accident when they had to make their own jewelry for a catwalk show by stringing crystals and beads onto suede. Gerard Yosca has used wood to make jewelry for some collections, saying, "Wood is a new semiprecious material." Philip Crangi mixes wrought iron and steel along with more traditional gold in making jewelry. Simon Alcantara, a self-taught jewelry designer, incorporates precious stones and bone into his work.

The hippie subculture also brought fashion cachet to the world of vintage and second-hand shopping. This was partly out of necessity (being a hippie didn't pay very well), but it also reflected the utopian vision of a counterculture that rejected ever more plastics in favor of recycling and renovation. As the green values of the 1960s and 1970s have gained widespread acceptance with the growing awareness of global warming, American accessory designers have responded with world-class design reinventions, for reasons both aesthetic and idealistic.

Right **Alexis Bittar, 2007** Alexis Bittar started out his career peddling vintage clothing and jewelry on the still-mean streets of the East Village in 1983. Interest in reappropriating the past has persisted in his work, which engages materials like Lucite alongside semi-precious stones and mixes modern, natural, and Art Nouveau forms.

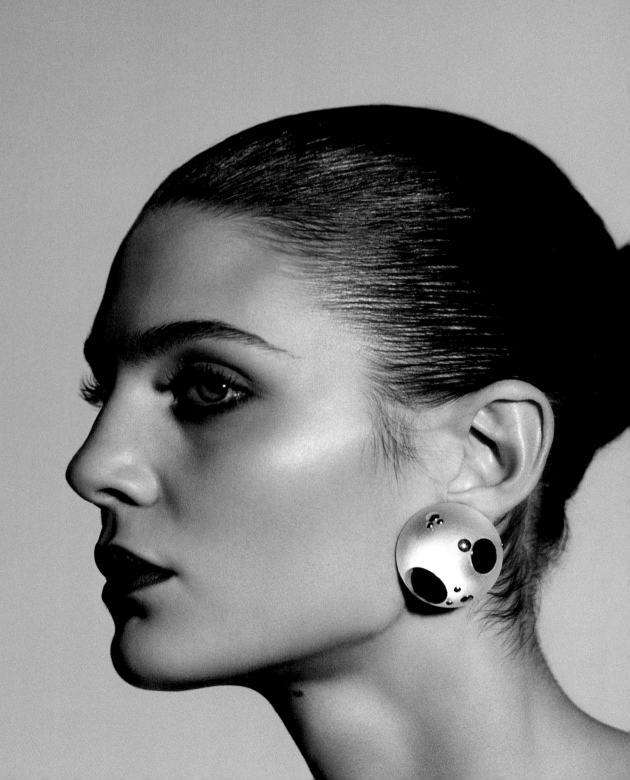

New York City's East Village, selling vintage clothing and jewelry, before creating his hand-carved Lucite pieces; Larry Leight of Oliver Peoples, who launched his company on boxes of antique eyewear found in a New York basement, which gave a name and a fount of retro looks to his line of antique and original eyewear designs; and Justin Giunta of Subversive Jewelry and Renee Lewis, both of whom source components of their reconstructed jewelry at flea markets.

By the mid-1970s, almost everyone seemed to want to take part in counterculture movements, leading to some embarrassing looks, like gold medallion necklaces on balding male accountants eager to share their chest hair farms. The counterculture had also worn out its welcome in the world of fashion with specific assaults on good taste like the well-intended but simply appalling Birkenstock sandal. The preppie trend, marked by a return to classics like pumps, Pappagallos, Weejuns, Sperry Top-Siders, straw-basket handbags, Coach purses, simple gold bracelets, and pearls, can be read as a reaction to perhaps too much freedom. Though the 1960s counterculture was ultimately undone by its own mainstream success, the increasing importance of American popular culture was not. As the idealistic hopes of the hippies waned, the appeal of the fundamental rebellion they represented remained. And that rebellion became the keynote of the more aggressive countercultures that followed in the 1970s and 1980s. Punk was the early arrival, launching in the early 1970s on the Lower East Side of New York City. It was marked by a poverty-chic, distressed, and destroyed aesthetic that would have been antifashion had its effects not been so calculated. The Ramones and Blondie sported Converse Chuck Taylor All Star sneakers during the punk era; the athletic mainstay had reached its peak in the 1960s, when it was ubiquitous in professional basketball, but was grabbed by downtowners in the 1970s and 1980s because it was cheap and came in black. Fetish accessories emerged during the punk era as well, mainly in an effort to shock. Overall, the exploration of the dark side offered by punk ultimately opened up whole new realms of subject matter for the worlds of rock and roll and fashion that have only recently been fully realized. Companies mining this area include Chrome Hearts, founded in 1989 by artisan-bikers Richard Stark, a carpenter and a leather salesman; John Bowman, a beltmaker; and Leonard Kamhoot, a silversmith, which specializes in leather and silver pieces with a decidedly outlaw air; Fetty, the Brooklyn-based concern of Justin Tranter, who started designing necklaces to sell at his glam band's shows; and Exhibitionist, launched in 2001 by the designer Michael Spirito and the entrepreneur Sloan Mandel, which provides jewelry with a touch of danger in the form of thorns and other sharp implements gleaming in necklaces.

The skate culture emerging from California shared values with New York punk and ultimately put a number of specialized clothing companies on the map, but its biggest success

Left **Band of Outsiders for Sperry Top-Sider, 2008** Venerable makers of preppie boat shoes get the pop makeover from Band of Outsiders.

mately put a number of specialized clothing companies on the map, but its biggest success story was catapulting the Vans sneaker company to prominence. Established as a small, flexible company in the 1960s, Vans made a tough, inexpensive sneaker and offered customized fabrics for only a dollar extra. In the 1970s, it began to sponsor pro-skater Stacy Peralta, bonding the company to a rising industry that combined athletic prowess with the irresistibly rebellious spirit that the skaters embodied. Vans has found this particular pop phenomenon so profitable that it continues sponsorship of extreme sports and its associated music culture into the twenty-first century.

Another style revolution, hip-hop, was born in New York City, emerging out of the Bronx and then across the nation and the world. A street style that was aspirational as well as confrontational, early hip-hop offered up heavy gold chains, ever-multiplying styles of sneakers, and retro headwear, like the fedora, to an initially wary public. Though hip-hop fashion was partially rooted in street styles of the past, especially the zoot-suiter and imitations of Hollywood gangsters, the in-your-face attitude and the demotic commitment to accessible items like athletic gear were totally new. The style was initially promoted within the downtown New York City scene, which absorbed graffiti and dance rhythms in particular into the spasms of postpunk creative foment of the early 1980s. Arising from this early hybrid was the fashion style of Madonna, who amalgamated African-American and Hispanic street styles with Catholic accoutrements and cheap rubber bracelets into her performances in a self-consciously multicultural club scene. Hip-hop's press into downtown was also driven by the strong influence of graffiti art, especially as it was realized in fashion, exemplified by the designs of Stephen Sprouse and the jewelry designer Janis Savitt's silver letter pins, which she created for Sprouse's 1984 fashion show at The Ritz, a popular East Village rock club. Ultimately, hip-hop style emerged from downtown as an independent entity and spread from graffiti artists and rappers to sports stars, the suburbs, and beyond. Its impact became undeniable and drove the sales of everything from Nike sneakers to Rod Keenan's custom hats.

American pop culture has almost become a palette for fashion in general—a collection of iconic images that can be mixed and matched at will to capture the mood of the moment. No one has proven more adept at this than Marc Jacobs, who finds as much inspiration in Pop's past as in the grand tradition of couture. Whether designing a signature pair of Vans or working in diamonds, Jacobs captures the American designer's unabashed love of low culture. And those are the popular heroics that will sustain the success of the American accessory designer in the twenty-first century.

Right **Tina Turner, 1961** Big shades to match a big voice. *Following pages* **Debbie Harry of Blondie, ca. 1977** The original Queen of Punk, Deborah Harry's style was to take the iconography of the bombshell blonde, systematically tear it down, and look good doing it. Originally enamored of thrift-shop style, Harry began a collaboration with designer Stephen Sprouse and allowed him to create her image, right down to the Edie Sedgwick eye makeup. The result was aggressive and deconstructed, but tempered with a luxe minimalism and has come to define the look of New York punk.

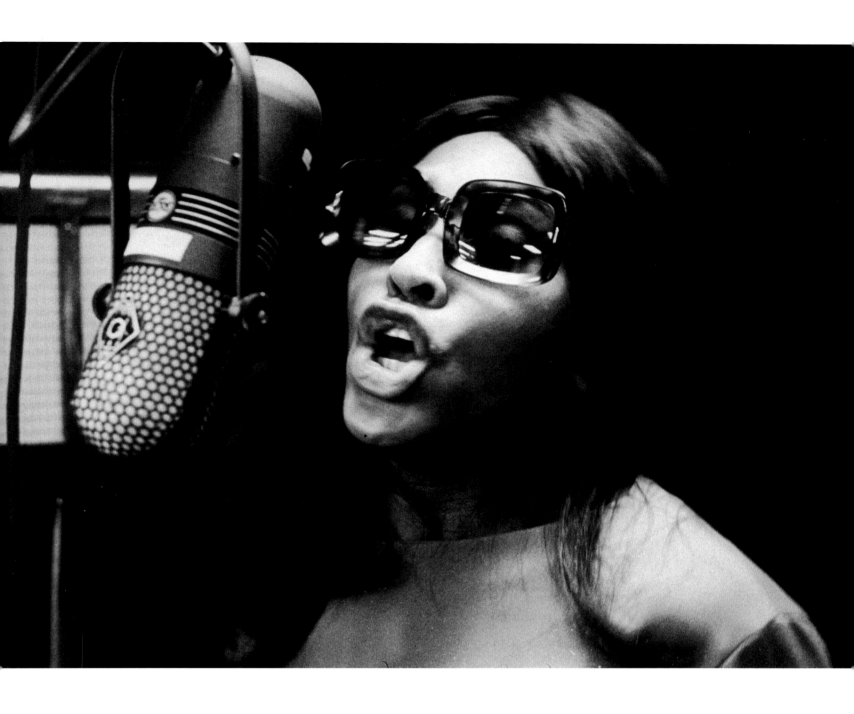

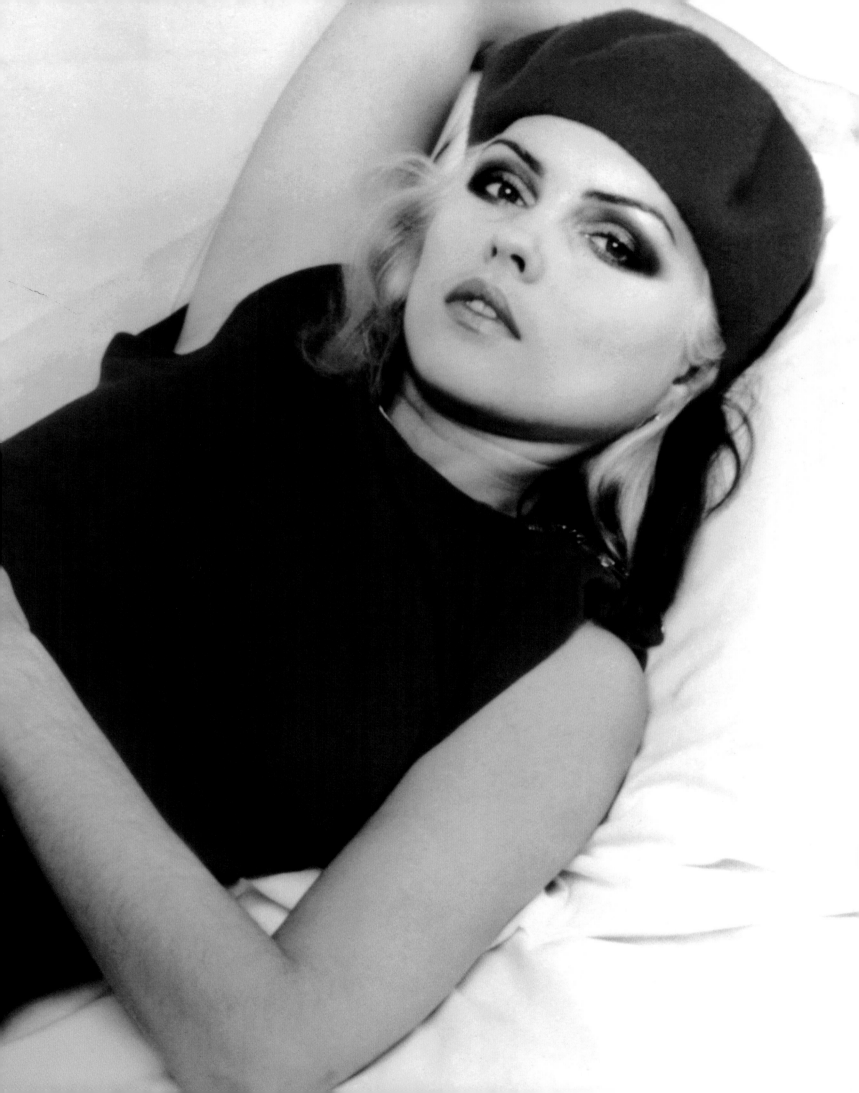

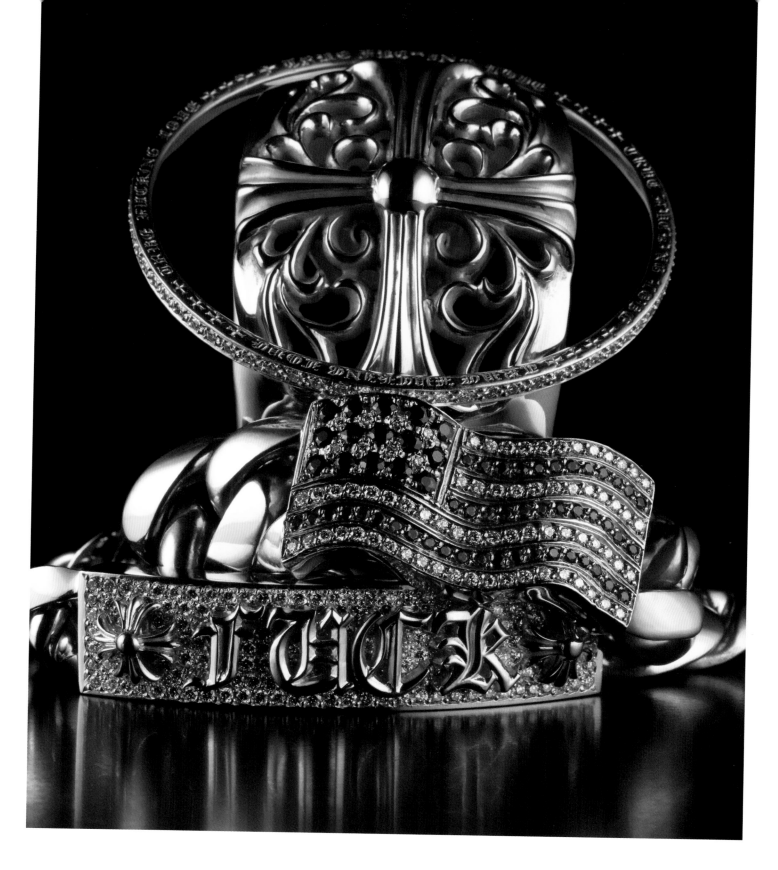

Chrome Hearts, 2006

Chrome Hearts's design riff on the iconography of the American outlaw biker, a figure that emerged after World War II and came to prominence during riots in Hollister, California in 1954 and through Hunter S. Thompson's account of the Hell's Angel's motorcycle club. Crosses, American flags, and motifs from car culture are transformed into jewelry.

Tom Binns, 2008

Above American-based Tom Binns's original creative impetus as a jewelry designer was Dada and the punk movement, specifically a collaboration with punk's British godparents Vivienne Westwood and Malcolm McLaren.

Kenneth Cole, 2008

Opposite Kenneth Cole's striking ad campaigns have always added an extra edge to his designs, be they the political ads of the 1980s or this 2008 image of rock performer turned model Theo Kogan and her extensive tattoos.

Nancy Sinatra wearing Beth Levine for Herbert Levine boots, ca. 1970

Left Nancy Sinatra claimed "These Boots Are Made for Walkin" in her 1966 hit, while Beth Levine designed the boots. A constant innovator who started designing for her husband Herbert Levine in the 1940s, Levine had anticipated the Pop sensibility several years in advance with her playful use of plastics for high style shoes.

Ex Ovo by Katrin Zimmermann, 2005-6

Opposite Katrin Zimmermann has been one of the tribe of travelers who saw the world in the 1980s and 1990s, ultimately bringing her appreciatation of the Chinese use of asymmetry to her jewelry and belt designs.

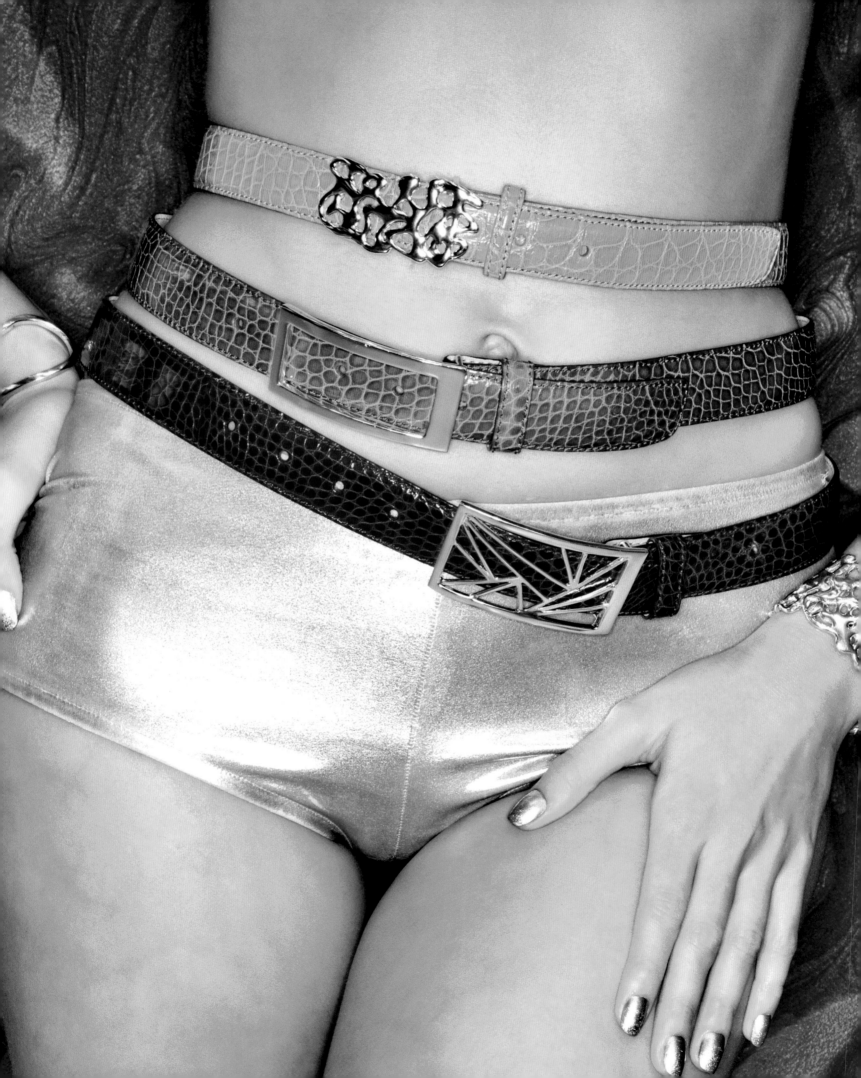

Simon Alcantara, 2007

Above This self-taught designer emphasizes
artisanal materials.

Janis Joplin, 1972

Opposite Janis Joplin, once voted "Ugliest Man on
Campus" in her home state of Texas, came to San
Francisco to find love, acceptance, and ultimately
great fame in both the hippie counterculture and
then the mainstream. The semi-nudist practice
on display here was perhaps one of the better
documented expressions of hippie style, but this
and the adornment with ethnic-inspired jewelry
reflected a sincere questioning of the mass cultural
values the baby boomers like Joplin had received.

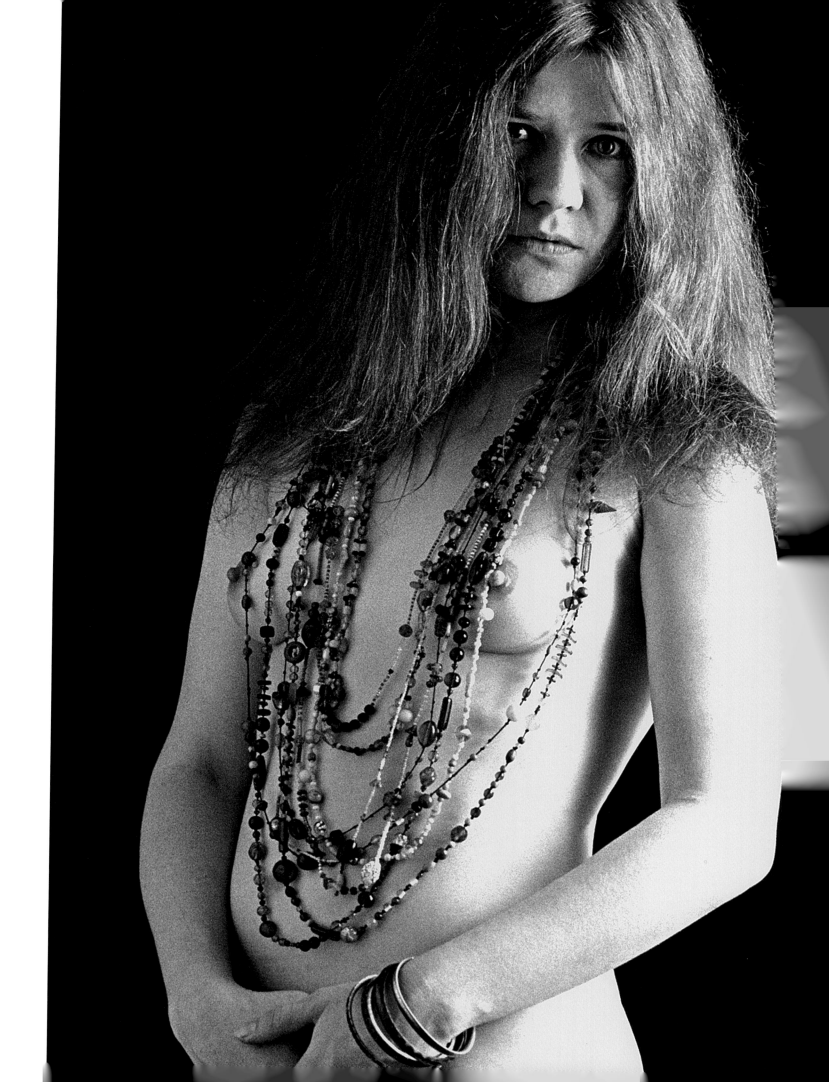

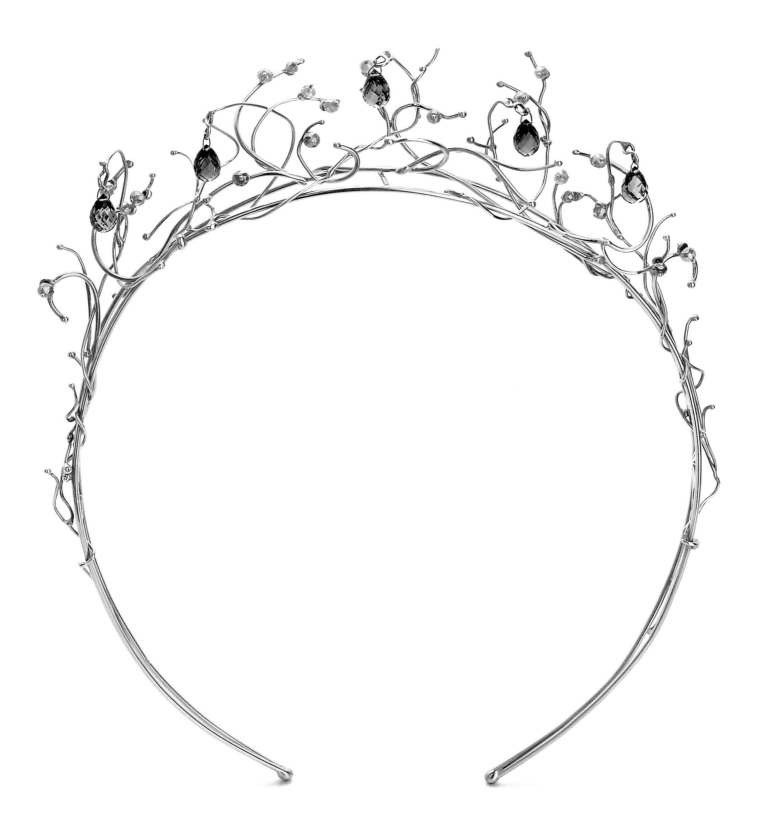

Dean Harris, 2004

Above Alongside diamonds, tourmalines, and opals, Dean Harris has used more unusual materials in his fine jewelry, including beetle wings, wood, horn, aluminum, and plastic.

Colette Malouf, 1999

Opposite New Age spirituality was introduced in America with the hippie movement's exploration of non-Western religious practices and the result has been a sometimes confused amalgam of spiritual signifiers transformed into fashion accessories. Colette Malouf's crystal bindi strap is prime example: Originally a Hindu religious sign, the bindi has since become a style statement.

Christian Roth, 1995

Above Christian Roth has cultivated his subcultural style-cred by landing his frames on rock stars, rather than movie stars.

Marc Jacobs, 2006

Opposite Marc Jacobs has consistently been interested in subcultural style, most famously designing the "grunge" line for Perry Ellis in the early 1990s. The rough knits of that particular pop cultural moment reveal themselves again in this 2006 hat.

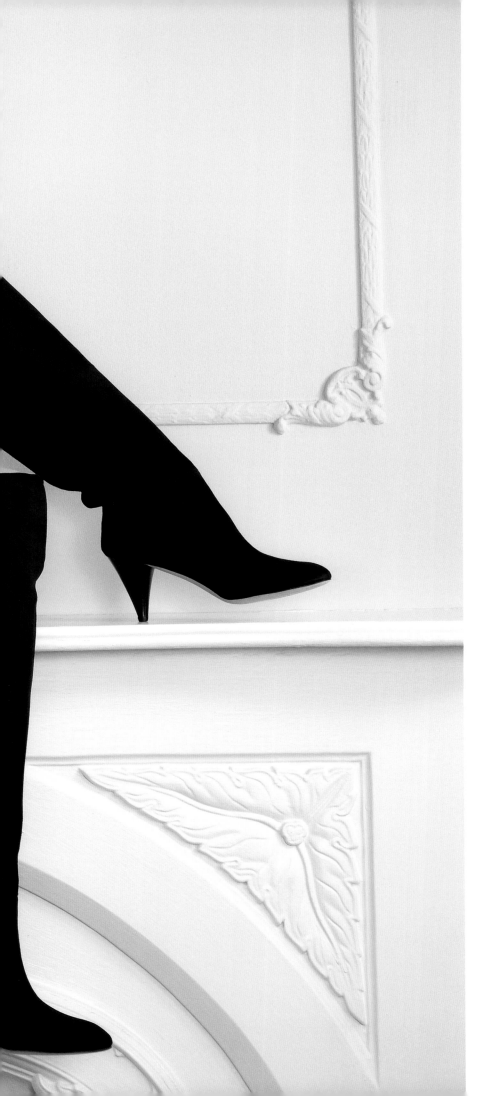

Loeffler Randall, 2007

Left Jessie Randall describes the look of her designs as "downtown elegance," and her sampling of hipster highlights like platform sandals and black suede boots bears this out.

Loree Rodkin, 2008

Following page, left With wearers like Marilyn Manson, Elton John, Avril Lavigne, Toni Basil, and Cher, jewelry designer Loree Rodkin has clearly keyed into contemporary rock style.

Stephen Sprouse, 1987

Following page, right Stephen Sprouse was the most important American designer to emerge from the early 1980s downtown scene that mashed up graffiti, punk, hip-hop, and high fashion. He brought that sensibility to his own accessory designs and to collaborations with jewelry designers like Janis Savitt.

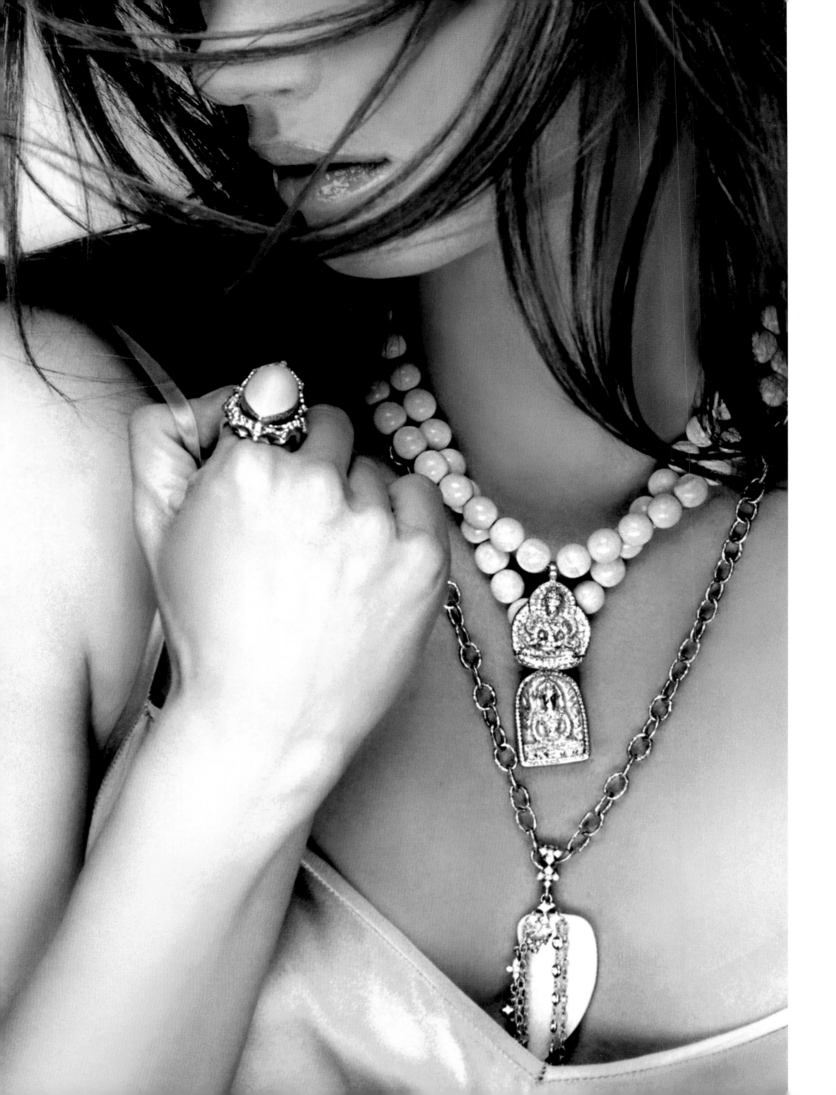

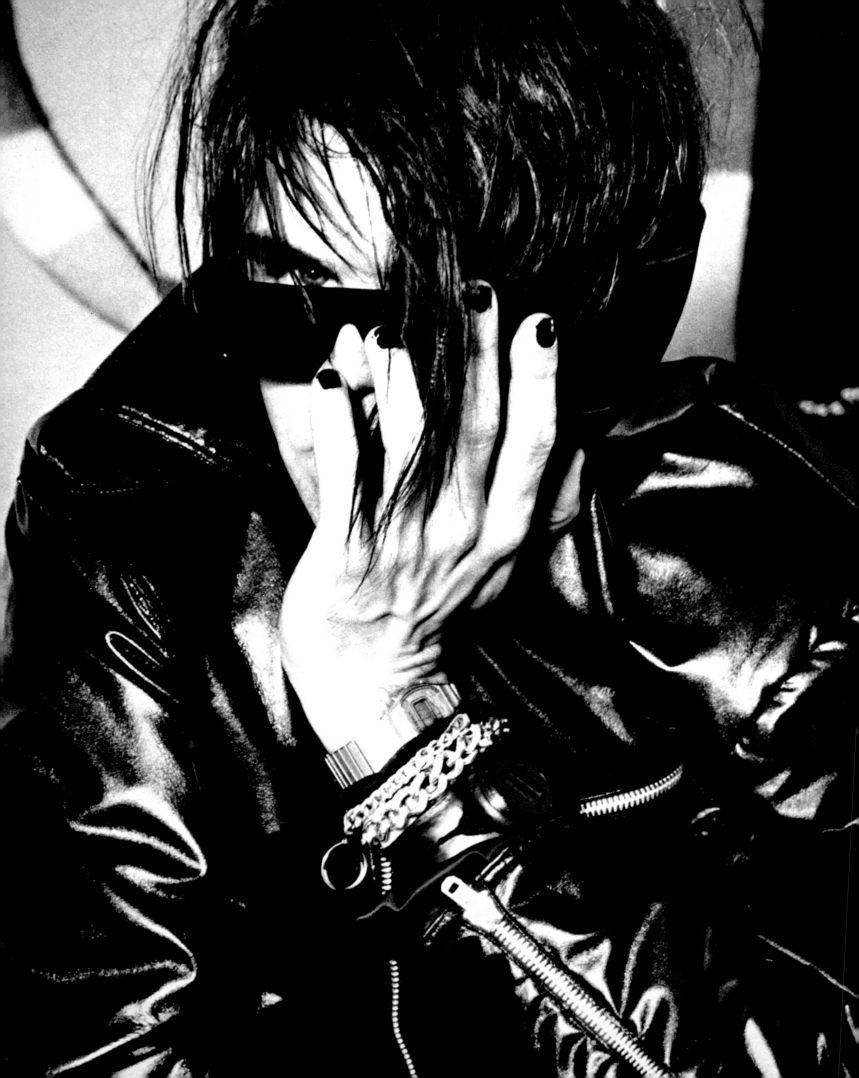

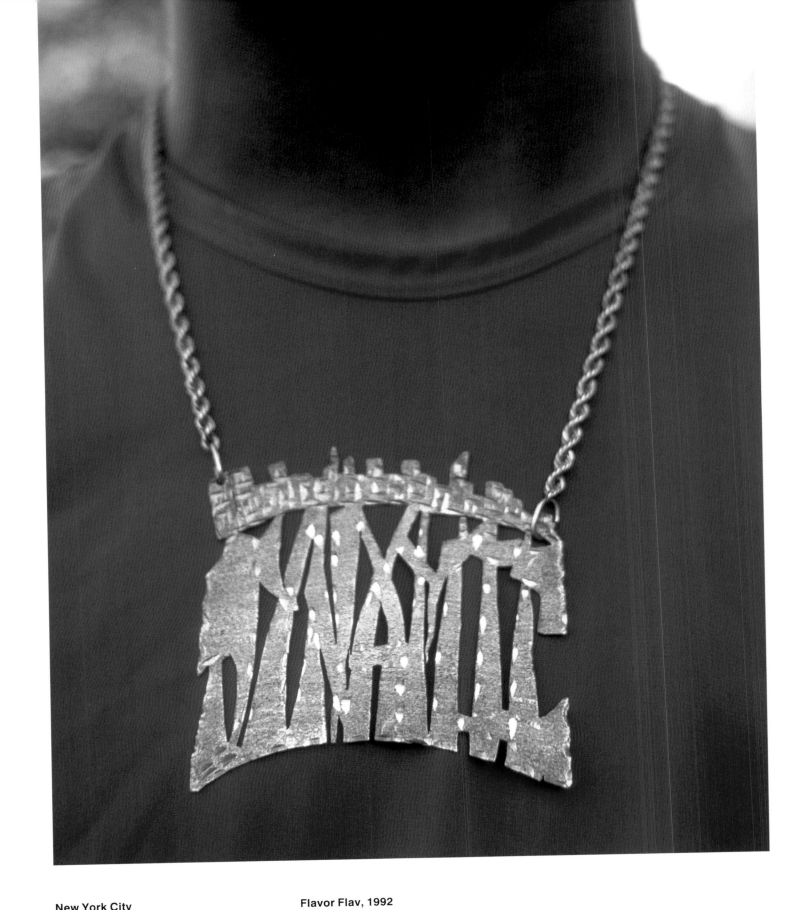

New York City

Above Street photographer Martha Cooper captures the current state of men's jewelry in hip-hop culture.

Flavor Flav, 1992

Opposite The final frontier of hip-hop aspirational jewelry: the grill.

Harry Winston, 1971

Above Harry Winston earrings are put into use as extremely expensive Surrealist props.

Amy Chan, 1995

Opposite Amy Chan takes the most traditional of women's accessories, the apron, and gives it an edgy spin. Her work is clearly not for the average housewife.

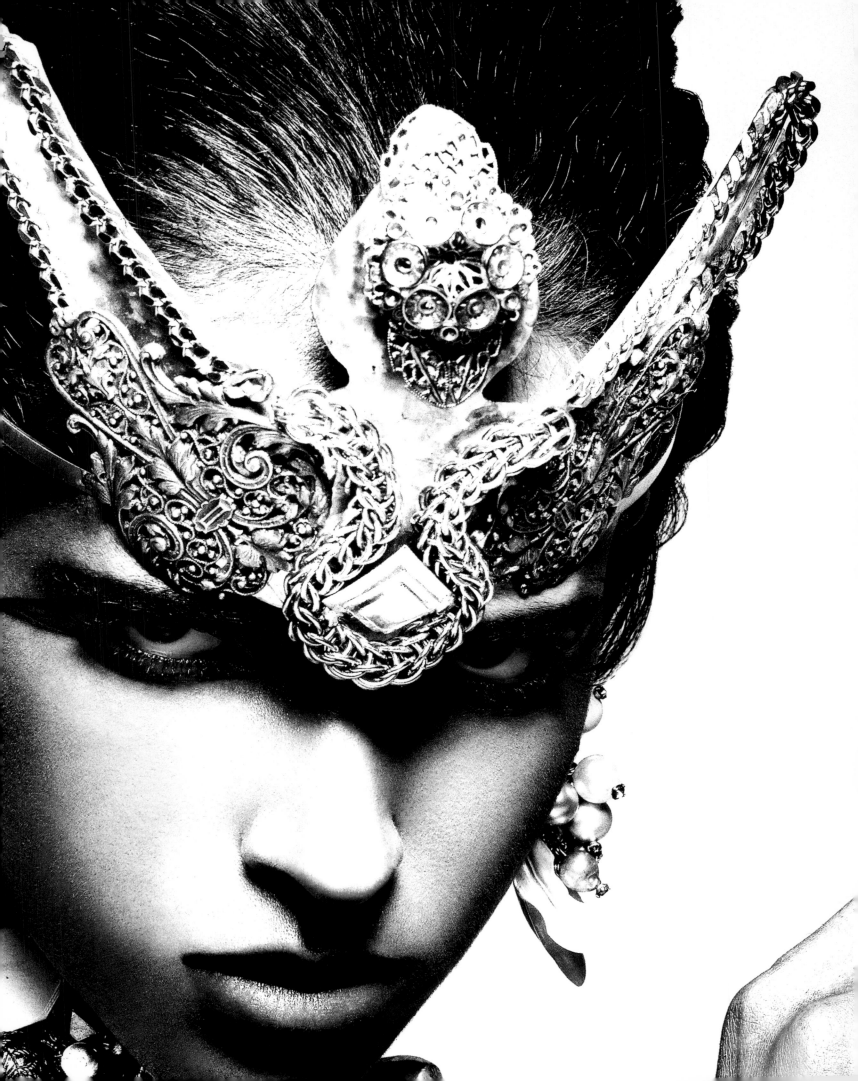

Philip Crangi, 2007

Right Working with materials and techniques more readily associated with the making of armor than jewelry, Philip Crangi is able to bring unexpected elements such as steel and wrought iron into his design.

Subversive Jewelry by Justin Giunta, 2008

Opposite Self-proclaimed "maximalist" Justin Giunta creates one-of-a-kind pieces by scouring flea markets and thrift stores for items he can deconstruct and then reconstruct into wearable art.

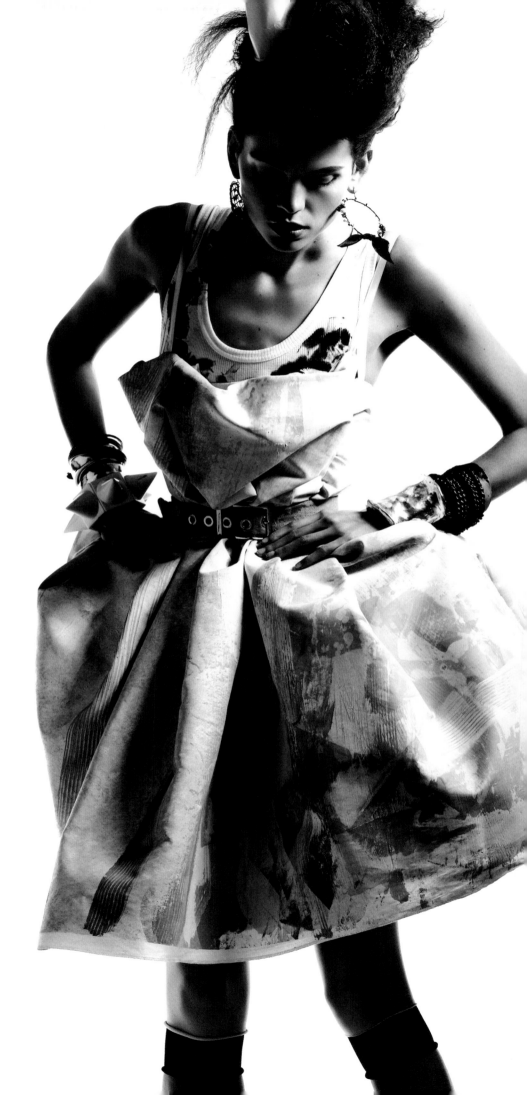

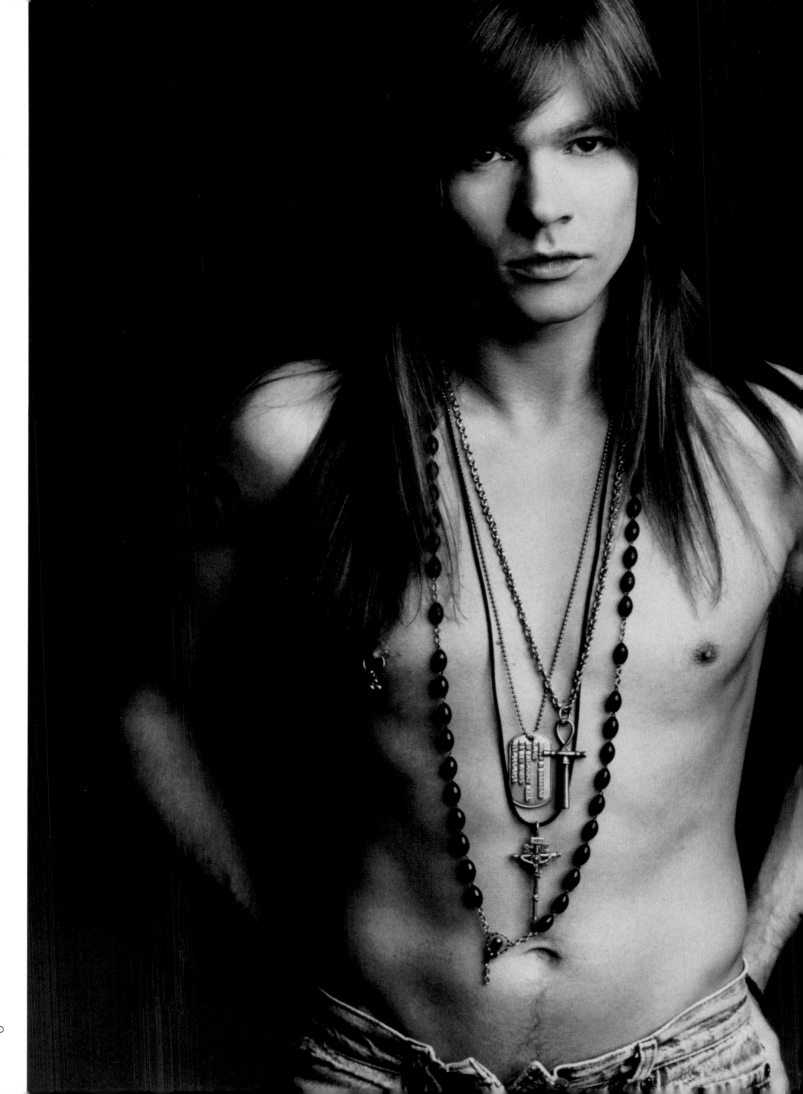

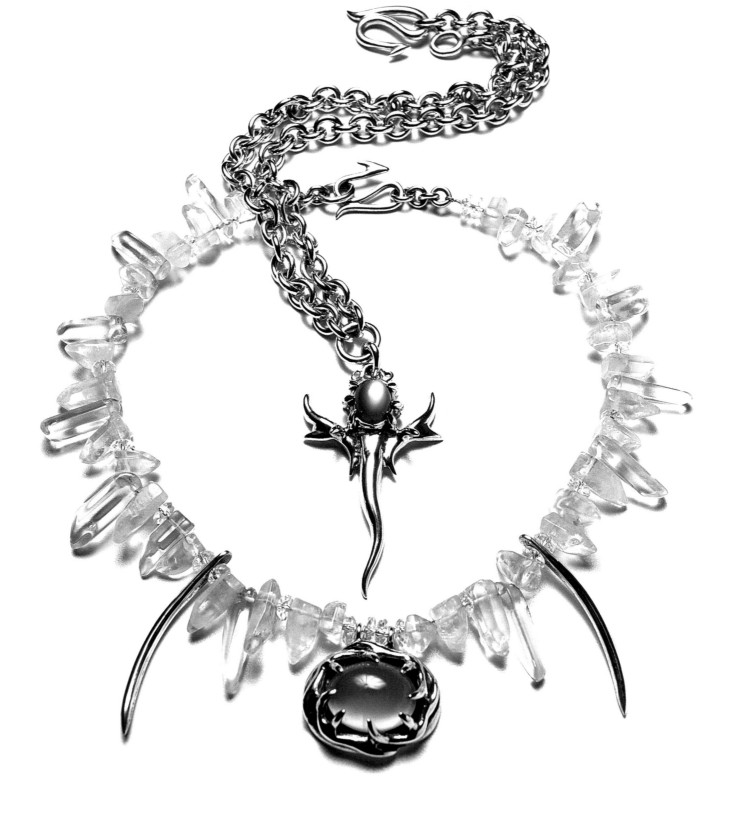

Michael Spirito of Exhibitionist, 2005

Above Though undeniably beautiful, the sharp edges and talon-like protrusions on some of Michael Spirito's jewelry suggest a fetishistic undertone to his designs, one that could only endear him to the Goth subculture that emerged in the club scenes in New York and London in the early 1980s.

Axl Rose, 1991

Opposite One of the shocking ideas of the hippie subculture was that men could wear jewelry. The theory was proven by rock stars like Axl Rose of Guns and Roses who counterbalanced any hint of femininity implied by his adornment with an often dangerous and aggressive posture. Still, the implications were so daunting to some that in the 1960s Tiffany & Co. refused to sell jewelry to a man if they had determined it would be for his own use. That policy has since been abandoned.

Combat boots, 1988

Above While British punks had factory shoemaker Dr. Martens to provide their disaffected footwear, American teens relied on Army/Navy surplus. Throughout the 1980s, boys and girls alike showed off their cheap and unfashionable combat boots at punk shows across the country, which ultimately made them terribly fashionable.

Loree Rodkin, 2008

Opposite While the sculpted metal cuff is associated with the working woman, the leather cuff has a lineage in hippie and punk subcultures, both of which lionized the primitive past that leather suggests.

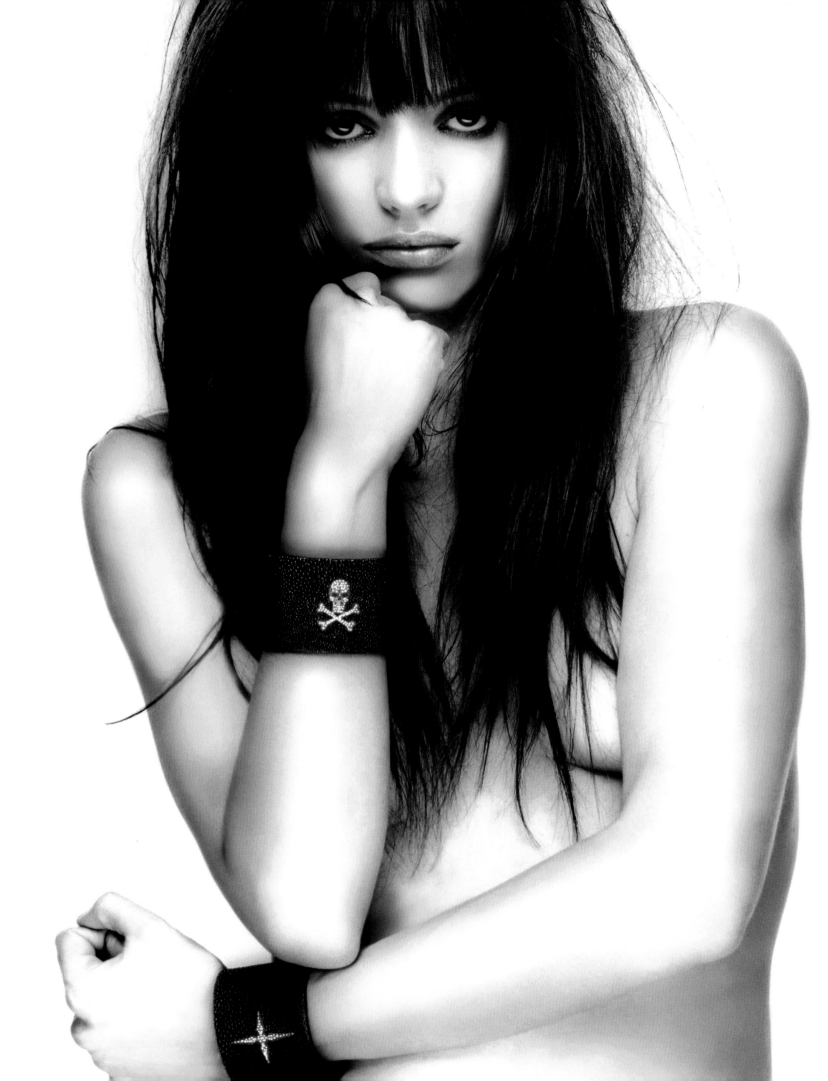

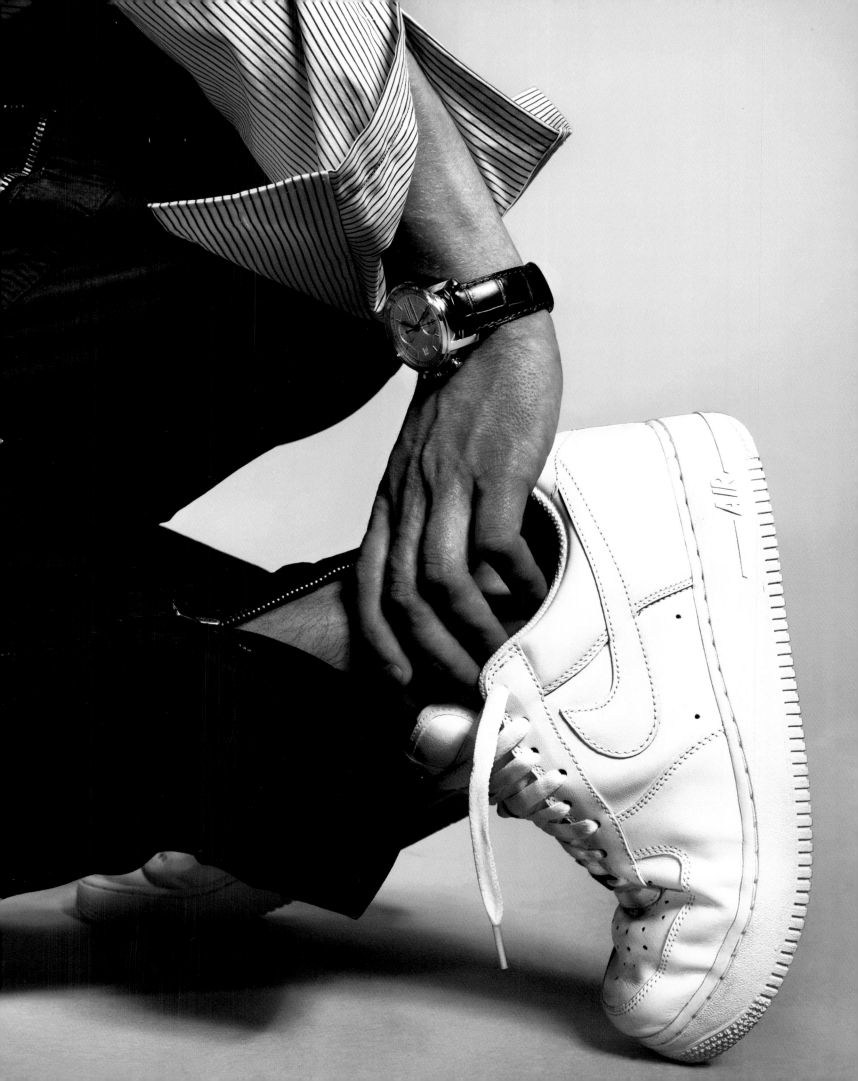

Marc Jacobs for Vans, 2006

Right Rising to prominence as a part of the Venice, California surfer/skater subculture, Vans sneakers have survived near ruin to remain the alternative sneaker today. The company has done this by cultivating its historical bona fides through sponsorship of the classic skate documentary *Dogtown and Z-Boys* and through continued association with skate culture and music through the Vans Warped Tour.

Nike, 2007

Opposite As a manifestation of popular culture, Nikes are mainly associated with serious sports and its fans. This is especially true in the case of the global phenomenon of Michael Jordan, whose Nike endorsement spawned catchphrases ("it's gotta be the shoes") and even served as a minor plot point in Spike Lee's film *Do the Right Thing*.

Converse, Sperry Top Sider, Marc Jacobs for Vans, and Vans sneakers, 2006

Following pages An array of all-American sneakers.

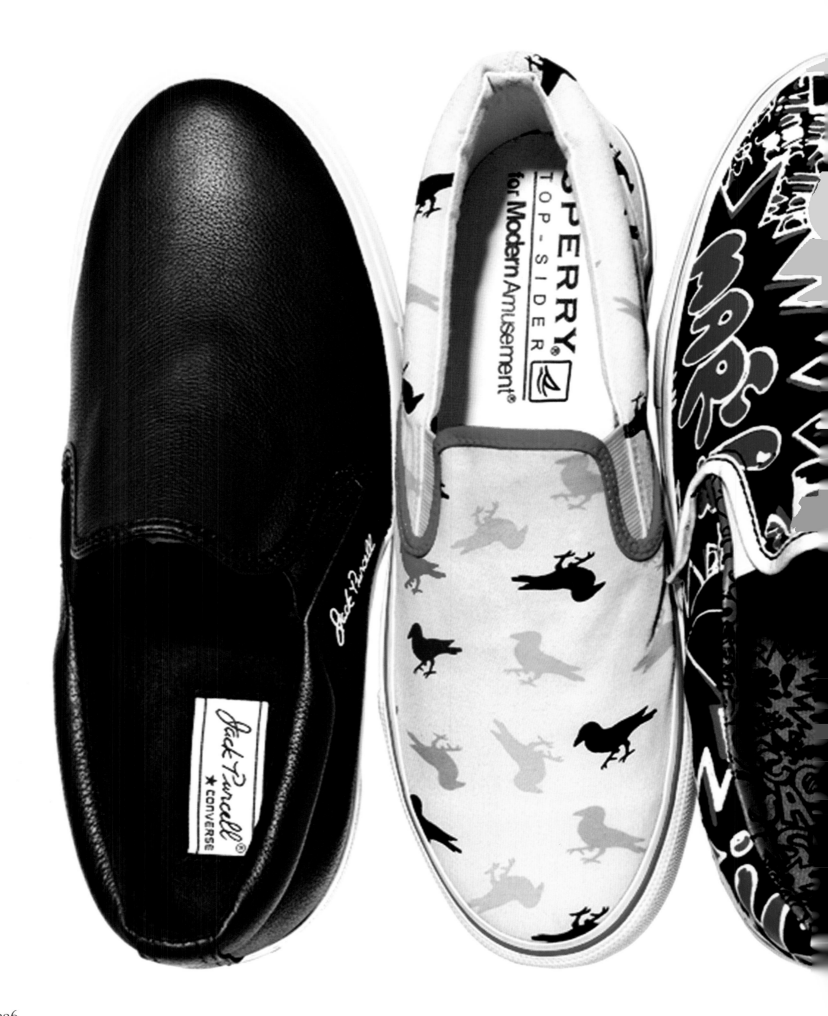

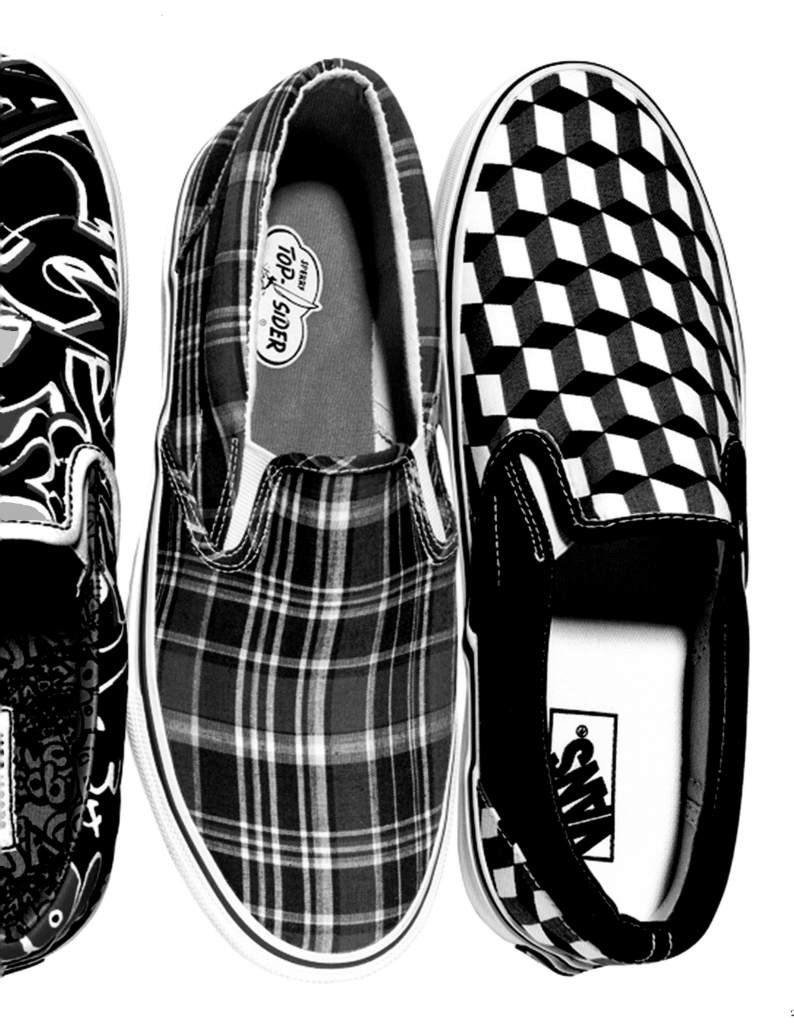

Cynthia Rowley, 2008

Above Cynthia Rowley's designs are always on the playful side of Pop.

Gunmetal, 2003

Opposite Gunnar Spaulding and George Gublo of Gunmetal bring a bit of the factory—in the form of an industrial zipper—to an undeniably elegant shoe.

Tory Burch, 2000s

Below Tory Burch's "Reva Ballerina," a revitalization of the classic ballet flat, shows her connection with unabashedly American design of the 1950s and the preppie style that has an affinity for that period.

Reva Robinson, 1960

Opposite Tory Burch's mother Reva Robinson (shown here at a hotel in Havana, Cuba) was both the inspiration and the namesake of the Reva Ballerina flat.

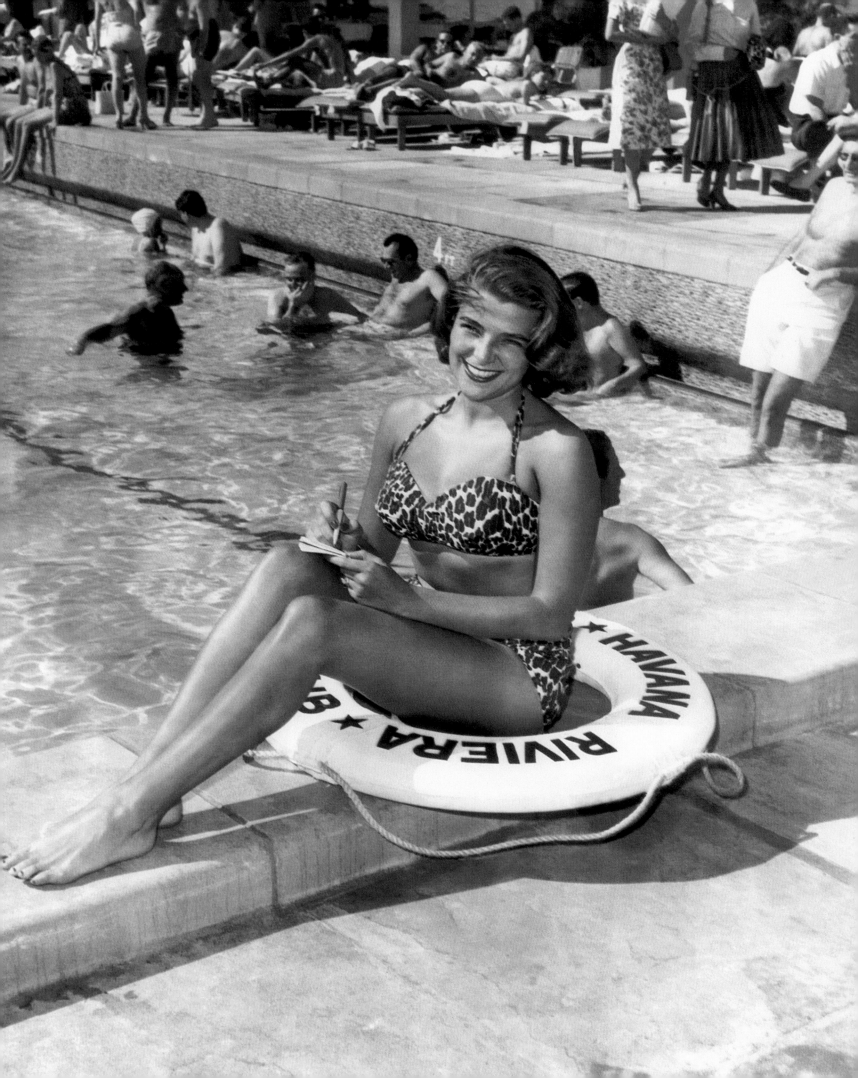

Jodie Foster in the film *Taxi Driver*, 1976

Right A very young Jodie Foster wears 1970s platform shoes in a costume designed by Ruth Morley.

Fred Astaire and Rita Hayworth in saddle shoes, 1942

Opposite Though they appeared on store shelves as children's shoes early in the century, saddle shoes were worn by adults and made famous on the feet of 1950s teenagers whose musical enthusiasms were the foundation for the pop culture of the 1950s.

New York City store window, 1970s

Following pages How it happened is a bit of a mystery, but platforms were considered dancing shoes in the 1970s and would also rise to comical heights before being abandoned as deeply uncool.

Gemma Kahng, 2008
Left The designer adjusts her feather headdress on a model, evocative of both the high-style "pop" hair of the 1960s and the punk obsession with the American Indian.

Candid image from The Cobrasnake website, 2000s
Opposite As the Internet becomes the primary medium for tracking youth culture, the speed of any style's rise and fall increases exponentially.

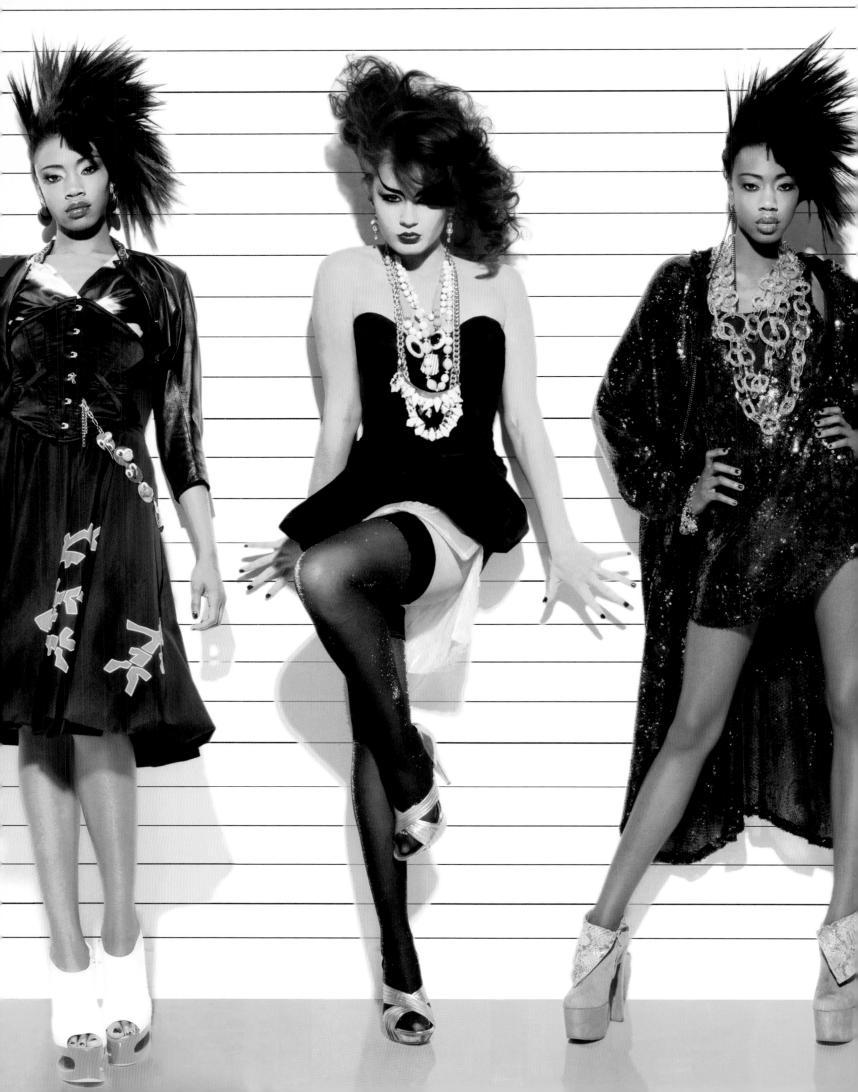

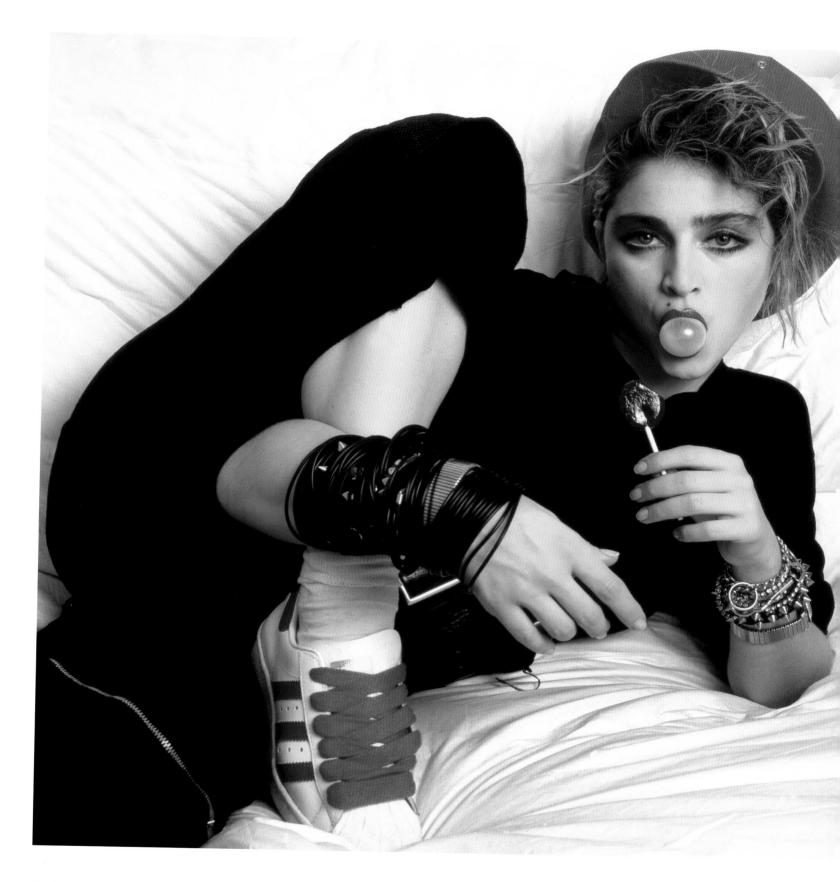

Madonna, 1982

Above Much to the horror of mothers across America, Madonna's early East Village boho chic look inspired legions of teen imitators and exposed early 1980s postpunk style to an uncomprehending nation.

Subversive Jewelry by Justin Giunta, 2008

Opposite Designer offers an arrary of his jewelry in this 1980s revival police line-up, including his Confetti Earrings, Faces Necklace, Cookie Monster, Victorian Glass Link Necklace, and Ultimate Charm Bracelet.

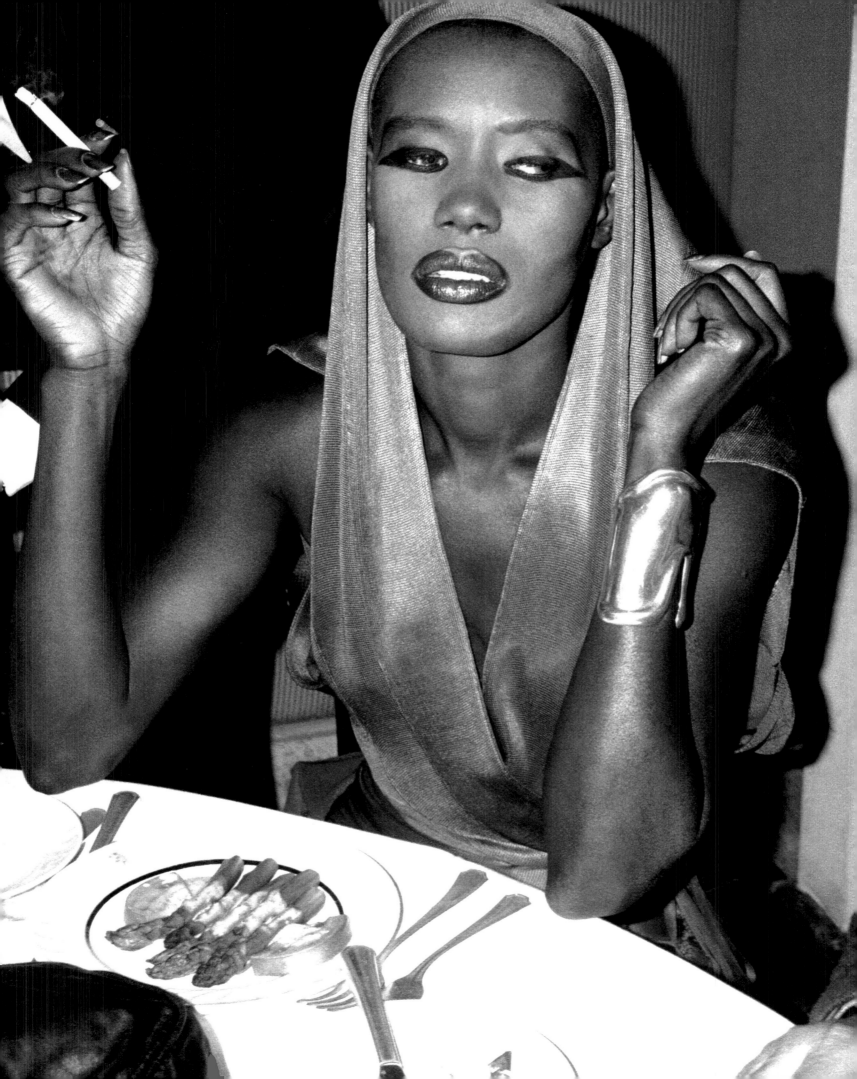

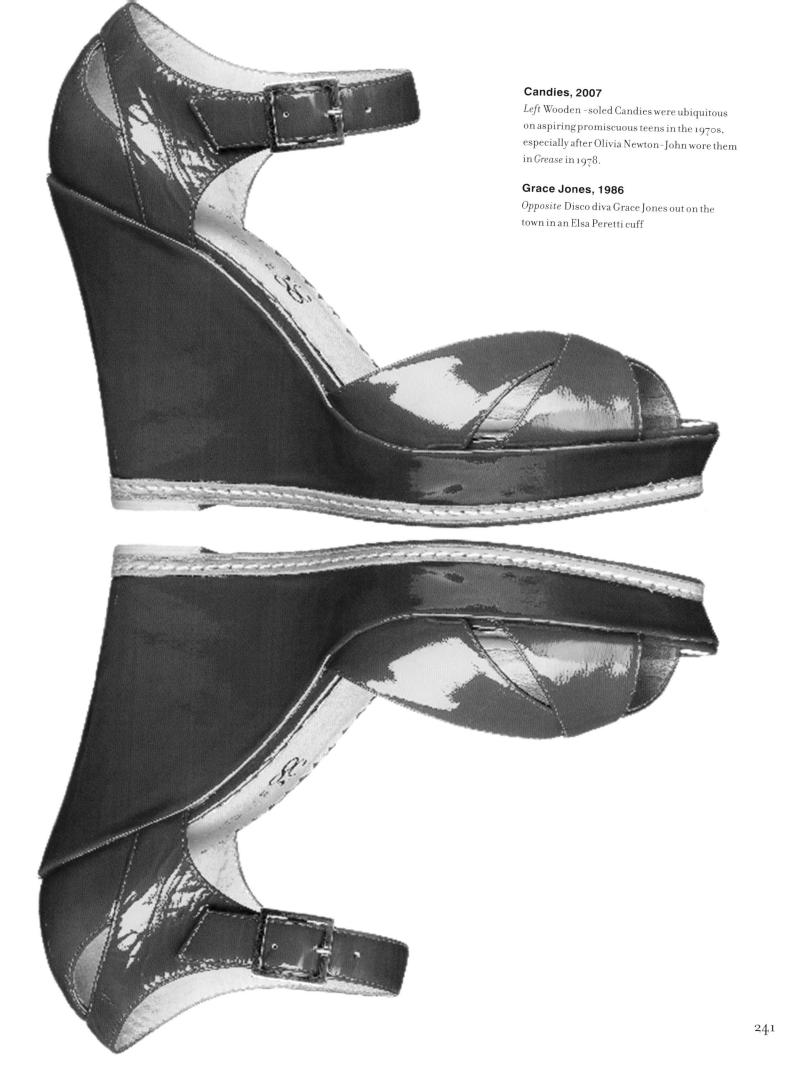

Candies, 2007

Left Wooden-soled Candies were ubiquitous on aspiring promiscuous teens in the 1970s, especially after Olivia Newton-John wore them in *Grease* in 1978.

Grace Jones, 1986

Opposite Disco diva Grace Jones out on the town in an Elsa Peretti cuff

Ten Thousand Things, 2007

Right Taking its name from a Daoist saying ("One thing begets 10,000 things"), this company embraces handmaking with all its irregularity and happy accidents.

Mimi So, 2000 and 2004

Opposite Mimi So brings a spirit of Zen to fine jewelry with her "Pyramid" ring, pave set with white diamonds in 18k white gold and her "Yin Yang" ring, pave set with black and white diamonds in 18k white gold.

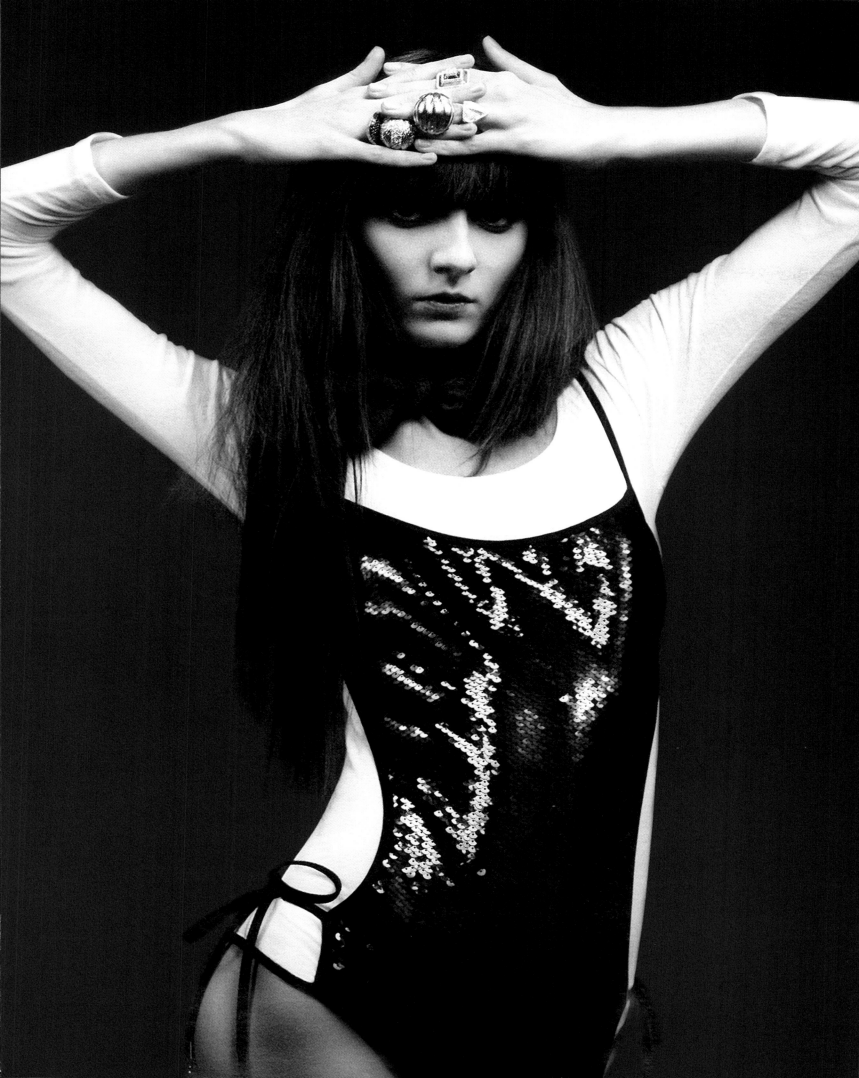

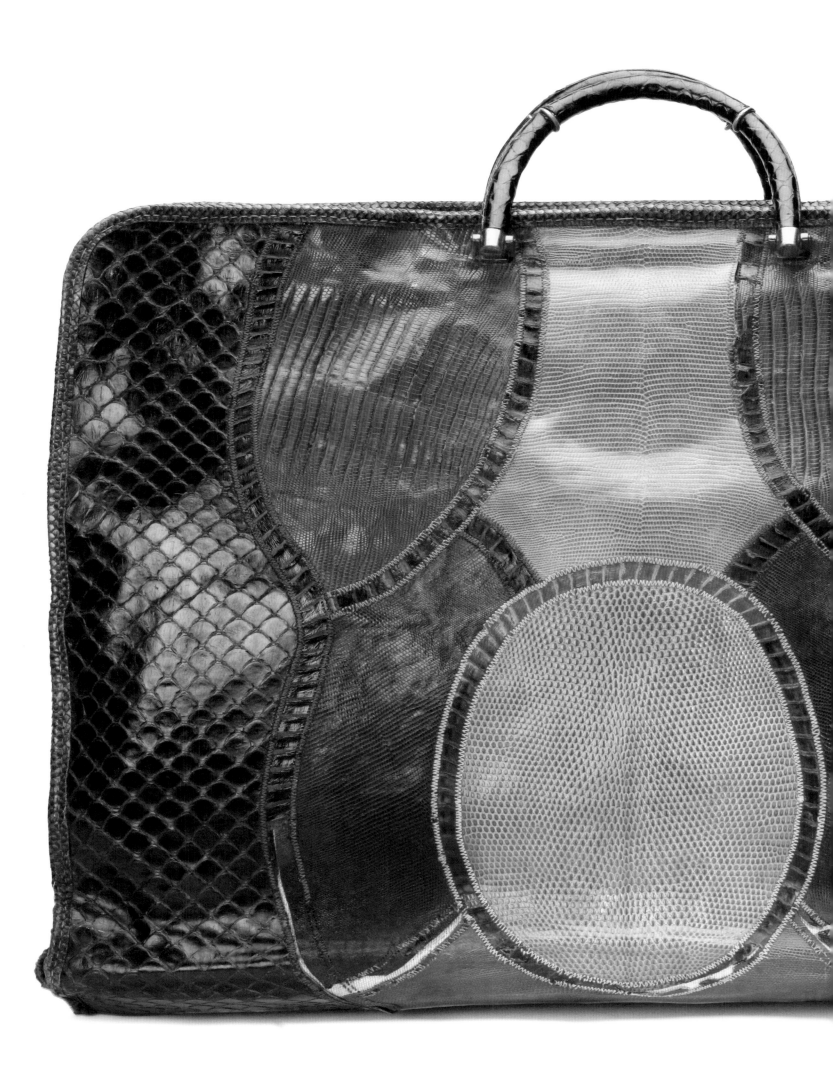

Carlos Falchi, 1974

Left Carlos Falchi's patchwork designs were born of necessity—when he first started designing, remnants were all he could afford. He ultimately made a virtue of these limitations and still seeks out discarded and neglected materials to see what he can invent next. This is a classic collage of python, lizard, alligator, and crocodile.

Carlos Falchi, 1971

Previous pages Carlos Falchi has had such great success as a designer, it seems counterintuitive to think of him as a DIY designer. Still, with a bathtub full of aniline dyes to create his colors, that is exactly how Falchi started his business before getting commissions from Miles Davis and Tina Turner for his leatherwork and finding himself, and his bags, at Henri Bendel.

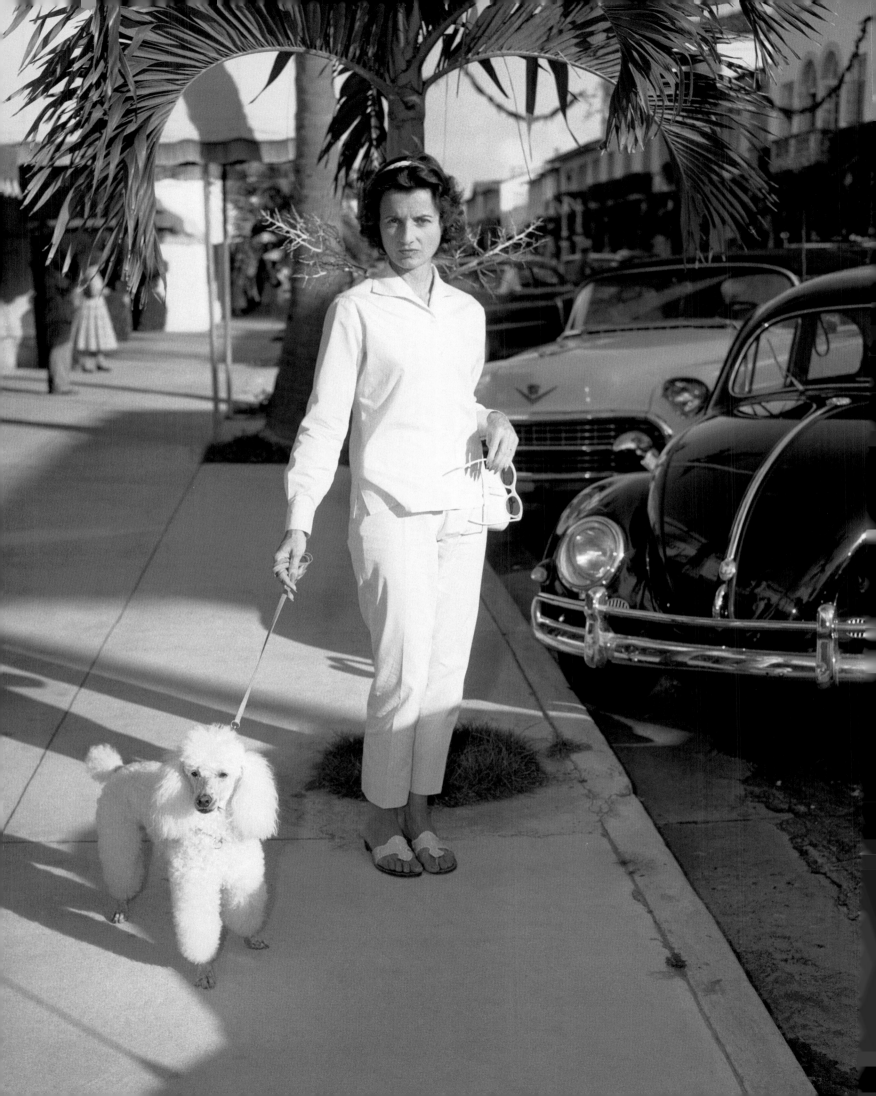

Jack Rogers, 2004

Below Contemporary Jack Rogers sandals.

Jack Rogers, early 1950s

Opposite Jack Rogers sandals rose to fame as resortwear sported by Jackie Kennedy and the socialites of Palm Beach. Here they are worn by socialite Jayne Wrightsman.

Tommy Hilfiger, Nantucket Knotworks, Brooks Brothers, American Eagle Outfitters, J.Crew

Following pages Preppie style was a pop culture phenomenon, but it was certainly not a subculture. If anything, preppie style as it emerged in the late 1970s was a reaction to the foment of garish Pop tarts, dirty hippies, and violent punks that had preceded it. Still, it had it's own version of "DIY," as seen here with the pink "cuff"—a sailor's knot bracelet.

Freddie Mercury, 1979

Above The easing of gender division introduced in hippie subculture in the 1960s was exploded into a spectacle by glam rock stars in the 1970s.

Rod Keenan, 2004

Opposite Rod Keenan's hats were first embraced by hip-hop and pop musicians, but the retro-revival they represent has since spread to hipster circles in enclaves like the Williamsburg neighborhood in Brooklyn, New York.

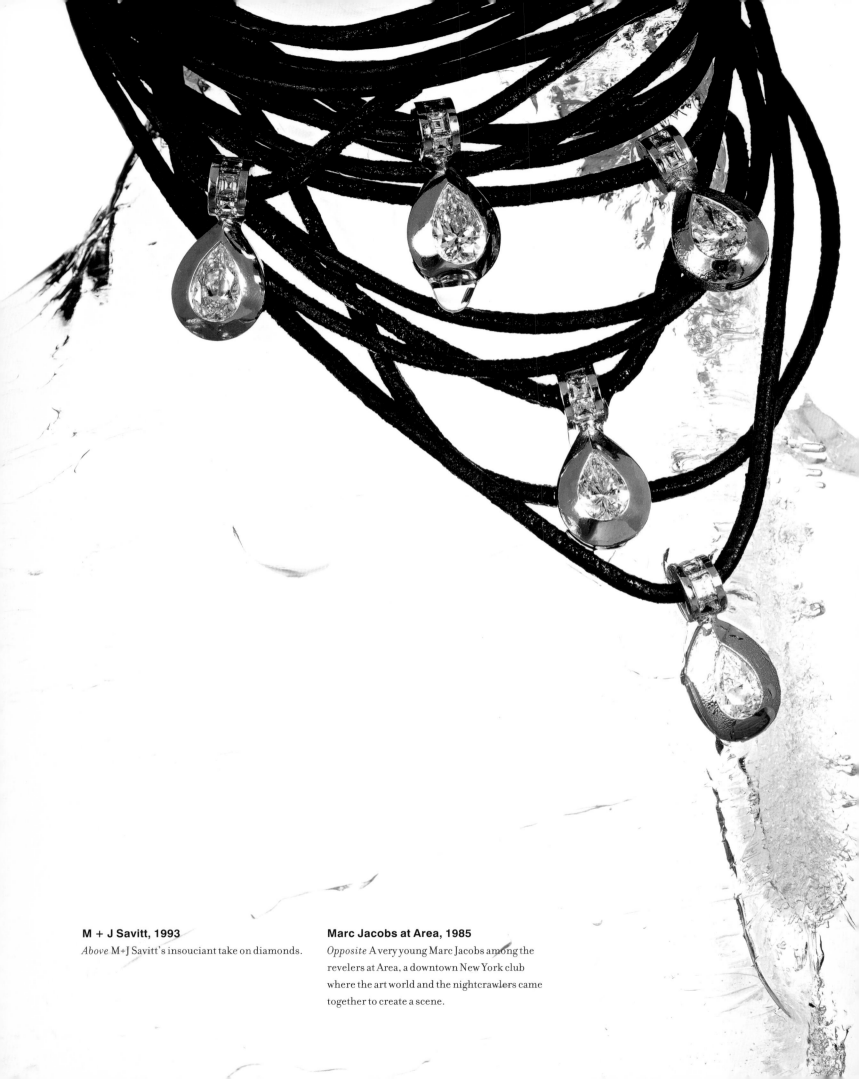

M + J Savitt, 1993
Above M+J Savitt's insouciant take on diamonds.

Marc Jacobs at Area, 1985
Opposite A very young Marc Jacobs among the revelers at Area, a downtown New York club where the art world and the nightcrawlers came together to create a scene.

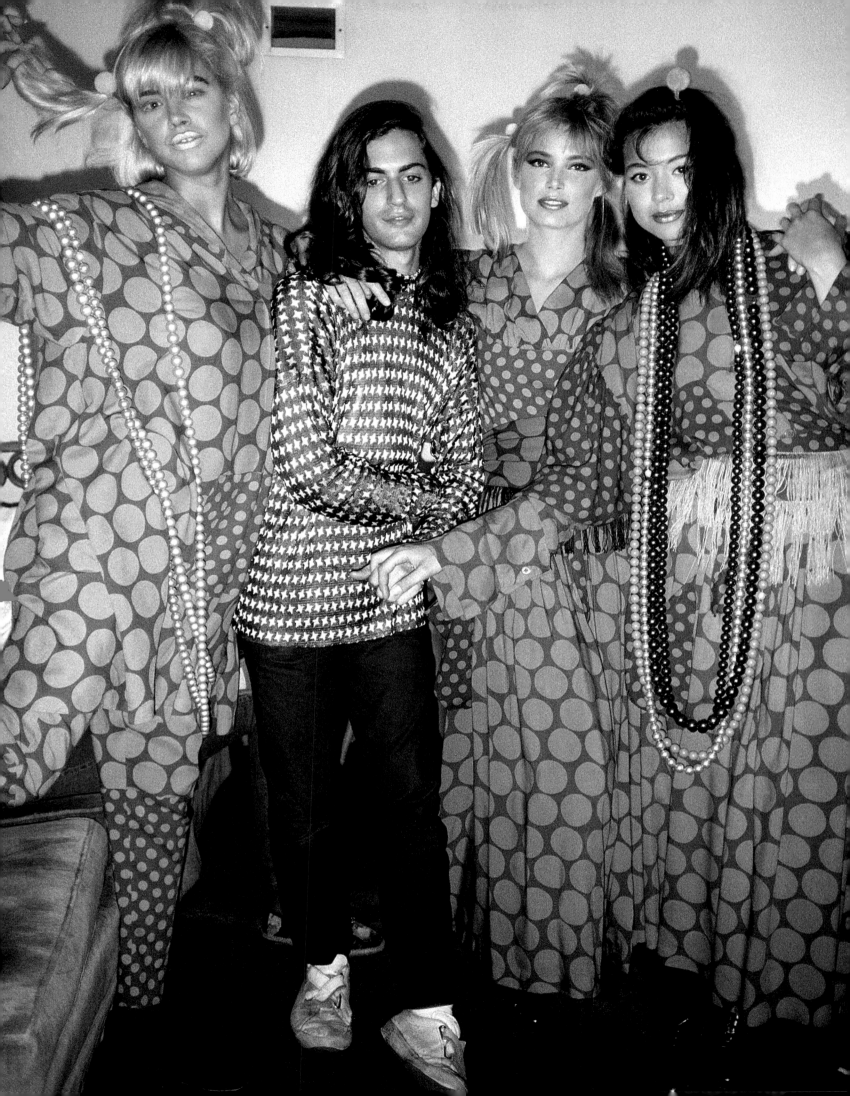

Mary Boone and Nicole Miller, 1989

Above Nicole Miller caught by Patrick McMullan, wearing one of her scarves.

Courtney Love, 1994

Opposite The riot grrl movement, an offshoot of grunge in the early 1990s, took gleeful pleasure in the malappropriation of hyperfeminine accessories. Movement standard bearers like Courtney Love took girlish items like barrettes or this pretty princess's tiara and juxtaposed them over the greasy hair and righteous disarray that characterized grunge.

Candid image from The Cobrasnake website, 2000s

Previous pages Another snapshot of clublife in the early 2000s.

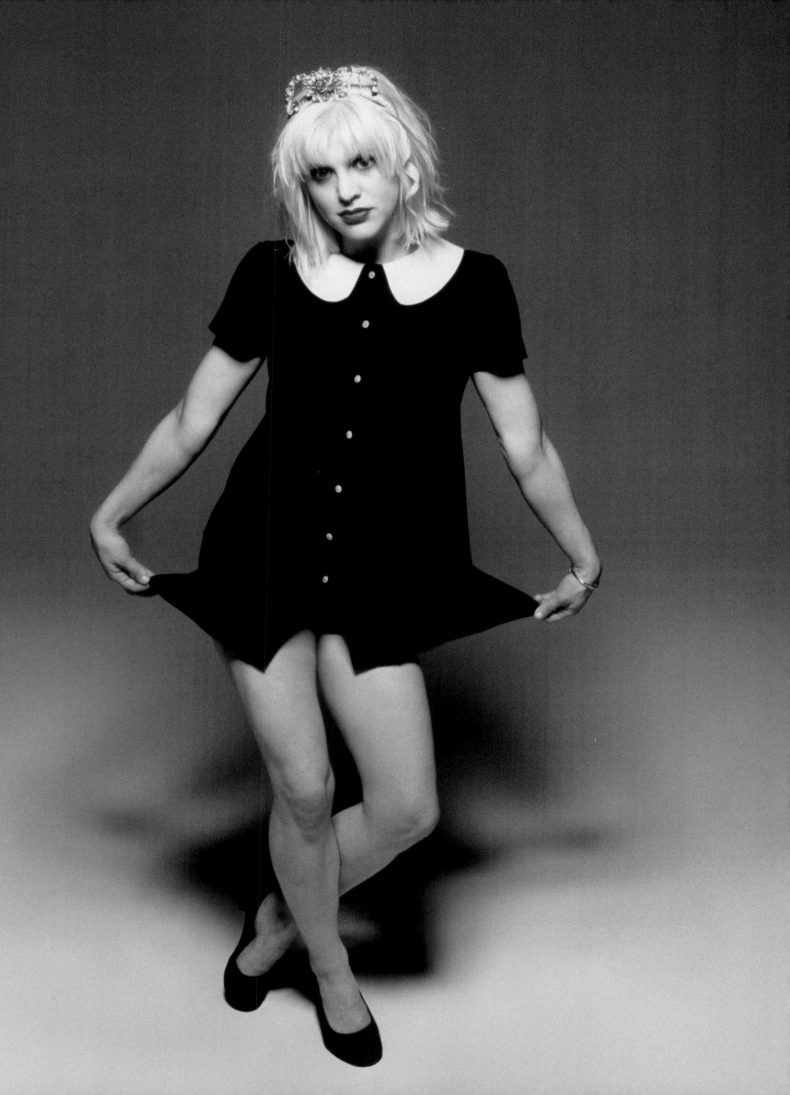

FUTURE

THE AMERICAN ACCESSORY IN THE
FUTURE

Accessory design is becoming a more demanding field in the twenty-first century, and American designers are well equipped to excel, especially in light of the technological possibilities offered to them. The demand is to address a morphing fashion culture, in which the ideals of beauty have changed, the professional aesthetic of the working woman has changed, and even travel has changed. Imagine, then, a reinvention of the simple American carpetbag: What place could this heavy, dusty soldier of the nineteenth-century carriage journey have in today's hybrid cars, super-fast trains and planes, or on the International Space Station? And how would it answer twenty-first century design demands like connectivity and sustainability? The carpetbag, already an example of the efficient use of a remnant material, would also need to be recyclable. It would need to be made of organically raised materials such as cotton or wool—or even fibers created from waste materials. And maybe the carpetbag's blanket function could be enhanced through the use of paraffin capsules in the weave, which could expand and retract to absorb or release heat as the ambient temperature required. What else could the bag do? Surely it would have a pocket for the Apple iPhone or the T-Mobile Sidekick. And maybe it would have a solar panel so that the electronic devices could always be recharged without drawing from an increasingly expensive power grid. What more? Maybe the traditional tag attached to the bag's sturdy handle would contain more than just the owner's name and address: The size of a Palm PC, it could back up information from one's PDA and read electronic tagging information embedded into objects. Imagine if the bag could inventory its own contents—a distinct possibility if its contents have an identification chip. (And that chip could be used to con-firm the authenticity of designer clothes. Is that a real Marc Jacobs? Your carpetbag would know.)

All the technology and components for the twenty-first-century carpetbag already exist (they are reposited in the materials resource libraries of worldwide companies such as Earth Pledge and Material ConneXion), and some of the concepts have been knocking around the literary world of science fiction since the nineteenth century. Even the future has a past, and that too is rooted in the ethos of American innovation. The science fiction genre was at first the purview of such European authors as Jules Verne and H. G. Wells, but it was often American inventors, such as Orville and

Opposite **Woven fiber optics, 2000s** Not for the shrinking violet: a new weaving process allows plastic fiber optics to be woven into textiles that emit light from an LED source. The lights can be set to change color. *Previous page* **Anne Hong, 2006** These Plexiglas bracelets are also a means of secret communication. They are designed to wirelessly send coded light patterns between two wearers up to 600 feet apart.

Wilbur Wright, who brought their fantasies to life. The shock and awe of late-nineteenth and early-twentieth-century industrialization first came to bear on fashion in the hands of the Italian Futurist movement. This group of artists wrote manifestos on men's and women's fashion and designed suits and hats inspired by their vision of the dynamic world of the machine and the metropolis, particularly as expressed through the use of overpowering color. They were, for the most part, ignored by the world of high fashion and contented themselves with sketches and theatrical designs of their clothing concepts. Back in America, Futurists took the form of industrial designers like Raymond Loewy, also inspired by the machine, who created a clean, streamlined aesthetic that was applied to everything from teapots to gas stations. They defined the look of modernity into the 1950s and saw it furthered in the hands of designers and architects such as Charles and Ray Eames and Eero Saarinen. These self-consciously Futurist concepts were finally realized in the American accessory during the Pop Art era of the 1960s by the fashion designer Rudi Gernreich, who streamlined his models with helmets and leggings in acid-bright polyesters, sometimes with transparent plastic panels.

The look of the space-age 1960s has persisted in fashion as a visual shorthand for the faith in the machine that it embodies. It can be identified as an inspiration whenever shiny fabrics, metal mesh, waxed leathers, latex, unapologetic plastics, and random robotics appear in store display cases. Though dismissed by some as a form of retro or simply "B-movie Futurism," designers mining this vein of inspiration can introduce cutting-edge materials into their work. Metallic and luminous fabrics are of particular significance here, and the design-consultant company Material ConneXion has sourced a number of them, including a nylon that has the appearance of wire mesh; textiles with metal yarns of copper or steel interwoven; a coating process that can "electroplate" textiles with metal oxides; woven and knitted fabrics with iridescent polyester film integrated into them; reflective textiles made from recycled cassette tapes; self-luminous fibers that can be knitted into three-dimensional forms using a CAD file; and fabrics interwoven with fiber optics. Supermodern materials have also found their way into jewelry, most recently as a part of Neiman Marcus's one-hundredth anniversary celebration, in 2007. Organized by Ignaz Gorischek, a vice president of the department store, an exhibition entitled "The Next 100 Years" connected designers John Hardy, Stephen Dweck, Ippolita, Judith Ripka, Evan Yurman, Jose and Maria Barrera, and Dominique Cohen with the Material ConneXion library of materials. The result was reimagined fashion jewelry using such materials as wood veneer, polypropylene beads, and tiles that incorporated fiber-optics channels.

This look of the future is conceived not only in the engineering laboratory but also in the same Hollywood dream factory that articulated the iconography of glamour in the twentieth century. As

Opposite **Moon glass** While Guido Mocafico's pearls on page 266 suggest the future, these glass spherules, obtained during the Apollo missions of the 1970s, seem primitively wrought—the components of a caveman's bead necklace.

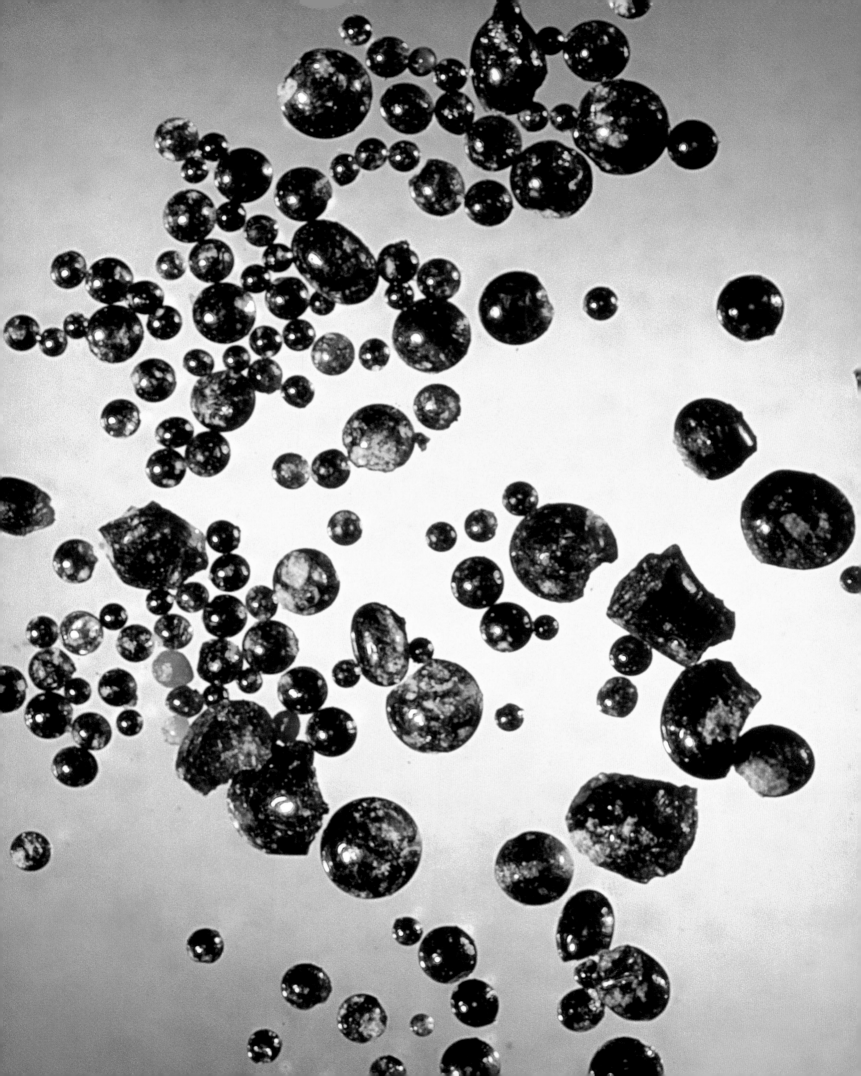

old-style Hollywood elegance recedes into period epics and the perfectly styled screen queens are subsumed by the dominance of the casually attired girl-next-door, the science-fiction fantasy film delivers a spectacle that magnetizes the global audience much as the studio stars did in the early decades of the twentieth century. Within this spectacle are the concepts and blueprints of what the American accessory could be. Some of the fantasies have already been realized: Personal computers and flip-up communicators used to be strictly the subject of science fiction, and that world, as envisioned by Hollywood, certainly inspired the product designers who transformed the global economy with their now indispensable digital objects of desire.

Of course, the immaterial material that is also transforming American accessory design is digitization itself—the revolution of the PC and the ultimate connectivity of the World Wide Web. It has wrought changes both large and small in the world of fashion. Some are mere transpositions: The traditional paper mail-order catalog is now scanned and posted to the Web to create the e-commerce industry, while the fashion faithful key their opinions into laptops and thus globalize their fashion gossip in the form of the fashion blog. But this cacophony feeds off major fashion-information Web portals like Style.com, which has thoroughly transformed the consumption of fashion with the overwhelming volume of images posted. Throughout most of the twentieth century, the runway show was an exclusive affair. The immediate descriptions were written ones, with maybe a few photos of notable pieces. The rest would be culled and curated by buyers and fashion editors to be seen months later, if at all. Today, every piece can be seen hours, if not minutes, after it first appears on the runway on Style.com, complete with a review of the show. The ultimate legacy of this digital revolution has been to accelerate the already rapid cycle of fashion, a process observed most recently in the rapid turnover of "It" bags in the early 2000s.

The future of the American accessory is also being impacted by the necessity of sustainability in production. This form of futurism has its roots in the 1960s counterculture, especially as that movement gained its back-to-nature impetus in the 1970s. That set of ideals was later augmented by the postapocalyptic vision of the future conceived in the punk movement, which found materials and inspiration in urban "ruins," as exemplified by the designs at countless "radical craft" fairs in American cities, where homemakers hawk their modern reticules made from things like bicycle inner tubes and other trashy treasures found in urban rag piles. Originally dismissed as a minor moral virtue embraced by the 1960s counterculture, the idea of ecologically intelligent design has gained increasing relevance, in part because many corporations have realized it may be cheaper to save the world than to destroy it.

The new resonance of sustainability as a sound business practice and the attendant idea that making and consuming can be transformed into a regenerative process has already provided a

Pearls Photographer Guido Mocafico captures the otherwordly possibilities of the most conservative and classic of gems, the pearl.

host of new materials for accessory designers. These are tracked by the nonprofit organization Material ConneXion, founded in 1997 by George M. Beylerian, which has committed to providing material assessment, certification, and sustainable solutions workshops for designers. Some new techniques that have emerged include dyeing materials with nontoxic plant dyes through an ionization process; the rediscovery and use of natural dyes such as indigo; the cultivation of heirloom strains of cotton that already contain strong color and do not require dyestuffs; and the imbuement of fibers with therapeutic properties, as in vitamin-enriched textiles and antimicrobial fabric made from bamboo. Material ConneXion also recommends products for the fast-developing market for organic hemp, cotton, and wool and promotes new sustainables like corn-based textiles and repurposed "waste" materials like the wool-like fabric made from chicken feathers. An expanded palette of leather is even being developed from the sea: Fish leather made from perch, tilapia, salmon, stingray, or other species is already being used in shoes and handbags. These small skins have unique and diverse textures and their collection can be combined with the practice of removing nonindigenous fish from bodies of water that have been invaded through human error. Even plastics, a staple material in American accessories since the late-nineteenth century, are being reimagined both as biodegradable (as in those made from abundant natural material, like switchgrass and corn) and as recycled materials, which can be compression molded to take any shape. This is the future of the American accessory—to make sustainability as much a part of design as aesthetics or functionalism.

Noble intentions and wonkish innovations aside, the ultimate role of the American accessory is as a "LUXURY." For luxury is always the true goal of American innovation. Once it was as simple as right and left shoes. What forms luxury will take in the future remains for the next generation of accessory designers to bring to life. An array of new materials suggests endless possibilities. We could even leave the heavy, warhorse carpetbag behind in favor of something lighter, fresher, more efficient—a flying carpet perhaps?

Chip A close up on one of the major players in the future of fashion: computer technology.

Women have always loved jewelry. . . .
The caveman gave the cavewoman
a shell with a hole in it strung on the
back hair of an elephant or something,
and that was the first necklace.

If a girl can't wear the diamonds; she'll wear the rhinestones.

Accessories are the way of adding color . . . I
love the idea, for evening, of bright-colored
satin small handbags. Poison green. Wear it
with a black dress.

The spectator pump: completely American.
The stacked leather heel, which you don't see very
much anymore.

If you look at the thirties films, all those diamond bracelets, which Diana Vreeland used to call service stripes for very good reason. It wasn't always a rich married lady who had those diamond bracelets. . . . The jewels were very glamorous, very glamorous.

A woman doesn't wear earrings to keep her ears warm.

"

Kenneth Jay Lane

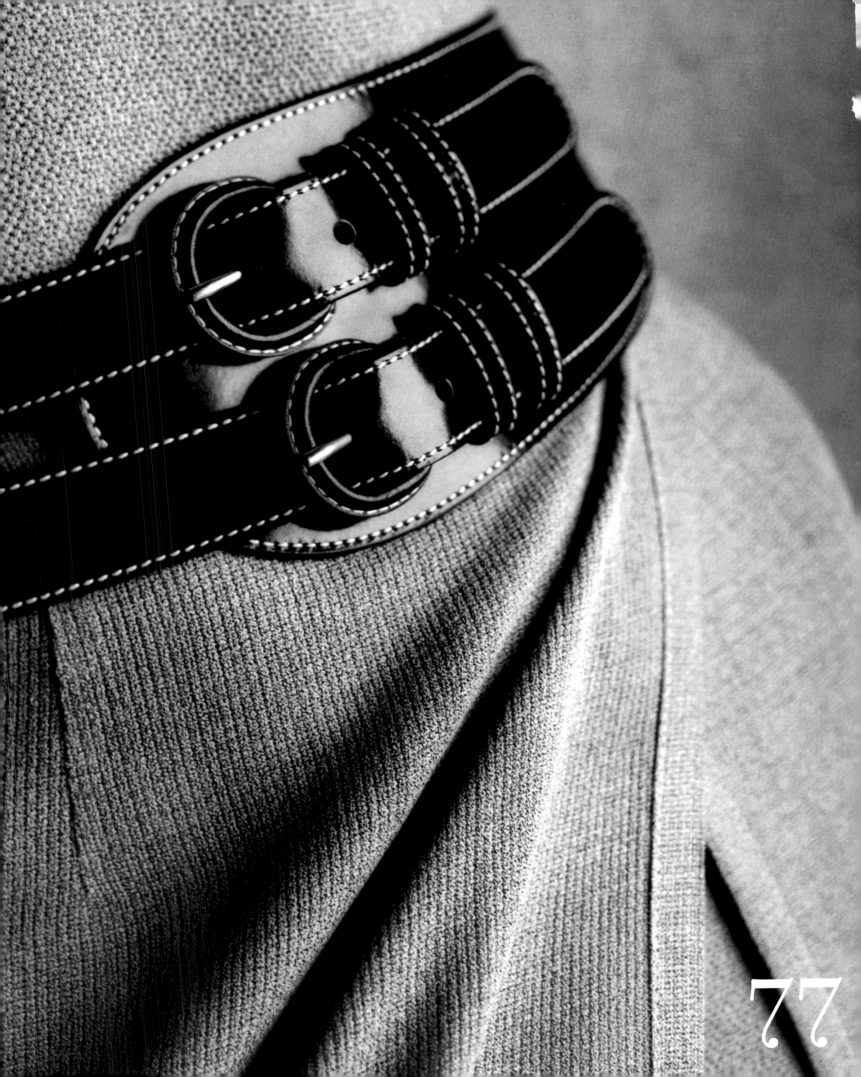

77

| | | | | | | |
|---|---|---|---|---|---|
| 1 | Joseph Abboud | 55 | Meg Cohen | 108 | Cindy Greene |
| 2 | Amsale Aberra | 56 | Peter Cohen | 109 | Henry Grethel |
| 3 | Reem Acra | 57 | Anne Cole | 110 | George Gublo |
| 4 | Carey Adina | 58 | Kenneth Cole | | |
| 5 | Adolfo | 59 | Liz Collins | 111 | Everett Hall |
| 6 | Simon Alcantara | 60 | Michael Colovos | 112 | Jeff Halmos |
| 7 | Linda Allard | 61 | Nicole Colovos | 113 | Douglas Hannant |
| 8 | Jeanne Allen | 62 | Sean Combs | 114 | Cathy Hardwick |
| 9 | Carolina Amato | 63 | Martin Cooper | 115 | John Hardy |
| 10 | John Anthony | 64 | Maria Cornejo | 116 | Karen Harman |
| 11 | Nak Armstrong | 65 | Esteban Cortazar | 117 | Dean Harris |
| 12 | Brian Atwood | 66 | Francisco Costa | 118 | Johnson Hartig |
| 13 | Max Azria | 67 | Victor Costa | 119 | Sylvia Heisel |
| 14 | Yigal Azrouel | 68 | Jeffrey Costello | 120 | Joan Helpern |
| | | 69 | Erica Courtney | 121 | Stan Herman |
| 15 | Mark Badgley | 70 | James Coviello | 123 | Lazaro Hernandez |
| 16 | Michael Ball | 71 | Steven Cox | 124 | Carolina Herrera |
| 17 | Jeffrey Banks | 72 | Keren Craig | 125 | Tommy Hilfiger |
| 18 | Leigh Bantivoglio | | | 126 | Carole Hochman |
| 19 | Jhane Barnes | 73 | Sandy Dalal | 127 | Janet Howard |
| 20 | John Bartlett | 74 | Robert Danes | | |
| 21 | Victoria Bartlett | 75 | Oscar de la Renta | 128 | Marc Jacobs |
| 22 | Dennis Basso | 76 | Donald Deal | 129 | Henry Jacobson |
| 23 | Bradley Bayou | 77 | Louis Dell'Olio | 130 | Eric Javits, Jr. |
| 24 | Richard Bengtsson | 78 | Pamela Dennis | 131 | Lisa Jenks |
| 25 | Dianne Benson | 79 | Kathryn Dianos | 132 | Betsey Johnson |
| 26 | Magda Berliner | 80 | David Dion | 133 | Alexander Julian |
| 27 | Alexis Bittar | 81 | Keanan Duffty | | |
| 28 | Sherrie Bloom | 82 | Randolph Duke | 134 | Gemma Kahng |
| 29 | Kenneth Bonavitacola | 83 | Henry Dunay | 135 | Norma Kamali |
| 30 | Sully Bonnelly | 84 | Stephen Dweck | 136 | Donna Karan |
| 31 | Monica Botkier | | | 137 | Lance Karesh |
| 32 | Marc Bouwer | 85 | Marc Ecko | 138 | Kasper |
| 33 | Bryan Bradley | 86 | Libby Edelman | 139 | Ken Kaufman |
| 34 | Barry Bricken | 87 | Sam Edelman | 140 | Rod Keenan |
| 35 | Thom Browne | 88 | Mark Eisen | 141 | Pat Kerr |
| 36 | Dana Buchman | 89 | Melinda Eng | 142 | Eugenia Kim |
| 37 | Tory Burch | | | 143 | Calvin Klein |
| 38 | Stephen Burrows | 90 | Steve Fabrikant | 144 | Michael Kors |
| | | 91 | Carlos Falchi | 145 | Reed Krakoff |
| 39 | Anthony Camargo | 92 | Pina Ferlisi | 146 | Regina Kravitz |
| 40 | Liliana Casabal | 93 | Andrew Fezza | 147 | Devi Kroell |
| 41 | Edmundo Castillo | 94 | Patricia Ficalora | 148 | Blake Kuwahara |
| 42 | Salvatore Cesarani | 95 | Eileen Fisher | | |
| 43 | Richard Chai | 96 | Tom Ford | 149 | Steven Lagos |
| 44 | Julie Chaiken | 97 | Istvan Francer | 150 | Derek Lam |
| 45 | Amy Chan | 98 | Isaac Franco | 151 | Richard Lambertson |
| 46 | Charles Chang-Lima | 99 | R. Scott French | 152 | Adrienne Landau |
| 47 | Natalie Chanin | 100 | Carolee Friedlander | 153 | Liz Lange |
| 48 | Georgina Chapman | 101 | James Galanos | 154 | Ralph Lauren |
| 49 | Ron Chereskin | 102 | Nancy Geist | 155 | Judith Leiber |
| 50 | Wenlan Chia | 103 | Geri Gerard | 156 | Larry Leight |
| 51 | David Chu | 104 | Mossimo Giannulli | 157 | Nanette Lepore |
| 52 | Eva Chun | 105 | Justin Giunta | 158 | Michael Leva |
| 53 | Doo-Ri Chung | 106 | Nicholas Graham | 159 | Monique Lhuillier |
| 54 | Carol Cohen | 107 | Marc Grant | 160 | Phillip Lim |

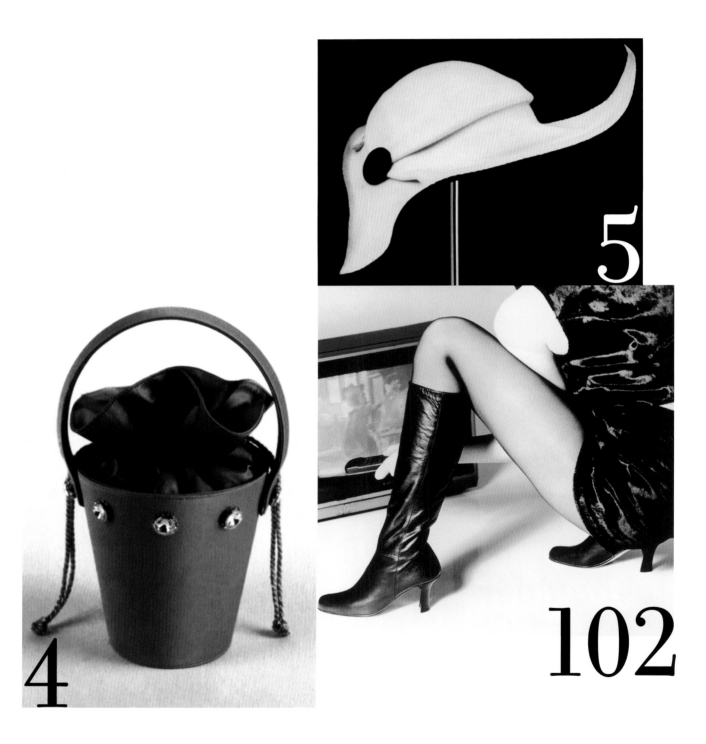

5

102

4

| | | | | | | |
|---|---|---|---|---|---|
| 161 | Adam Lippes | 214 | Linda Platt | 268 | Laurie Stark |
| 162 | Elizabeth Locke | 215 | Tom Platt | 269 | Richard Stark |
| 163 | Tina Lutz | 216 | Alexandre Plokhov | 270 | Cynthia Steffe |
| 164 | Bob Mackie | 217 | Laura Poretzky | 271 | Steven Stolman |
| 165 | Jeff Mahshie | 218 | Zac Posen | 272 | Jay Strongwater |
| 166 | Catherine Malandrino | 219 | Lilly Pulitzer | 273 | Jill Stuart |
| 167 | Maurice Malone | 220 | James Purcell | 274 | Karen Suen-Cooper |
| 168 | Colette Malouf | | | 275 | Anna Sui |
| 169 | Isaac Manevitz | 221 | Jessie Randall | | |
| 170 | Robert Marc | 222 | Tracy Reese | 276 | Robert Tagliapietra |
| 171 | Mary Jane Marcasiano | 223 | William Reid | 277 | Elie Tahari |
| 172 | Lana Marks | 224 | Mary Ann Restivo | 278 | Vivienne Tam |
| 173 | Jessica McClintock | 225 | Kenneth Richard | 279 | Rebecca Taylor |
| 174 | Jack McCollough | 226 | Judith Ripka | 280 | Yeohlee Teng |
| 175 | Mary McFadden | 227 | Patrick Robinson | 281 | Gordon Thompson |
| 176 | Mark McNairy | 228 | David Rodriguez | 282 | Monika Tilley |
| 177 | David Meister | 229 | Eddie Rodriguez | 283 | Zang Toi |
| 178 | Andreas Melbostad | 230 | Narciso Rodriguez | 284 | Isabel Toledo |
| 179 | Gilles Mendel | 231 | Jackie Rogers | 285 | Rafe Totengco |
| 180 | Gene Meyer | 232 | Alice Roi | 286 | John Truex |
| 181 | Carlos Miele | 233 | Lela Rose | 287 | Trina Turk |
| 182 | Nicole Miller | 234 | Christian Roth | 288 | Mish Tworkowski |
| 183 | James Mischka | 235 | Cynthia Rowley | | |
| 184 | Richard Mishaan | 236 | Rachel Roy | 289 | Patricia Underwood |
| 185 | Isaac Mizrahi | 237 | Ralph Rucci | 290 | Kay Unger |
| 186 | Paul Morelli | 238 | Kelly Ryan | | |
| 187 | Robert Lee Morris | | | 291 | Carmen Marc Valvo |
| 188 | Miranda Morrison | 239 | Gloria Sachs | 292 | Koos van den Akker |
| 189 | Rebecca Moses | 240 | Jamie Sadock | 293 | Nicholas Varney |
| 190 | Kathy Moskal | 241 | Selima Salaun | 294 | John Varvatos |
| 191 | Kate Mulleavy | 242 | Angel Sanchez | 295 | Joan Vass |
| 192 | Laura Mulleavy | 243 | Behnaz Sarafpour | 296 | Adrienne Vittadini |
| 193 | Matt Murphy | 244 | Janis Savitt | 297 | Michael Vollbracht |
| | | 245 | Arnold Scaasi | 298 | Diane von Furstenberg |
| 194 | Gela-Nash Taylor | 246 | Jordan Schlanger | 299 | Patricia von Musulin |
| 195 | Josie Natori | 247 | Ricky Serbin | | |
| 196 | Charlotte Neuville | 248 | Christopher Serluco | 300 | Marcus Wainwright |
| 197 | David Neville | 249 | Ronaldus Shamask | 301 | Tom Walko |
| 198 | Rozae Nichols | 250 | George Sharp | 302 | Vera Wang |
| 199 | Lars Nilsson | 251 | Marcia Sherrill | 303 | Cathy Waterman |
| 200 | Roland Nivelais | 252 | Sam Shipley | 304 | Heidi Weisel |
| 201 | Vanessa Noel | 253 | Kari Sigerson | 305 | Stuart Weitzman |
| 202 | Charles Nolan | 254 | Daniel Silver | 306 | Carla Westcott |
| 203 | Maggie Norris | 255 | Howard Silver | 307 | John Whitledge |
| 204 | Peter Noviello | 256 | Michael Simon | 308 | Edward Wilkerson |
| | | 257 | George Simonton | 309 | Gary Wolkowitz |
| 205 | Sigrid Olsen | 258 | Paul Sinclaire | 310 | Angela Wright |
| 206 | Luca Orlandi | 259 | Pamela Skaist-Levy | 311 | Sharon Wright |
| 207 | Rick Owens | 260 | Michelle Smith | | |
| | | 261 | Maria Snyder | 312 | Gerard Yosca |
| 208 | Marcia Patmos | 262 | Mimi So | 313 | Jean Yu |
| 209 | Edward Pavlick | 263 | Peter Som | 314 | David Yurman |
| 210 | Christina Perrin | 264 | Kate Spade | | |
| 211 | James Perse | 265 | Gunnar Spaulding | 315 | Gabriella Zanzani |
| 212 | Robin Piccone | 266 | Peter Speliopoulos | 316 | Katrin Zimmermann |
| 213 | Mary Ping | 267 | Michael Spirito | 317 | Italo Zucchelli |

In July 2008 – after the completion of this book – the CFDA admitted the following twenty-eight new members: Ron Anderson, Michael Bastian, Andrew Buckler, Sophie Buhai, Rachel Comey, Philip Crangi, Erica Davies, Holly Dunlap, Cheryl Finnegan, Dana Foley, Jenni Kayne, Naeem Khan, Eunice Lee, Fiona Kotur Marin, Lisa Mayock, Malia Mills, Sandra Müller, Thakoon Panichgul, David Rees, Robin Renzi, Brian Reyes, Loree Rodkin, Kara Ross, Amy Smilovic, Anna Corinna Springer, Sue Stemp, Scott Sternberg, Araks Yeramyan.

16

21

64

224

35

272

54

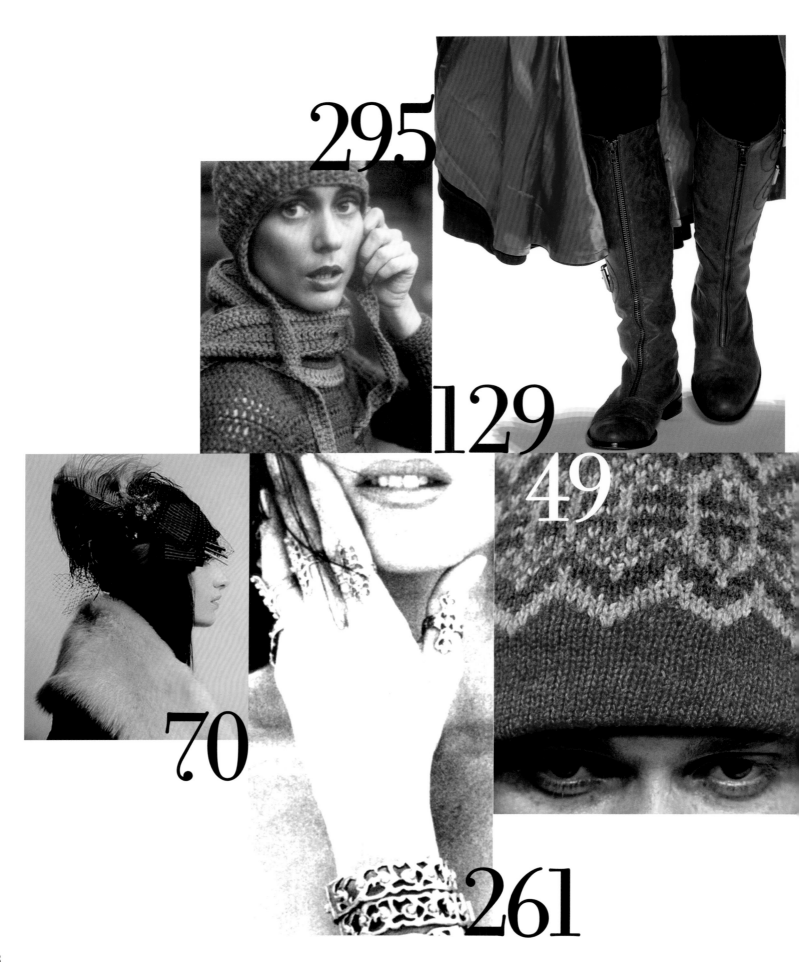

295

129

49

70

261

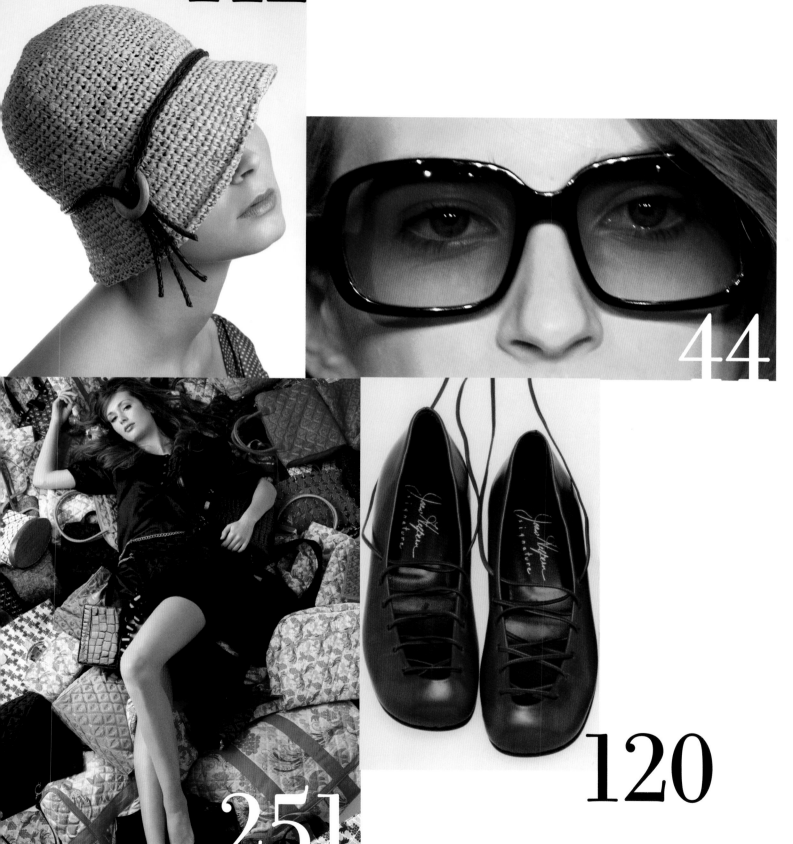

142

44

251

120

246

293

260

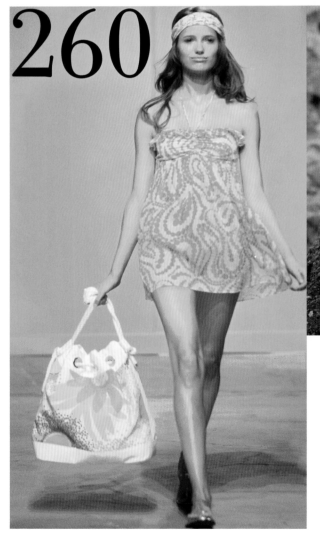

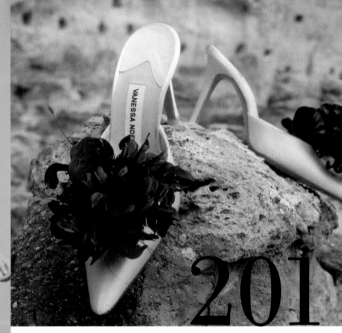

201

280

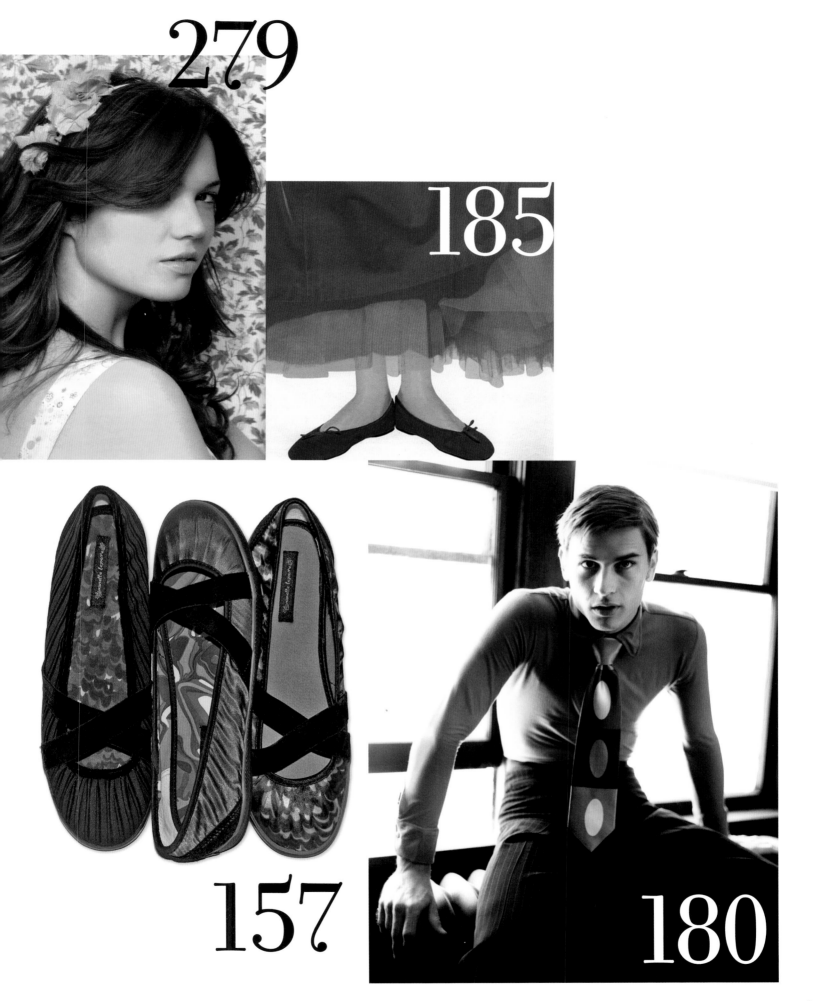

279

185

157

180

CFDA Fashion Award Winners 1981/2008

2008

Womenswear Designer of the Year *Francisco Costa for Calvin Klein*
Menswear Designer of the Year *Tom Ford*
Accessory Designer of the Year *Tory Burch*
Swarovski Award for Womenswear *Kate & Laura Mulleavy for Rodarte*
Swarovski Award for Menswear *Scott Sternberg for Band of Outsiders*
Swarovski Award for Accessory Design *Philip Crangi*
Eugenia Sheppard Award *Candy Pratts Price*
International Award *Dries Van Noten*
Geoffrey Beene Lifetime Achievement Award *Carolina Herrera*
Board of Directors' Special Tribute *Mayor Michael R. Bloomberg*

2007

Womenswear Designer of the Year *Oscar de la Renta and*
Lazaro Hernandez & Jack McCollough for Proenza Schouler (tie)
Menswear Designer of the Year *Ralph Lauren*
Accessory Designer of the Year *Derek Lam*
Swarovski Award for Womenswear *Phillip Lim*
Swarovski Award for Menswear *David Neville &*
Marcus Wainwright for Rag & Bone
Swarovski Award for Accessory Design *Jessie Randall for*
Loeffler Randall
Eugenia Sheppard Award *Robin Givhan*
Fashion Editor *Washington Post*
International Award *Pierre Cardin*
Geoffrey Beene Lifetime Achievement Award *Robert Lee Morris*
Eleanor Lambert Award *Patrick Demarchelier*
Board of Directors' Special Tribute *Bono & Ali Hewson*
American Fashion Legend Award *Ralph Lauren*

2006

Womenswear Designer of the Year *Francisco Costa for Calvin Klein*
Menswear Designer of the Year *Thom Browne*
Accessory Designer of the Year *Tom Binns*
Swarovski's Perry Ellis Award for Womenswear *Doo-Ri Chung*
Swarovski's Perry Ellis Award for Menswear *Jeff Halmos,*
Josia Lamberto-Egan, Sam Shipley & John Whitledge for Trovata
Swarovski's Perry Ellis Award for Accessory Design *Devi Kroell*
Eugenia Sheppard Award *Bruce Weber*
International Award *Olivier Theyskens*
Lifetime Achievement Award *Stan Herman*
Eleanor Lambert Award *Joan Kaner*
Board of Directors' Special Tribute *Stephen Burrows*

2005

Womenswear Designer of the Year *Vera Wang*
Menswear Designer of the Year *John Varvatos*
Accessory Designer of the Year *Marc Jacobs for Marc Jacobs*
Swarovski's Perry Ellis Award for Womenswear *Derek Lam*
Swarovski's Perry Ellis Award for Menswear *Alexandre Plokhov for Cloak*
Swarovski's Perry Ellis Award for Accessory Design *Anthony Camargo*
& Nak Armstrong for Anthony Nak
Eugenia Sheppard Award *Gilles Bensimon*

International Award *Alber Elbaz*
Lifetime Achievement Award *Diane von Furstenberg*
Award for Fashion Influence *Kate Moss*
Board of Directors' Special Tribute *Norma Kamali*

2004

Womenswear Designer of the Year *Carolina Herrera*
Menswear Designer of the Year *Sean Combs for Sean John*
Accessory Designer of the Year *Reed Krakoff for Coach*
Swarovski's Perry Ellis Award for Ready-to-Wear *Zac Posen*
Swarovski's Perry Ellis Award for Accessory Design *Eugenia Kim*
Eugenia Sheppard Award *Teri Agins*

International Award *Miuccia Prada*
Lifetime Achievement Award *Donna Karan*
Fashion Icon Award *Sarah Jessica Parker*
Eleanor Lambert Award *Irving Penn*
Board of Directors' Special Tribute *Tom Ford*

2003

Womenswear Designer of the Year *Narciso Rodriguez*
Menswear Designer of the Year *Michael Kors*
Accessory Designer of the Year *Marc Jacobs for Marc Jacobs*
Swarovski's Perry Ellis Award for Ready-to-Wear *Lazaro Hernandez*
& Jack McCollough for Proenza Schouler
Swarovski's Perry Ellis Award for Accessory Design *Brian Atwood*
Eugenia Sheppard Award *André Leon Talley*
International Award *Alexander McQueen*
Lifetime Achievement Award *Anna Wintour*
Fashion Icon Award *Nicole Kidman*
Eleanor Lambert Award *Rose Marie Bravo*
Board of Directors' Special Tribute *Oleg Cassini*

2002

Womenswear Designer of the Year *Narciso Rodriguez*
Menswear Designer of the Yea *Marc Jacobs*
Accessory Designer of the Year *Tom Ford for Yves Saint Laurent Rive Gauche*
Perry Ellis Award *Rick Owens*
Eugenia Sheppard Award *Cathy Horyn*
International Award *Hedi Slimane for Dior Homme*
Lifetime Achievement Award *Grace Coddington*
Lifetime Achievement Award *Karl Lagerfeld*
Fashion Icon Award *CZ Guest*
Creative Visionary Award *Stephen Gan*
Eleanor Lambert Award *Kal Ruttenstein*

2001

Womenswear Designer of the Year *Tom Ford*
Menswear Designer of the Year *John Varvatos*
Accessory Designer of the Year *Reed Krakoff for Coach*
Perry Ellis Award for Womenswear *Daphne Gutierrez*
& Nicole Noselli for Bruce
Perry Ellis Award for Menswear *William Reid*

Perry Ellis Award for Accessories *Edmundo Castillo*
International Designer of the Year *Nicolas Ghesquière for Balenciaga*
Lifetime Achievement Award *Calvin Klein*
Eugenia Sheppard Award *Bridget Foley*
Humanitarian Award *Evelyn Lauder*
Eleanor Lambert Award *Dawn Mello*
Special Award *Bernard Arnault* for his Globalization of the
Business of Fashion with Style
Special Award *Bob Mackie* for his Fashion Exuberance
Special Award *Saks Fifth Avenue* for their Retail Leadership of Fashion
Targets Breast Cancer

2000
Womenswear Designer of the Year *Oscar de la Renta*
Menswear Designer of the Year *Helmut Lang*
Accessory Designer of the Year *Richard Lambertson & John Truex*
Perry Ellis Award for Womenswear *Miguel Adrover*
Perry Ellis Award for Menswear *John Varvatos*
Perry Ellis Award for Accessories *Dean Harris*
International Designer of the Year *Jean-Paul Gaultier*
Lifetime Achievement Award *Valentino*
Humanitarian Award *Liz Claiborne for the Liz Claiborne and
Art Ortenenberg Foundation*
Most Stylish Dot.com Award *PleatsPlease.com*
Special Award The Dean of American Fashion *Bill Blass*
Special Award The American Regional Press presented to *Janet McCue*
Special Award *The Academy of Motion Picture Arts & Sciences* for Creating
the World's Most Glamorous Fashion Show

1998/1999
Womenswear Designer of the Year *Michael Kors*
Menswear Designer of the Year *Calvin Klein*
Accessory Designer of the Year *Marc Jacobs*
Perry Ellis Award for Womenswear *Josh Patner and Bryan Bradley for Tuleh*
Perry Ellis Award for Menswear *Matt Nye*
Perry Ellis Award for Accessories *Tony Valentine*
International Designer of the Year Award *Yohji Yamamoto*
Lifetime Achievement Award *Yves Saint Laurent*
Eugenia Sheppard Award *Elsa Klensh*
Humanitarian Award *Liz Tilberis*
Special Award *Betsey Johnson* for her Timeless Talent
Special Award *Simon Doonan* for his Windows on Fashion
Special Award *InStyle Magazine* for Putting the Spotlight
on Fashion and Hollywood
Special Award *Sophia Loren* for a Lifetime of Style
Special Award *Cher* for her Influence on Fashion

1997
Womenswear Designer of the Year *Marc Jacobs*
Menswear Designer of the Year *John Bartlett*
Accessory Designer of the Year *Kate Spade*
Perry Ellis Award for Womenswear *Narciso Rodriguez*
Perry Ellis Award for Menswear *Sandy Dalal*

International Designer of the Year Award *John Galliano*
Lifetime Achievement Award *Geoffrey Beene*
The Stilleto Award *Manolo Blahnik*
Special Award *Anna Wintour* for her Influence on Fashion
Dom Pérignon Award *Ralph Lauren*
Special Award *Elizabeth Taylor* for a Lifetime of Glamour
Special Tributes *Gianni Versace & Princess Diana*

1996
Womenswear Designer of the Year *Donna Karan*
Menswear Designer of the Year *Ralph Lauren*
Accessory Designer of the Year *Elsa Peretti for Tiffany & Co.*

Perry Ellis Award for Womenswear *Daryl Kerrigan for Daryl K.*
Perry Ellis Award for Menswear *Gene Meyer*
Perry Ellis Award for Accessories *Kari Sigerson and
Miranda Morrison for Sigerson Morrison*
International Designer of the Year Award *Helmut Lang*
Lifetime Achievement Award *Arnold Scaasi*
Eugenia Sheppard Award *Amy Spindler*
Dom Pérignon Award *Kenneth Cole*
Special Award *Richard Martin & Harold Koda*

1995
Womenswear Designer of the Year *Ralph Lauren*
Menswear Designer of the Year *Tommy Hilfiger*
Accessory Designer of the Year Award *Hush Puppies*
Perry Ellis Award for Womenswear *Marie-Anne Oudejans for Tocca*
Perry Ellis Award for Menswear *Richard Tyler / Richard Bengtsson
& Edward Pavlick for Richard Edwards (tie)*
Perry Ellis Award for Accessories *Kate Spade*
International Designer of the Year Award *Tom Ford for Gucci*
Lifetime Achievement Award *Hubert de Givenchy*
Eugenia Sheppard Award *Suzy Menkes*
Special Award *Isaac Mizrahi & Douglas Keeve for Unzipped*
Special Award *Robert Isabell*
Special Award *Lauren Bacall*
Dom Pérignon Award *Bill Blass*

1994
Womenswear Designer of the Year *Richard Tyler*
Perry Ellis Award for Womenswear *Victor Alfaro and Cynthia Rowley (tie)*
Perry Ellis Award for Menswear *Robert Freda*
Accessory Award for Wome *Robert Lee Morris*
Accessory Award for Men *Gene Meyer*
Lifetime Achievement Award
Carrie Donovan/Nonnie Moore/Bernadine Morris
Eugenia Sheppard Award *Patrick McCarthy*
Special Award *Elizabeth Tilberis*
Special Award *The Wonderbra*
Special Award *Kevyn Aucoin*
Special Tribute *Jacqueline Kennedy Onassis*

CFDA Fashion Award Winners 1981/2008

1993
Womenswear Designer of the Year *Calvin Klein*
Menswear Designer of the Year *Calvin Klein*
Perry Ellis Award for Womenswear *Richard Tyler*
Perry Ellis Award for Menswear *John Bartlett*
Lifetime Achievement Award *Judith Leiber/Polly Allen Mellen*
International Award for Accessories *Prada*
Eugenia Sheppard Award *Bill Cunningham*
Special Awards *Fabien Baron/Adidas /Converse/Keds/Nike/Reebok*
Industry Tribute *Eleanor Lambert*

1992
Womenswear Designer of the Year *Marc Jacobs*
Menswear Designer of the Year *Donna Karan*
Accessory Designer of the Year Award *Chrome Hearts*
Perry Ellis Award *Anna Sui*
International Award *Gianni Versace*
Lifetime Achievement Award *Pauline Trigère*
Special Awards *Steven Meisel/Audrey Hepburn/
The Ribbon Project/Visual AIDS*

1991
Womenswear Designer of the Year *Isaac Mizrahi*
Menswear Designer of the Year *Roger Forsythe*
Accessory Designer of the Year Award *Karl Lagerfeld for House of Chanel*
Perry Ellis Award *Todd Oldham*
Lifetime Achievement Award *Ralph Lauren*
Eugenia Sheppard Award *Marylou Luther*
Special Award *Marvin Traub/Harley Davidson/Jessye Norman/
Anjelica Huston/Judith Jamison*

1990
Womenswear Designer of the Year *Donna Karan*
Menswear Designer of the Year *Joseph Abboud*
Accessory Designer of the Year Award *Manolo Blahnik*
Perry Ellis Award *Christian Francis Roth*
Lifetime Achievement Award *Martha Graham*
Eugenia Sheppard Award *Genevieve Buck*
Special Awards *Emilio Pucci/Anna Wintour*
Special Tribute *Halston*

1989
Womenswear Designer of the Year *Isaac Mizrahi*
Menswear Designer of the Year *Joseph Abboud*
Accessory Designer of the Year Award *Paloma Picasso*
Perry Ellis Award *Gordon Henderson*
Lifetime Achievement Award *Oscar de la Renta*
Eugenia Sheppard Award *Carrie Donovan*
Special Award *The Gap*
Special Tribute *Giorgio di Sant'Angelo/Diana Vreeland*

1988
Menswear Designer of the Year *Bill Robinson*
Perry Ellis Award *Isaac Mizrahi*
Lifetime Achievement Award *Richard Avedon/Nancy Reagan*
Eugenia Sheppard Award *Nina Hyde*
Special Award *Geoffrey Beene/Karl Lagerfeld for House of Chanel/Grace
Mirabella/Judith Peabody/The Wool Bureau Inc.*

1987
Best American Collection *Calvin Klein*
Menswear Designer of the Year *Ronaldus Shamask*
Perry Ellis Award *Marc Jacobs*
Eugenia Sheppard Award *Bernadine Morris*

Lifetime Achievement Award *Giorgio Armani, Horst, Eleanor Lambert*
Special Awards *Arnell/Bickford Associates and Donna Karan/Manolo
Blahnik/Hebe Dorsey/FIT/Giorgio di Sant'Angelo/Arnold Scaasi/Vanity Fair*
Special Tribute *Mrs. Vincent Astor*

1986
Perry Ellis Award *David Cameron (first recipient)*
Lifetime Achievement Award *Bill Blass/Marlene Dietrich*
Special Awards *Geoffrey Beene/Dalma Callado/Elle Magazine/
Etta Froio/Donna Karan/Elsa Klensch/Christian Lacroix/Ralph Lauren*

1985
Lifetime Achievement Award *Katharine Hepburn/Alexander Liberman*
Special Tribute *Rudy Gernreich*
Special Awards *Geoffrey Beene/Liz Claiborne/Norma Kamali/Donna
Karan/Miami Vic/Robert Lee Morris/Ray-Ban Sunglasses / "Tango
Argentino"*

1984
Lifetime Achievement Award *James Galanos*
Special Tribute *Eugenia Sheppard*
Special Awards *Astor Place Hair Design/Bergdorf GoodmanKitty
D'Alessio/ John Fairchild/Annie Flanders/Peter Moore NIKE/ Robert
Pittman MTV/Stephen Sprouse/Diana Vreeland/Bruce Weber*

1983
*Jeff Aquilon/Giorgio Armani/Diane De Witt/Perry Ellis/Calvin Klein/
Antonio Lopez/Issey Miyake/Patricia Underwood/Bruce Weber*

1982
Bill Cunningham/Perry Ellis/Norma Kamali/Karl Lagerfeld/Antonio Lopez

1981
*Jhane Barnes/Perry Ellis/Andrew Fezza/Alexander Julian/Barry
Kieselstein-Cord/Calvin Klein/Nancy Knox/Ralph Lauren/Robert Lighton/
Alex Mate & Lee Brooks/Yves Saint Laurent/Fernando Sanchez*

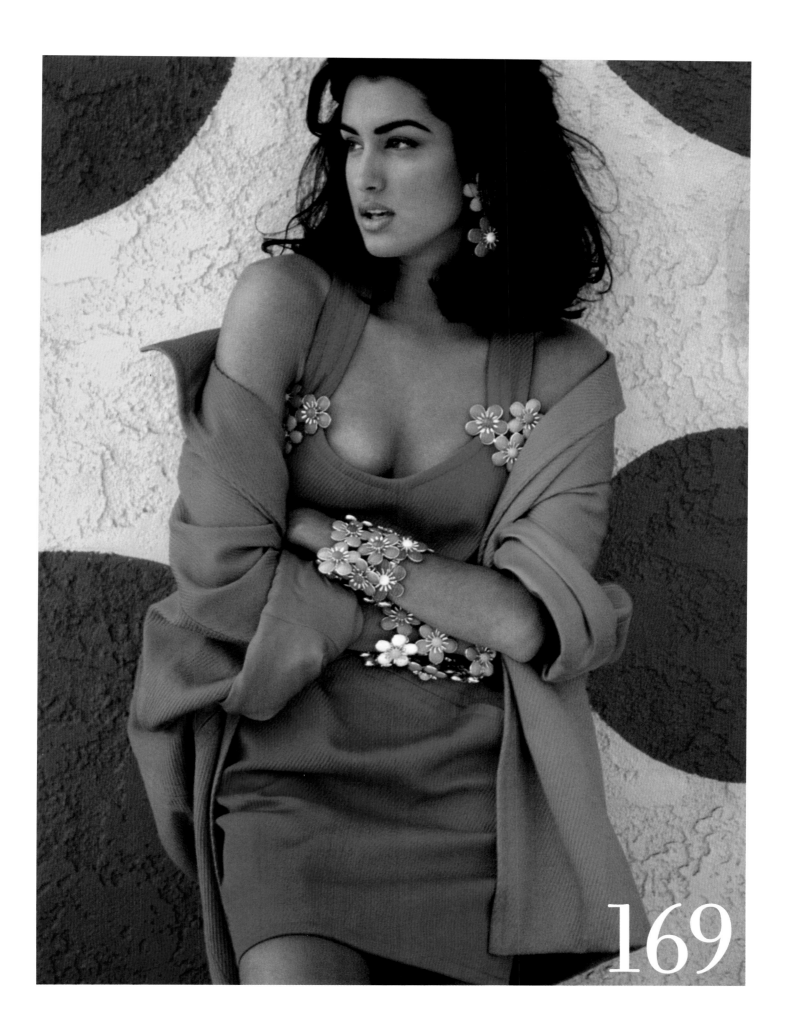

169

CREDITS

The still life artwork that appears on the opening pages of each chapter in *American Fashion Accessories* was commissioned by the CFDA for this edition and photographed by Andrew Bettles.

Collection; p.163 © Elgort Arthur, Condé Nast Archives; p.164 © Nathaniel Goldberg; p.165 Photo by Alban Christ; p.166 © Warner Bros/The Kobal Collection; p.167 Courtesy PHI; p.168 Columbia Pictures/Photofest © Peter Sorel, Columbia Pictures; p.169 Christopher Gentile/ Condé Nast Archive © Condé Nast Publications; p.170 AFP/Getty Images © 2007 Getty Images; p.171 © 2007 Getty Images; p.172 © Bruce Weber, courtesy Ralph Lauren; p.173 © Jim Arndt; p.174 © James White; p.175 courtesy Everett Collection; p.176 courtesy of Phillips de Pury & Company; p.177 © Micaella Rossato; p.178-179 © Mario Testino, courtesy Michael Kors; p.180 Tabitha Simmons/ Condé Nast Archive © Condé Nast Publications; p.181 © Bettmann/Corbis; p.182 © Ellen von Unwerth; p.183 © Bettmann/Corbis; p.185 © Andrew Bettles; p.186 © Patrick Demarchelier, Condé Nast Archives; p.188, left Thierry Bearzatto © Chrome Hearts; p.188, center © Dan Jackson; p.188, right courtesy Mary Ping; p.189, left © David Roemer, courtesy Dennis Basso; p.189, center © Michael Crouser; p.189, right © Jonathan Skow; p191 © Alasdair McLellan; p.192 Courtesy of Band of Outsiders; p.195 Photo by Murray Garrett/Getty Images; p.196-197 © 2007 Getty Images; p.198-199 Laurie Lynn Stark © Chrome Hearts; p.200 © Horst Diekgerdes; p.201 © Terry Richardson; p.202 © 2007 Getty Images; p.203 © Frank Versonsky; p.204 © Simon Alcantara; p.205 © Bob Seidemann; p.206 Photo by Diane Vasil; p.207 © David Kressler, courtesy Dean Harris; p.208 © Anton Corbijn; p.209 © Inez & Vinoodh, Trunk Archive; p.210-211 © Noah Sheldon; p.212 © Kristina Loggia; p.213 © Roxanne Lowitt; p.214 © Martha Cooper; p.215 © Jesse Frohman; p.216 Courtesy of Harry Winston; p.217 courtesy of Amy Chan; p.218 © Kengo Yamada of super sonic, *Senses Magazine*; p.219 © Nathaniel Goldberg; p.220 © Herb Ritts; p221 Photo by Michael Spirito; p.222 © Ann Giordano/Corbis; p.223 © Kristina Loggia; p.224 © Richard Burbridge; p.225 © Tom Schierlitz; p.226-227 © Tom Schierlitz; p.228 © Dean Isidro; p.229 © William Eadon; p.230-231 courtesy of Tory Burch; p.232 courtesy of the Everett Collection; p.233 © Steve Schapiro/Corbis; p.234-235 © Corbis; p.236 © Mark Hunter (thecobrasnake); p.237 courtesy of Gemma Khang; p.238 © Aaron Cobbett; p.239 © Corbis; p.240 © Patrick McMullan; p.241 © Davies & Starr; p.242 © Cornett Grant/Conde Nast; p.243 © Horst Diekgerdes; p.244-245 courtesy Carlos Falchi; p.246 © A. Saunder; p.248 Hulton Archive © Getty Images; p.249 © Jem Production, courtesy Jack Rogers Shoes; p.250-251 © Keith King; p.252 © Nathaniel Goldberg; p.253 Getty Images ©1979 Georges DeKeerle; p.254 Courtesy of M+J Savitt; p.255 © Patrick McMullan; p.256-257 © Mark Hunter (thecobrasnake); p.258 © Patrick McMullan; p.259 © Corbis; p.260 © Andrew Bettles; p.262 Courtesy of Material Connexion; p.265 © Rueters; p.266 © Guido Mocafico 2000/The Fashion; p.269 © Getty Images; p.272 © Mathew Ralston, courtesy of Louis Dell'Olio; p.274 Number 5 Photograph © 1968 The Metropolitan Museum of Art; p.274 Number 4 The Metropolitan Museum of Art, Gift of Carey Adina, 1995; photograph © 1999 The Metropolitan Museum of Art; p.274 Number 102 © Michael Marienthal, courtesy of Nancy Geist; p.276 Number 16 © Rock & Republic; p.276 Number 64 © Zero Maria Cornejo; p.276 Number 21 Photography by Bela Borsodi; p.276 Number 224 Photography by Amy Holman, courtesy of Mary Ann Restivo; p.277 Number 35 © Dan Lecca, courtesy of Thom Browne; p.277 Number 54 © Elaine Castillo Keller, courtesy of Carol Cohen; p.277 Number 272 Courtesy of CFDA and Jay Strongwater; p.278 Number 295 Photography by Richard Mauro, courtesy of Joan Vass; p.278 Number 129 Courtesy of Henry Jaconbson; p.278 Number 70 Photography by Alex Norden, courtesy of James Coviello; p.278 Number 261 Courtesy of Maria Synder; p.278 Number 49 Courtesy of Ron Chereskin; p.279 Number 142 © Nico Lliev, courtesy of Eugenia Kim; p.279 Number 44 Photography by Dan Lecca, courtesy of Chaiken Clothing; p.279 Number 251 Photography by Ryan Rish, courtesy of Marcia Sherrill; p.279 Number 120 Photography by Dan Lecca, courtesy of Joan Helpern; p.280 Number 246 RSP Productions (Ron Saltiel), courtesy of Jordan Schlanger; p.280 Number 293 Photography by Michael Oldford @ Square Moose; p.280 Number 260 Photography by Tim Darwish; p.280 Number 201 Photography by John Aquino/Condé Nast Archives; p.281 Number 279 Photography by Brian Bowen Smith, courtesy of Rebecca Taylor; p.281 Number 185 Photography by Dewey Nicks, courtesy of Isaac Mizrahi; p.281 Number 157 courtsey of Keds; p.281 Number 180 Photography by Stewart Shining, courtesy of Gene Meyer; p.285 Photography by Patrick Demarchelier.

All credits are based on information received by deadline and CFDA apologizes for any credit informatonion that may be missing.

ACKNOWLEDGMENTS

Among CFDA's membership, we are proud to count America's foremost accessory designers. It is all too often that these designers go unrecognized for their innovation and creativity. *American Fashion Accessories* was commissioned by the Council of Fashion Designers of America to pay tribute to those members and others working in accessories, and to document a growing and influential sector in the American Fashion Industry. A special thanks to our editor Candy Pratts Price, who is the preeminent authority on accessories, and is respected around the world for her incredible eye for detail. Throughout her career, she has been on the look-out for all that is "surprising and clever and new", although, more times than not, she is the guiding force behind the start of a trend or the next "It" item. It was Candy who had the keen insight to bring the best talent to this book with a team that included Art Tavee and Jessica Glasscock. Thank you Art and Jessica! This book is extra special thanks to Andrew Bettles whose orginal photography opens each chapter. We are deeply grateful for his work on this project. I am grateful to CFDA President Diane von Furstenberg for caring for and constantly working on behalf of all designers, and whose vision made this book possible. I must thank Prosper and Martine Assouline for publishing *American Fashion Accessories* and our editor Esther Kremer. Also thanks to Amy Trombat, Allison Power, Cyrene Mary and everyone at Assouline for your hard work. Special thanks to Steven Torres of Style.com and the CFDA Staff —especially Nicole Borel-Saladin, Katie Campion and Cari Engel. Your work on this book is unforgettable. But it is really all of the designers, editors, photographers, agents, models and everyone else who allowed us access to utilize your work, to whom we are most indebted. Without you, this book could not have been put together. Steven Kolb Executive Director CFDA

Aaron Cobbett; Aaron De Mey; Aaron Watson; Adam Garel-Frantzen; Adolfo; Agyness Deyn; Ai Asai; Albert Watson; Alec Friedman; Alex Toy; Alexandra Carlin; Alexis Bittar; Alicia Colen; Alixe Boyer; Allison Power; Amber Valletta; Amy Holman; Amy Trombat, Andis Akerfelds; André Leon Talley; Andrea Fodera ; Andrea Maiolano; Andrea Rosengarten; Andreas Melbostad; Angela Highsmith; Angela Niles; Anis Khalil; Anita Martignetti; Ann Stordahl; Anna Natsume; Anna Sui; Anna Wintour; Anne Hong; Annie Leibovitz; Arlena Pordoy; Art + Commerce; Art Partner; Art Tavee; Arthur Elgort; Artists Rights Society; Asa Larsson; Assouline; Aude Bouquet; BagBorroworSteal.com; Band of Outsiders; Barbara Kasman; BCBG; Ben Charland; Beth Griffin; Bette-Ann Gwathmey; Beverly Solidon; Bill Melnick; Billy Daley; Billy Farrell; Billy Jim; Bob Seidemann; Botkier; Brandy J. Smith; Brent at Photofest; Briana Genero; Brian Bowen Smith; Bridget Foley; Brittnee Nicol; Brooke German; Bruce Davidson; Bryan Langston; Buffy Birrittella; Caitlin Maloney; Calvin Klein; Cameron Mcvey; Candice Marks; Candy Pratts Price; Cara Serio; Carlos Falchi; Carol Cohen; Carolee; Carolina Amato; Caroline Sturgess;Caroline Trentini; Carson Glover; Carton Davis; Carey Adina; Cathy Waterman; Catie Davenport; Céline Stevens; Central Talent Booking; César Recio; Charlie Scheips; Chloe Charlesworth; Christian Roth; Christiane Mack; Christopher Bartley; Christy Turlington; Chrome Hearts; Claire Typaldos; Claudia Lebenthal; Claudia Mata; Coach; Cobrasnake.com; Cole Haan; Colette Malouf; Company Agenda; Conagra Foods; Constance Winant; Contact Press Images; Converse; Corbis; Corey Kelly; Cornelia Adams; Coromoto Atencio; Courtney Calhoun; Courtney Crangi; Cristina Dennstedt; Cybil Powers; Cyd Mullen; Cynthia Leung; Cynthia Rowley; Cyrene Mary; D+V Management; Dalila Solis; Damian Monzillo; Dan Jackson; Dan Lecca; Dana Caruso; Dana Gati; dandvmanagement. com; Dangi Chu; Danielle Billinkoff; David @ DNA Models; David Behl; David Dion; David Evans; David Pillinger; David Schoerner; David Vandewal; David Yurman; Dawn Lucas; Dawn Mello; de facto inc.; Dean Harris; Dean Voykovich; Dee deVries Salomon; Della Smith; Dennis Gleason; Denis Piel; Designers Management Agency; Dewey Nicks; Devi Kroell; Diane von Furstenberg; Digital Visualization Inc.; Dirk Standen; DNA Models; Donna Karan; Donna Peda; Dtouch; Ebony Dee Cheyne; Edmundo Castillo; Elaine Leung; Elaine Castillo Keller; Eleanor Banco; Elite New York, Bowen 2006; Jason Young; Elizabeth Garrett; Elizabeth Musmanno; Elizabeth Watson Agency; Amy Lin; Elle Magazine; Ellen Gross; Ellen Guidone; Ellen Olson; Ellen Von Unwerth; Elyse Connolly; Emi Koizumi; Emmanuel Tanner @ Marek and Associates; Eric Alger; Eric Delph; Eric Javits; Erica Courtney; Erika Imberti; Esther Kremer; Eugenia Kim; Everett Collection; Ex Ovo; Exhibitionist; Felicia Jocus; Filipa Fino; Fiona Thomas; Frank Veronsky; Fusion Model Management; Gabrielle Sirkin; Gail Yong; Gemma Kahng; Gene Meyer; Geoffrey Beene Foundation; Gerard Yosca; Getty Images; Gilles Bensimon; Grace Limantra; Greg Kadel; Gregory Mastianni; Guido Mocafico; Gulf Oil; Gunmetal; Guy Oseary; Hamilton South; Hanako Shapiro; Harriet Mays Powell; Harry N. Abrams, Inc.; Harry Winston; Hearst; Heather Bordin Prizer; Heather Bracher Severs; Heidi C. Koch; Henry Jacobson; Hiro; Hitomi Kaneda; HL Group; Horst Diekgerdes; Howard Greenberg Gallery; Ibby Clifford; Ikon Models Fashion; IMG; Inez & Vinoodh; International Center of Photography; Irving Solero; Isabel Asha Penzlien; Isaac Manevitz; Isaac Mizrahi; Ivan Shaw; Jack Dutsch; Jae Choi at The Collective Shift; James Coviello; James Moore; James White; Jamina Gonzalez; Janis Savitt; Jason Weisenfeld; Jay Lawrence Goldman; Jay Strongwater; Jeannie Rosi; Jeffrey D. Smith; Jeffrey Kalinsky; Jennifer Algoo; Jennifer L. Crawford; Jennifer Ramey at IMG World; Jenny Lim; Jess Frost; Jesse Frohman; Jessica Glasscock; Jessica Marx; Jill Ikonomopoulos; Jim Arndt; Joan Helpern; Joan Vass; Joanna Jordan; Joe Di Condina; John Aquino; John Bigelow Taylor; John Hardy; John Hubba; John Varvatos; Johnathan Emus; Jonathan Skow Photography; Jordan Schlanger; Joseph Boitano; Joyce; Judith Leiber; Judy Casey Inc.; Judy Hummel; Julia Hansen; Julie Chaiken; Julie Crisman; Julie Gilhart; Julie Vaysbord; Justin Giunta; Justin Guarino; Karen Obrien; Karen Peterson; Kate Moss; Kate Spade; Kate Waters; Katherine Erwin; Kathryn O'Brien; Katie Berkery; Katie Campion; Katrin Zimmermann; KCD; Keds; Keith King; Kellie Probst; Ken Downing; Kenda ll Tracewski; Kengo Yamada; Kenneth Cole; Kenneth Hair Salon; Kenneth Jay Lane; Kerry Quinn; Kira Prazak; Krista B. Fragos; Kristen Bowman; Kristina Dashuk; LaForce + Stevens; Lambertson Truex; Lana Sanders; Larry Leight; Lauren Attermann; Lauren Fluhart; Lauren K. Meisels; Lauren Pollack; Lauren Turner; Lauren Winer; Laurence Vuillemin; Laurie Lynn Stark; Leah Jacobson; Leigh Montville; Leon Yuan; Leonor Mamanna; Lilace Hatayama; Lili Root; Linda Buckley; Linda Fargo; Lindsey Ridell; Ling Tan from IMG; Lisa Jacobson; Lisa Smilor; Liz Claiborne; Liz Landa; Loeffler Randall; Loree Rodkin; Lori Krauss; Lorna Donohue; Louis Dell'Olio; Louise Dahl Woolfe; Luana Onori; Luigi Murenu; M + J Savitt; Madonna; Magnum Photos, Inc.; Malcolm Carfrae; Man Ray; Map Inc; Mara Elise; Marc Beckman; Marc Jacobs; Marc Rahr; Marcia Sherrill; Marcy Roberts; Margaret Zaragoza; Maria Cornejo; Maria Fernanda Meza; Maria Snyder; Marice P. Galli; Marie Cuypers; Mario Martins; Mario Testino; Marisa Crocco; Mark Edward Inc; Agatha Relota; Mark George; Mark Hunter; Mark McKenna; Mark Tanno; Marlies Dwyer; Martha Cooper; Martin Munkácsi; Mary Ann Restivo; Mary Ping; Marylin Agency; Material ConneXion; Mathew Ralston; Matt Murphy; Mauricio Hermosillo; Me & Ro; Media Mix NYC; Melissa Galandak; Melissa Haggerty; Melissa Regan; Meredith Melling Burke; Meredith Paley; Merlin Bronques; Merrideth Miller; Micaela Rossato; Michael Ball; Michael Crouser; Michael Fink; Michael Kors; Michael Maarienthal; Michael Morelli; Michael R. Thom; Michael Ross; Michael Schwarz; Micheal Oldford @ Square Moose; Michael Shulman; Michael Spirito; Michelle Finocchi; Michelle Marsili; Michelle Sack; Michelle Smith; Miki Higasa; Miles Aldridge; Mimi So; Mish Tworkowski; Missy LaMonico; Moira Sykes; Monica Botkier; Monique Boniol; Muriel Quancard-Johnson; Nancy Geist; Nancy Risdon; Nanette Lepore; Naomi Brown; Narciso Rodriguez; Nathalie Wiesner; Nathaniel Goldberg; New York Magazine; Nicolas Moore; Nicholas Varney; Nico Liev; Nicole Borel-Saladin; Nicole Cari; Nicole Chonowski; Nicole Miller; Nicole Mucciolo; Nicole Simithraaratchy ; Nike; Nilly and Liz at Streeters NYC; Noah Sheldon; Noelle Hoeppe; Norman Jean Roy; Octavio Olvera; Oliver Peoples; Paola Kudacki; Pascale Cohen; Patricia McMahon Photography; Patricia Underwood; Patricia von Muslin; Patrick McCarthy; Patrick McGregor; Patrick McMullan; Patrick O'Connell; Patti Cohen; Peita at Hiro Studio; Peoples Revolution; Peter Arnold; Phi; Philip Crangi; Phillips de Pury & Company; Picturehouse; Playboy; PR Consulting; Rafe Totengco; Ralph Lauren; Ralph Siciliano; Ramell Thornton; Raymond Meier; Rebecca Roberts; Rebecca Taylor; Reed Krakoff; Reuters; Rhea Landig; B.J. Gillian; Trevor Bowden; Richard Burbridge; Richard Lambertson; Richard Lombard; Ricky Serbin; Rina Yoshikoshi; Robert Lee Morris; Robert Marc; Robyn Berkley; Rock & Republic; Rod Keenan; Rodney Smith; Ron Chereskin; Roopal Patel; Rosemarie Mueller; Roswitha Graser; Roxanne Lowit; Roxanne Lowit Photographs. Inc; Russell Nardozza; Ryan Risch; Sabrina Ganier; Sally Singer; Sam Wasserman; Samantha Gregory; Sarah Anderson; Saul Rosen; Scott Gray; Scott Sternberg; Scottie Walden; Selima Salaun; Senses Magazine; Seth at Terry Richardson Studio; Shannon Oliverio; Shantel Burgess; Sharon Miko; Shoko at Roxanne Lowit Photographs. Inc; Shoky Monfared; Si Newhouse; Silano; Simon Alcantara; Sloan Mandell; Slow and Steady Wins the Race; Sogole Honarvar; Sophie McDonnel; Sperry; Stan Herman; Stephanie at artmixphotography.com; Stephanie at Patricia McMahon Photography; Stephanie Bonk; Stephanie L. Miller; Stephanie Lake; Stephanie Reynolds; Stephen Dweck; Stephen Frandsen; Steven Torres; Stewart Searle; Streeters NYC; Stuart Weitzman; Style.com; Susannah Draper; Tabitha Simmons; Tamara Prezioso; Tania Fernandez; Tenique Bernard; Terry Richardson; Terry Richardson Studio; The Bonnie Cashin Foundation; The Herb Ritts Foundation; The Leiber Museum; The Metropolitan Museum of Art; The Museum at the Fashion Institute of Technology; The New York Times; Therese Raimondi; Thierry Bearzatto; Thom Browne; Tiffany & Co.; Todd Shemarya Artists Inc.; Tom Binns; Tom Booth; Tom Florio; Tom Schierlitz; Tommy Hilfiger; Tony Sambalos; Tory Burch; Tracy Paul & Company, Inc.; Tricia Gesner; Trina Turk; Trunk Archive; UCLA Library, Department of Special Collections; United Talent Agency; V Magazine; Valerie De Joya; Valerie Steele; Vanessa Noel; Vanessa Vasquez; Vanity Fair; Vera Wang; Vicente Pouso; Victoria Bartlett; Virginia Smith; W; Wendy Israel; Wenlan Chia; Whiting + Davis; WWD; Zac Posen.

Special thanks to all CFDA members.

... and thanks to those who long to carry the "It" bag, those who make a statement with their jewelry and those who obsess over the latest shoes – without you, accessories would not be the influence in fashion they are today.